# GRANT WOOD

# GRANT WOOD

## A Study in American Art and Culture

James M. Dennis

*A Studio Book*    The Viking Press    New York

To Claudia and David and John

"What I miss most are the songs in the fields. No one sings them any more . . . and there are no more plows. I love a plow more than anything else on a farm."

—ARSHILE GORKY,
as quoted by
Ethel K. Schwabacher
in *Arshile Gorky* (1957)

First published in 1975 by The Viking Press, Inc.
625 Madison Avenue, New York, N.Y. 10022
Published simultaneously in Canada by
The Macmillan Company of Canada Limited
Printed in U.S.A.

Library of Congress Cataloging in Publication Data
Dennis, James M.
    Grant Wood: A study in American art and culture.
    (A Studio book)
    Includes bibliographical references and index.
    1. Wood, Grant, 1892-1942.
ND237.W795D46     759.13 [B]     75-23108
ISBN 0-670-34784-1

# Contents

# Illustrations

# Color Plates

# Acknowledgments

I wish to acknowledge my indebtedness to Mrs. Nan Wood Graham, who generously provided me with information about her brother's career and with special insights into his art. A week of research at her home in southern California, where I explored personal records and scrapbooks, was enriched by her gracious, good-humored responses to my many inquiries.

Many other people also helped to make the research for this book a pleasant experience for me. The late Arnold Pyle, Grant Wood's assistant in Cedar Rapids, furnished me with valuable first-hand observations concerning Wood's best-known works from 1928 to 1932. I thank as well Mr. and Mrs. Frank Wood for an informative interview one afternoon at their home in San Diego. For information regarding Grant Wood in Iowa City I am pleased to have had the opportunity to talk to Dr. and Mrs. George D. Stoddard, Edwin Green, and Park Rinard.

I am grateful to Donn Young, former director of the Cedar Rapids Art Center, for helping me to locate many Grant Wood pictures and to John B. Turner for permitting me to study and photograph his collection and examine his father's scrapbook of Grant Wood memorabilia. For his unfailing patience in photographing the many Grant Wood works in eastern Iowa, I am indebted to George Henry of Cedar Rapids. I wish also to thank Gordon Fennell for his friendship and encouragement during my visits to Cedar Rapids.

Of the many people who welcomed me into their homes to view and discuss their Grant Wood paintings I am especially grateful to Miss Frances Prescott, Mrs. Marvin Cone, Mr. and Mrs. James B. Sigmund, Mr. and Mrs. Van Vechten Shaffer, Mr. and Mrs. Peter O. Stamats, Mr. and Mrs. Melvin Blumberg, and Mrs. Arnold Pyle.

The Special Collections Division of the University of Iowa Library, the Davenport (Iowa) Municipal Art Gallery, and the Archives of American Art provided me documentary material for which I am grateful. I also wish to thank Robert Levy for sharing his research on the conditions of Iowa farming during the Depression and for the information he gathered concerning the Little Gallery in Cedar Rapids. It is my special pleasure to acknowledge a large debt of gratitude to Arlette Klaric for typing and editing the manuscript through its various drafts. I am also grateful to Barbara Burn for her expert editorial guidance. Finally, my appreciation to the University of Wisconsin and to the National Endowment for the Humanities for granting me funds to complete the final stages of research and writing.

J.M.D.

# Introduction

More than just a famous painting in the Art Institute of Chicago, Grant Wood's *American Gothic* has furnished the American public with an entertaining self-image through forty-five years of a rapidly changing world. Thousands of color reproductions, the latest a jigsaw puzzle, and hundreds of parodies in the form of advertisements, cartoons, and political and social satire have guaranteed a lasting national popularity to the totemic couple. A few other Wood paintings, in particular *Stone City, Daughters of Revolution,* and *The Midnight Ride of Paul Revere,* also enjoy a measure of national fame, but, otherwise, familiarity with Wood's career is concentrated in Cedar Rapids, Iowa, where the artist was born and lived most of his life. While his best-known art is generally categorized as "regionalism," this label fails to account for the many efforts of his early years or to characterize satisfactorily his successful pictures of the 1930s. Consequently, a basic purpose of this book is to acquaint the reader with the development of Grant Wood's virtually self-taught art, from his earliest works up to and including his mature style as represented by *American Gothic,* and to locate his position in the history of American art and culture.

With the exception of an unauthorized, anecdotal biography, *Artist in Iowa; A Life of Grant Wood,* written rather hastily by Darrell Garwood soon after Wood's death and published in 1944, no book has concentrated exclusively on his life and work. Only a few small exhibition catalogues have appeared over the past three decades. The Fifty-third Annual Exhibition of American Painting and Sculpture at the Chicago Art Institute late in 1942 included a commemorative display of forty-eight Grant Wood pictures, twelve of which are reproduced in the exhibition catalogue. The catalogue also contains a brief essay of remembrance by Park Rinard, whom Wood had appointed to be his official biographer but whose full-length study has not yet appeared in print. In early 1957 the Davenport (Iowa) Municipal Art Gallery held an exhibition entitled "Grant Wood and the American Scene" in which *American Gothic* appeared for the last time outside Chicago. The modest catalogue of this exhibition was supplemented in 1964 by a larger pamphlet illustrating Davenport's Grant Wood holdings, which had been significantly enlarged in that year with a purchase from the artist's sister, Mrs. Nan Wood Graham. In 1959 a comprehensive Grant Wood exhibition was organized by the University of Kansas Museum of Art, accompanied by a small, well-illustrated catalogue; and in 1973 the Cedar Rapids Art Center published a large catalogue when the extensive Turner collection of Wood's early work was donated by John B. Turner II.

As this dearth of publications on Grant Wood's art might suggest, a truly comprehensive account of his career presents a challenging task. Numerous paintings, sketches, and drawings by Wood are widely dispersed throughout the United States and abroad, some yet to be identified as his. He kept no records of his early works and gave many of them away, which only serves to compound the problem of compiling an accurate catalogue of his total production.

The four-part essay of this monograph begins with a discussion of the successive changes in Wood's subject matter, form, and technique. In this first part I have emphasized that from the very beginning of his career, under the influence of the Arts and Crafts Movement, he was preoccupied with decorative design. To measure his progress through the 1920s I have compared examples of his work with those of two American contemporaries, John Sloan and Edward Hopper, and three moderate French "modernists," Pierre Bonnard, Edouard Vuillard, and Maurice Utrillo. I have also assessed the relevance of fifteenth- and sixteenth-century Northern European paintings and contemporary German art to Wood's major change of style by 1930 when he completed both *American Gothic* and *Stone City.*

However, a descriptive analysis of style alone is not enough to

understand and appreciate the works that Grant Wood created during the Depression years, not only his satirical pictures but also his idealized depictions of Iowa farm lands and farmers. Although painters in the United States had from the time of John Singleton Copley aspired to formal training and apprenticeship, they enjoyed only a limited opportunity to study painting as a "fine art" in the long-established European tradition. Whenever imaginative composition or singularity in content has been achieved in American art, they frequently derived, as in Grant Wood's case, from a semi-schooled independence born of isolation. Thus it is difficult and often impossible to apply traditional art-historical methods to the study of American art, whether these involve an analysis of "schools" of style or iconographic interpretation.

Although Wood based several of his satirical pictures on literature, and in one case (*Main Street*) accepted a commission to provide illustrations for a contemporary novel of social satire, his regionally inspired farm scenes of patterned fields and ornamental foliage are in large part personal fancies free of any direct artistic derivation in either design or imagery. Unique in American painting, these inventive idylls can nonetheless be identified with an extended public longing for the bucolic, a longing that has attained mythic proportions in both popular literature and political rhetoric since Thomas Jefferson. Therefore, in order to understand the cultural and social relevance of Wood's painting, I have turned to the history of American ideas, departing from customary art-historical methods to view these pictures as products of given historical preconditions and contemporary economic circumstances.

In Part II of this monograph I have concentrated on Wood's satiric interpretations of national fables and on his portrait caricatures, emphasizing the cosmopolitan qualities in his work, his humorous and perceptive insights into the restrictive social structure in which he found himself and his contemporary Americans. His reservation about the narrow outlook of an ingrown society is also witnessed in his determination to develop an art that would reach far beyond the area in which he had matured and from which he derived inspiration. In Part III, therefore, I have traced the emergence of Wood's personal form of regionalism, comparing and contrasting it with other regionalist points of view expressed by Thomas Hart Benton and John Steuart Curry in painting, and in literature by the Southern Agrarians, who attacked industrial urbanization as the primary enemy of regional culture. Grant Wood labored diligently to organize and encourage local schools of art as the bases for a rural Midwestern regionalism which would unite with regionalist art from other parts of the country. As he set it forth in the essay *Revolt Against the City* (reprinted here in the Appendix), Wood sought through this proposed league to establish a national tradition of locally nurtured "realist" painting, whose standards would ostensibly guard against the remnants of an effete academic classicism and protect the United States against that dreaded disease originating in the School of Paris: modern abstraction.

Part IV deals with the social as well as cultural significance of Grant Wood's decorative idealization of "farmer material" as he developed it into landscape and figural form. Since colonial times, as the United States was being transformed by the machine from a rural to an urban nation, Americans have persistently envisioned a land of pastoral self-sufficiency, a great green garden of farms tended by noble yeomen and their families. Enlisting the aid of American intellectual historians, in particular recent studies of the agrarian myth, I have attempted to show how Wood's stylized farmscapes and farm figures embody that perpetual American dream as no other American artist had done before.

# Chronology

1891    February 13. Grant DeVolson Wood born on a farm near Anamosa, Iowa, son of Francis M. and Hattie D. Weaver Wood.

1901    March. Death of father.
September. Mother moves from farm with three sons and daughter to Cedar Rapids, Iowa, twenty-five miles away.

1910    June. Graduates from Washington High School, Cedar Rapids.
Enrolls for summer term in the Minneapolis School of Design and Handicraft and Normal Art to study design under Ernest Batchelder.

1911    Enrolls for second summer at handicraft school, Minneapolis.

1911–1912    Teaches at Rosedale country school near Cedar Rapids. Attends night class in life drawing taught by Charles A. Cumming at the University of Iowa, Iowa City.

1913–1914    Works as designer at Kalo Silversmiths Shop in Chicago. Attends night classes at Chicago Art Institute.

1914–1916    Opens silversmith shop called the Wolund Shop, with a partner, Christopher Haga.
Goes out of business by end of 1915 and returns to Cedar Rapids.

1916–1917    Builds house in Kenwood Heights, Cedar Rapids, for mother, sister, and himself.

1918    Enters Army and designs camouflage in Washington, D.C., for artillery.

1919    September. Begins teaching art in Cedar Rapids public schools at Jackson Junior High.
October. Exhibits twenty-three small paintings in two-man exhibition with Marvin Cone at Killian's Department Store in Cedar Rapids.

1920    Summer. In Paris, paints with Marvin Cone.

1922    September. Transfers as art teacher to McKinley High School, Cedar Rapids.

1923–1924    Autumn. Attends Académie Julien in Paris.
Winter. Paints in Sorrento, Italy.
Spring and summer. Paints in French provinces and Paris.

1924    Autumn. Moves into studio-apartment above garage of Dave Turner's mortuary in Cedar Rapids.

1925    May. Retires from public school teaching.
Portraits of workers at Cherry Company dairy equipment manufacturing plant in Cedar Rapids.

1926    June and July. Exhibits forty-seven paintings at Galerie Carmine, Paris.

1927    January. Receives commission to design stained-glass window for Cedar Rapids Veterans Memorial Building.

1928    September. Travels to Munich to supervise manufacture of the Memorial Building stained-glass window.

1929    *Portrait of John B. Turner, Pioneer. Woman with Plants.*

1930    *American Gothic. Stone City.*

1931    *Midnight Ride of Paul Revere. Birthplace of Herbert Hoover.*

1932    Summer. Teaches at Stone City Colony and Art School, which he co-founded and helped to direct.
*Daughters of Revolution. Arbor Day.*

1933    Summer. Teaches at Stone City Colony during its second and last session.

1934    Named director of Public Works of Art Project in Iowa and begins murals for Iowa State University Library, Ames, Iowa.
*Dinner for Threshers.*
Becomes Associate Professor of Fine Arts at the University of Iowa.

1935    March. Marries Sara S. Maxon and purchases house in Iowa City.
One-man exhibitions at Lakeside Press Galleries, Chicago, and Ferargil Galleries, New York.
*Death on the Ridge Road.*
October. Death of mother.

1936    *Spring Turning.*

1937    Does first lithographs and completes illustrations for Limited Editions edition of Sinclair Lewis' *Main Street.*

1939    Divorces Sara Maxon Wood.
*Parson Weems' Fable.*

1941    *Spring in the Country. Spring in Town.*

1942    February 12. Dies.
October 29–December 10. Fifty-third Annual Exhibition of American Painting and Sculpture at Art Institute of Chicago includes Grant Wood memorial exhibition of forty-eight works.

# GRANT WOOD

# I

# The Craftsman-Painter
# Discovers the Imagination Isles

# 1. The Early Landscapes: from Indian Creek to Stone City

Grant Wood for the most part taught himself to paint. Two summer courses in design at a Midwestern art school and sporadic visits to life-drawing classes in Iowa, Chicago, and Paris over a space of some ten years mark the extent of his professional education. For a period of two decades, from before 1910 to the late 1920s, he made scores of small-scale panel paintings, the majority of which consist of trees enclosing a central area of open space. The remaining works that he produced before his major change in subject matter, style, and theme in 1929 were backyard views of his home town, Cedar Rapids; oil sketches of unobtrusive attractions painted on tour in Europe; a few portraits; and some surprisingly accomplished allegorical works for public commissions.

From the time of his early drawings, Grant Wood displayed an imaginative eye for pictorial design. In the watercolor sketches of birds and flowers that he did in the sixth and seventh grades, he characteristically isolated a bluebird on a branch, or a sprig of iris, blossom and bud (Figure 1). In the abstract, their tangible forms activate the blank paper by creating a patterned interplay of shapes.[1] In the watercolor *Currants* (Figure 2) of 1907, a cluster of fruit and small stems forms a circular pattern loosely outlined on buff-tinted manila paper. Hesitantly described leaves contribute to the multiplication of varied shapes.[2] During the spring of 1908 he directed his attention to larger plants and trees in nature studies painted in watercolor. His descriptions of the mass or textures of individual limbs and leaves in these works were secondary to the compositional arrangment of dark trunks and branches, and by carefully proportioning intervals of lines and contours he managed to create concentrated areas of what appear to be free-form shapes.

In a sketch of a winter tree, its four trunks sending bare limbs over Cedar Rapids' Indian Creek (Figure 3), Wood conformed to a traditional formula of classical landscape. The tree arches over a central body of water to counter and contain the foreground, while the surface play of spreading trunks, the angles and curves of subordinate limbs, dramatize the decorative quality of the picture, playing down picturesque "swimming-hole" sentiments.

In his yearbook illustration *Graduating Senior*, Grant Wood personified the senior class of Washington High School in Cedar Rapids in the form of a single, roughly rendered, misshapen figure (Figure 4). Flanked by dark shadows, an emerging student stands on the edge of a step, his oversized suit resembling a gnarled vine of highlights and uneven folds. His hands are shoved insecurely into his jacket pockets, a gesture that offsets the token confidence of a broad-brimmed hat thrown back on the head to reveal a childish face staring out with a disturbing sincerity. With solemn wit, Wood viewed the graduate as an uncertain boy costumed and posed in the clothes of a man with a hesitant foot, feeling for the first step into adulthood.

Perhaps with similar trepidation, Wood, two years later, set out to pursue his own career in art. On the night of his graduation from high school in June 1910 he traveled by train to Minneapolis to attend the School of Design, Handicraft, and Normal Art.[3] His purpose was to enroll in a summer design course taught by Ernest A. Batchelder, a leading American advocate of the English Arts and Crafts movement (Figure 5), with whose theories Wood had become acquainted through articles in *The Craftsman*, a magazine dedicated to handicraft, its history and continued practice. Before enrolling in the visiting instructor's course, Wood had, by improvising all the required equipment, completed a series of lessons in basic design that Batchelder had published in the magazine. From these formative experiences Wood not only learned how to make jewelry,

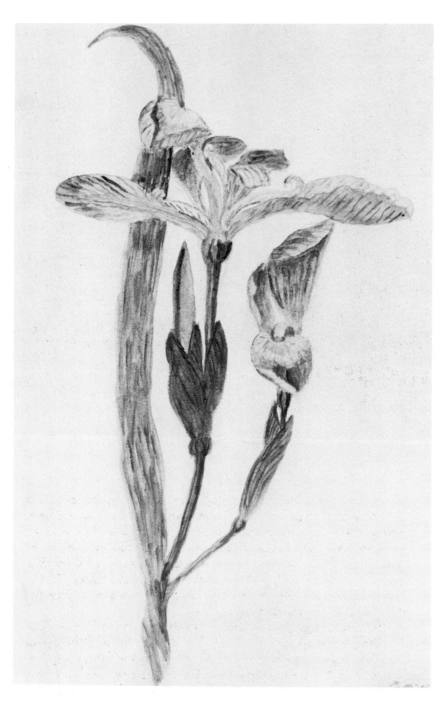

1. *Iris*, c. 1905.
Watercolor on paper, 11″ × 8½″.

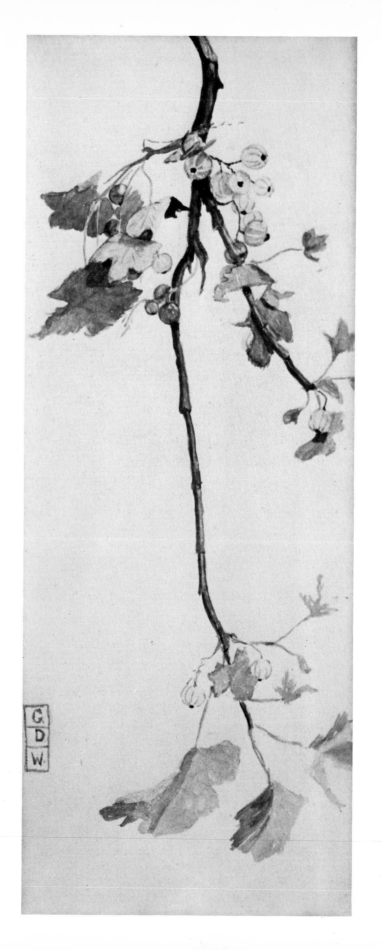

2. *Currants*, 1907.
Watercolor on paper, 11¾″ × 4¾″.

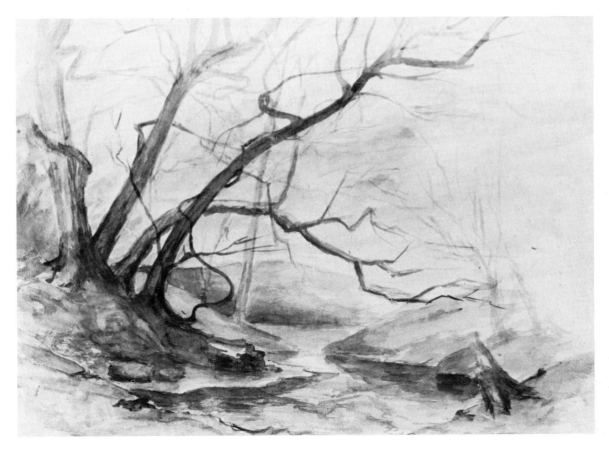

3. *Winter Tree over Indian Creek,* 1908.
Watercolor on paper, 8″ × 12″.

copperware, ornamental iron fixtures, and furniture; he was also eventually to apply many of Batchelder's basic principles of design, technique, and materials to the art of painting.

Art Nouveau, best remembered in the United States through Tiffany art glass, accommodated Wood's conception of an imaginary landscape in a 1912 painting, *Decorative Landscape with Crocuses* (Figure 6). Created as an ornamental piece for his friend Kate Loomis, the painting reflects the influence of the many book illustrations that preserved the salient features of this waning style. During the winter of 1910–1911 he had used Kate's small metal shop to make jewelry, and in late 1912 he helped decorate the interior of her new house. By then he had spent a second summer at the handicraft school in Minneapolis despite Batchelder's absence and had taught for a year in a one-room school outside Cedar Rapids. He had also collaborated with another friend, Paul Hanson, in writing articles on the ancient craft of constructing log cabins[4] and, without enrolling, had attended an evening life-drawing class at the University of Iowa. The landscape painting is expressive of this

period of searching in Wood's newly launched career; the long limb of a large tree gropes for companion trunks on the opposite side, bending to the low segmental arch of the frame. The central space opens onto a barren background sparsely populated with wild crocuses, giving the painting a mysterious, fairy-tale quality. The flowers provide the only colors, subdued purple and green, in the scheme of brown and gray that was keyed to the quiet interior for which the painting was designed.

Still undaunted by his failure to establish himself professionally after two years out of school, Wood returned to Washington High School hoping to do some murals depicting episodes in the history of Iowa. His presentation designs in opaque watercolors failed, however, to interest the school board, which refused to consider his scheme. Disheartened, the young painter left for Chicago in the spring of 1913. There he found a low-paying job at the Kalo Silversmiths Shop and the next academic year attended night classes at the Art Institute. In June 1914 he and a fellow Kalo craftsman, Christopher Haga, a Norwegian immigrant, formed a partnership;

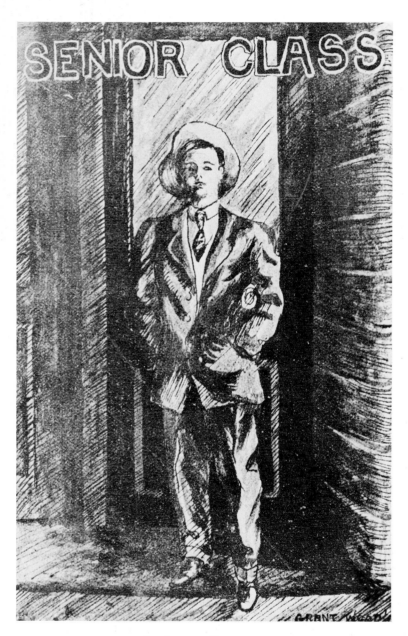

4. *Graduating Senior*, 1908.
Ink and wash drawing on paper for yearbook
illustration, 6¼″ × 4⅛″.

5. Ernest A. Batchelder: Illustration from his
book *The Principles of Design*, 1903, page 75.

they rented a farmhouse in Park Ridge and made jewelry and accessories under the name of the Wolund Shop. After an idle summer they ended their gainless venture late in 1915. During this Chicago period Wood produced a small, heavily painted panel entitled *Shadows* (Figure 7). In spite of its conventional open center outlined by arched limbs, the texture and surface patterning of the painting resemble the experimental abstractions done by a number of contemporary American painters who had gathered around Alfred Stieglitz and the European avant-garde works he exhibited in his small Fifth Avenue gallery, "291." Marsden Hartley and Arthur G. Dove were by this time applying principles of analytical cubism to their compositions of natural subjects and would continue to do so in their quest to express inner visions. Wood, on the other hand, must have been bewildered by the abstract painting and sculpture in the European sections of the 1913 Armory Show, when its traveling version came to the Art Institute of Chicago in the spring. Whatever his initial reaction, there is little indication, except in the work *Shadows*, that the newly inaugurated art had an immediate impact on Wood's methods of painting.

In January 1916, approximately a week after he had registered at the Art Institute for the first time as a full-time student, Wood, destitute, suddenly returned to Cedar Rapids, his train fare home

6. *Decorative Landscape with Crocuses*, 1912.
Oil on canvas, 12″ × 32½″.

borrowed from a friend. Fourteen years of oblivion were to follow before he would delight Chicago and the Art Institute with *American Gothic*, his permanent pass to unanticipated fame. But for the moment, unforeseen family financial difficulties sent him into an unsettled district on the edge of Cedar Rapids called Kenwood Heights. Here he lived with his mother and sister in a makeshift shelter barely protected from the elements while he built a small house which they moved into early in 1917.[5] In the course of this trying interval of virtual isolation, a year-long return to nature, Wood made at least one picture. Rustic in subject matter, his gray-toned, matte-finished canvas entitled *The Dutchman's, Old House with Tree Shadows* (Figure 8) describes silhouetted trees casting a complex of shadows across a weathered frame farmhouse. In spite of the late-afternoon drama of shadows on its roof, the house recedes to a backdrop role against which the arrangement of verticals and diagonals plays the lead at stage center. Sunlight and shadow do not register as optical sensations but as alternating patterns in a delicate balance of forms.

During his year in the Army, from late 1917 to late 1918, Grant Wood at first confined himself to drawing portraits of fellow enlisted men and their officers at Camp Dodge in Iowa (Figure 11). His art talents gained him a transfer to Washington, D.C., where,

for the remaining months of the war, he was put to work devising camouflage schemes for artillery. Back home in Iowa after his discharge, he resumed painting small panel pictures of local subjects. In October a selection of these unobtrusive works appeared in a two-man exhibition at Killian's Department Store together with paintings by his lifelong friend Marvin Cone. Of the twenty-three panels displayed by Wood, at least eleven were studies of ordinary outbuildings and barns occasionally dotted with incidental human figures (Figures 27–31). The rest of the paintings were landscapes in which trees continued to predominate, both as primary points of interest and as controlling factors of the design (Figures 12–14). In all of these paintings the boughs of the trees spread from one side of the canvas, generally the left, across the middle ground of the picture, while the foreground remains empty save for a few sketched-in plants, shadows, and fence posts. This compositional system thus creates a large angular frame for the center of the landscape, which features either a patch of sky breaking through near the horizon or a lightened area invariably patterned by silhouetted limbs and leaves. Other than providing this central attraction, light is not conceived of as a visual sensation, so that Wood's early painting cannot be considered a pure form of Impressionism. Using a relaxed technique of loosely applied paint, he modulated shadows or shaded sections,

8. *The Dutchman's, Old House with Tree Shadows,* 1916.
Oil on canvas, 13″ × 15″.

7. *Shadows,* 1914.
Oil on canvas, 9¾″ × 7½″.

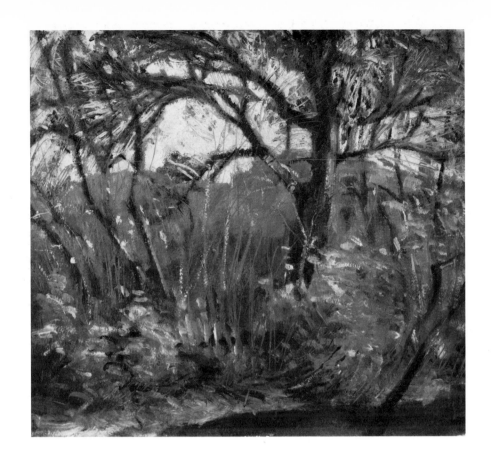

9. *Fall Landscape*, c. 1919.
Oil on composition board, 13″ × 15″.

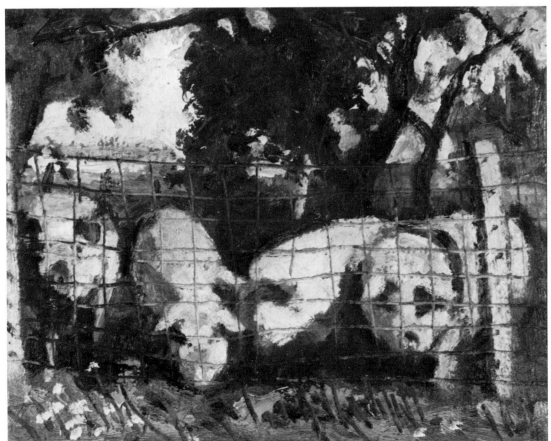

10. *Pigs Behind Fence, Feeding Time*, c. 1919.
Oil on composition board, 6½″ × 8½″.

11. *Portrait of Captain George C. Proud,* 1918.
Pencil and chalk on paper, 9¾″ × 7½″.

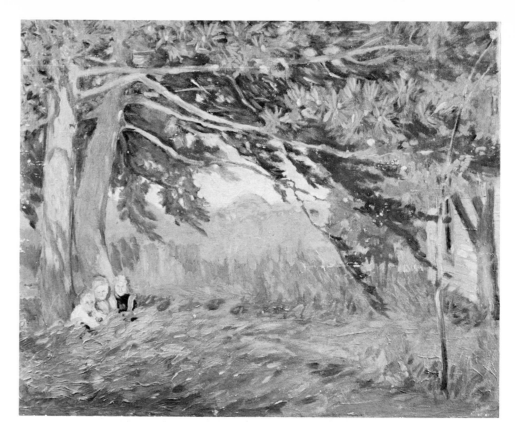

12. *Sheltered Spot, Kenwood,* c. 1919.
Oil on composition board, 15″ × 18⅛″.

such as the underside of a bough, which seldom blur to suggest atmosphere but stand out against intermediate greens as sharply as do the brown trunks and limbs. Equally heavy blue strokes of sky, painted onto the leaves, protrude over the surrounding pigment. Most areas, regardless of what is being described, bear the decisive touches of a one-quarter or one-half inch brush, but in describing details, Wood used a smaller soft brush as well as an occasional quick scratch through wet paint to suggest high grass or some other linear growth.

This easy trick can be observed in a painting called *Fall Landscape,* c. 1919 (Figure 9), and in a small tree picture featuring four pigs entitled *Pigs Behind Fence, Feeding Time,* c. 1919 (Figure 10). In the former, tall weeds sweep upward in long curves scratched through strokes of changing leaf colors. A small, dark sapling cuts concentrically across the lower right corner toward a large middle-ground trunk which is joined by four smaller trees on the left. Intertwining limbs are silhouetted against a blue sky to form a freely patterned, arched cap for the composition. In the second painting, Wood looped a similar tree design through two patches of sky over the pig forms; and, to balance out the scratches in the trees, he scored in freehand a grid screen on the surface to represent a wire fence with leaves of grass below. Wherever Wood employed this technique of incising, he allowed the warm brown of the raw, unsized panel to show through the surface greens and blues which have been laid on with a small palette knife. The composition board, usually ginger-brown, shows up in broad distributions of foliage and sets the tonal key for entire pictures. Several paintings that incorporate this distinctive technique, as well as the tree-framed composition featuring a cleared central area, are *Sheltered Spot, Kenwood,* c. 1919 (Figure 12), and *Leaning Trees,* 1920 (Figure 13).[6] A small, delicately colored tree painting, *Quivering Aspen,* 1917 (Figure 14), Wood's earliest work in the 1919 exhibition, is unusual for its even texture of distinct brush strokes. Small touches of pigment function as leaves against an off-white sky, while more generous strokes below read as weeds and shadows until they move upward into the light yellow-greens of a curving meadow. In this area paint exists as little more than paint, but the bending tree trunk and limbs stand out as an inlay of firm details and incised edges, as if previously rendered by pen and ink with only minute areas of untouched gray panel around the smallest branches.

13. *Leaning Trees*, 1920.
Oil on composition board, 13″ × 14⅞″.

None of these paintings evokes a distinct mood. Trees serve simply to provide a natural design of boughs and branches for a centralized patterning of highlighted pigment. Between tree and earth there is nothing of the nineteenth-century sentiment of reaching for the ultimate, and no individual trees appear to stand strong against the sublime forces of nature. Despite an occasional shadow, there is seldom an atmosphere of changing weather, or of a particular season or time of day, and little sense of momentary impression.

*Yellow Shed and Leaning Tree*, c. 1919 (Plate 1), presents a gnarled tree trunk bent over a shed spotted with thick yellow ochre; seen from a distance, the spots carry as highlights of sun streaming through the leaves above. Like the rough textures of yellow and green below and to the left, these yellow patches stand out as concrete strokes of bright paint against darker values. Evenly scattered spots of light blue mingle with a pattern of white to produce a surface resonance subdued by distinct verticals.

The ardent warmth of *Yellow Shed and Leaning Tree* would seem to confirm the relative comfort and composure of Wood's existence by 1920. A year earlier Miss Frances Prescott, principal of Jackson Junior High School, had risked hiring him as an art

14. *Quivering Aspen*, 1917.
Oil on composition board, 11″ × 14″.

15. Photograph of 5 Turner Alley, Grant Wood's studio apartment, 1925–1934. Carriage house of the George B. Douglas mansion, Turner Mortuary, Cedar Rapids, Iowa.

OPPOSITE
16. *Road to Florence*, c. 1925. Oil on canvas, 25½″ × 21¼″.

teacher, ignoring his lack of full certification and his need to overcome a chronic shyness. His teaching was foreseeably unmethodical, but in his unspoiled, childlike manner he made art entertaining and apparently even inspiring, especially with group projects, murals, stage settings, and theatrical presentations. He continued to teach intermittently for four years, and when Miss Prescott transferred to the new McKinley High School in 1922, she took him with her.

Wood had spent the summer of 1920 in Paris, and in the late summer of 1923, longing for a more extended visit, he took a year's leave of absence to go back abroad. Months of painting in Europe contributed a great deal to his desire to be an independent artist, and he subsequently retired from secondary education after another term of teaching upon his return in 1924. As an incentive to this decision, Wood's newly found patron David Turner invited him to live rent-free in the second story of a carriage house belonging to the mansion that Turner had recently purchased to serve as his funeral home (Figure 15 and Plate 9). In return, Wood would continue with the interior decoration he had begun and would provide paintings for the walls. A companion pair of paintings completed in this new studio-residence and based on sketches brought back from Italy indicate that Grant Wood's few landscapes of European origin, while they continue the closed, center orientation of his earlier works, tend to be animated compositions of more complex components. In *Road to Florence*, c. 1925 (Figure 16), a large oil sketch executed on canvas with a palette knife, a road slopes away to a tiny red-clad figure overwhelmed by a cumulous mass of drab ochre and green which forms a pair of low-lying trees. Bright sunlight casts a large shadow spreading toward the white highlight of what is presumably Florence far below. In *Storm on the Bay of Naples*, 1925 (Plate 7), Wood framed a rare touch of the sublime and robust personality of nature in an archway of windblown trees silhouetted against the sea.

Using the opposite device of asymmetry, Wood conveyed in *Ville d'Avray* (Figure 17), probably completed at about the same time, a sense of quietude at the edge of a pond, whose space recedes from the foreground and winds upward to a pathway shaded by trees. Smooth surfaces of water and path are brushed in horizontally to offset the more detailed aspects of grass, trunks, and leaves pressed on or scratched in with a palette knife.

Wood's new intensification of mood and increased complexity of design and technique permeate a small palette-knife sketch,

17. *Ville d'Avray*, c. 1925.
Oil on canvas, 19¾″ × 24⅛″.

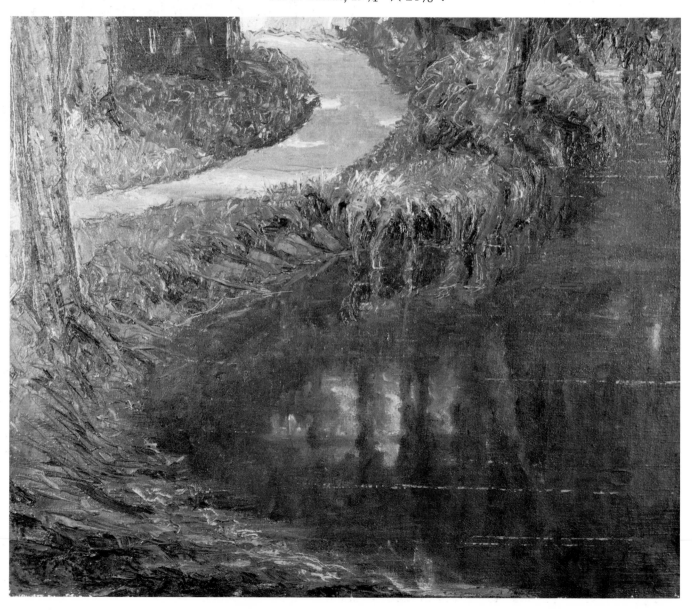

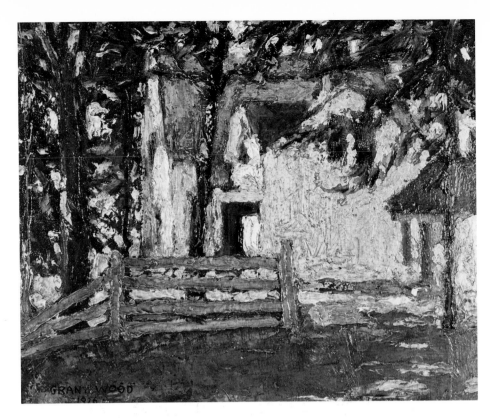

18. *Grandmother Wood's Farmhouse*, 1926.
Oil on composition board, 8⅜″ × 10⅜″.

*Grandmother Wood's Farmhouse* of 1926 (Figure 18). The house, standing in a shady grove of olive-green trees, is highlighted with thickly applied off-white paint which projects as much as an eighth of an inch or more. A warm sun color runs along the base of the house and out into the foreground, inviting entrance into the gray-toned atmosphere of the shadowy setting. The subject obviously held good associations for the painter and his family.

Of all the outdoor paintings that Wood produced during the 1920s, two pictures featuring cornshocks (Figures 19 and 20) are as spontaneous in their color-light sensations as any he would ever achieve. Painted with a palette knife, these paintings were made during the fall and early winter of 1927 at Waubeek, Iowa. Since Wood was on the point of completing a large dining room mural (now destroyed) of this same subject for the "Corn Room" of the Hotel Chieftain in Council Bluffs, he was obviously experienced in portraying an autumn field stacked with the harvest.[7] A sense of immediate presence even in the small-scale paintings no doubt derived from his wish to place hotel diners in harvest-time surroundings. In both panel paintings, straggly, picturesque shocks occupy the lower halves, casting shadows over a rough field of stubble. The time is late afternoon, but the sunlight remains bright and diffused with high-keyed warm colors. A background house and trees unite with the corn shocks through coincidences of contour to assure a centralized focus above a spacious foreground.

In Cedar Rapids Wood often returned to Indian Creek for convenient, comfortable landscape subjects. In several closed, self-contained compositions, a quiet stream flows through the foreground while trees invariably designate the middle ground (Plate 8 and Figures 21–23). The top half in each example illustrated is dense

with leafage, yet one can still perceive distinct trunks and branches dwindling into the background through openings of bright sun color. As in earlier works, these areas of highlight register alternately as casual illusions to light and as patches of tactile, opaque pigment.

Throughout this selection of Grant Wood's landscapes from early youth to his young middle years, no dramatic change of direction in subject matter or style develops. Although he showed isolated signs of experimenting with Art Nouveau and abstraction around 1912 to 1914, by the time of his exhibition with Marvin Cone at Killian's Department Store his paintings had become distinctly and even quaintly conservative. He traveled increasingly from the day of his high-school graduation until 1928, but his experiences seem to have worked a minimum effect on his manner of painting. Once he fixed his personal view of nature and adopted certain conventions of technique and composition, he did not question them. His last journey to Europe, however, took him in 1928 on a special mission to Munich, and it was this trip that triggered the major change of style in *American Gothic* and *Stone City* of 1930.

But before that sudden transformation Grant Wood's painting in general and his landscapes in particular remain sequestered and secure from any immediate stylistic influence. From the time of his boyhood beginnings he recorded only those spiritually sheltered responses to the world permitted by the enclosed sphere of his gentle outlook. As suggested in the small oil sketch of his grandmother's house, Wood's tree-dominated views painted during the last half of the 1920s tend toward the traditionally picturesque, maintaining conventions adopted by the earliest American landscape painters. Between approximately 1924 and 1930 his paintings display two

19. *Cornshocks,* 1927.
Oil on composition board, 13″ × 14⅞″.

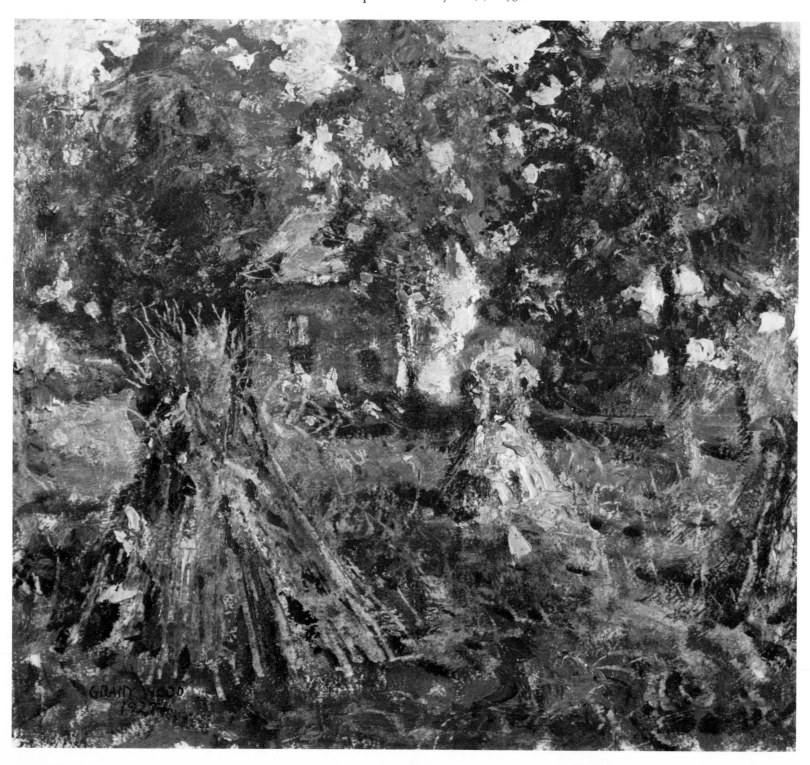

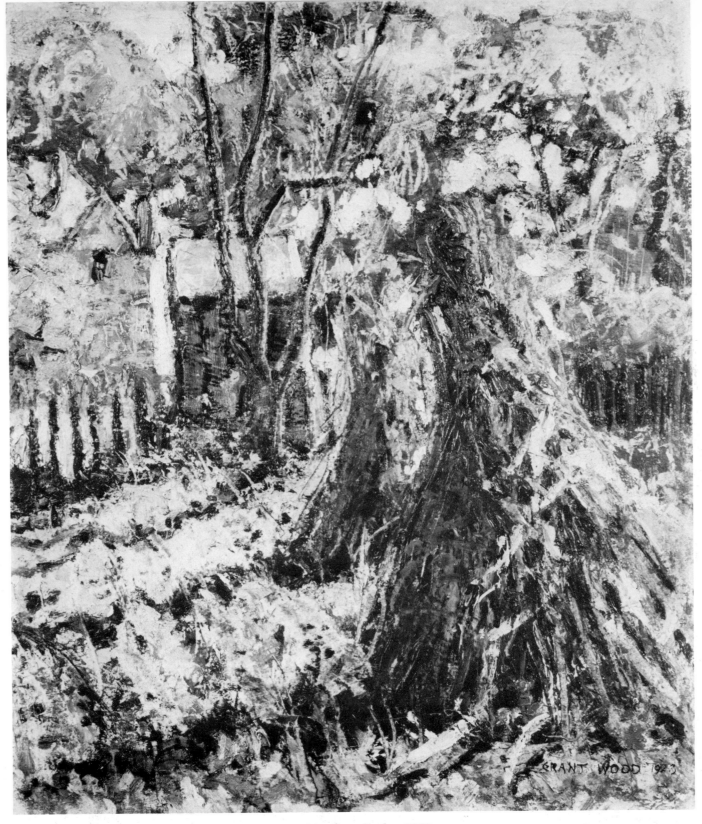

20. *Cornshocks*, 1928.
Oil on composition board, 15″ × 13″.

21. *Indian Creek, Autumn,* 1928.
Oil on composition board, 19″ × 23⅛″.

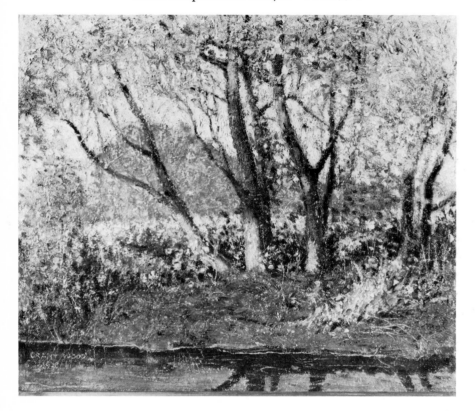

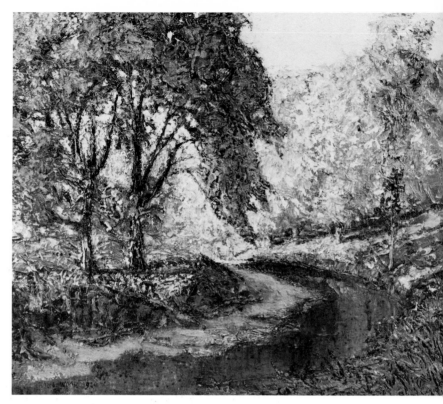

22. *Iowa Autumn, Indian Creek,* 1926.
Oil on canvas, 17¾″ × 21½″.

dominant traits inherited from the polite romanticism of a century earlier: ready access into a space defined and flanked by leafy trees, and the use of calm bodies of water or quiet, contained land areas in or near the center of the picture. Spanning the decade, *Midsummer, Cowpath* (Figure 24) began as an oil sketch in the early twenties and was finished as a large canvas in 1929. In it a cowpath bends around a stand of trees and moves over a slight rise to a group of farm buildings in the background. A central opening leads to a salmon-pink barn with violet shadows that compensate for a barren foreground as a pleasantly warm focal point.

In contrast to this conventional walk-in view of a hillside farm, *Trees and Hill, Oaks* of 1932 (Figure 25) puts nature on formalized display from an elevated vantage point. The bright sun situated behind the viewer casts dark, blue-green shadows through the five evenly spaced trees, while smooth, slender stems nod to the earth, their warm brown leafage silhouetted against a gradated blue sky. Distinct blades of grass and detailed leaves have replaced the broad stroke, the palette-knife impasto, and the loose scratches of the

1920s. Peripheral elements, such as the shadow of a tree top at the bottom left, the fallen leaves, the fanciful trees on either edge, and the flesh-tinted background foliage, are painted with a small soft brush. The spontaneous, roughly patterned surface has almost disappeared except for the sky-blue paint that breaks through the leaves in irregular blotches, forming a contrast with the delicate lace of shadows on the hillside. Using a meticulously crafted finish, Wood indicated a new attitude toward invention of stylized landscape forms. While he would continue from here on to draw his forms from individual models, with *Trees and Hills, Oaks* he had already begun to transcend the arbitrary and accidental aspects of nature. The eroded banks and brushy tangles of Indian Creek have vanished. Rough margins of natural growth and decay are cropped and trimmed as if in accordance with agricultural improvement. The precision handcraft of Wood's painting techniques and the patterned refinements of nature in his landscapes of the thirties give assent to the technological ordering of land cultivation.

23. *Indian Creek, Midsummer,* 1928.
Oil on composition board, 14⅞″ × 13″.

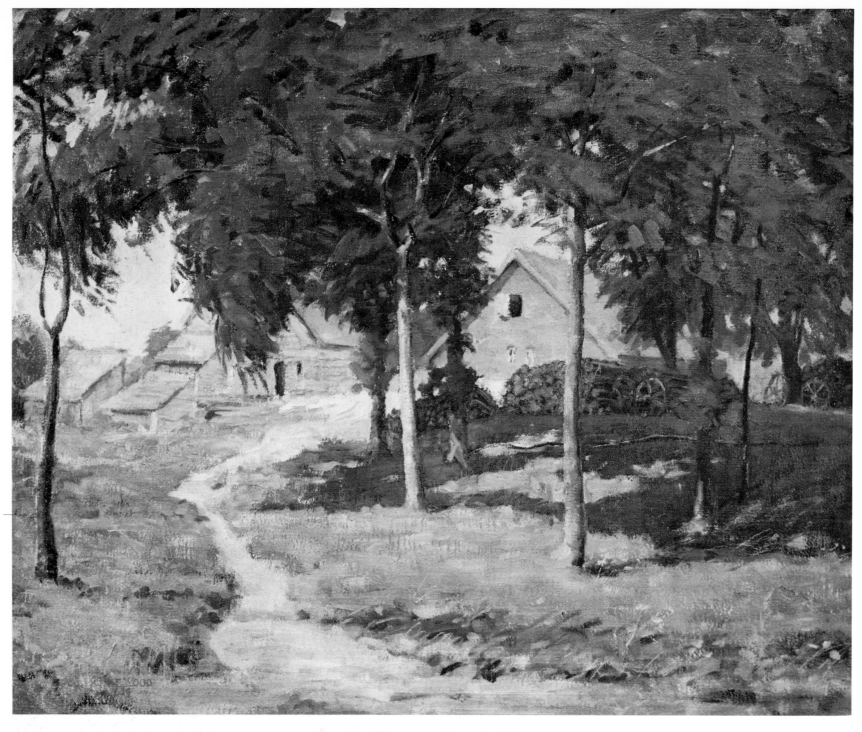

24. *Midsummer, Cowpath*, 1929.
Oil on canvas, 28¾″ × 36¾″.

25. *Trees and Hill, Oaks,* 1932.
Oil on composition board, 31⅜″ × 37⅜″.

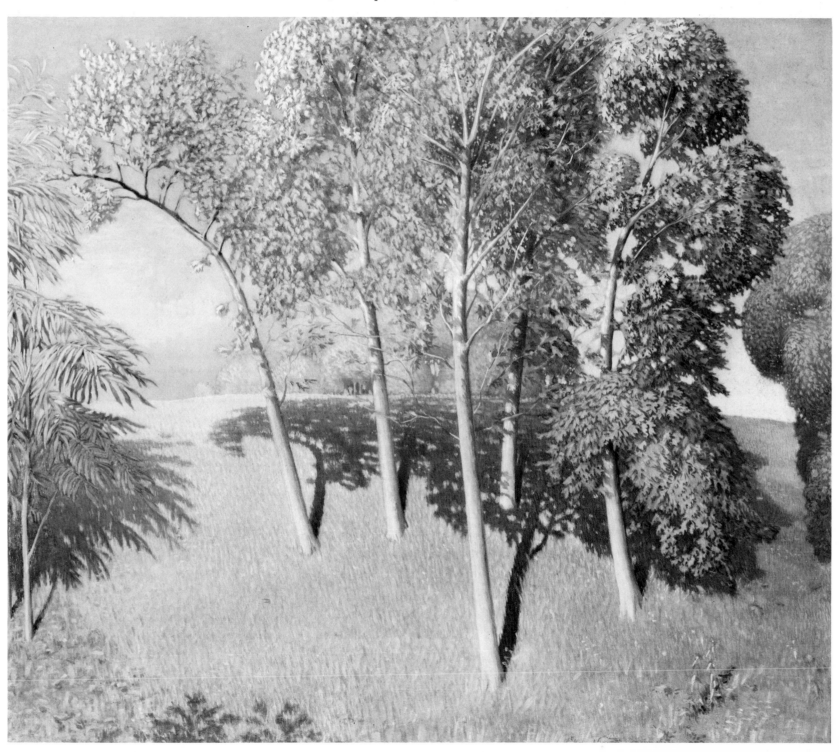

# 2. Backyard View of Europe

Grant Wood held a steady stylistic course for at least two decades, not only in his landscape paintings but also in his other works, such as the series of small intimate paintings he produced on his rather myopic explorations of Europe during the 1920s. They offer pleasant, pedestrian interpretations of living quarters and squares in Paris and an assortment of back streets and medieval entranceways collected from provincial towns in Italy as well as France.

By using the techniques and compositions of snapshot souvenir views, Wood avoided the street-level bustle of city living and a discerning look at the urban environment. In this sense his European paintings compare in content and style with the earlier street scenes of such moderates among modern French painters as Pierre Bonnard, Edouard Vuillard, and Maurice Utrillo. Inclined to surface virtuosities and picturesque attractions, Grant Wood's innocuous remembrances of distant cities appear very remote from the urban realism of his American contemporaries: for example, John Sloan's sidewalk confrontations with the masses and Edward Hopper's detached observations of metropolitan isolation amidst canyons of city space.

On his travels through Europe, with very few exceptions, Wood curiously overlooked the open countryside as subject matter, passing by farms for villages and seeking out quiet neighborhoods and parks removed from the large squares or famous boulevards in Paris. Major monuments appear only rarely in the background and are usually ignored in favor of modest, more manageable views of colorful, out-of-the-way points of interest: stuccoed tenements, gates, and Gothic doorways. He avoided the extremes of bustling crowds and empty fields in his European paintings and included only incidental isolated figures, usually working-class women seen at a distance against endless walls. On the whole, his subject matter consists of the little discoveries that delight the independent, leisurely tourist sensitive to picturesque detail.

Aside from the obvious differences in setting, no major change in Wood's paintings surfaced during his initial summer abroad in 1920. The small back-street pictures he produced in the French metropolis are essentially extensions of the backyard views that he had exhibited a little less than a year after returning home from the Army, such as *Sheltered Spot, Kenwood* (Figure 12) and *Yellow Shed and Leaning Tree* (Plate 1). These views of his own wooded retreat near the edge of town in the hilly area of Kenwood[1] contain the same combination of subject matter that he would continue abroad; sunlit walls, occasional trees, and cast shadows enliven an outdoor enclosure inhabited from time to time by small figures. In these works an even level of undisturbed contentment prevails, freed of any serious concern beyond the easy solutions of composition and casual choices of paint and technique to record the experience of a quiet place.

Before and after his year in the service Wood had selected secluded areas out in back, arbitrarily confined by coarse structures. In such pictures as *Feeding the Chickens* (Figure 26), *The Horse Traders* (Figure 27), and *Old Sexton's Place* (Figure 28), painted between 1917 and 1919, the observer, situated at eye level, looks into a small interior space where the ground recedes to a mid-picture point and stops at the base of a shed. The stage in each case is set with an open foreground of soft shadows, which leads into an area of heightened colors indicating sunlight. Rectangular forms representing wood structures absorb the light on either side into pastel reds or blues or reflect it from modulations of white, while dark doors and windows stand out on the surface and tree trunks and green boughs fill out the borders. Scattered over the ground, incidental objects and chickens lend vitality to an otherwise peculiar lack of theme.

In *Old Sexton's Place* Wood did take some exception to this detachment. The white cross standing in what appears to be a burial

38

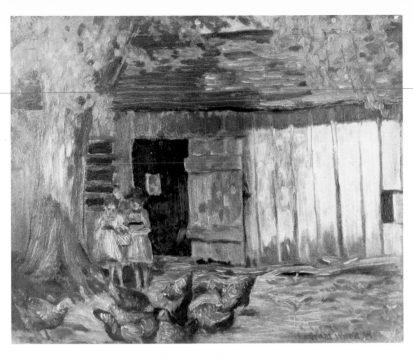

26. *Feeding the Chickens*, c. 1919.
Oil on composition board, 11″ × 14″.

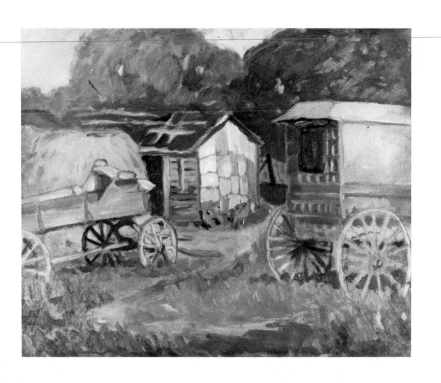

27. *Horse Traders*, c. 1919.
Oil on composition board, 11⅛″ × 14″.

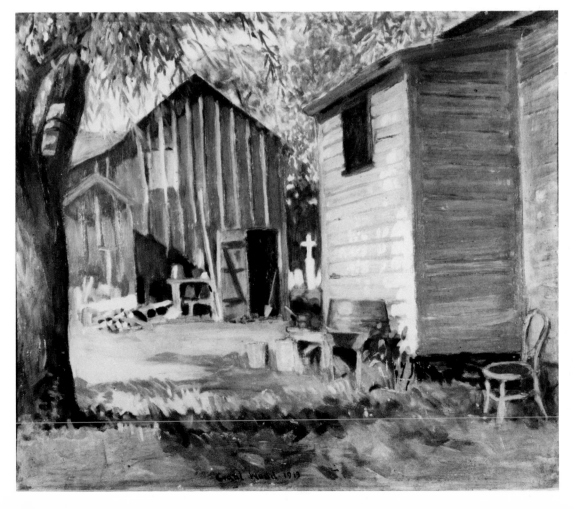

28. *Old Sexton's Place*, c. 1919.
Oil on composition board, 15″ × 16″.

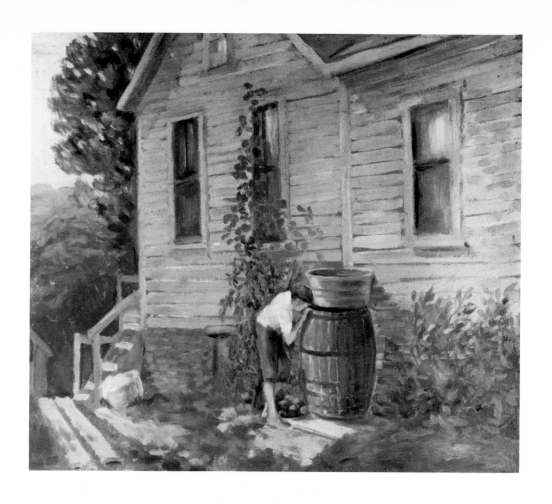

30. *Looking for Wigglers*, c. 1919.
Oil on composition board, 18¾″ × 15″.

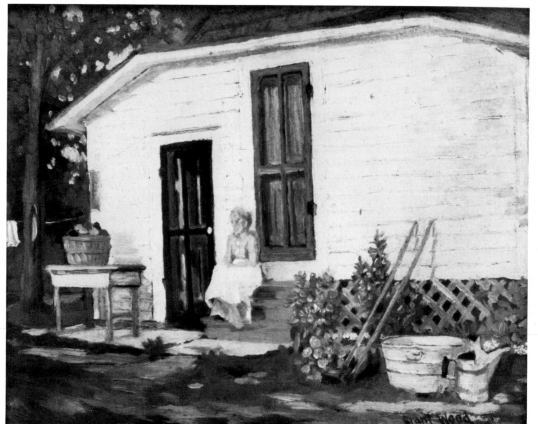

29. *Retrospection*, c. 1920.
Oil on composition board, 11″ × 14″.

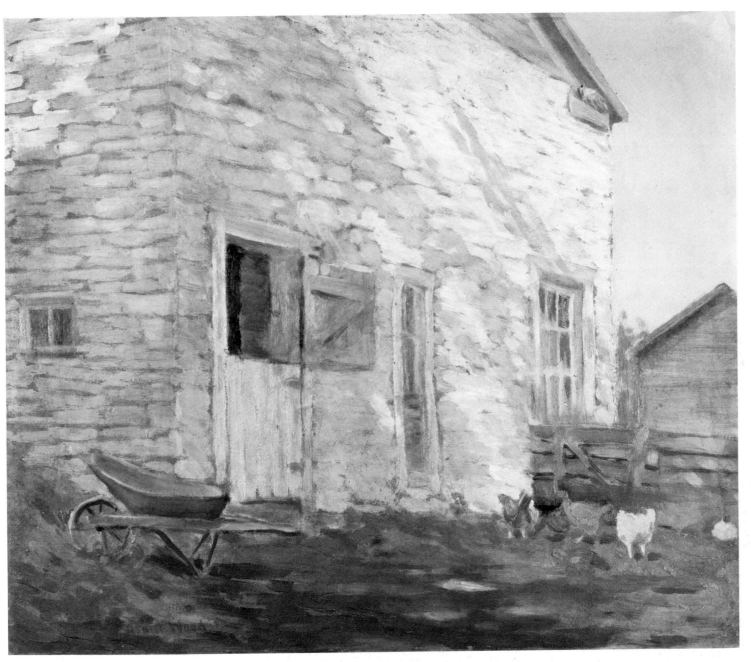

31. *Old Stone Barn*, c. 1919.
Oil on composition board, 14⅞″ × 17⅞″.

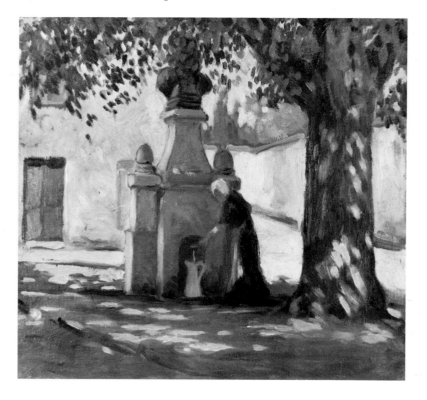

32. *Fountain of Voltaire, Châtenay,* 1920.
Oil on composition board, 13⅛″ × 15″.

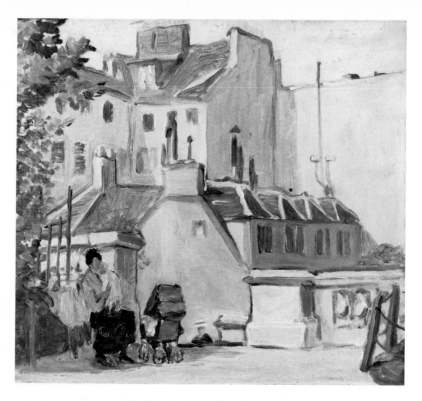

33. *Back of the Pantheon,* 1920.
Oil on composition board, 13⅛″ × 15″.

plot in the background projects as a provocative focal point amidst the abandoned paraphernalia of a simple life. The empty chair and the vacant door with a spade leaning in the direction of the cross suggest absence and contribute to a depth of mood seldom achieved in the early works. For the most part, however, when figures present themselves in these small panels, they hardly supersede the assorted backyard objects in expressing an overt human content. The small, sketched-in forms of two little girls in *Feeding the Chickens* function chiefly as juxtaposed spots of bright color in addition to providing a title for the work. Much of their attraction lies in the oily trans-lucence of the paint, which rises in opaque ridges from the brush pressed down to describe their Sunday dresses.

The introduction of a small figure as a point of title in *Retro-spection,* c. 1920 (Figure 29), and *Looking for Wigglers,* c. 1919 (Figure 30), adds to the subject matter without substantially con-tributing to content. The old woman and the barefoot boy enhance the summertime moment but would scarcely be missed if absent. Another work from this period merely depicts one wall and a corner of an old stone barn which once stood in back of a restaurant on First Avenue in Cedar Rapids, c. 1919 (Figure 31). The play of sun

and gray shadows over rough white stones competes with the anec-dotal detailing of a wheelbarrow, a half-opened stall door, and a few chickens. In this picture Wood documented a familiar small-town encounter, fixed in time with no hint of movement or change, a commonplace sight concealed from Main Street and pictorially blessed with a preindustrial immunity to the rapidly changing out-side world.

This sequestered view colored Grant Wood's European experi-ences so that his subject matter, style, and technique remained at home, essentially untouched by the artistic revolutions of the post-war period. The city vignettes from his summer in Paris evidence the work of a technically talented, primarily self-taught mid-Ameri-can with a natural eye for cohesive composition. Conditioned by the backyard enclosure, safe and secure, he adapted his format to ob-scure squares and streets in France employing the same "picture-taking" techniques that he used at home. Standing across the street or square from his subject, he produced his own postcard views with the conventions of space, light, and color that he had adopted in Iowa. In the village of Châtenay on the southern edge of Paris, the intimate squares and narrow, walled-in streets provided him a com-

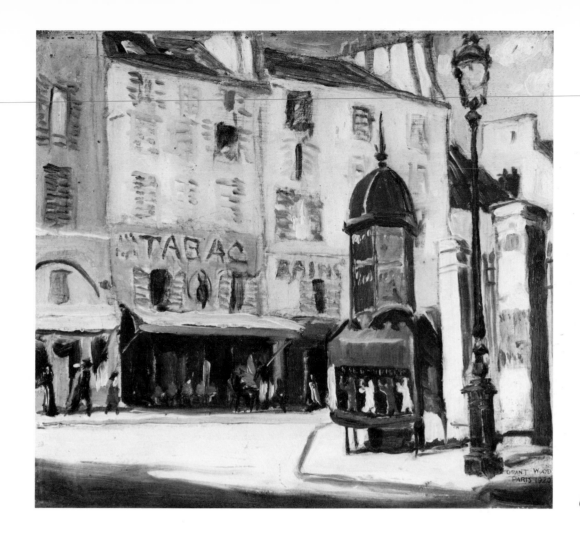

34. *Paris Street Scene with Café*, 1920.
Oil on composition board, 13¼″ × 15⅛″.

fortable setting for his small oil panels. In *Fountain of Voltaire, Châtenay*, 1920 (Figure 32), a woman in black with white cap and apron merges with a bulky gray stone fountain from which she draws water. The pictorial appeal lies in the composition's plain, solid structure of sun-flecked tree trunk, fountain, and wood door, all three of which recede at measured intervals into a brightly illuminated background which gradually ascends to a patch of blue sky.

Wood used similar arrangements of space, light, and buildings in his 1920 Paris street scenes, such as *Corner Café, Paris* (Plate 2), *Back of the Pantheon* (Figure 33), and *Paris Street Scene with Café* (Figure 34). These appealing jumbles of stuccoed walls punctuated by windows, gables, and chimney pots would overflow the panels were they not held in check by dark border areas. In each painting the shallow recession of an empty street leads the eye to a low-level accumulation of details, loosely painted as single figures, sidewalk cafés, and shadows. The slightly crooked walls and the unevenly painted surfaces give the assortment of forms an appearance of pastry frosted in pastel violets, greens, and blues. An overall gray, tinted with blue and touched with violet and warm

tans, complements the tone of the composition board. In another painting of 1920 Wood pictured a cluster of houses behind an ancient stone gate (Figure 35). The brown panel can be seen through the moss-green color of the gate and reappears as a warm background for the white sky as well as for the black shadows in the archway, rapidly brushed in.

When Grant Wood ventured into the squares and parks of Paris, he made quiet experiences of them. No modern traffic gains entrance, and only a few small figures stroll and occasionally pause in the open-stage foreground. Large historic monuments do not register as such but perform as backdrop enclosures; for example, the classical portico of the *Pantheon*, 1920 (Figure 36), more than fills the upper right quarter of the panel yet assumes a gold-tinted translucence. It replaces for the time being the clapboard house of *Looking for Wigglers* and the *Old Stone Barn* in Cedar Rapids. A pushcart enters, and stick figures evolve with an agile flick of a small brush as they approach Rodin's *The Thinker*. In *Paris Street Scene, Church of Ste.-Geneviève* (Figure 37), probably his most daring oil sketch of this period, Wood attempted to alter his normally neutral foreground by bringing the subject forms to the surface as a con-

43

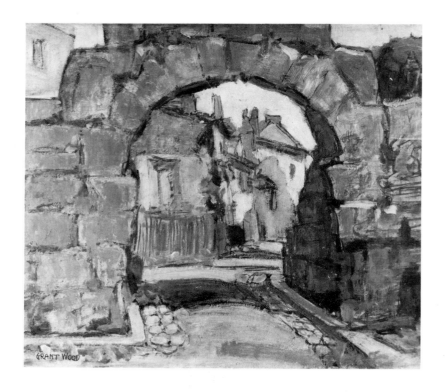

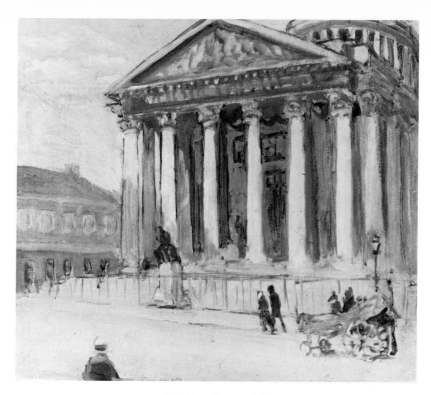

36. *Pantheon,* 1920.
Oil on composition board, 13″ × 15″.

35. *Street Scene through Gate, Roman Arch,*
1920.
Oil on composition board, 13″ × 16⅛″.

trolled, slightly cubistic arrangement of straight verticals and horizontals. A lone striding figure, darkly silhouetted against a light blue area, accentuates the emptiness of the middle ground. This rare bit of animation functions as a focal point, assisted by two brief diagonals on either side of the picture. The mother and child, although obscured by the purple tones descending throughout the bottom half, contribute a distant but reassuring domestic image to the strange world of the Rue Championnet. Their vertical form coincides with the church façade, especially with its bell tower, sunlit in yellow ochre, pink, and white.

The only monuments to be honored in the foreground of Grant Wood's Paris paintings are those of figurative sculpture. The bronze groups in *Misty Day, Fountain of the Observatory* (Figure 38) and *The Runners, Luxembourg Gardens* (Plate 3) and the close-up rendering of Coysevox's horse and rider in *Tuileries Gate and Obelisk* (Figure 39) are the most animated figures he was ever to paint. Possibly they provided an opportunity for him to study something of late-baroque group composition, an early purpose of young American painters abroad since the time of West and Copley. Although they are essentially still lifes of figures painted in miniature, the sculptures are given an elevated, off-center position, to be relished from the street below as special attractions unknown to

Wood's Chicago and Cedar Rapids. In grand, open spaces against bright backgrounds, the strangely cavorting nudes create irregular patterns, like the foliated overgrowth of a high culture. Yet amusement accompanied admiration from the culturally embarrassed American's point of view, and, refreshingly exposed at this level of humor, these figures occupied a favored position among his European subjects.

In each case a rough pencil sketch on the panel, followed by freely stroked paint, again allows the warm brown of the panel to show through loose strokes and scumbles. Furnishing a glimpse into the act of art, this sense of immediacy, so prevalent among both modernists and moderates by the turn of the century, was to continue in Wood's paintings of the twenties, balancing his tendency toward a highly tooled finish. For example, in *Fountain of the Observatory* (Figure 40), which Wood painted upon his return to Cedar Rapids in the fall of 1920, he apparently intended to retain something of the spontaneity recorded in his original small panel *Misty Day, Fountain of the Observatory.* Initially he had allowed the crowning globe of Carpeaux's fountain to be slightly cut off at the top while he concentrated on the supporting figures and bronze sea horses rearing out of the basin, whose visual energy continues throughout in the broad brushwork of the architecture, foliage, and

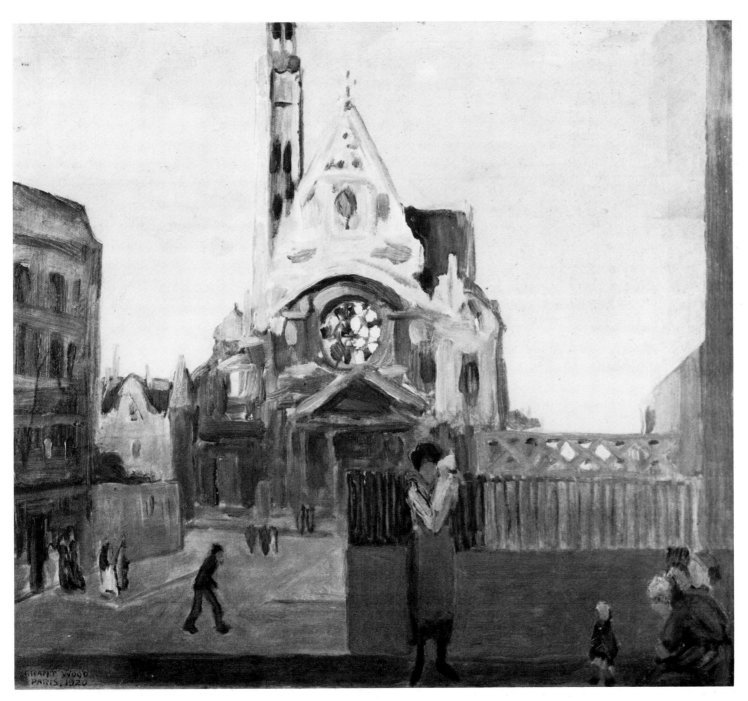

37. *Paris Street Scene, Church of
Ste.-Geneviève,* 1920.
Oil on composition board, 13″ × 15⅞″.

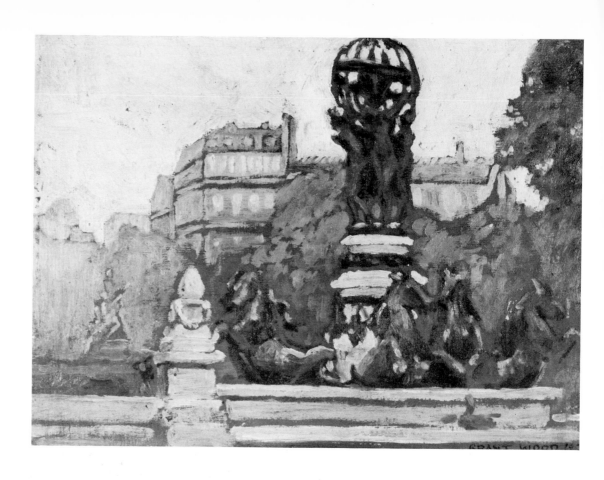

38. *Misty Day, Fountain of the
Observatory,* 1920.
Oil on composition board, 7″ ×9⅞″.

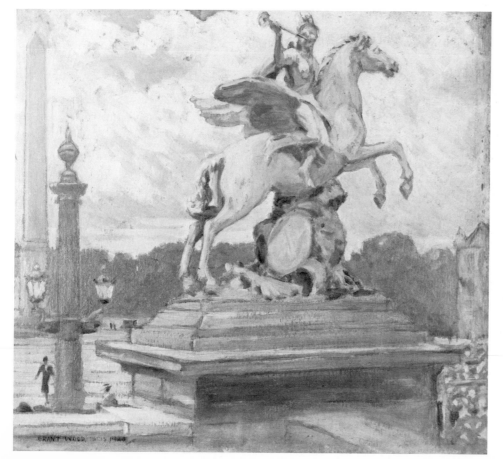

39. *Tuileries Gate and Obelisk, Paris,* 1920.
Oil on composition board, 13″ × 14⅞″.

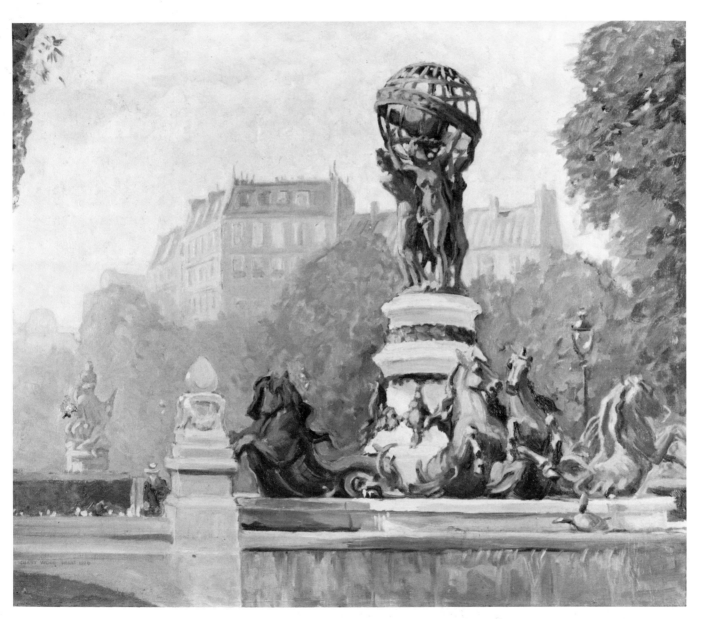

40. *Fountain of the Observatory,* 1920.
Oil on canvas, 19¾″ × 24″.

sky. The wide edge of slate-gray underpainting that outlines the major forms creates a contrasting textural accent for highlights and the general details painted in thick pigment. In the finished version, however, this sketch quality disappears for the most part as the objects are filled out and made solid. Details of sculpture, architecture, and trees come into clearer focus, while light and atmosphere vary from the sharp, descriptive contrasts of the fountain to the softly defined building in the background. Colors change accordingly from the overcast tones of blue, green, tan, and dull white in the early study to the heightened warm tones of the second version, climaxing in the point of red on a figure emerging from the park below and to the left of the fountain. To set off these technical refinements, the open, horizontally oriented composition of the Paris sketch gives way to a more conventional landscape arrangement. The entire fountain is scaled down in proportion to a larger expanse of sky, and an added fringe of leaves on the left aids the tree to the right in enclosing the space. Consequently, in the end, only a few details such as the bronze horses retain a semblance of the original spontaneous view.

A technically refined spontaneity is generally characteristic of Wood's early style, and the minor monuments of architectural sculpture that he chose in Paris as his featured subject matter lent themselves well to this treatment. Revisiting France during his year abroad between the fall of 1923 and the fall of 1924, he could not resist returning to one more figural fountain (Figure 41). A small version of the Trevi Fountain in Rome, the Fountain of the Medici in the Luxembourg Gardens attracted the craftsman's eye with its sculpture emerging from the niches of a baroque wall and water spilling from one basin to another, flanked by a balustrade topped with urns and an ornate iron fence. In spite of a uniform distribution of details, the large crouching figure of Polyphemus and the reclining figures of Acis and Galatea below represent the main attraction of the painting. The vanishing lines of the balustrade slowly ascend to them, while the foreground urn and the tree contain them through a coincidence of contours.

While little stylistic change took place in Wood's European sketches and paintings, his choice of subject matter during his full year abroad grew increasingly specialized and the closed composi-

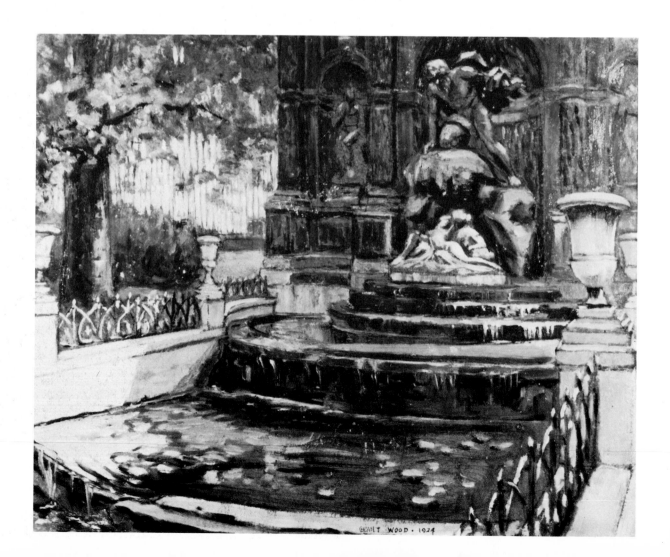

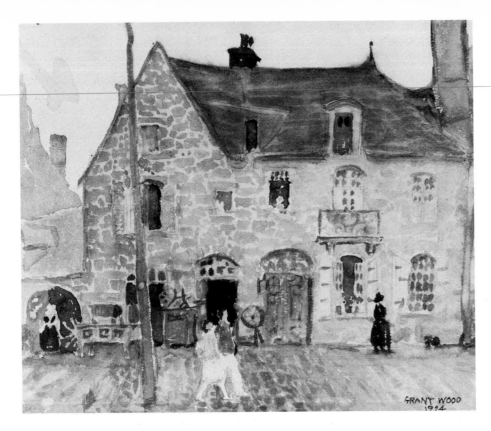

42. *House with Blue Pole, Paris,* 1924.
Watercolor on paper, 8½″ × 11″.

LEFT
41. *Fountain of the Medici, Luxembourg Gardens,* 1924.
Oil on composition board, 12¾″ × 14⅜″.

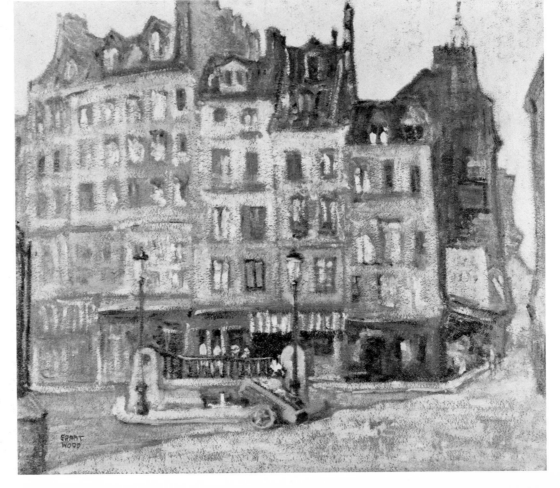

RIGHT
43. *Latin Quarter, Square in Paris,* c. 1924.
Oil on composition board, 17½″ × 20¾″.

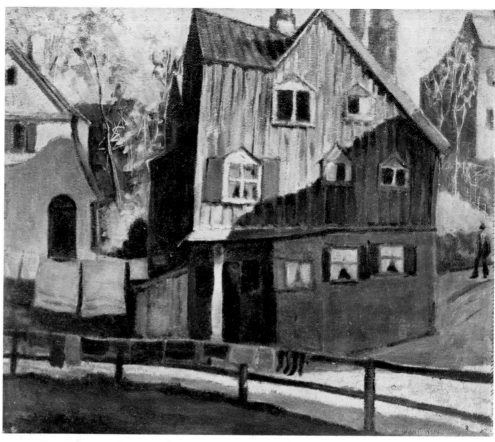

45. *Red Bedding*, c. 1928.
Oil on composition board, 23″ × 26⅞″.

44. Will Bradley: Cover for *Collier's Weekly*,
1900.

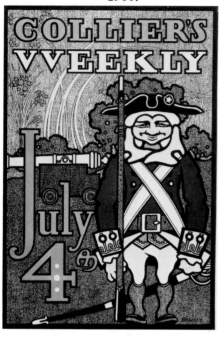

tion that originated with his early backyard vision altered accordingly. In three small paintings done after his return to Paris—a watercolor *House with Blue Pole*, of 1924 (Figure 42), and two scenes of quaint tenement houses rising as one from small squares (Figure 43 and Plate 4)—Wood resumed his former vantage point a comfortable distance from the subject. The space of each picture generously accommodates small, idle figures, lamp posts, and, at the far side, shop fronts. A toylike green bus has stopped for passengers in the 1926 painting, the only acknowledgment by Wood of the motorized vehicles that were gradually filling the streets of Paris.

Unlike his earlier back-street views, the old structures here, which take up three quarters of each painting, flatten out on a surface plane, their irregular rooftops silhouetted against the sky. By means of careful paint handling within the confines of the architecture and around its edges, Wood allowed the narrow but clearly perceptible borders of the warm brown panel to give the buildings a crisp, gingerbread appearance, replacing the doughy white stucco walls in the paintings of 1920. In the undated painting called *Latin Quarter*, probably made during his year abroad, the textured reverse side of the composition board sports a light frosting of dry-brushed

white paint, making the picture look all the more edible. In *Street Scene with Green Bus* a more robust technique of scraping in the area of the grassless circular square continues upward through an open tree, the shape of which neatly encompasses the building.

The gingerbread style of these paintings recalls a popular type of commercial illustration and advertising art that began to appear in American magazines before World War I. Concurrent with the famous book illustrations of Howard Pyle and his students, Will Bradley, a well-known Chicago Art Nouveau poster and ad designer of the nineties, introduced a vogue of heavily outlined cartoon figures characterized by quasi-medieval stylization when he became art director for *Collier's* magazine at the turn of the century (Figure 44). Wood was naturally well acquainted with such picture-making, having grown up with it, and its influence appears sporadically in his European works. As late as 1928, during a final visit abroad, he produced a few oil sketches of house fronts in Munich, the last paintings to display his particular brand of this confection (Figures 45 and 46).

In painting Old World architecture Wood progressively moved in on it, responding in close-up compositions to the physical sub-

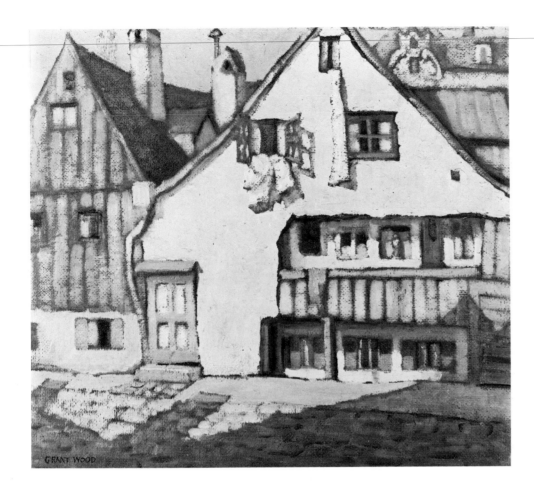

46. *Yellow House, Munich,* c. 1928.
Oil on composition board, 18″ × 20¾″.

stance of masonry walls and arched entranceways. From this modest change in vantage point evolved a series of pictures featuring medieval doorways and gates. Exhibited in the small Galerie Carmine on the Rue de Seine during the summer of 1926, these works signaled the end of Wood's French experience. The painting *Street of the Dragon,* 1925 (Figure 47), foreshadows these final impressions of Europe. Wood places the viewer inside a narrow courtyard with irregular, rough-surfaced walls looming overhead, restricting sunlight to the upper stories and leaving only a broken edge of blue sky visible. While some illusion of space results from an intuitive perspective, the building interior tends to splay outward. The deep archway, out of which a tiny female figure emerges, marks the end of a shallow, slowly receding ground plane, which constitutes but a small fraction of the entire painting. Combining vertical strokes of tan with the beige of the panel and a mossy-green tone, Wood gave the painting surface something of a wall texture through his use of direct impasto.

Spatial illusion diminishes as the walls come closer to the picture plane in the doorway and portal pictures that Wood apparently started in Italy during his winter in Sorrento in 1923–1924. The actual crust of pigment in *Italian Farmyard* (Figure 48) and *Portal with Blue Door, Italy* (Figure 49) vies with the illusive appeal of masonry and stucco. In France arched Romanesque and Gothic doorways provided enticing distractions of architectural and sculptural detail, but neither the carvings nor the narrow strip of ground at the foot of these French pictures could interfere with Wood's predominant wall surfaces encrusted with paint, spread on or scumbled, scraped or scratched. Périgueux and St. Emilion offered Wood an assortment of masonry entrances, which he usually treated as picturesque ornaments on the walls containing them. For instance, in *Port du Clocher, St. Emilion* (Figure 50), *Ruins Périgueux* (Figure 51), and *Indoor Market, St. Emilion* (Figure 52), the plain stone surfaces dominate. However, the ornamental arches were delightful discoveries, and Wood, with his love of the Gothic, sketched them freely. The accretions of slowly decaying ancient stone, also sensuously appealing, invited simulation through various means of applying or removing pigment. Gray, brown, and greenish in color, the paint acquires a beautifully dingy quality indistinguishable from the original surfaces themselves. Sunlight reflections falling on Wood's painted walls assume a concrete form and on occasion

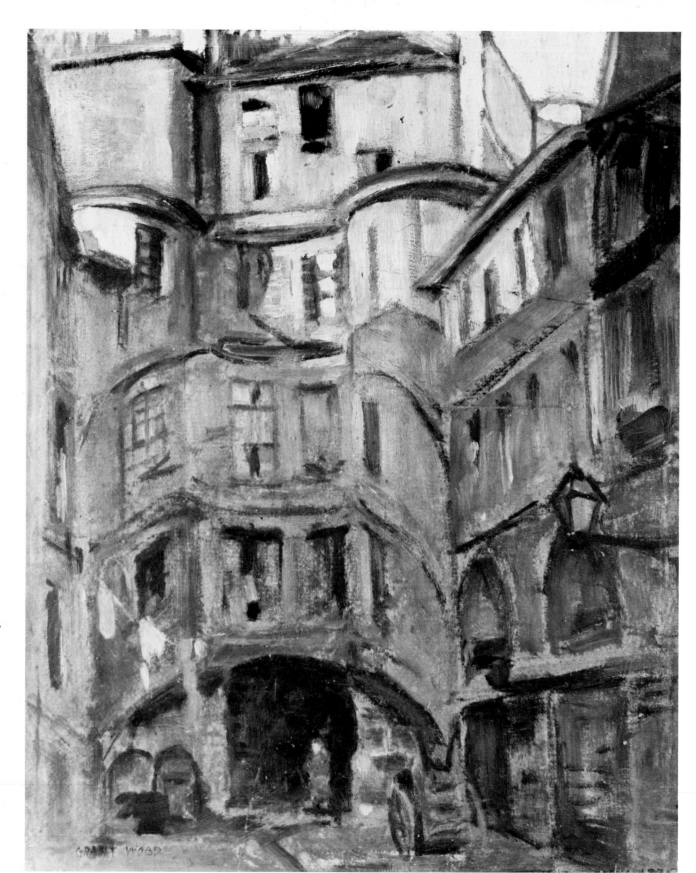

47. *Street of the Dragon, Paris,* 1925.
Oil on composition board, 15⅞″ × 13″.

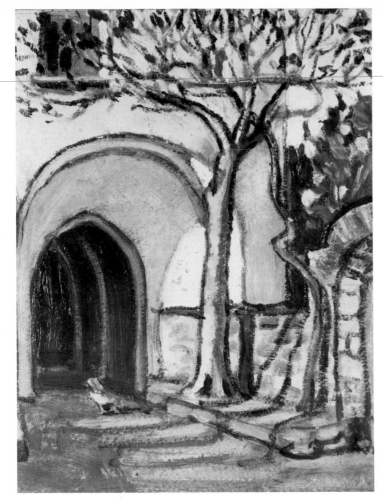

48. *Italian Farmyard*, 1924.
Oil on composition board, 10⅛″ × 8″.

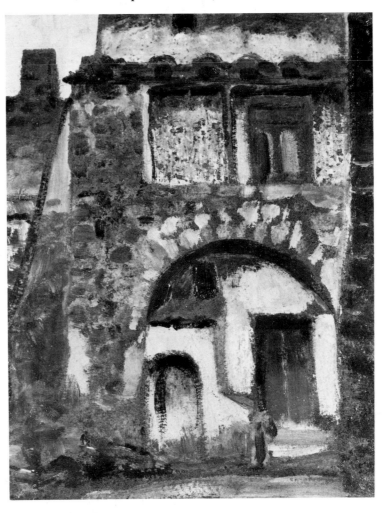

49. *Portal with Blue Door, Italy*, 1924.
Oil on composition board, 10⅛″ × 8⅛″.

project like low relief, never predominantly visual as an experience but tactile in their exaggeration.

In the paintings *Door with Old Crest, Périgueux*, 1926 (Figure 53), *Doorway, Périgueux*, 1927 (Figure 54), and *Yellow Doorway, Church Portal, St. Emilion*, 1927 (Plate 5), the entrances are expanded as central features. In each work the paved approach to a threshold measures only a few steps, while the doorway and its immediate area of wall slant perceptibly away from the picture plane. As sketched into the paintings, the stone moldings and sculpture of the portals happily avoid the slick finish of architectural rendering. By the time of his Paris exhibition in 1926, Wood had mastered a technique of freely applied vertical and horizontal strokes, alternating with an exposed dry-brush surface and enlivened by the heavy additions of a palette knife. Sculptures, as if seen from afar on a bright day, are lodged in the splayed arch and niches of

the *Yellow Doorway* and project pictorially as thick cream white, in quiet contrast to modest amounts of red-orange, deep blue, and emerald green at the door.

The paint surfaces of Grant Wood's small panels of doorways and walls share the stone-and-mortar consistency which George Moore, the English critic and man of letters, attributed to Claude Monet's Rouen Cathedral series. In fact, Moore's statement commending Monet for having "striven by thickness of paint and roughness of the handling to reproduce the very material quality of the stonework"[2] might be more accurately applied to these pictures by Wood. For unlike Monet, who died the year of Wood's exhibition, the Iowa artist could not resist the building façade as a structure of solid parts, however limited its spatial volume.

While Monet in the early nineties was seeking, as he said, "instantaneity, especially the envelope, the same light spreading

51. *Ruins, Périgueux,* c. 1924.
Oil on composition board, 16″ × 13″.

50. *Port du Clocher, St. Emilion,* c. 1924.
Oil on composition board, 16″ × 12⅞″.

52. *Indoor Market, St. Emilion,* c. 1924.
Oil on composition board, 12¾″ × 13⅛″.

everywhere,"³ Wood continued through the twenties to paint objects as tangible forms of reference whether they be trees patterned against the sky or fountains and buildings. Even though he was later to refer to his earlier "impressionism," he showed little inclination toward strictly optical vision, which was essentially countermanded by his conservative handling of space as well as by his affection for solid details. His technique confirms that he did not see color in conjunction with light, and it reveals little tendency toward an optical fusion effected by uniform textures of interwoven complementary hues. Thus, while he might paint a picture outdoors in one sitting, he did not record a purely optical, plein-air experience, captured at a glance with a vibration of bright colors. Value contrast and perspective construction, no matter how intuitive, persist as constant factors in a cautious process of design regulated on the surface by precise contour lines, coincidences of edges, and ruled diagonals.

The post-Impressionist traditions of abstract pictorial space as advanced by such disparate painters as Paul Gauguin, Henri Matisse, Paul Cézanne, and the Cubists held little significance for Wood's painting, which was much more in sympathy with the earlier street scenes of Bonnard, Vuillard, and Utrillo. During his third stay in Paris in the summer of 1924 Wood would have had an opportunity to see a retrospective exhibition of Bonnard's paintings at the Galerie Drouet, but any similarity between the work he was doing either before or after that summer and the style of the French colorist is probably coincidental. If the growing intensity of Bonnard's color scheme at the turn of the century is disregarded, some resemblance can be noted between the Paris street scenes the French-

man was still painting at that time (Figure 55) and Wood's views of the same subject matter twenty years later. Both avoided the great boulevards and favored instead residential neighborhoods with buildings and shops viewed from across a street empty of traffic except for a few slow-moving passersby. Bonnard, however, was confident about creating a cohesive surface pattern and allowed for more pavement as a light, flat ground to accommodate dark shapes, usually figures. Rapid sketching and a free, thin-to-thick application of paint were techniques common to both painters, although Bonnard's brush strokes are smaller and more uniform than Wood's multiple technique of the mid-twenties.

Alongside the French artist's advanced but still relatively moderate style of the early 1920s, Wood's paintings obviously assume a conservative appearance. His rather isolated Midwestern training in design, interrupted by financial difficulties and the Army, had permitted him only limited opportunities to study painting in any form, and his independent efforts did not get well under way until after the war. Consequently, it is not surprising to find his use of space, light, and color outdated next to that of a mature modern master in Paris. In Bonnard's paintings distorted proportions and perspective encourage a dazzling interplay of colors on the picture plane: extreme complementaries of blues and oranges vie for attention against vibrant reds and greens far beyond the limits of local colors.

In the few street scenes by Edouard Vuillard, a vertical line of sight propels upward through tilted planes. Thus, large areas of space come to the surface, activated by mottled paint in pastel colors. Since Vuillard often painted in oil on unprepared cardboard,

53. *Door with Old Crest, Périgueux,* 1926.
Oil on composition board, 16″ × 13″.

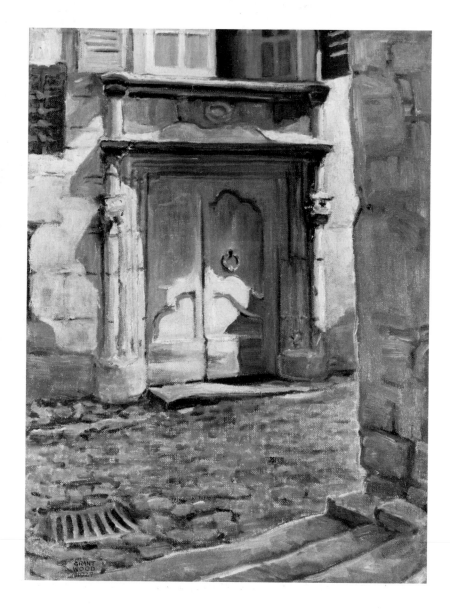

54. *Doorway, Périgueux,* 1927.
Oil on canvas, 24⅛″ × 18″.

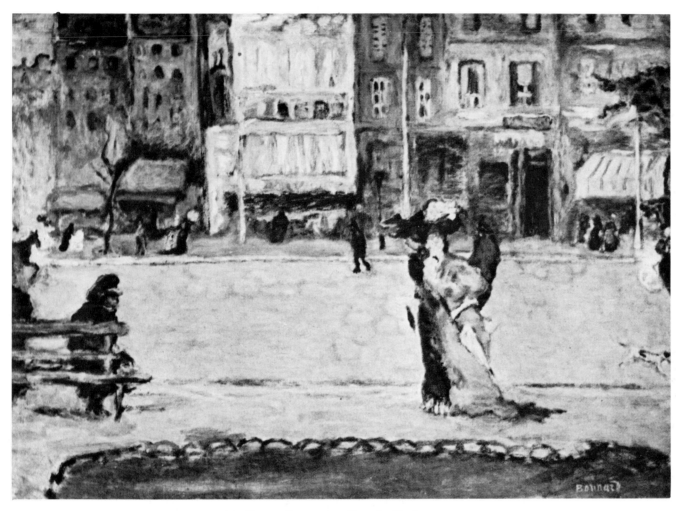

55. Pierre Bonnard: *Rue de Clichy*, 1900.
Oil on canvas, 25″ × 36″.

such rapidly executed pictures as the studies for *Place Vintimille*, c. 1906 (Figure 56), include scattered areas of the untouched tan surface, an elementary point of technique that Grant Wood shared with the French artist.

Although Maurice Utrillo was confined to an environment and a tragic way of life unimaginable to a rural Iowa mind, his paintings demonstrate a similar predilection for the back streets of the great metropolis. Ironically more innocent looking in technique than those of the American, Utrillo's paintings, such as *An Old Street in Villefranche-sur-Mer*, c. 1928 (Figure 57), often depict relatively empty streets dominated by the light grays of nondescript stuccoed dwellings. Light, which is never treated as tangible but merely implied, casts brief scribbles of shadow underneath his yarn-doll figures, which also make occasional appearances in Wood's paintings of Paris (see Figure 42). But Utrillo's method of buttressing walls with determined black outlines differs greatly from the American's gentle touch. Such are the distinguishing marks of the two respective personalities: the urgency of Utrillo's attempt to control his immediate reality, in contrast to the calm pleasure experienced by the visitor's casual investigation of a foreign environment.

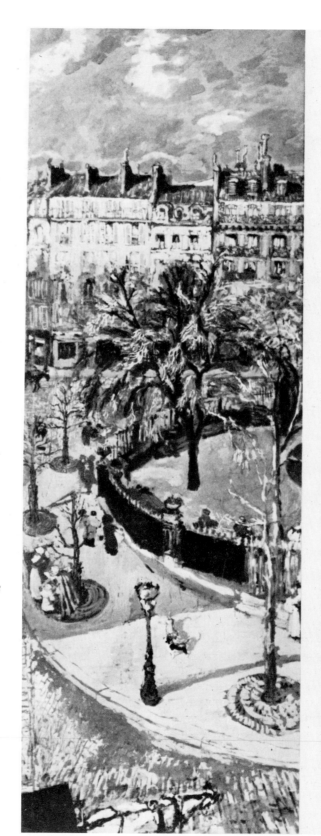
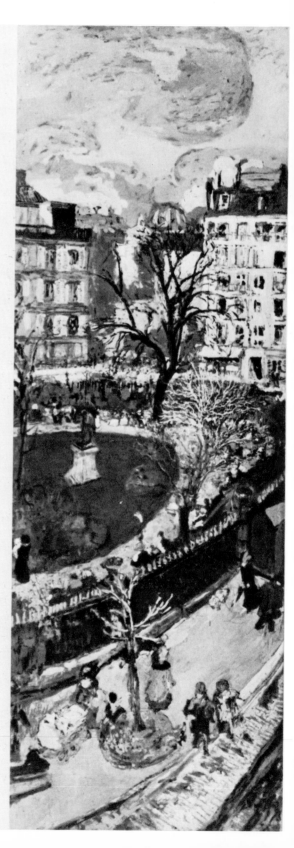

56. Edouard Vuillard: *Studies for Place Vintimille*, c. 1906.
Distemper on paper glued to panel, each painting 76½" × 26½".

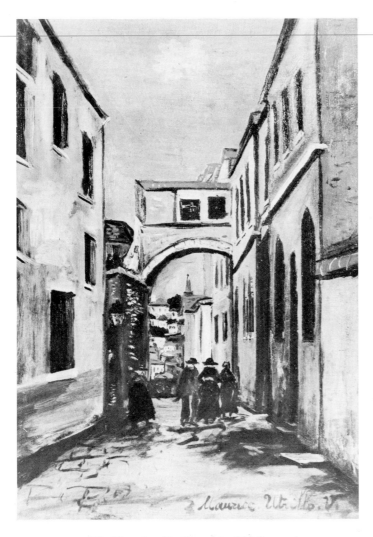

57. Maurice Utrillo: *An Old Street in Villefranche-sur-Mer*, c. 1928. Oil on canvas, 15″ × 21″.

By the time he reached the age of thirty, Grant Wood's provincial American background apparently left him more resistant to the temptations of French painting than the New York–trained painters launched by Alfred Stieglitz more than a decade earlier into the revolutionary art movements of Paris. Moreover, the time of his arrival during the years immediately following the war was a period of fewer opportunities for even the most cosmopolitan American student of painting to gain entry into the haphazard community of avant-garde artists. Wood had gone to Paris in 1920 with his hometown friend and fellow painter Marvin Cone, who had been in France as a soldier in the war. Neither was socially aggressive, and while Cone could speak French, his companion made little effort to learn the language and seemed in fact to enjoy getting by with signs

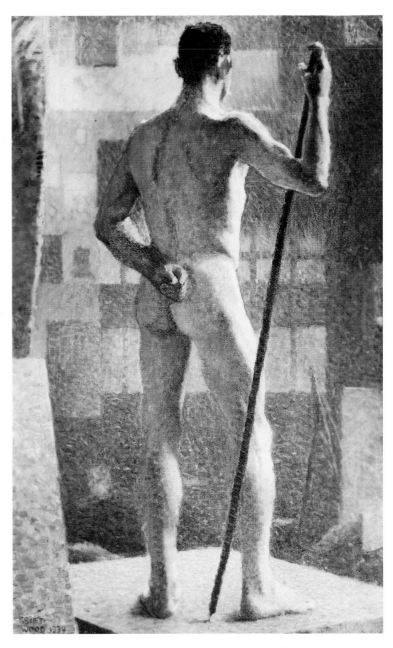

58. *Life Study, Académie Julien, Paris, "The Spotted Man,"* 1924. Oil on canvas, 32″ × 20″.

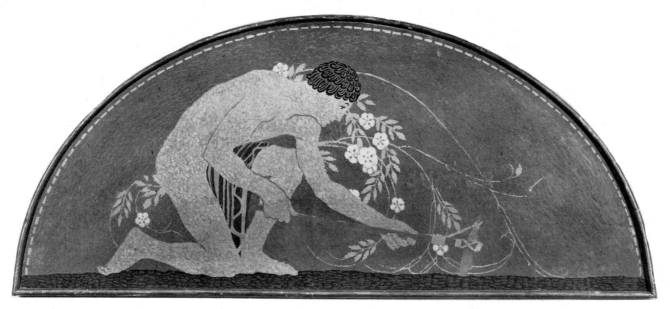

ABOVE AND OPPOSITE
59. *Summer* and *Spring, from Four Seasons
Lunettes,* c. 1922–1925.
Oil on composition board, each painting
20½″ × 39½″.

60. *First Three Degrees of Free Masonry,* 1921.
Oil on canvas, triptych,
25″ high × 18″ + 41″ + 18″.

61. *The Adoration of the Home,* 1922.
Oil on canvas glued to wood panel, 28″ × 81¼″.

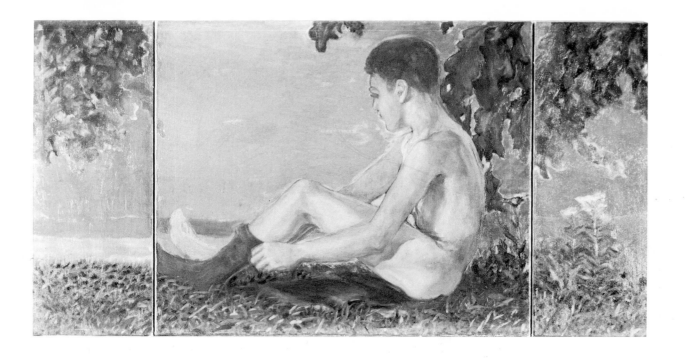

62. *Nude Bather*, c. 1920.
Oil on canvas, triptych,
24″ high × 10″ + 30″ + 10″.

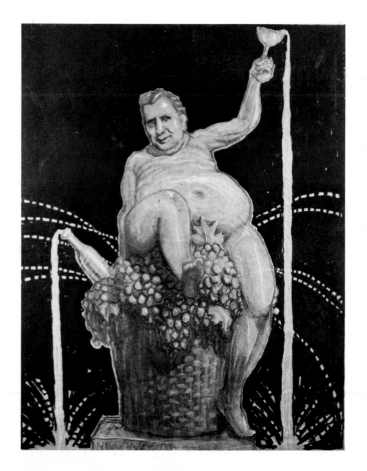

63. *Charles Manson as Silenus*, 1938.
Chalk and paint on paper, 36″ × 29″.

and drawings for the necessary day-to-day exchanges. Living in a *pension* on the Square de l'Abeille, Boulevard Port-Royal, they did not attend any classes, painting instead through the hot days of July into August completely on their own. While Cone later said that they studied in the museums on rainy days, Wood wrote home at the time that he ventured out in the rain to sketch, running for shelter every few minutes.[4] On postcards to his mother he relayed a rather cryptic progress report that by mid-July he was working diligently painting faster and feeling better satisfied with the results. On Bastille Day the two Americans stayed in their room and painted. Soon after, Wood appeared somewhat discouraged about his efforts, but by August his work was again going well and he did not want to stop. "I got three dandies yesterday," he wrote, adding that one of them was painted from a café table on a busy sidewalk.[5] The only people he mentioned seeing were those with whom they had daily commerce, the landlady Mme. Betat, a café proprietor, and the food peddlers. Summer in Paris went by very quietly with a couple of light operas to climax their limited cultural activities.

Roaming the city from Montmartre to the Luxembourg Gardens and from Jean Baptiste Camille Corot's pond, Ville d'Avray, to Versailles in search of subject matter, they were far removed from the intellectual milieu of Gertrude Stein and only remotely acquainted with the two decades of modern French art represented at 27 Rue de Fleurus. When it was time to leave, Wood wrote of his growing confidence and admitted that he wanted to stay longer, that his visit seemed like a dream.[6] On the other hand, he optimistically predicted that he would have easily over a thousand dollars' worth of paintings to bring home.[7] During their last week, in the middle of August, the two friends sketched in Montmartre, doubtlessly planning to return as soon as possible.

When he did get back to France three years later for an entire year abroad to himself, his first purpose was to attend "Julien's Academy" on the Rue du Dragon. His enrollment there bears witness to his conservative approach to art training, following the precedent of several generations of American art students. As his predecessors had done, he attended life class where students drew or painted from the model, receiving only sporadic criticism. His interest held out longer than it had almost eight years earlier at the Chicago Art Institute, at least long enough for him to complete an oil study of a male nude (Figure 58) and go to the Quat-z-Arts ball.

This studio painting, later reworked with smaller "broken" brush strokes, is one of several academic exercises distributed throughout Grant Wood's major periods.[8] An awkward drawing of the Discus Thrower, labeled "Athletics," numbers among the illustrations he had contributed to a high-school yearbook, and ten years later local commissions permitted him further opportunity to attempt the allegorical male. Spring and summer from a set of *Four Seasons* (Figure 59), lunettes painted in 1920 for the McKinley High School Library in Cedar Rapids, signify planting and sowing as silhouetted contour drawings of nude youths. A year later he honored the Masonic Library of Anamosa, Iowa, with a trisected Maxfield Parrish setting in which he painted statuary figures symbolizing the *First Three Degrees of Free Masonry*, with Rodin's *The Thinker* sitting in as the "Entered Apprentice" (Figure 60).[9] Much more personal in its introduction of individual figures, a large canvas of 1922, which served as an outdoor sign advertising a Cedar Rapids realty company, divides *The Adoration of the Home* (Figure 61) between agriculture and industry, implying that the suburban house held high by the female allegory of the city rewards both.[10] Behind the burly workers on the right, a mincing Mercury enters as the god of commerce, waving his caduceus and carrying a purse. Developed from a life drawing, the mortal man Mercury belongs to a limited assortment of meagerly clad male figures reaching into the next decade toward Grant Wood's apotheosis of the farmer. A nude bather (Figure 62) and a caricature Silenus (Figure 63) forecast the more ennobled rustic bather (see Figure 184).

After no more than two months at "Julien's Academy" Wood had acquired sufficient poise to join a group of art students for a winter in Sorrento, where he resumed painting small panel sketches, mostly landscapes and fragments of old buildings. Some of these works he sold from a one-man exhibition hung in the lobby of the Hotel Coccumello, where he and his acquaintances roomed together. Other paintings were peddled for whatever the poor market of Sorrento could afford, and this financed his stay until spring. Then he traveled north to concentrate on pictures of medieval portals and doorways, sketching them on a tour through Bordeaux, Brittany, and Belgium before returning to the streets and outskirts of Paris for the summer.

The resemblance of his quaint street scenes to earlier interpretations by post-Impressionist French artists, while tenuous, nonetheless measures Wood's distance from contemporary urban realists in

his own country. Though not a total stranger to American cities, he was inattentive to their crowds of inhabitants, super structures, and enormous spaces as subject matter even before his rural regionalist commitment. John Sloan, in following Robert Henri's Whitman-esque attitude toward art as subordinate to an immediate response to life, succeeded in gathering human-interest material on New York streets, and his paintings present mildly humorous interpretations of simple pleasures (Figure 64), interrupted by a few instances of hard-ship. While the urban reality of Sloan swarms with people, Wood's sense of an intimate community understandably diminished in his paintings as he temporarily abandoned Cedar Rapids for France, Italy, and Germany. Over there the familiarity of a local backyard or bend in a creek, with its untold associations, was left behind by the artist as tourist. Wood's scenes of Europe, much less impassioned than Sloan's views of life in lower Manhattan, casually translate strange buildings, sculpture, and stone doorways into friendly forms, companions for the barns and sheds of his previous backyard paint-ings. But the unfamiliar, foreign scenes treated in this way tend to assume a storybook quality with something of the window-winking, bulging benevolence of Frank Baum's Land of Oz.

At home in the shadow of the Sixth Avenue Elevated or peering over the black rooftops of 23rd Street, Sloan surveyed a congested world of human drama that Grant Wood passed by in Chicago to paint relatively obscure architectural attractions in European towns and cities. His enthusiasm for medieval arches and the craft of ornamental relief might well have been kindled by illustrated articles in *The Craftsman* magazine on the subject and by Batchelder's teachings. Focusing on masonry and stone carving of the Middle Ages, the articles tendered observations about the proper use of tools in relation to a given material, discussed the proper proportioning of a form to the composition as a whole, and, what was to have greatest relevance to the content of Wood's mature painting, offered a defini-tion of personality in a work: "Art as craft need not be exclusively individualistic but should bear a cultural personality, that anony-mous quality which makes Greek art Greek and Gothic art Gothic."[11] In the summer 1909 issue of *The Craftsman* Batchelder ended an article on architectural carving as an expression of indi-viduality with a statement of advice that Grant Wood would take to heart twenty years later: "We search the world over, look every-where but within ourselves to find some thought to render with our

tools, everywhere but to the abundant life about us to find some motif or suggestion."[12]

A closely related point of view regarding the future of painting in the United States came from Edward Hopper in 1927.[13] Stress-ing the value of nationality in art, he admired the American painter who stayed home stylistically and disliked those who tried to keep up with the latest styles emanating from Paris. The independence he esteemed in Sloan, whose work he called "consistent and of one piece . . . an indication of a personal vision so strong and urgent as to allow no time for bypaths,"[14] would later apply to Wood.

While Sloan at this time actually was undergoing a devastating change in theme and technique which carried him away from his innate talent for urban realism, Hopper's provocative methods of interpreting the impersonal city had reached full maturity. In his painting *Corner Saloon*, 1913 (Figure 65), he had taken up a posi-tion directly across the street, as Wood did in Paris, to record slow-moving figures at a distance. But within ten years he assumed un-usual angles of view, often extremely acute, in order to dramatize the massive city structures of steel and stone and arbitrary volumes of space (Figure 66). Nothing moves, especially not his isolated fig-ures frozen in the glare of the sun or in the light of the dynamo. The internal warmth of Sloan or the sheltered affection felt by Grant Wood for his subject matter finds no place in Hopper's art.

Working less directly within a safety zone of pictorial conven-tions, Wood bridged the distance from Iowa to Europe by gathering handmade structures, including backyard sheds and medieval door-ways, within the protective preserve of his small panels. His street scenes of Paris from 1920 vaguely resemble Hopper's style, but only in their treatment of light and shadow or in their consistency of paint. The hard angularity and abrupt value changes abstracted by the city artist could not possibly have diverted the self-taught painter of a Midwestern town from the dappled shade of a tree or the gradual slope of a hillside. In their landscapes of the 1920s the two stand far apart. As Hopper looked out over an expansive space to a broad strip of sunlit and distinctly shaded forms, Wood re-treated to an enclosure of trees and peered out at a patch of sky to find a decorative pattern through a tangle of limbs. Only after he had had enough of both European architecture and Indian Creek would he move out into broad open spaces and come into his own.

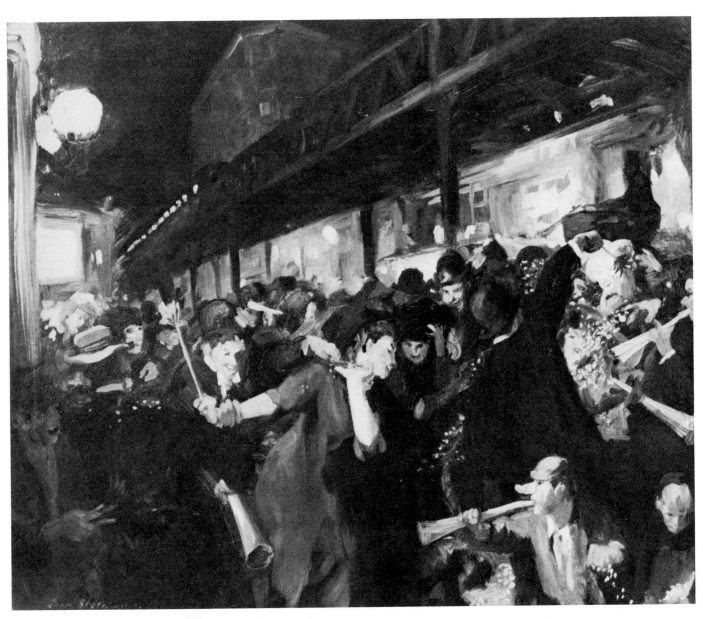

64. John Sloan: *Election Night in Herald Square,* 1907.
Oil on canvas, 26″ × 32″.

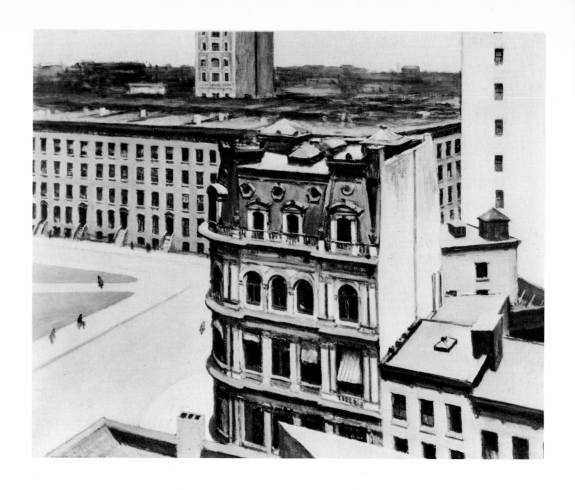

66. Edward Hopper: *The City*, 1927.
Oil on canvas, 28″ × 36″.

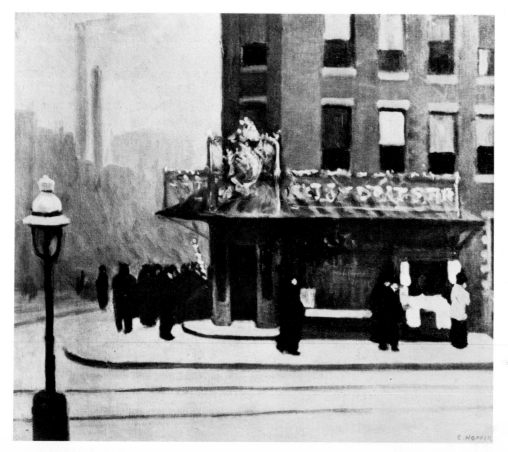

65. Edward Hopper: *Corner Saloon*, 1913.
Oil on canvas, 24″ × 29″.

# 3. *American Gothic* and Late Gothic

Grant Wood's creation of a stained-glass window for the Veterans Memorial Building in Cedar Rapids served as an unplanned prelude to *American Gothic*. The project not only tested his natural abilities and training in craft but also opened the way to a complete modification of his painting style and to new areas of content. Wood went to Munich in 1928 to supervise the execution of the window, and the art, both old and recent, that he saw there presumably inspired this change of technique, a new compositional treatment of decorative details, and the employment of familiar local subjects for larger symbolic purposes. A brief succession of thematic portrait paintings, from the midst of which *American Gothic* arose, reveals certain vague signs of derivation from fifteenth- and sixteenth-century Late Gothic and Northern Renaissance paintings, whose decorative qualities Wood indeed admired. The austere lack of specific emotions and the severity of unanimated figures precisely contoured against backgrounds parallel in plane also imply a collateral affinity with the "New Objectivity" of contemporary painters in Munich. Whatever the art-historical relevance of such comparisons, the evolution of *American Gothic* from its conception as a thumbnail sketch to the finished panel assumed an innovative course of independent design and purpose. It bequeathed a plethora of interpretations open to endless conjecture as to its iconic identification with the fluctuating values underlying the outwardly changing culture of the United States.

Almost a decade after the Armistice, Cedar Rapids started to build its new Veterans Memorial Building, which was to feature a large arched area that called for an enormous stained-glass window (Figure 68). Having been awarded the window commission at the beginning of 1927, Grant Wood completed his first drawings by spring, when he signed a contract.[1] The preliminary sketches show a large academic figure representing the Republic holding a palm frond and a wreath over six smaller figures intended to wear uniforms of enlisted men from the nation's major wars (Figure 69). On the window these would grow to a height of six feet, while the goddess Republic, seemingly suspended above a bronze tablet set in stone, would measure sixteen feet.[2] A screen of clearly patterned blue and green oak leaves serves as a backdrop for the soldiers and for the large, rounded feet of the allegorical figure. Stylized, storybook clouds billow up around her lavender gown, offset by an edge of gently shaded, uniform folds. Delicate facial features contrast incongruously to the heavy outline of the shoulders, arms, and hands. A blue and gold headdress stands out abruptly against an arbitrary sky area.

Indicative of his diligent craftsmanship, Wood devoted months of labor to the window's design and fabrication. He mounted a full-scale working drawing, twenty-four by twenty feet, on fifty-eight sections of board assembled in the recreation room of the Quaker Oats plant. There he and his assistant Arnold Pyle, working on a scaffold, modified lines and spaces in order to achieve a proper sense of proportion for the figures when viewed from below. In January 1928 the cartoon was approved by the memorial window commission, and the art glass company of Emil Frei in St. Louis agreed to stain and assemble the glass in Munich.[3] In September Wood went to Germany to supervise the final stages (Figure 68). By working over the cartoons with chalk, he approximated the desired color scheme. After he saw the Southern German craftsmen, who were accustomed to working with Christ figures and saints, repeatedly transform the soldiers' faces into "medievalized images," he quickly learned the technique of painting glass with an iron-oxide stain in order to reproduce the features as originally conceived. After several attempts the faces were fired; despite some slight degree of individuation, they endure with a uniformity of expressionlessness.[4]

Plagued by difficulties and delays during the window's final stages, Wood nevertheless took advantage of the experience as an

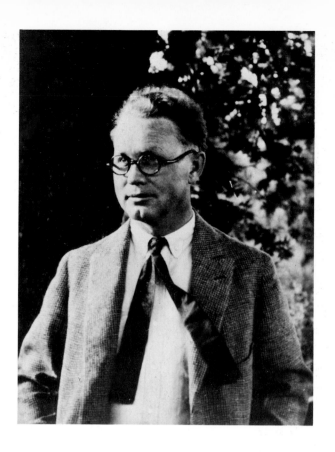

67. Photograph of Grant Wood, c. 1928.

opportunity to reevaluate the direction of his painting. An extensive project of handicraft, the stained-glass window called for clearly designed parts fitted together in a linear composition, completely predetermined through preparatory drawings which left little to chance or accident. Its installation in March 1929, therefore, marked a time of significant change from an intuitive approach to painting small-panel oil sketches to the development of a strong inclination for finished craft, which he had already been putting to practical use in creating house interiors for his more affluent friends and acquaintances in Cedar Rapids.[5] The window had required precision of technique and composition which by way of daily demand might also have motivated him to renew his respect for the craftsmanship of fifteenth- and sixteenth-century Flemish and German painters, of whom he had first learned from *The Craftsman* magazine twenty years earlier.[6] Work on stained glass, with its symmetrical formality of architectural design and its meticulously refined forms glazed in translucent colors, more than likely provided a new incentive for Wood to investigate Late Gothic and Northern Renaissance painting. Examples were available to him in the Alte Pinakothek and at the Germanisches National-Museum in Nuremberg, which he visited during his stay in Germany.[7]

In an interview for the *Christian Science Monitor* during the spring of 1932, Wood verified that his admiration for fifteenth- and sixteenth-century paintings of the North was reinforced in Munich. He had always been fond of them, particularly the works of Hans Memling, which he said he had studied assiduously. In reacting

against "modernist" works in the annual exhibition at Munich's Glas Palast, he felt especially drawn to the "rationalism" involved in Late Gothic and Northern Renaissance methods of designing cohesive compositions overlaid with a multiplicity of details. He also was intrigued by what he vaguely termed "story-telling pictures." However, without citing examples, he cautioned against this direction of painting because pictures could so easily become "illustrative and dependent on their titles."[8] Netherlandish and German masters offered a solution to this problem in the "decorative" quality they gave to drapery and other details of dress and setting as integrated compositional forms. But never did he indicate any interest in the prescribed iconographic significance of specific details in fifteenth- and sixteenth-century painting. He seemed only concerned that artists incorporated familiar elements of contemporary life from their particular locales into paintings as a means of conveying traditional symbolism. On that basis, he wished to introduce what he considered "decorative adventures" into his new paintings and was quoted as saying: "The lovely apparel and accessories of the Gothic period appealed to me so vitally that I longed to see pictorial and decorative possibilities in our contemporary clothes and articles."[9]

The degree to which Grant Wood applied his increased acquaintance with the Late Gothic may be determined by comparing his post-Munich portrait paintings with those he produced at an earlier date. In 1918 he had drawn precise pencil and chalk likenesses of his comrades and officers in the Army (see Figure 11). A year later he painted a bust-length study of Marvin Cone, whose

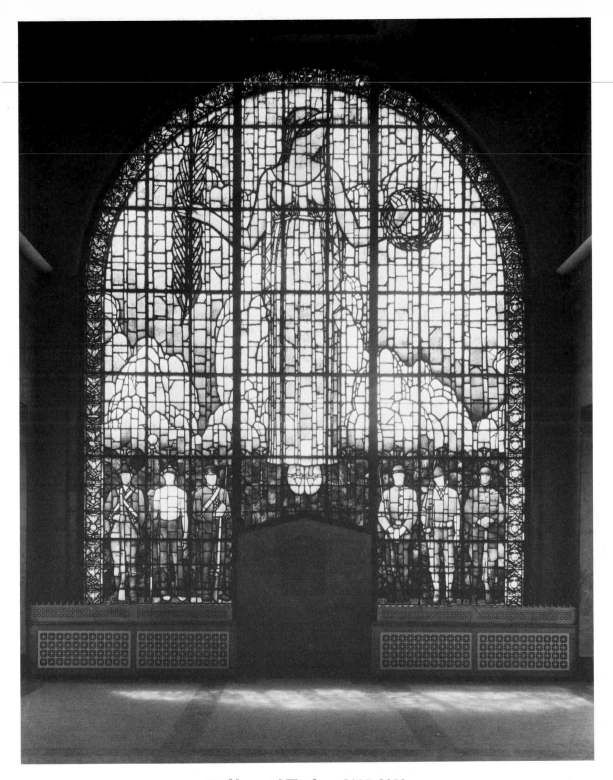

68. *Memorial Window,* 1927–1929.
Leaded stained glass, 24′ × 20′.

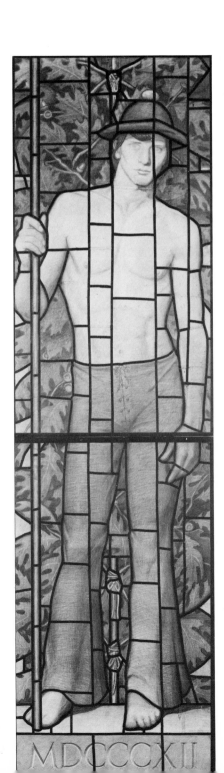

69. *Cannoneer, War of 1812.*
Drawing for stained glass window, 1927–1928.
Charcoal, ink, and pencil on paper,
79¾″ × 22¾″.

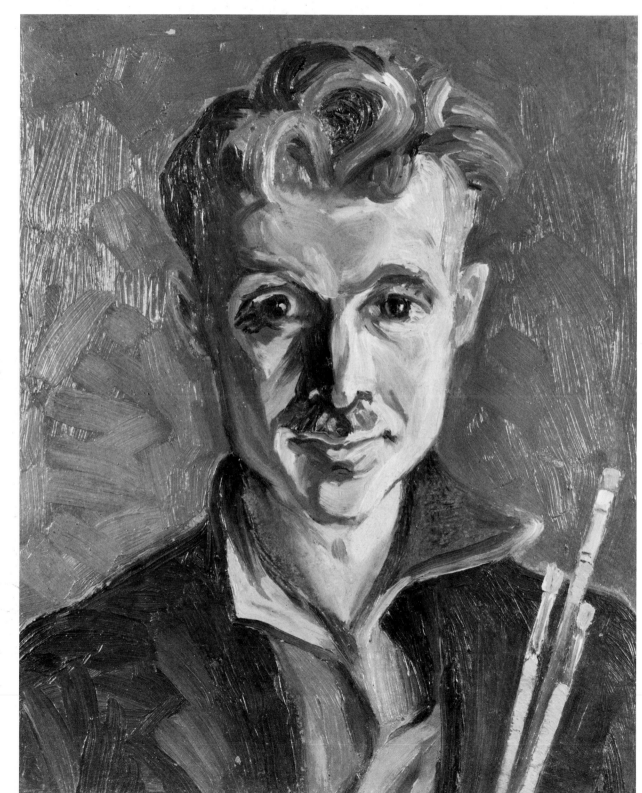

70. *"Malnutrition," Portrait of
Marvin Cone,* c. 1919.
Oil on composition board, 13″ × 11″.

70

71. *Portrait of Sally Stamats*, 1927.
Oil on canvas, 13⁵⁄₁₆″ × 15½″.

72. *Portrait of John B. Turner, Pioneer,* 1929.
Oil on canvas, 30″ × 25″.

long face and dark eyes he caricatured in thick paints with a free flowing stroke (Figure 70). However rapid the execution, it is a sensitive testimony of their lasting friendship. In 1922, between his trips to Paris, the allegorical "outdoor mural" *The Adoration of the Home* (Figure 61) incorporates portraits of local people, including his friend Paul Hanson as the carpenter. Two years later he returned to a painterly technique for seven action portraits of workers at their jobs in the Cherry dairy equipment plant (see Figures 148–154). In 1927, commissioned by the Herbert Stamatses to do a portrait of their baby girl Sally, he positioned her in a heavy armchair and painted her round face in a single plane of light (Figure 71). Drawn to the decorative appeal of the wallpaper, in painting the background he contrasted its delicate flower print to the bulk of the black wood chair. Thus by 1928 Grant Wood had had substantial experience in portraying the people around him, displaying a growing restraint of line and surface from head to detail with decorative emphasis on the latter.

The number of Wood's portraits, primarily half length, increased during the years immediately following his visit to Germany. While their general bearing and countenance compare with the pious stringency of fifteenth-century portraiture, close-up individuation and personal thematic intentions leave little indication of an eclectic borrowing from any particular artist of that period. John B. Turner, the eighty-four-year-old father of the artist's patron, posed for Wood in front of an early map of Linn County (Figure 72), in which views of early buildings surround shapes of subdued primary hues that designate townships south of Cedar Rapids. By using this chart as a backdrop, Wood appropriately recognized the businessman "pioneer" for his post-frontier role as a practical civilizer.[10] The addition of an oval frame, reserved in early American portraiture to grace the church elder, complements the expression of undaunted self-confidence compounded by a subtle curl of wit at the corners of Turner's mouth.[11] After completing this portrait, Wood painted his mother sitting and holding a venerable snake plant, flanked by a begonia and a philodendron, in *Woman with Plants* (Plate 15). Her elevated position above a hill farm landscape of fields and trees, with her head against the sky, symbolizes her exalted status as a farmer's wife and earthbound mother. Black dress, rickrack-trimmed apron, cameo brooch, plants, and hands flatten out as surface shapes countering the illusion of a spacious landscape and the three-dimensional face.

The lapse in continuity from head, hands, and background to apparel and accessory detail carried over into *Arnold Comes of Age*

(Figure 73), which depicts Wood's assistant Arnold Pyle. Honoring the youth's reaching maturity, Wood paid symbolic tribute to this moment with a butterfly at Arnold's elbow and a backdrop remembrance of a swim from the carefree past. Gradations of light and dark give structure to the slender young face, while a soft-focus glaze compresses the planes of the background, which is divided into shallow parallel zones of river, cornfield, trees, and horizon. Countering these illusions of volume and spatial recession, the concise silhouette of the dark sweater shape lifts to the surface to join the butterfly that appears to alight on the picture plane. This discrepancy among solid, flat, and atmospheric forms resulted, in the opinion of art historian Oskar Hagen, from the conflicting desires of the artist both to render an object illusionistically and to simulate a primitive appearance.[12]

If Grant Wood had intentions of developing a primitivistic style based on examples of either fifteenth-century Northern European painting or early American portraiture, as Hagen suggested, the theory gains no support from his portraits of children. Young Gordon Fennell (Figure 74) sits upright on the edge of a huge overstuffed chair, with bright lights on either side illuminating his momentarily expressive face and the smooth baby-round surfaces of his hands, which toy with a ball. Two years later Wood persuaded Mrs. Michael Blumberg of Clinton, Iowa, to permit her son Melvin to wear his favorite clothes for his portrait (Plate 17). Wood obviously delighted in obliging the boy's football fantasy and in indulging his own enthusiasm for the decorative by rendering every square of the brightly patterned argyle sweater. His personal vision of delicate ornamental trees, which descend into a valley from a precisely painted sprig of sumac and are separated from the boy in space and spirit, contains no more of a primitive affectation than the deliberately rendered figure and the well-inflated football. In taking each likeness, Wood competed with the close-up studio camera and accordingly recorded facial features finely focused on the picture plane. He selected direct light, close above and slightly to the side, as if from a flood lamp, to illuminate the face, extending the effect with highlights in the sitter's eyes. Folds of skin, wrinkles, and structural planes build up and fade out in value or color tone through a gradual application of sable brush and oil pigment, evolving stroke upon stroke from opaque underpainting to the last translucent touches.[13]

Though at first glance there seems to be a general resemblance in detail and technique between the small bust-length portraits of Mary and Susan Shaffer (Figures 75 and 76) and the advanced

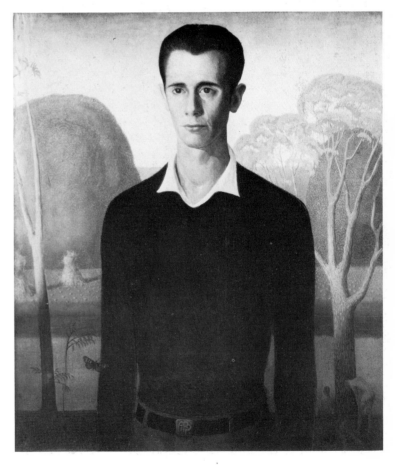

73. *Arnold Comes of Age, Portrait of Arnold Pyle*, 1931.
Oil on composition board, 23″ × 27″.

74. *Portrait of Gordon Fennell, Jr.,* 1929.
Oil on canvas, 24" × 20⅛".

75. *Portrait of Mary Van Vechten Shaffer,* 1930.
Oil on composition board, 15¼" × 13".

76. *Portrait of Susan Angevine Shaffer,* 1930.
Oil on composition board, 15¼" × 13".

naturalism of Dürer and Holbein, the spontaneity of expression and gesture in the portraits of the sixteenth century are not equaled in the Shaffer pair. For the most part, Grant Wood's figures are fixed into position, frozen in pose, submitting their features as well as details of dress or setting to the artist's infatuation with what he judged to be "the decorative quality in American newness." Promoted to this high priority, designated objects, patterns, and textures relieve his portraiture of the severity concentrated in the largely emotionless, firmly set faces. Referring to those portraits immediately preceding and following *American Gothic,* Wood stated in 1932:

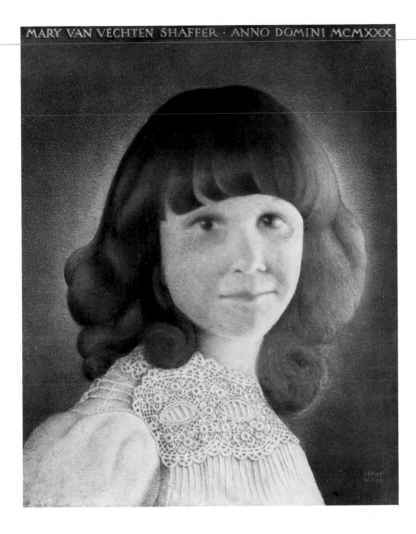

MARY VAN VECHTEN SHAFFER · ANNO DOMINI MCMXXX

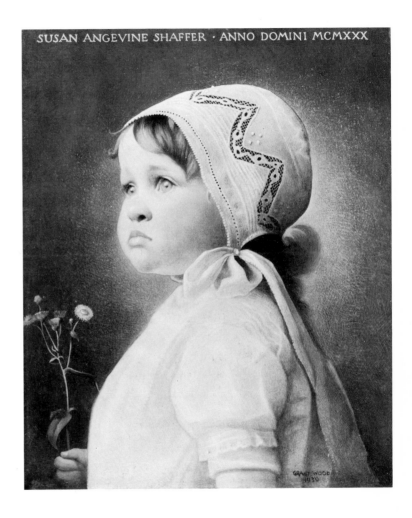

SUSAN ANGEVINE SHAFFER · ANNO DOMINI MCMXXX

Gradually, as I searched, I began to realize that there was real decoration in the rickrack braid on the aprons of the farmers' wives, in calico patterns and in lace curtains. At present, my most useful reference book, and one that is authentic, is a Sears Roebuck catalogue. And so, to my great joy, I discovered that in the very commonplace, in my native surroundings, were decorative adventures and that my only difficulty had been in taking them too much for granted.[14]

In addition to the distinctive features of technique, characterization, and "decorative" enhancement of details in his portraits of the late 1920s and early 1930s, Grant Wood's concern for developing his own interpretive art of regionalism and his discovery of satire further distinguish his figure painting from Late Gothic and Northern Renaissance stylistic traditions and from all prescribed systems of complex iconography. His interpretations of the local milieu, aimed at its rural regionalist-agrarian traits, and the activation of his good-natured, comic sense of satire also separated his art from the dominant trend of modern German painting that he witnessed in Munich in 1928. While his *Self-Portrait* (Figures 77 and

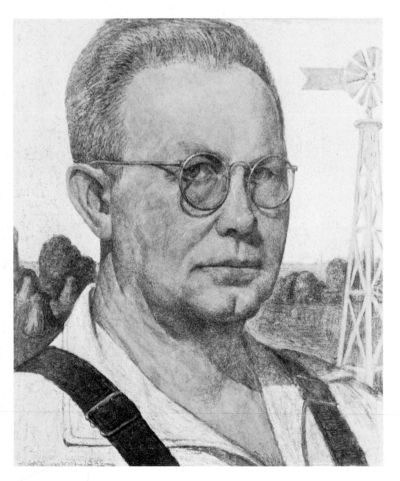

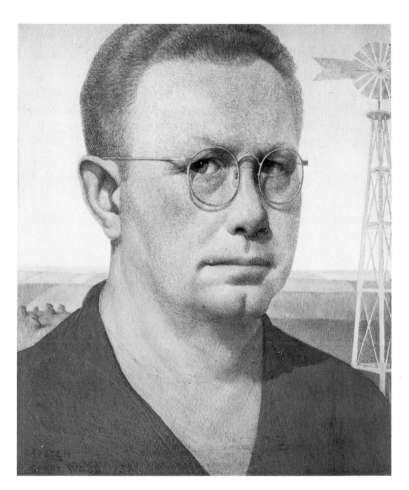

78. *Self-Portrait*, unfinished, 1932–1941.
Oil on masonite, 14½″ × 12″.

77. *Sketch for* "*Self-Portrait*," 1932.
Chalk and pencil on paper, 15¼″ × 12¾″.

78) recalls in its composition a personal portrait by Georg Schrimpf (Figure 79), one of Munich's leading painters during the 1920s, the differences in content outweigh any stylistic similarities.

The figure of Frau Schrimpf, her abrupt foreground presence superimposed upon a landscape, has no relation to the background distance which extends for miles. Enclosed by a bare table top, a ledge, and a pale green drapery merging in tone with the sky, the woman wears a simple, robelike maroon dress with an austere absence of accessories. Her short black hair forms a flat curvilinear frame for a face generalized to the point of caricature, with smooth surfaces, finely delineated features, and oversized eyes staring blankly at the observer. Her elongated hands rest on the table as inanimate objects, ceramic in finish. The most detailed area of the painting, the green landscape of river and trees, features a distant village and atmospheric hills in a receding succession of even furrows.

A deep landscape of open farm fields rolling back in parallel folds also furnishes the background for Grant Wood's mirror image. As a drawing in charcoal and chalk, the farmscape was first conceived with close-up shocks and bushy trees, but in the end the space was cleared and a neat diagonal succession of detailing moves from five distant cornshocks to steel-rimmed glasses to the top of a metal windmill in the upper right corner. Even the features of Wood's face and the short shadows they cast from a midday sun participate in the composition as decorative elements. They create a curious frontal view out of a three-quarter pose, with a vertical axis running from the fold of his cleft chin to the bridge of his glasses where it intersects a horizontal accent. Both artists described every element in their paintings as an isolated object. Only the most resourceful linear relationships secure their compositions from multiplicity. But, unlike the *Self-Portrait*, the German painting minimizes historical, social, mythical, and regional allusions for sake of a severe, abstracted realism dubbed, most appropriately in the case of Schrimpf, *Neue Sachlichkeit*, a new objectivity. Such a determined evasion of overtly stated external associations, or of any literal meaning free of psychological analysis, stands far removed from Wood's aspirations toward discernible thematic purposes in his pictures. As he realized and warned, however, a principle of popularly recognized themes might steer painting precariously close to story-telling illustrations, damaging to its substance as a fine art.

In his painting entitled *Appraisal* (Figure 80), the narrative performance of the two portrayed figures tends to restrict an im-

79. George Schrimpf: *Portrait of Frau Schrimpf,* 1922. Oil on composition board, 27½″ × 19½″.

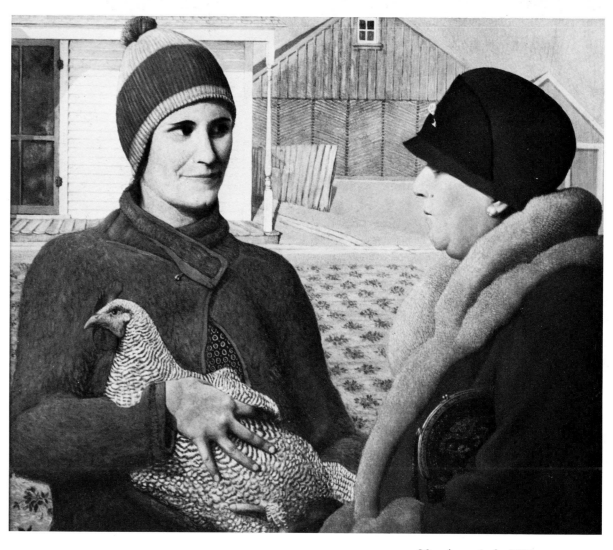

80. *Appraisal,* 1931.
Oil on composition board, 29½″ × 35¼″.

mediate understanding to its original title, *Clothes.*[15] Playing the worn-out gray bulk of poor farm cloth against the customized elegance of rich city garb of fur-trimmed browns, the artist awarded the most beautiful coat of all to the bar rock chicken. Closer inspection and some knowledge of his other paintings idealizing farm life lead one to realize that the women are also engaged in a socially thematic exchange based on the artist's love of the agrarian. The farm woman unassumingly provides; the city woman consumes. The farm woman is virtuous, close to the soil, one with the animals. The city woman comes to the country adorned with a dead animal, shielded from nature by her armor of cosmopolitan clothes. Labor and leisure are clearly distinguished between the two figures. To intensify the theme, an air of rural purity from the background bolsters the farm woman against the onslaught of the city. The potato patch and the boards of plain wood construction advance to the surface in pristine, orderly patterns of fresh green, white, and a low-keyed terra-cotta pink.

*American Gothic* (Plate 16) skillfully combines a personal iconography drawing upon a visual pun, portrait caricature, comic satire, and rural regionalism with an eccentric unification of "decorative" elements derived from local sources. The artist's sister, Nan, and his dentist, Dr. B. H. McKeeby, are posed in costume as counterparts to a modest Carpenter Gothic house abounding with social and cultural implications. After painting *American Gothic,* Wood regretted the years he had spent in search of centuries-old subject matter, such as picturesque dwellings and doorways in Europe, and said:

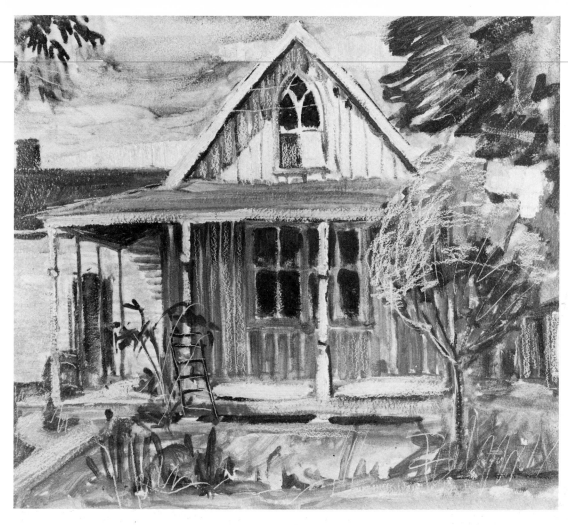

81. *Oil Sketch of House for*
*"American Gothic,"* 1930.
Oil on composition board, 13″ × 15″.

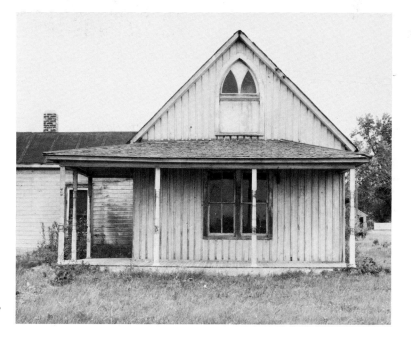

82. Photograph of *American Gothic* house,
Eldon, Iowa.

"I know now that our cardboardy frame houses on Iowa farms have a distinct American quality and are very paintable. To me their hard edges are especially suggestive of the Middle West civilization."[16] Ironically, his hard-edged personification of a basic middle-America started out in his old manner as an oil sketch of a small board-and-batten house that he discovered in the village of Eldon, Iowa, during a casual outing in 1930 (Figure 81). The painting, done on the spot, is composed of a direct view of the house seen from the road, flanked by spring-green trees very freely scribbled in with highlights of scratching. The house was painted in a quick watercolor technique with a textured combination of oil washes, dry scumbling, and opaque white. The yard is alive with loose strokes and scratches filling the foreground with weeds and a small round tree.

In essence the picture summarizes his Cedar Rapids landscapes of trees and the many panel paintings he did in Europe of obscure dwellings and medieval arches. This house survives as a picturesque remnant of the nineteenth-century Gothic Revival as it was interpreted for the American farm by the architects Alexander Davis and Andrew Downing (Figure 82). The original window was topped by a wide pointed arch properly proportioned by the carpenter who built the house as a rather squat box resting directly on the ground. Wood promptly stretched the whole structure vertically into a narrower gable, heightened the porch, and elongated the window to look more like a fully developed Gothic arch of the thirteenth century.

These adjustments suggest that Wood had something more in mind than just a landscape view of an old frame house, which he would normally have depicted unaltered with only marginal distortions arising from the spontaneous sketch. Moreover, he also had his companion of that day take photographs of the house for later reference to such minor details as the porch posts.[17] Thus, from his experience of thematically portraying his mother as a rural woman, closely identified with the soil through her plants and the farm landscape, and from this background motif basically completed in a single sketch, he apparently set out to develop a predetermined theme. The next phase demanded an appropriate match of figures.

The first full sketch of his envisioned pair (Figure 83) was done on the back of an envelope in pencil, labeled "American Gothic," and ruled with a grid of six lines for enlargement. In it the gable and window undergo further elongation, and a second narrow Gothic arch appears on the rear addition of the house near the left side of the drawing. The heads of the two half-length figures are separated by the same general proportion of space as in the painting. However, in spite of its pointed gable, the house lacks the height of the final version since the porch roof barely rises above the center and the peak is well below the top edge of the picture.

Even so, Wood established the interrelationship of shapes from the beginning, as the long oval heads narrow at the chins and the sloping shoulders echo somewhat too obviously the sharp angle of the trial gable. The overall downward pull of the composition settles in the mouths, which curve down at the corners in a mutual expression of disapproval or even hostility. The austere costumes have been defined to the stage of bibbed overalls, starched shirt, and dark jacket for the man, while a large scalloped collar on the woman will later be replaced by the brown print, mail-order apron trimmed with rickrack. The clever touch of the three-tined pitchfork has yet to be added, and the hand temporarily grips what is perhaps more appropriate for a small-town man, a garden rake.

These preliminary sketches make it evident that Grant Wood intended to develop his theme for *American Gothic* on two corresponding levels. His studies with Batchelder and his choice of subject matter in Europe during the mid-twenties demonstrate his fondness for the Gothic arch, and he was amused to rediscover it in such an incongruous place as on a "cardboardy" cottage in southern Iowa. On this level of simple delight he immediately planned a visual pun, proceeding from the window to the invention of occupants whose shape and form he deemed suitable for the house. Soon after the finished painting went on exhibit late in 1930 at the Chicago Art Institute, he explained this process somewhat defensively to the rural readers of the *Des Moines Register*. Some of them had been offended by the subject as it was introduced to them under the mistaken title of *An Iowa Farmer and His Wife*. He wrote:

Any northern town old enough to have some buildings dating back to the Civil War is liable to have a house or a church in the American Gothic style. I simply invented some American Gothic people to stand in front of a house of this type.

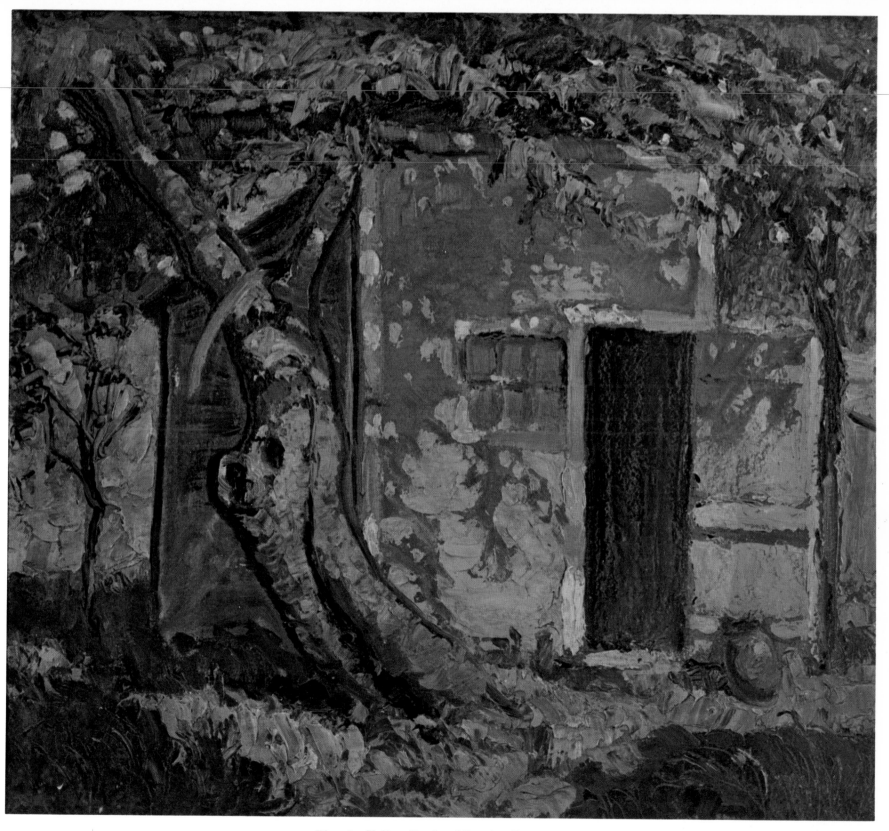

Plate 1. *Yellow Shed and Leaning Tree,* c. 1919.
Oil on composition board, 13″ × 15″.

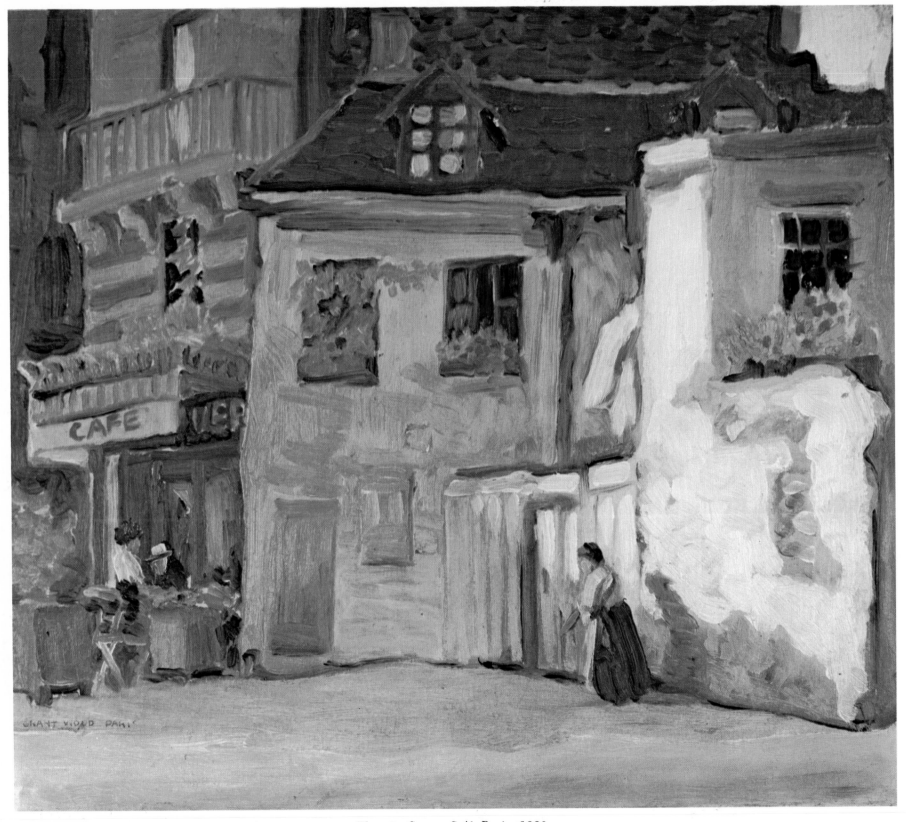

Plate 2. *Corner Café, Paris,* 1920.
Oil on composition board, 13″ × 15″.

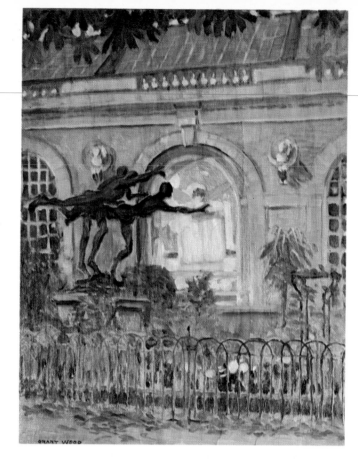

Plate 3. *The Runners, Luxembourg Gardens,* 1920.
Oil on composition board, 15¾″ × 12½″.

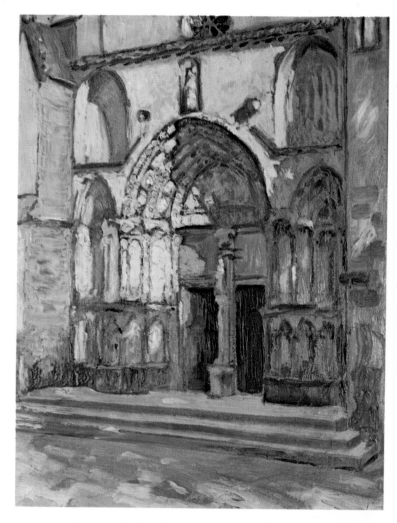

Plate 5. *Yellow Doorway, St. Emilion,* 1927.
Oil on composition board, 15⅞″ × 13″.

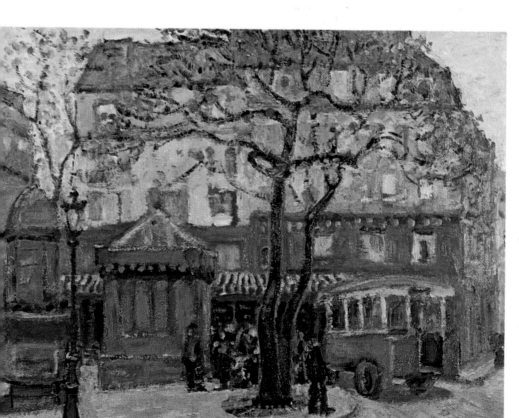

Plate 4. *Paris Street Scene with Green Bus,* 1926.
Oil on composition board, 16¼″ × 13½″.

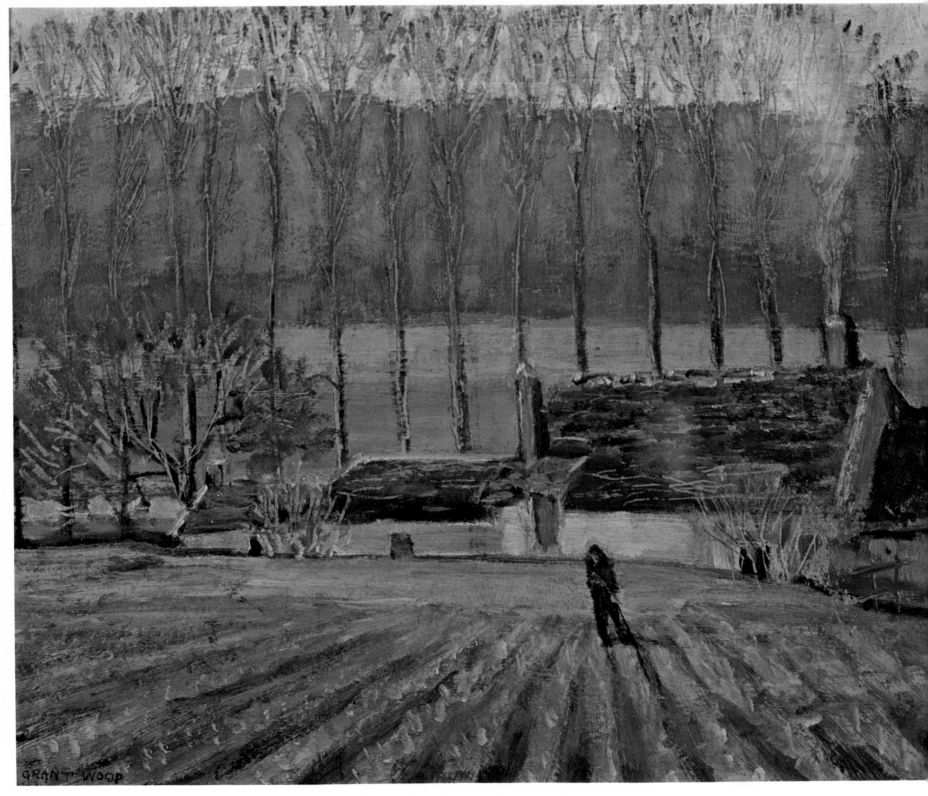

Plate 6. *Truck Gardens, Moret,* 1924.
Oil on composition board, 12¾″ × 15¾″.

It was my intention later to do a Mission bungalow painting as a companion piece, with Mission bungalow types standing in front of it. The accent then, of course, would be put on the horizontal instead of the vertical.

The people in American Gothic are not farmers but are smalltown, as the shirt on the man indicates. They are American, however, and it is unfair to localize them to Iowa.[18]

Wood therefore defended his picture at its earliest exposure to local criticism as no more than a play on visual forms and humorously suggested a perpendicular counterpart. However, the window holds a second, more profound significance than the eye of the beholder and perhaps even that of the artist may have at first seen. It involves urban appraisal of a rural frame of mind and the resultant negative conception accentuated by the traditional associations of a Gothic arch, so often used in romantic literature to suggest an awesome condition.[19]

Although Wood's Gothic window is neatly reconstructed and freshly painted, in contrast to the vacant eyes of Poe's bleak mansions, it does contribute, as a rectangular or round window could not, to the forbidding severity of the faces formally related to it. Also, as the forwardmost factor in a kite-shaped closure secured at its base by a fist, the pitchfork suddenly projects menacingly into clear, magic focus. Unable to escape from its legendary identification as a punitive weapon, over and above its function as a practical tool, it issues a warning to strangers against sudden approach or against any attempt to enter the premises from the edge of the road. It wards off outside threats as determinedly as do the lightning rod and the church steeple—the fourth and fifth prongs pointing toward the sky.

Devoid of all expression, showing neither compassion nor melancholy, pain nor pleasure, the man and woman are permanently armed against any conclusive speculation as to what they stand for. They will listen to a stranger's query but never answer. The spectator therefore confronts interminably the quiescent couple that haunts the national imagination. Only class, hygiene, and general location can be surmised; otherwise, the two are as closed from further acquaintance as the front of the house behind them. Their mouths are sealed as tightly as the shades of the porch windows, which are drawn to the sills though well protected from the sun by a broad roof. A curtain trimmed with a chain-in-ring pattern behind the divided Gothic frame veils the interior from view, while eyes bore through the observer or avoid contact altogether by gazing to the side, across the direct line of vision.

It is impossible to follow the direction of the woman's translucent blue sight, which at first seems to be fixed on the head of the man but then shifts into the distance only to return to focus on some immediate target, perhaps on a companion standing at the viewer's side. This mystery aside, the woman clearly asserts her superiority, with only a hint of trepidation about her mouth and brows. The loose strand of hair snaking to her collar connotes recalcitrant authority and emits a talismanic quality to counteract the spell of bewilderment inflicting her companion. Contrary to the severe regularity of the man's barn, however, a touch of human warmth rests at the end of the rickrack in the two potted plants carried over from the previous summer's portrait of the artist's mother. Nevertheless, in compliance with the centrally oriented composition, which grew formally and symbolically on axis from the middle background to the immediate foreground, the spirit of American Gothic withstands any mediating latitude from without. It allows no room for sentimentality or compassion to intercede, and thereupon Grant Wood's propensity for irony and his comic sense of satire intervene.

Utilizing an associative motif as the controlling factor of form and content in a painting marks a significant juncture in Grant Wood's career. Out of a growing dissatisfaction with local landscape impressions or oil sketches of picturesque doorways, he had begun to search for a new basis of expression from which to paint. Through the memorial window of 1927–1928 and his opportunity to review Late Gothic and Northern Renaissance painting from originals in Germany, he entered a transitional phase manifest in thematic portraiture, with American Gothic at its center as the pivotal point of his career. Never satisfied with likenesses alone, he now wished to augment his figures with associative accessories. In his first attempts he permitted the lives of two elderly sitters, his mother and John B. Turner, to determine their respective settings. A farm landscape accompanies the farm woman into town, and an old map of Linn County encircles the business "pioneer" of the community.

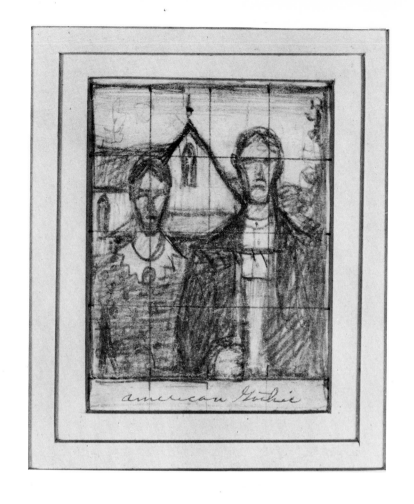

83. *Sketch for "American Gothic,"* 1930.
Pencil on paper, 3¼" × 2⅜".

In *Arnold Comes of Age* and *Appraisal,* as in *American Gothic,* the personal identity of the portrayed decreases in importance for establishing a theme. The message, as in his later portrait *Victorian Survival* (see Figure 108), lies exclusively with the age and physical type of the sitter and the apparel, accessories, and backgrounds. A telephone, a contrast in costuming, a farmyard, and a bathing scene determine the success of the relatively anonymous figures in embodying their respective picture titles. The title of *American Gothic* captions the restrictive standards and sentiments evoked by the architecture of its old house. In introducing what was destined to become the nation's most famous Gothic window, Wood evidently realized that decorative elements need not limit their function to isolated, formal "adventures" within a composition but indeed might initiate the conception and realization of abstract symbolic imagery.

Landscape, too, when unencumbered by externally imposed aesthetic or stylistic conventions, would also mature as an independent mode of Wood's personal expression. Thus a nineteenth-century literal naturalism or a purely formalist obliteration of nature encounters a new alternative. Grant Wood's unique, personalized farmscapes, liberated from traditional styles and immune to extremes of modernist distortion, unfold an earthborn fantasia conceived by his affection for the decorative and cultivated by his imagination.

# 4. *Stone City* and the Fantasy Farmscape

While Grant Wood narrowed his range of subject matter in the late 1920s and early 1930s to thematic portraits and increasingly refined landscapes, he did experiment briefly with still lifes. Limiting himself primarily to floral subjects, he nevertheless employed a greater variation of technique and composition than in his early landscapes and European views. In manner and mood his flower paintings anticipate several of the characteristics found in his more famous works of the 1930s. There is humorous ingenuity in his junk-sculpture still life *Lilies of the Alley* (Figure 84), and from his preoccupation with the ornamental evolved the paintings *Calendulas* (Plate 13) and *Cocks-combs* (Figure 85) with their decorative accessories of pottery and porcelain. Wood's lifelong attraction to intricate surface patterns inspired the directly painted arrangements of blossoms picked from his own garden (Figure 86). This still-life interval, though bearing little resemblance in technique and theme to the paintings following *American Gothic,* demonstrates the continuity of his sophisticated approach to problems of pictorial design and color.

Of the pictures from his last decade, the farmscapes achieve the most abstract level in composition and content. Through them Grant Wood's mature art compares with the current trend toward a modern style of representational painting in the United States. His inventive sense of ornamental design and his imaginative interpretation of reality, especially in his treatment of space, transport his farmscapes beyond the conventions of the picturesque and Impressionism to a realm of abstract fantasy approaching the border zones of Surrealism found in American painting in the early 1930s.

Concurrent with *American Gothic,* Wood's first major landscape painting *Stone City* (Plate 12 and Figure 87) developed in the summer of 1930 from an oil sketch (Plate 11). Unlike the comfortably enclosed compositions of his tree-filled landscape panels of the 1920s, the *Stone City* sketch displays an open sweep of spacious, rolling countryside viewed from an exaggerated elevation. From the lower right corner of roughed-in farm buildings and trees, the high bank of the quarry, to which the settlement owes its name, and the sunlit side of a green hill open to release a road, which climbs out of the valley to a rounded horizon at the top of the panel.

The diminishing ribbon of cream-colored road figures prominently as a central accent against the green, darkly shaded tree areas scattering to both sides. The cohesive composition is built up from broad, vertical brush strokes, decisively impasted and scumbled. At this point Grant Wood came close to doing over nature according to Cézanne. An illusion of recessive space depends on a slight diminution of size. The viewer's eye moves upward, undeterred by the atmospheric perspective of a few years earlier when Wood painted a small landscape panel from a high eye level entitled *Young Artist on Kenwood Hill* (Figure 88) and two slightly later paintings of mountains in Colorado (Figures 89 and 90). Showing little enthusiasm for the well-worn subject matter of mountain scenery, Wood in the latter paintings relegated the high peaks to a background haze of blues and grays.[1]

The finished version of *Stone City* conveys at first glance a closed, curvilinear composition of a spacious horizontal subject. From an indefinitely lofty height one looks down into the picture's deepest planes along rows of new corn which accelerate over the hill to a farmyard below. Only the fence posts survive as remnants of the conventional foreground space foils of classical landscapes, and the middle area is filled in as a basin of toyland buildings, trees, animals, and figures. The river glows from a descending sun, challenged by the shady diagonal of dark trees. Luminous contours and contrasting shadows edge the surrounding hillsides inward toward a central point above the bridge where the road begins its long climb. Yet the restless lines flowing inward sweep out again with the turbulence of activated air currents. From suspended and shifting points

84. *Lilies of the Alley*, c. 1922–1925.
Earthenware flowerpot, wire, bottlecaps, shoe
horn, gears, plaster, and paint,
11″ × 11¼″ × 7″.

of view the observer fails to find easy access, and, while the perspective of the buildings puts the horizon line in a middle level at the base of the quarry, the incalculable distances from corn to cow to horse to high banks and to the northbound road beyond add to the uncertainty. The rising hills contribute a sensation of continuous change as they roll circular trees down their flanks.

Calm is restored on the distant terrain, where contours smooth out in conformity to the horizontal emphasis of the long elliptical curve in the road as it swings through the valley. In a modest way this alteration of spatial velocity first occurred in an isolated landscape Wood sketched in France entitled *Truck Gardens, Moret, 1924* (Plate 6). Here too the eye is carried downward along planted rows of a foreground field to converge on a figure and a horizontal farmhouse. The distances are short, however, and a potential depth of space falters at a row of high poplars which screen the background from the middle-ground buildings. A model for such horizontal space extension viewed as a panoramic succession of stylized focal areas was available to Wood at the Alte Pinakothek in Munich. In the long panel painting *The Seven Joys of the Virgin* (Figure 91) Wood's favorite fifteenth-century painter, Hans Memling, combined city views with landscape. Narrative events in late medieval settings are separated by intervening spaces occupied by loaflike rock formations that shelter colorful horsemen. The Nativity, the

Adoration of the Magi, and the Resurrection take place on a broad foreground ridge high above the middle ground, which descends to a walled town of towers far below. In *Stone City* Memling's distant landscape of the background near the top of the panel appears to find a parallel. Memling's uniformly rounded hills fold one into another with overlapping contours while narrow roads wind through the valleys and generalized trees decorate the slopes.

Following his trip to Germany, Wood made in 1929 two paintings that anticipate the space of *Stone City*. In the autumn landscape for *Woman with Plants* (Plate 15) open fields beyond a tree-clustered farm disappear along a slightly curving contour against the sky. Still closer in composition and style to *Stone City* is a cohesively designed painting entitled *Black Barn* (Plate 10), with its rhythmic accent of unfolding hills. With fence posts leaning to the sides, the high foreground of this small but important work opens up to a circular middle-ground closure which encompasses a barn and its dark shadow located above a sloping meadow and a gasoline sign. Rounded trees carry the composition to the upper corners, and three patches of dark blue sky proceed across the top. Although the *Stone City* sketch of the next summer directs the eye immediately into the background of the culminating picture, the final design and distribution of its hill forms more closely resemble *Black Barn*.

85. *Cocks-combs,* c. 1925–1929.
Oil on canvas, 21½″ × 21¼″.

86. *Sunflower with Zinnias,* 1930.
Oil on composition board, 24″ × 30″.

87. *Stone City,* 1930.
Oil on composition board, 30¼″ × 40″.

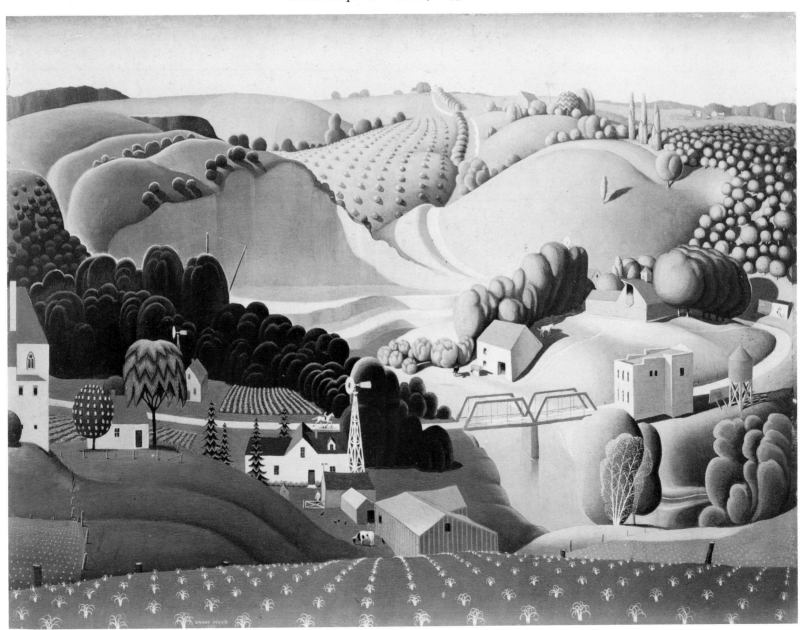

88. *Young Artist on Kenwood Hill,* c. 1925.
Oil on composition board, 10⅞″ × 13⅞″.

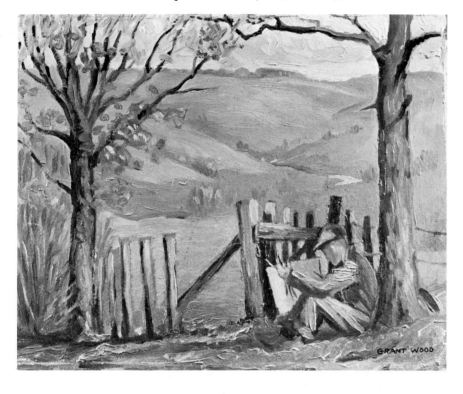

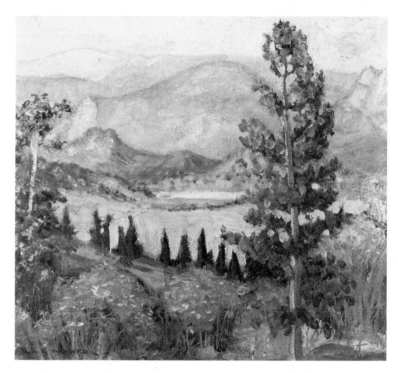

89. *View of Mary's Lake in Estes Park,*
*Colorado,* 1927.
Oil on composition board, 12⅞″ × 15″.

Wood continued to begin with oil sketches in determining space for major landscapes subsequent to *Stone City* (Plate 12). Quickly laid down in broad brush strokes of heavy paint, each study nevertheless conforms to a basic design of curving diagonals. In *Young Corn* (Plate 22) the short-lived ornateness of patterned trees from 1930 yields to distended forms, hovering like viscous green clouds of smoke over the smooth contours of rolling fields. A low-lying array of stylized foliage encircles the belly of a hill which gently declines into a field tended by a farmer and his children. As with *Stone City*, the observer scans the sun-filled bottom land from above along rows of corn falling off into the valley. With the inviting appeal of its reclining female forms, the painting could settle easily into the background of *Stone City*, joining the other physical attributes behind the quarry. The plow of *Fall Plowing* (Plate 21) stands sacrosanct and pure against wide open, precisely detailed fields. Superseding the sketch, in the finished painting Wood fitted every element into a clearly pronounced order; the farm land, the "moderne" trees, the house and barn, all commemorate the indomitable advance of the machine and the efficiency of its linear fabrication through an open space.

Wood increased his use of the wide-angle view in subsequent paintings, such as *Spring Plowing* (Figure 92), *Arbor Day* (Plate 25), *Near Sundown* (Plate 26), and *Spring Turning* (Plate 34). As the foreground slope recedes into space, the observer glides aloft, soaring out over the land, visually airborne. Figures and fence posts, farther below than ever, inch along the surface of attenuated hillsides, details of their texture, light, and shadow undiminished regardless of the distance. Discarding a conventional counterbalance of landscape elements leading into a centralized focal area, Wood has painted a great span of earth, creased and folded in gently undulating contours, that continues indefinitely at constant intervals along each side. Details that once functioned as eye-catching spots of surface decoration have been minimized to no more than tiny points of reference across an open plane. Abstract design, or as Wood termed it, the "decorative," now applies to the picture as a whole; light, shadow, and the patterned imprint left on the land by clearing and cultivation have been generalized into ornate forms.

Using elaborate, close-at-hand detailing, Wood effected a compression of space in a pair of late farmscapes, similar in basic design to four watercolor still lifes of flowers, fruits, and vegetables (Fig-

90. *Long's Peak from Loch Vale, Estes Park,*
*Colorado,* 1926.
Oil on composition board, 13″ × 15″.

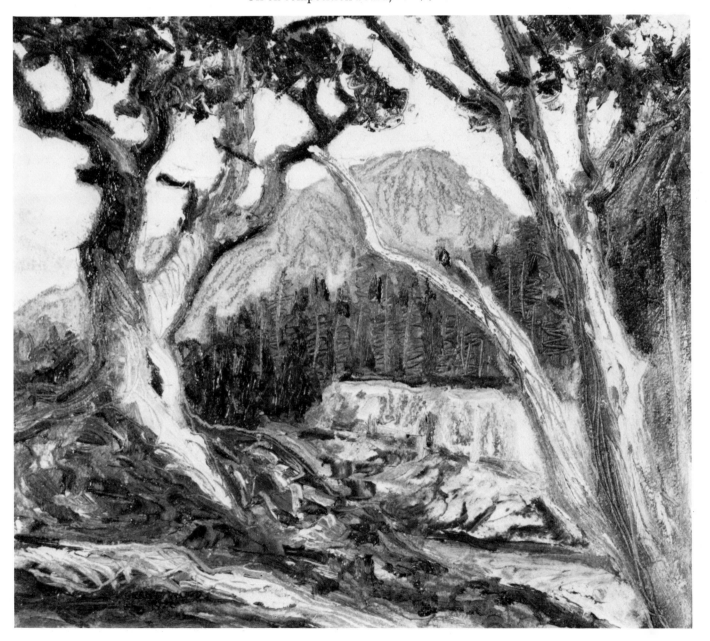

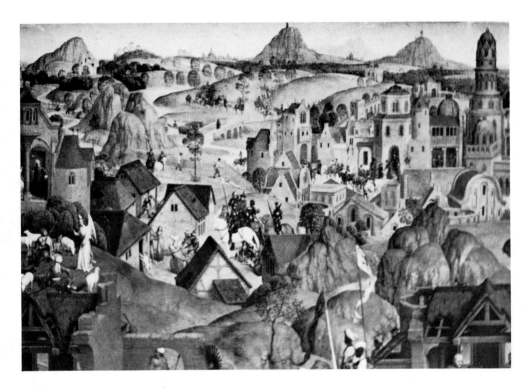

91. Hans Memling: *The Seven Joys of
the Virgin,* detail, 1480.
Oil on wood panel, 31⅞″ × 74⅜″.

ures 93–96) from the same period. With the intimacy of a still life, *Haying* (Plate 35) and *New Road* (Plate 36) lower the viewer's vantage point to a slight elevation above the nearest objects. The background rises immediately out of the foreground zone, encountering no thrust of deep recession until it reaches a horizon near the top of the panel. Wood controlled the center of these paired landscapes with an angular configuration that he employed in the four still lifes and secured both positions at points of convergence near the middle of each of their borders. In his last major farmscape, *Spring in the Country* (Figure 97), Wood achieved a synthesis of this compositional device and a wide-open recessive space. Center-bound angles coinciding with the painting's figures, tree, and clouds take form on the picture plane against the deep recession of fields and farms which Wood projected for miles toward a sharply contoured horizon.

While Grant Wood's farmscapes surrender none of their logic of perspective to dreamlike suspensions of objects and figures, nor permit the juxtaposition of random elements collected from widely separated experiences spanning long periods of time, they do include spatial illusions favored by contemporary American painters of a quasi-Surrealist persuasion. The proximity of observer to foreground in *Spring in the Country,* the configural integration of figures to their setting and the rate or distance of recession to a distinct horizon line recall pictorial devices employed by Peter Blume, for example, in his picture *South of Scranton* (Figure 98). In it the New York painter recorded a trip from the industrial landscape of Pennsylvania to the harbor of Charleston, South Carolina, "welding" his impressions together through a manipulative process of free association. His precise delineation of particulars, the tangibility of light and shadow, and the absence of atmospheric perspective justify a comparison between the contrasting fantasies of the two painters. Nonetheless, even an indirect affinity with the original Surrealism of Max Ernst, Yves Tanguy, or Joan Miró is tenuous. Their purported effort to release the subconscious as a creative agent of art through

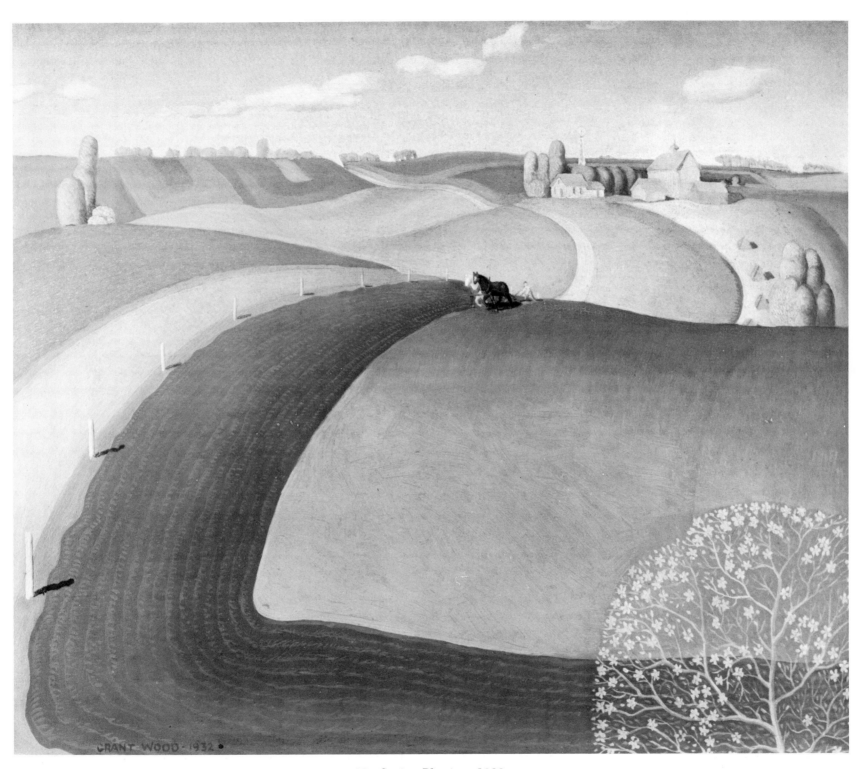

92. *Spring Plowing,* 1932.
Oil on masonite, 18¼″ × 22″.

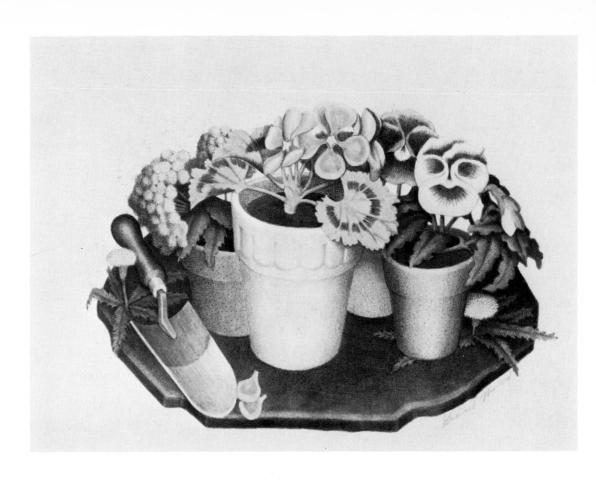

94. *Tame Flowers*, 1938.
Hand-colored lithograph, 7″ × 10″.

93. *Wild Flowers*, 1938.
Hand-colored lithograph, 7″ × 10″.

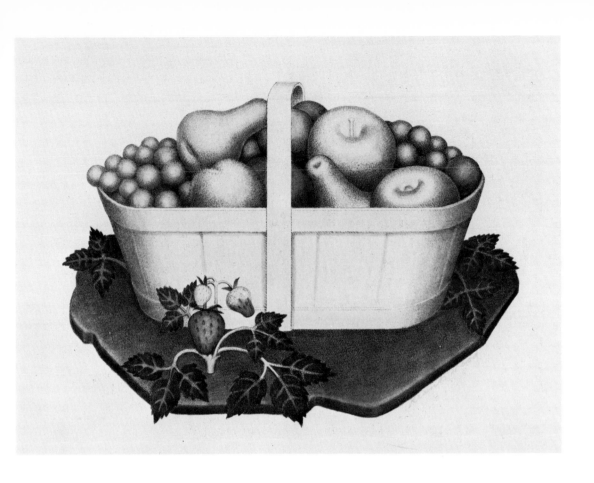

95. *Fruits*, 1938.
Hand-colored lithograph, 7″ × 10″.

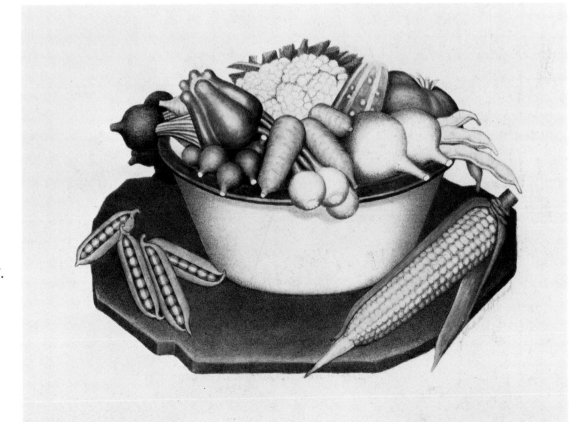

96. *Vegetables*, 1938.
Hand-colored lithograph, 7″ × 10″.

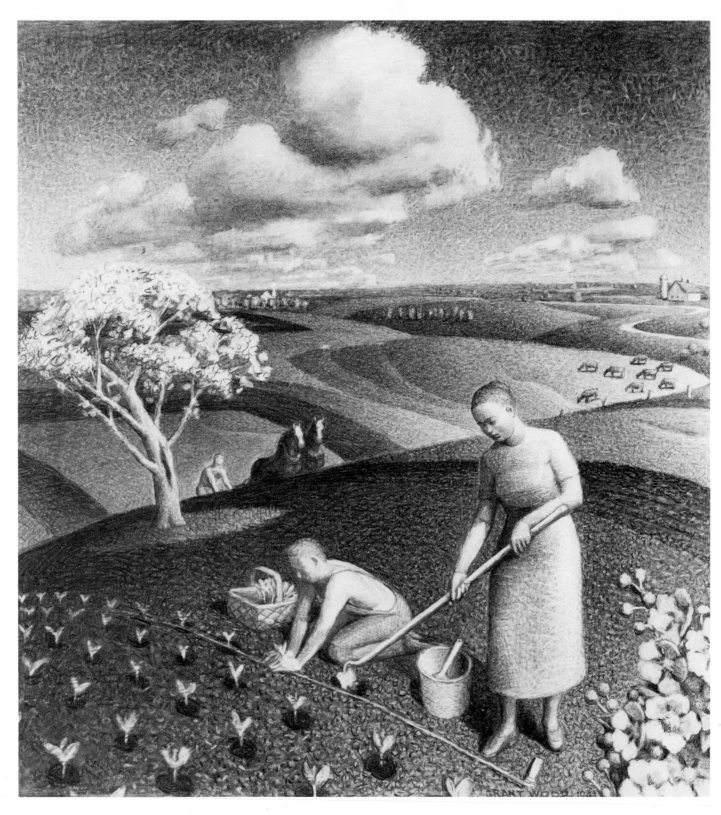

97. *Cartoon for "Spring in the Country,"* 1941.
Charcoal, pencil, and chalk on paper, 23½″ × 21½″.

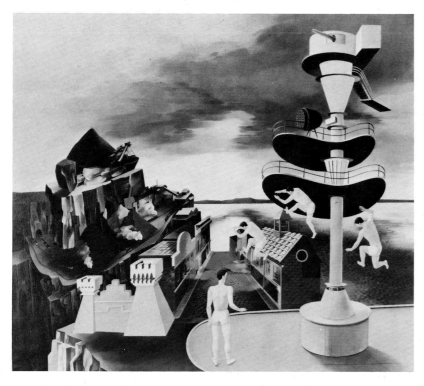

98. Peter Blume: *South of Scranton*, 1931.
Oil on canvas, 56″ × 66″.

psychic automatism generally met with skepticism among American representational painters.

Ben Shahn, a leading artist trusted and admired by all factions, accepted the concept of a vast "inner landscape" beyond the boundaries of consciousness, "almost infinitely fruitful of images and symbols," but he firmly believed that the most able self must be the conscious self, or the "intending self."[2] His principle "that outer objects or people must be observed with an acute eye for detail" and that all such observation "must be molded from an inner view"[3] lent a degree of clarity to an ill-defined premise unfurled for the 1943 Museum of Modern Art exhibition *American Realists and Magic Realists*. Dorothy Miller, the exhibition director, legitimized a contemporary "trend" of "sharp focus and precise representation" as an American tradition of either outer-world "realism" or the "magic realism" of the imagination detected in works of late-eighteenth- and nineteenth-century predecessors. Judging from her passing reference to Grant Wood landscapes as "decoratively mannered," the fusion of inner and outer realities within the spatial dynamics of his fantasized world failed to suggest itself to her.[4]

In his free play of picture space, Grant Wood allowed his imagination to stray consciously from the given fact to fanciful varieties of natural forms. The inventions of his "intending self" emerged as ornamental adjuncts to his design theory of the "decorative." His pictorial composition at its best may be compared with post-Impressionist "Modernism," which, he stated, "has added too many powerful tools to the kit of the artist to be forgotten."[5] This desire to rise above narrative or anecdotal restrictions of subject matter through abstract form reflects a universal standard that gained general acceptance among artists in the twentieth century at the expense of symbolic meaning. However, the pointed conceit of Wood's descriptive shapes in his mature pictures secure them permanently to the significance of communicating personal ideas and associations, whether in the form of comic satire or national myth.

As early as 1921 Wood had promoted freedom of imagination as a natural condition of youth and art. His full statement of this sentiment was written as an introduction to a landscape scroll, one hundred and fifty feet long, which he guided his class of ninth-grade boys in producing for the school cafeteria. On presentation day, as

the "frieze straight out of Fancyland" was unrolled, he invited the audience to accompany him on a trip through the Imagination Isles. What he had prepared for this occasion reads, in light of his mature landscape style, like a personal contract in which he committed himself to a world of make-believe, regretting the loss that our "imagination machinery" suffers in a materialistic society so efficiently dedicated to the disintegration of the individual imagination.

Embarking on the trip through the Imagination Isles, the visitor was greeted by a beckoning array of what Wood described as "brilliantly colored trees of shapes unknown to science, silhouetted against purple mountains. Mountains whose snowcapped peaks pierce the saffron skies. Fantastic tropical plants with luscious fruits and flowers in amazing profusion wait only your coming and choosing."[6] Then, after a warning that no human body but only the spirit could visit these islands, Wood lectured to his audience about the ill effects of materialism on the imagination:

> Almost all of us have some dream power in our childhood but without encouragement it leaves us and then we become bored and tired and ordinary. In most of our studies we deal only with material things or in ideas that are materialistic. We are carefully coached in the most modern and efficient ways of making our bodies comfortable and we become so busy about getting ourselves all nicely placed that we are apt to forget the dream spirit that is born in all of us. Then someday when we are physically comfortable we remember dimly a distant land we used to visit in our youth. We try to go again but we cannot find the way. Our imagination machinery is withered just as our legs or arms might wither if we forget for years and years to use them.[7]

To avoid becoming heavy of body and "hard spirited," Wood advised the young to exercise their imaginations through travel, literature, music, and art. In concluding his talk, he related the vegetables served in the cafeteria to the frieze by describing them as products of the Imagination Isles, and the resultant imagery is prophetic of the plant life in his landscapes a decade later. Baked potatoes were to be imagined as "the succulent seed-vessels of the magical mingo tree," while boiled cabbage was transformed into the "crisp and tender leaf of the Clishy-Clashy vine." Finally, the creamed peas dissolved into "pellets of foam driven by playful waves upon a phantom beach."[8]

Six years later, after an extended stay in Europe, he would find release for his imagination through a large archway of stained glass for the Cedar Rapids Veterans Memorial Building. From that point on, his past artistic experiences would come together in pictures identified with his homeland region but lifted from the actual through a purifying process of fancy. All imperfections of nature would be erased through abstractions of the tangible substance below, and the observer carried up and away from the toil and trouble of working the soil.

As *Stone City* grew from its preliminary oil sketch, the hills were abstracted into bare body forms rising tight-skinned from the earth, unblemished by natural causes or man's mutilation. Even the quarry, a large scar in the sketch, is transformed into a decorative shape with a ruffled top and a fringe of small, spherical trees. Resembling green peas, the woods on the right spill over a hillside, while dark green foliage, marching to the bank of the river as a double-file parade of green peppers, repeats the streamlined cloud formations of his memorial window. Individual trees around the houses turn scalloped and dappled as ornaments transplanted from the colorful overmantel painting for the Herbert Stamats home during the same year (Plate 24). The two elaborate sprays of flowers go to seed along the bottom border of a curved frame, while imaginatively painted trees combine their puff balls and plumage to encroach upon the fragile house with an animalistic clawing similar to the late foliated nightmares of Jean Honoré Fragonard. While orientalized patterns of willowware china may have provided a possible inspiration for Wood's more fanciful trees, the overgrowth of these sublime plants would devour a teacup. In Wood's second topographical fantasy painted one year later, he nearly overwhelmed the Iowa birthplace of President Herbert Hoover (Plate 19) with threatening trees of exotic leafage. Only their overall design holds them in check as they tower above the house. The obscure house and a lone figure surrounded by an open lawn painted blade by blade stand isolated from the stylized oak tree in front and the background assortment of make-believe. This surge of inventiveness continued to operate in subsequent landscapes where solid trees, although less flamboyant in design, embellish the contours of turgid forms.

In a lengthy tribute to Grant Wood, Thomas Craven, the energetic drummer of Thomas Hart Benton, revealingly dismissed the

Plate 7. *Storm on the Bay of Naples,* 1925.
Oil on canvas, 19⅞″ × 24″.

Plate 8. *Indian Creek,* c. 1929.
Oil on canvas, 16″ × 20⅛″.

Plate 9. *Sunlit Corner, #5 Turner
Alley,* 1925–1928.
Oil on composition board, 19¼″ × 15¼″.

101

Plate 11. *Stone City* (sketch), 1930.
Oil on composition board, 13″ × 15″.

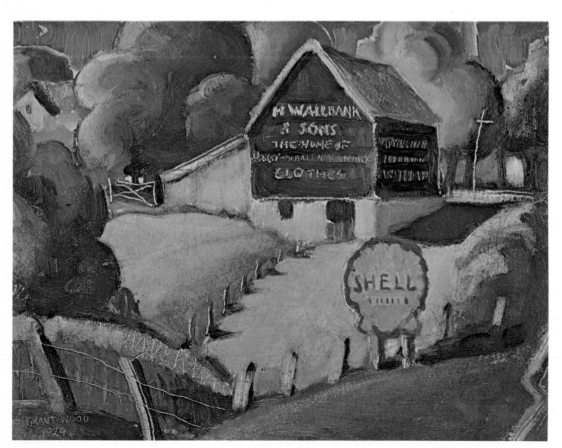

Plate 10. *Black Barn*, 1929.
Oil on composition board, 9½″ × 13″.

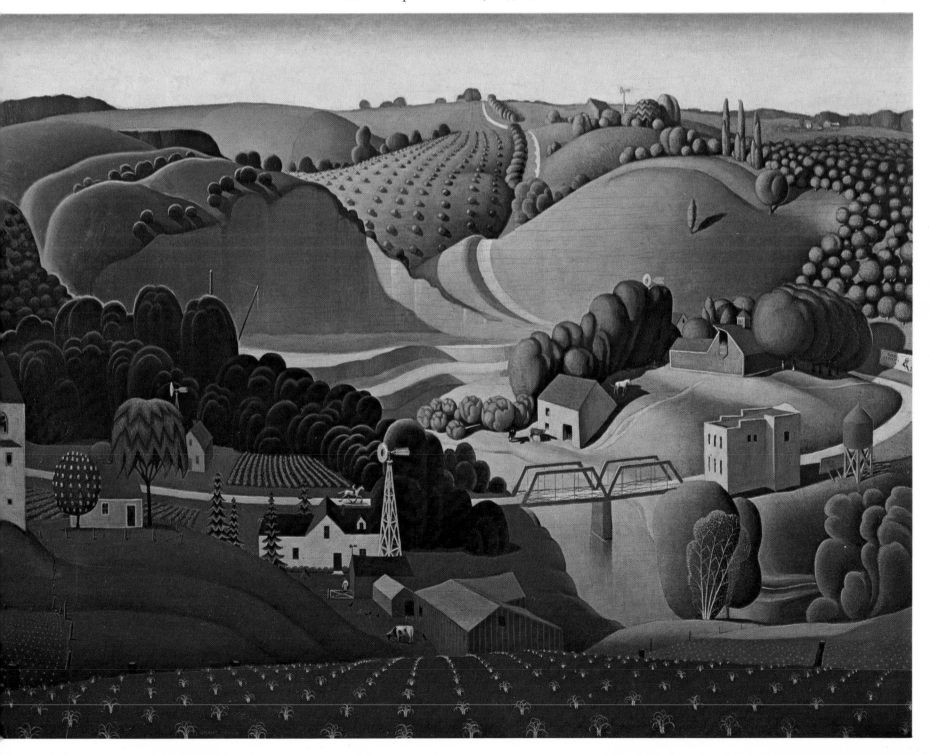

Plate 12. *Stone City*, 1930.
Oil on composition board, 30¼″ × 40″.

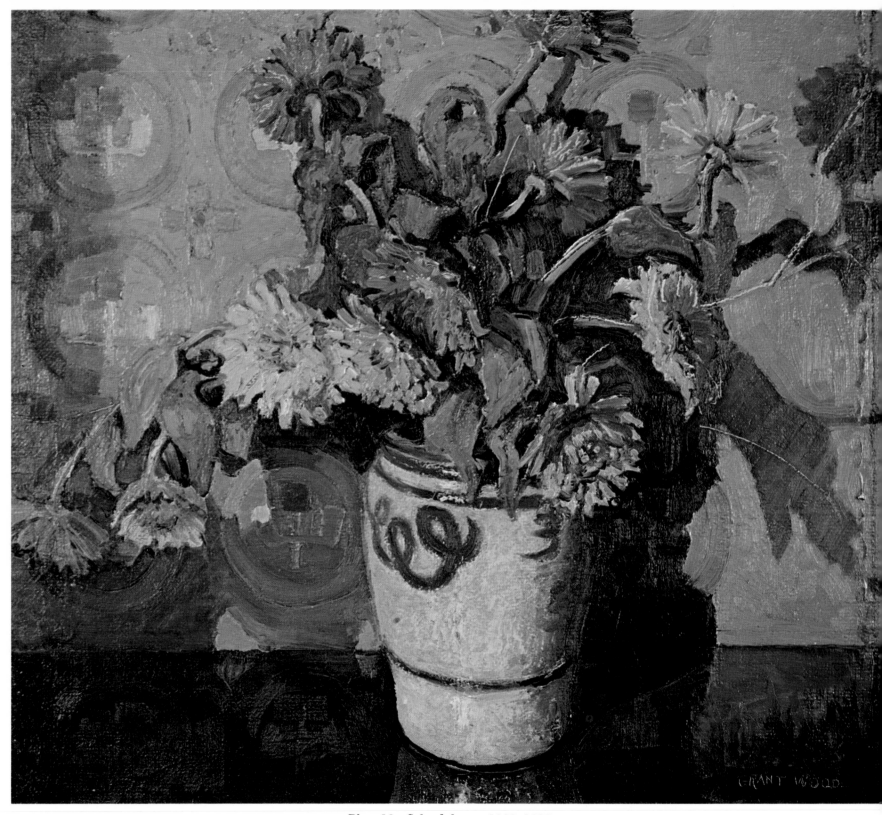

Plate 13. *Calendulas,* c. 1928–1929.
Oil on composition board, 17½″ × 20¼″.

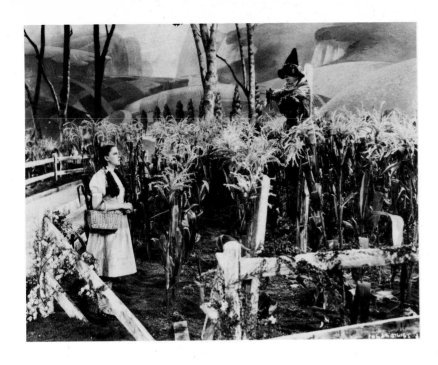

99. Still from *The Wizard of Oz*, MGM, 1939.

Iowan's landscapes as being far too abstracted from reality. Ironically, his negative criticism brings out what now would appear to be some of the most praiseworthy features of the art:

His work in this vein, with its spongy trees, curlicue roadways and miniature houses, has the charm of novelty and makes appropriate overmantel decorations for quaint drawing rooms, but it expresses little. What saves it from frivolity, and from being little more than the indulgence of a fantastic inventiveness usually exemplified by the makers of pictures of the never-never land, is the basic planning.

He should paint a naked statement of the Iowa terrain, a closely studied, realistic job without frills or fantasy, a picture in which the trees and farms are as sharply characterized as the faces of his portraits.

But his latest painting, *Spring Turning*, gives no hint of such an undertaking. Going to the other extreme, he has simplified the country into an abstraction, into immense and vacant and billowy protuberances which do not look like earth but like mechanical forms covered with green pigment.[9]

In sharpening his own sometimes ambiguous point of view, Grant Wood advocated a complete break from the big Eastern cities in his personal manifesto of Regionalism, a lengthy essay of 1935 entitled *Revolt Against the City* (reproduced in Appendix). By remaining in his native region, a Midwestern student of painting could free himself of the "colonial spirit" and establish his own style.[10] While Wood aimed a few remarks at the expatriate intelligentsia in Paris and alluded to American pseudo-Parisians, he did not specify abstract art of any variety as the enemy to defeat. His revolt was not against modern French techniques, whatever they might be, but against American adoption of a "French attitude" and the use of French subject matter. The acceptance of one's own life and milieu was as equally valid as the French considered theirs to be when based on "an honest reliance by the artist upon subject matter he can best interpret because he knows it best."[11]

His juxtaposing of native resources and cosmopolitan experience paralleled a basic dichotomy in Grant Wood's landscape paintings of the thirties. These works envelop their viewers in a mythical state of down-home innocence, providing for some a momentary sense of belonging. At the same time, they spirit the viewer away from any raw facts or burdensome responsibilities. Within their world a flight of fancy can suddenly replace the farmer and his plow with Paul Revere riding a hobby horse over a dreamland road (Plate 14) or with the boy George Washington demonstrating his legendary honesty through the iconic head of the Father of Our Country (Plate 39). The release from a waning reality to a transcending unreality is thus accomplished through a sophisticated trick of Wood's imagination, perhaps naïve in transfiguration but altogether calculated as an attempt to regain an easily lost realm of the human mind. The set designers for the movie version of *The Wizard of Oz* appreciated this in fabricating the film's two landscapes (Figure 99). The real world of Kansas is viewed through a farmyard by Curry, but as Dorothy sets out from the city of the Munchkins on her journey to Oz, the make-believe world into which the yellow brick road travels is a Grant Wood landscape.

# II

# The Cosmopolitan Satirist

# 5. A Comic-Sense View of American Fables (and Foibles)

The strict supervision of social standards, attitudes, and customs by aging matriarchs in the community, and a fundamentalist belief in patriotic legends on the part of the American public at large, prompted Grant Wood's most controversial paintings. His ability to transform his amused disaffection for both areas of orthodoxy into gentle yet effective satire gave him a means of expanding his painting into an art of national expression. Behind an easygoing amiability, he displayed a healthy skepticism toward individuals or institutions who concocted or perpetuated deceptive elaborations of historical truth, sentimental imagery, affectations of taste, or social pretenses in the name of tradition. Not committed to an ardent program of cultural conservatism, he freely exercised his imaginative prowess in his parodies on favorite fables in American folklore. Playing the cheerful iconoclast, he relished any opportunity to debunk the allegiance traditionally required for embellishing and eulogizing anecdotes of history.

Wood's satirical paintings and lithographs and his illustrations for a deluxe edition of Sinclair Lewis' *Main Street* crossed regional boundaries in their amiable attacks on elitist chauvinism and provincial complacency. As Wood gained command of irony and comedy as instruments of social commentary, his career following *American Gothic* seemed to take on a new cosmopolitan air. He began to travel extensively as the invitations to lecture and to judge exhibitions increased. Extravagant critical acclaim greeted each newly finished work, and a growing public eagerly anticipated the next. His patronage extended far beyond Cedar Rapids to Manhattan and Beverly Hills through the efforts of a New York dealer, who also made a few scattered sales to private and public collections in the Midwest. With renewed confidence, Wood set about the task of stimulating and organizing a system of art centers that he hoped would create a national school of American regionalism.

Early examples of Grant Wood's comic sense can be seen in three decorative pencil drawings from the 1920s that caricature the undying fable of the Wild West. Spoofing Eastern notions about small-town Western existence, Wood filled Main Street of Parlor City with a destructive charge of buffaloes (Figure 100), though there is scarcely a hint of menace in the burlesque assortment of stylized animals rearing on chorus-girl legs or curtseying on pointed patent-leather pumps. In the second drawing of the series (Figure 101) slender, bare-skinned Indians steal union suits from the clothesline and basket of a preoccupied pioneer housewife. And for the finale Wood provided the inevitable chase scene with a Hollywood cowboy brandishing a bone in hot pursuit of a fat, blanketed Indian clutching a doll baby (Figure 102).

In a geographic about-face of the East-West parody, Wood converted the Massachusetts setting of Longfellow's tale of Paul Revere into a Midwestern river valley dominated by high cylindrical bluffs which resemble silos or grain elevators (Plate 14). Except for the colonial-style houses, the unidentified village (either the Medford, Lexington, or Concord of the poem) might stand a few miles northeast of Cedar Rapids, along the Wapsipinicon River. By taking such liberties with the overwrought myth-making of Longfellow, Wood subtly toyed with the poet's appeal to the popular imagination, carefully refraining from the melodrama of looming figures such as those exploited by N. C. Wyeth or Walt Disney. Instead, the dramatic moment depends on sensations of vast spaces and eerie light. Soaring above the scene, the observer might gasp at the great distance the heroic messenger must cover to spread "his cry of alarm." And no amount of full moonlight could transform even the smoothest of concrete roads into such a fluorescent ribbon of light. The most convincing evidence of Wood's desire to deflate Longfellow's saga is in his portrayal of the trusty steed. Mocking the patriot-versemaker's theatrics of "a bulk in the dark," "a hurry of hoofs," and "a steed flying fearless and fleet," the amused painter hazarded the fate of a nation on the outstretched legs of a rocking horse.[1]

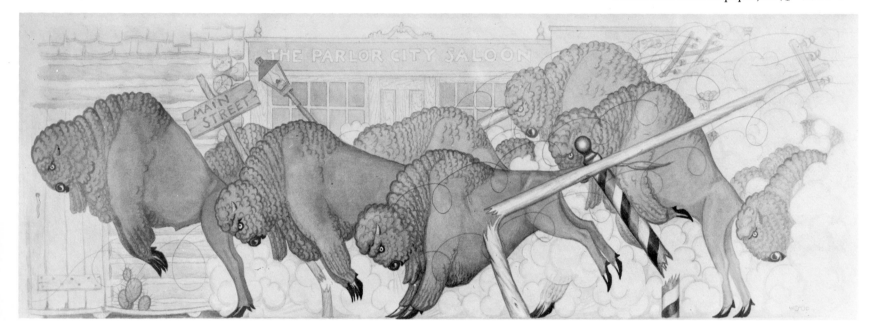

Within the national hierarchy of legendary heroism the image of *Washington Crossing the Delaware* ranks so high as to make any comic distortions of the subject verge on blasphemy. Nevertheless, Wood put the famous painting by Emmanuel Leutze to good satirical use by adopting it as a standard of patriotic devotion in one of its perverse extremes. In *Daughters of Revolution* (Figure 103 and Plate 23), painted during the Depression-bound election year of 1932, Grant Wood projected three intentionally stereotyped caricatures, compiled from yearbooks of the Daughters of the American Revolution, onto the idealized group of George Washington and his crew. More precious than blue willow china or a tatted lace collar, the steel engraving, mottled gray with age, certifies the uniform complacency of the three faces. Wood's painting is a masterpiece of understatement and contains no malice to disturb its purpose. Nonetheless, the artist's view of this naïve ancestor worship as a form of class snobbery and racial certification undermines the affection he usually reserved for elderly women. In contrast to the inviting compassion of his mother in *Woman with Plants* (Plate 15), the soft focus of facial features in *Daughters of Revolution* deceives only

momentarily. Across the teacup barrier the aloof eyes register no recognition, and the compulsively curled hairdos match the severity of the necklines. Echoing the contour of the boat, the tightly set mouths of the three Daughters punctuate the steadfast advance toward the enemy shore.

Personally offended by the ladies of a local D.A.R. chapter which had publicly denounced the fabrication in Germany of his stained-glass war memorial window, Grant Wood might have retaliated more bitterly. Instead, he wisely elevated his sights, dropped "American" from the title (*Daughters of Revolution*), and precipitated a controversy of interpretation that continues today.[2] The Daughters themselves failed to reach a consensus, though a Cedar Rapids member who claimed to speak for all her friends "who glory in the fact that their ancestors fought for American freedom" demanded that "this hideous monstrosity" be removed from a local gallery where it was being forced upon the public.[3] In Boston, on the other hand, a chapter censorship committee responded with laughter and applause when a lantern slide of the painting was projected onto their screen.[4] The *Chicago Daily News* art critic,

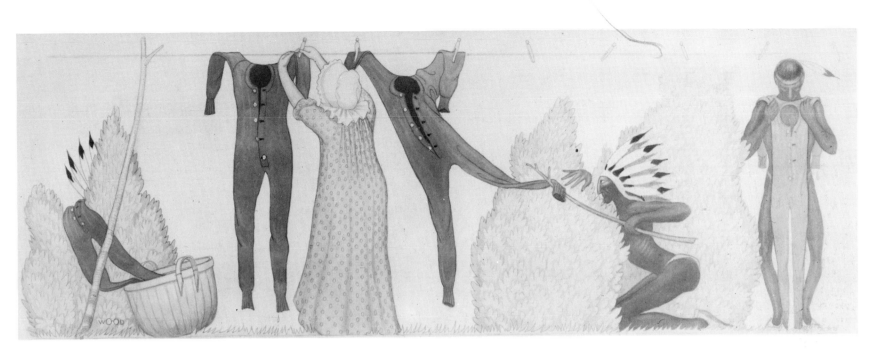

101. *East Coast View of the West: Indians Steal Long Johns,* 1923.
Pencil and wash on paper, 28¾″ × 10″.

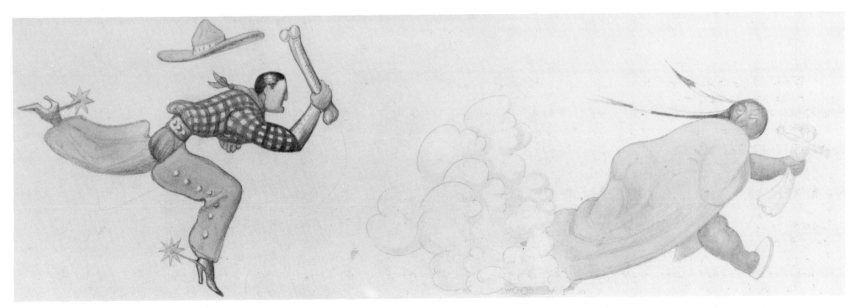

102. *East Coast View of the West: Cowboy Chases Indian,* 1923.
Pencil and wash on paper, 24½″ × 8″.

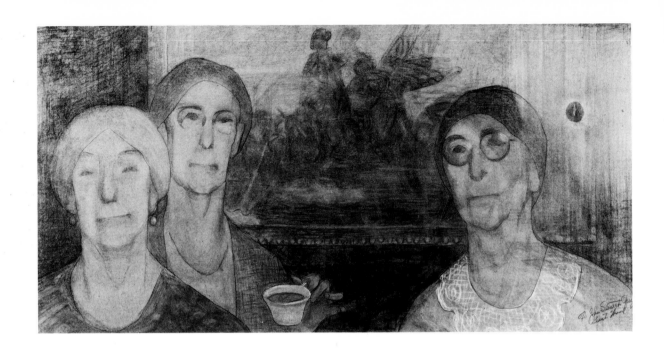

103. *Sketch for "Daughters of Revolution,"* 1932.
Pencil, charcoal, and chalk on paper, 22″ × 41¾″.

C. J. Bulliet, praised the painting as enthusiastically as he had *American Gothic*, which he had initially mistaken as a primitive painting. With an improved eye for the sophisticated technique and subtlety of content, he now declared that *Daughters of Revolution* would endure as a "social lampoon," free from the usual transience of political satire.[5]

This judgment doubtlessly pleased the artist and must have temporarily reassured him as to his success as a satirist. The art world in general categorized him as such, and even Gertrude Stein reportedly respected his "devastating satire."[6] But, with the exception of *Daughters of Revolution*, Wood was inclined to deny the existence of satire in his work by 1935, other than those he perceived in any "realistic statement."[7] Because reality often begets irony, Grant Wood preferred light comedy to caustic criticism in commenting on fixed patterns of traditionally tailored behavior or belief. In retrospect, he explained his interpretation of the Daughters of the American Revolution as a sympathetic but determined exposé of their "great inconsistency" as Americans: "They were forever searching through great volumes of history and dusty records, tracing down their Revolutionary ancestry. On the one hand, they were trying to establish themselves as an aristocracy of birth, on the other they were trying to support a democracy."[8]

An amused tolerance for the storymaker's exploitation of popular taste for patriotic tales and a good-natured jest at the literal-thinking public combine in Wood's most idiosyncratic picture.

Curiously contrived to feature the storyteller who points out the central episode of his story, the *Parson Weems' Fable* of 1939 (Plate 39) succeeds as a comedic tribute to an enterprising mythmaker whose taste for whimsical showmanship found an appreciative audience in Grant Wood. Without a local regionalist theme or setting to command the limelight, the painting promotes Wood's satiric insight into Weems' sentimental folklore as national mythology.

Once again the immediate public reaction, as recorded in print, was both indignant and entertained. Those who expected a "dearest boy" responding with the famous refrain "I cannot tell a lie" puzzled over the child-sized body supporting the famed Gilbert Stuart portrait head. Unfamiliar with both the Weems tale and the art-historical reference of the head, the literal-minded public could only disclaim the face as too "smug" to suit the honest and brave little George. Echoing this response, *The Chicago Tribune* surmised that Wood had to be "motivated by fiendish desire to belittle great men."[9] Evidently enjoying the notoriety, the artist, in the best comic tradition, refused to rationalize the play-on-images basic to his eccentric translation of Weems. As a parody on the fable, the painting focuses on the moment of truth when "the sweet face of youth brightened with the inexpressible charm of all-conquering truth" and when his father, overwhelmed by his saintly son, exclaims, "Glad am I, George, that you killed my tree; for you have paid me for it a thousandfold. Such an act of heroism in my son is

worth more than a thousand trees, though blossomed with silver, and their fruits of purest gold."[10]

The official dollar-bill image of Washington enhances the nobility of spirit demonstrated in the confession and parodies the sentimental fancy of the text. Had the portrayal been an accurate likeness of a boy, it might have left only an impression of routine naughtiness reprimanded. But, as if colored by hindsight, the father's eager forgiveness of his child seems to say that this is no mere truant child but a potential Father of the Country. Prompted by this line of thinking, Wood depicted the famous tree incident as such a moment of divination: as young George self-righteously refuses to surrender the hatchet, he assumes his traditional status of overindulged idolatry. By way of contrast, reality intervenes with a model of good conduct in the background area, where a black slave boy, the compositional parallel to Washington, dutifully helps his mother pick ripe cherries. Thus it was not at all Grant Wood's intent to belittle a

great man. Rather, he had presented a good-humored demonstration of the popular failure to divorce myth and reality, a failure ironically confirmed by public reaction to the picture. Through the person of the adulating father blind to the errant act of his son, Wood teased a self-proclaimed democratic society for its undiscerning deification of the *Pater Patriae*.

Out of respect for Parson Weems' shrewd imagination and his ability to mystify his readers with apocryphal tales, Wood stationed the inveterate sermonizer in the foreground of the painting. His face resembling a colonial portrait, Weems beckons to the observer and, in the manner of Charles Willson Peale's *Artist in His Museum*, pulls back a heavy, fringed drapery to reveal his creation.[11] From his elevated position Weems invites inspection of the fatal slash, and a diagonal succession of gestures directs the observer's gaze toward the bright red-orange hatchet. The foreground, which is ambiguously staged with the cherry-red draperies, acts as an intermediary

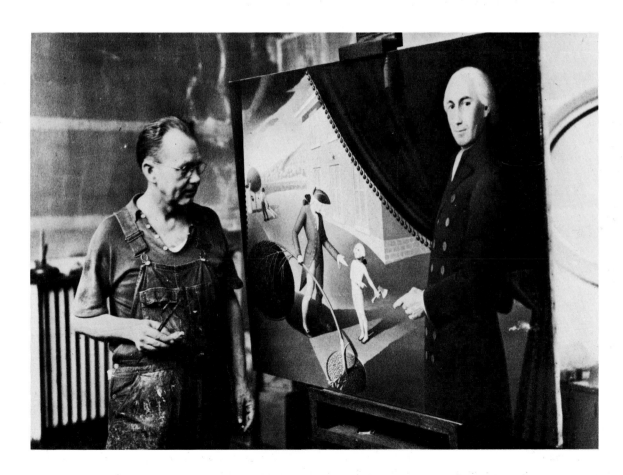

104. Photograph of Grant Wood with
*Parson Weems' Fable*, 1939.

113

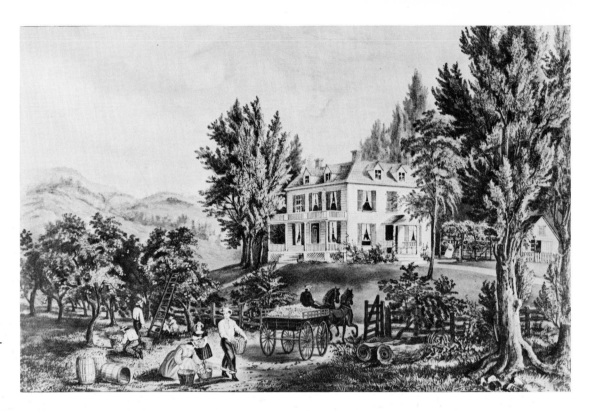

105. F. F. Palmer: *The Farmer's Home—
Autumn*, 1864.
Currier & Ives hand-colored lithograph,
8½" × 13½".

to unite the immediate present addressed by the sanctimonious guide with an idyllic green plantation which seems to symbolize an Edenic genesis for the republic.

In defending his treatment of the fable, Grant Wood stressed the need to fashion such historical fiction for an enlightened generation, which, although aware of the deception involved, would nevertheless appreciate the value of preserving such color and imagination as an important facet of American literature. What is more, elaborations on the original inventions could aid in rekindling a fascination with the past and counteract the scientific method of "analytical historians and debunking biographers," which restricts education to historical fact. To this end the artist took a tip from the good parson, as he put it, and used his imagination freely in filling out his interpretation of the Weems fable (Figure 104).[12]

Alongside Wood's satiric forays against social pretense and the distortion of historical truth, he also played pranks with popular American status images. The earliest of these works coincides with his exploration of local subject matter for its promise of compositional and thematic adventures. While working on *American Gothic* and *Stone City* in 1930, Wood made a whimsical mantelpiece painting of the house and grounds belonging to a prosperous friend (Plate 24). In making this smiling comment on the growing suburban drive to affect an early American heritage, Wood glorified a preindustrial aristocracy as it was envisioned in popular graphic form a century ago. The proud owner, tipping his silk hat, rides into an elaborate plantation of ornamental trees. His wife and children, masquerading as mid-nineteenth-century gentry, stroll to the end of a brick path leading from their neocolonial house. Thus unfolds a richly colored parody on F. F. Palmer views of ideal rural domesticity printed and distributed throughout the country by Currier and Ives (Figure 105).

The theme of the self-made man was also central to Grant Wood's most elaborate, ironic topographical view made a year later. In his full-scale drawing for *The Birthplace of Herbert Hoover* (Figure 106) an inset in the lower left corner featuring the cabin home of the beleaguered President conjures up the venerable tale of lowly origins. In the finished painting as well (Plate 19) a guide far below points out the original dwelling and again secures the thematic point. That a Quaker boy from the tiny village of West Branch, Iowa, could become President confirmed the common-man focus that was introduced to the mythology of political democracy by Andrew Jackson's election campaign. Following the precedent of "Old Hickory," a lowly cabin birth for the professional politician evolved into an expedient status image in national campaigns. However, the virtue of a humble beginning, especially when exploited for high political office, must have lost its appeal to the common man in

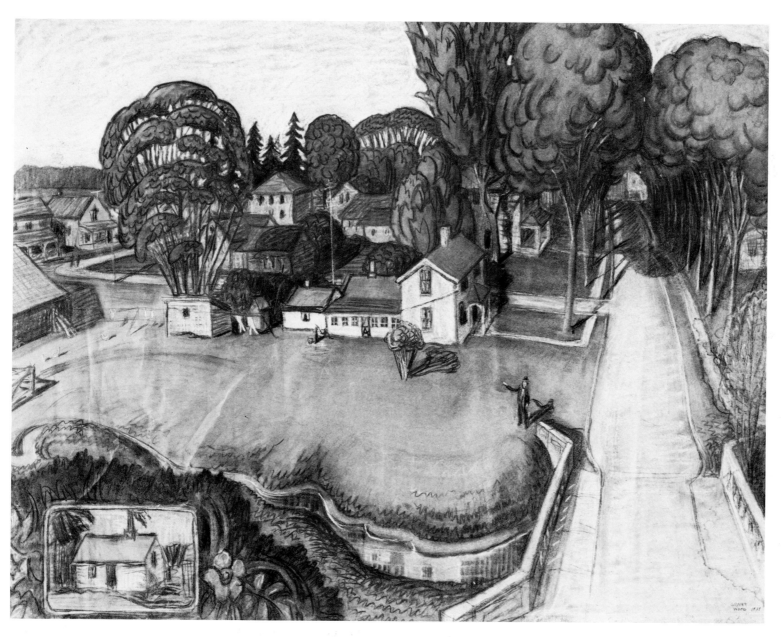

106. *Sketch for "The Birthplace of Herbert Hoover,"* 1931.
Chalk and pencil on paper, 39⅜″ × 29⅜″.

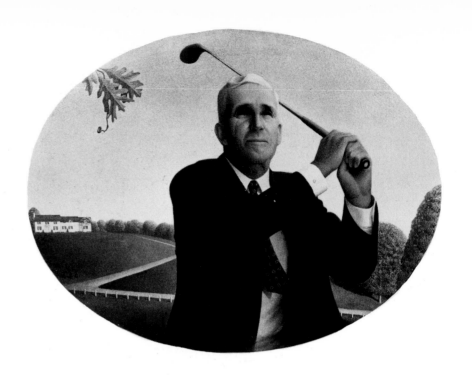

107. *The American Golfer, Portrait of Charles Campbell*, 1940. Oil on masonite, oval, 36" × 48".

the midst of a full-blown depression. Consequently, Wood's playful presentation of Hoover's birthplace would have been extremely paradoxical in 1931, when the President precipitated the dispossession of many families from their homes by rejecting all proposals for federal relief to the unemployed. The immaculate white cabin, snuggled behind a larger house and situated in a grove of stately trees, might well have aroused contempt in view of the tarpaper, tin, and cratewood "Hoovervilles" festering on the edges of industrial cities. Wood's initial intention for *The Birthplace of Herbert Hoover* was probably no more than to aim a well-directed jest at the antiquarian sentiments attached to the stereotyped rags-to-riches symbol. Coincidentally, the turn of historical events made it possible for the observer to read irony or implied criticism into the content of an otherwise politically noncommittal picture.[13]

Conventions of early American painting, such as the pose and position of Parson Weems or the prideful display of real estate in topographical pictures, delighted Grant Wood as curiosities of pretension. In this spirit he added a traditional eighteenth-century oval format to a contemporary portrait of *John B. Turner, Pioneer* (see Figure 72) in order to lend an aura of antiquity. The retired businessman emerges as a respectable elder of the community, made monumental by the oval frame reserved for colonial divines. Ten years later, in fulfilling a similar commission, the artist went even further with his use of early-American devices in portraying a robust small-town banker and community booster. Handsome Charles Campbell of Kalamazoo, Michigan, as *The American Golfer* (Figure 107) completes his swing with a searching gaze upward. Behind him, the club head and the oak branch draw attention to the Campbell colonial residence. This resplendent backdrop, with grounds pruned to perfection, lends proof to Campbell's descent from the prestigious merchant-class gentry of New England, who were likewise posed before sprawling estates in colonial portraiture.[14]

The most authentic use of colonial motifs in Grant Wood's portraits can be found in the oval portrait of his sister, Nan (Plate 18). Having earlier transformed her into a timeless, ageless archetype for *American Gothic*, he devoted eight weeks to a living likeness, complete with casual summer blouse and fashionable marcel hair style. The streamlined succession of uniform waves of hair complements the arch of penciled brows and the pronounced rhythm of the bold polka-dot pattern. Black against blonde, Nan's butterfly bows interrupt the steady cadence and draw attention to a trace of a smile. Despite these hints of contemporary chic, other elements in the picture convey the air of a colonial costume piece. The chick-in-hand studying a ripe plum, the Hitchcock chair, and the drapery swag recall the era of Boston's John Singleton Copley.

Wood made many other subtle gibes at popular American status images, using antiquated pictorial conventions to taunt the self-appointed guardians of community behavior and morals. He would intensify an almost genotypic uniformity of countenance and features, most notably an interminable stare of vigilant suspicion, to intimidate the observer either directly or through an accompanying figure. A tense response most often originates from the traditional role of the American woman as a tenacious safekeeper of family, home, and the community in matters of the spirit, morality, and culture. Thus the villager in *American Gothic* stands, with his head cocked, like a sentry at his post, patiently awaiting directions from the woman who stands alert and watchful at his side. Possessing none of the latent compassion suggested in his eyes, she glowers over his shoulder, wary of outside intrusion.[15]

108. *Victorian Survival,* 1931.
Oil on composition board, 32½″ × 26¼″.

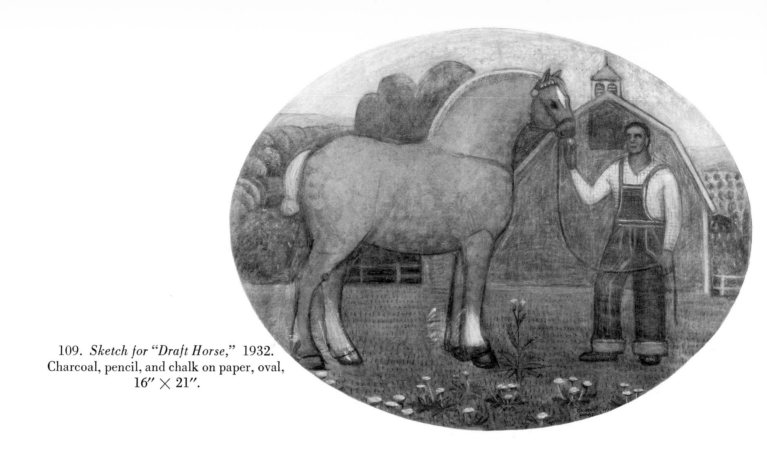

109. *Sketch for "Draft Horse,"* 1932.
Charcoal, pencil, and chalk on paper, oval,
16″ × 21″.

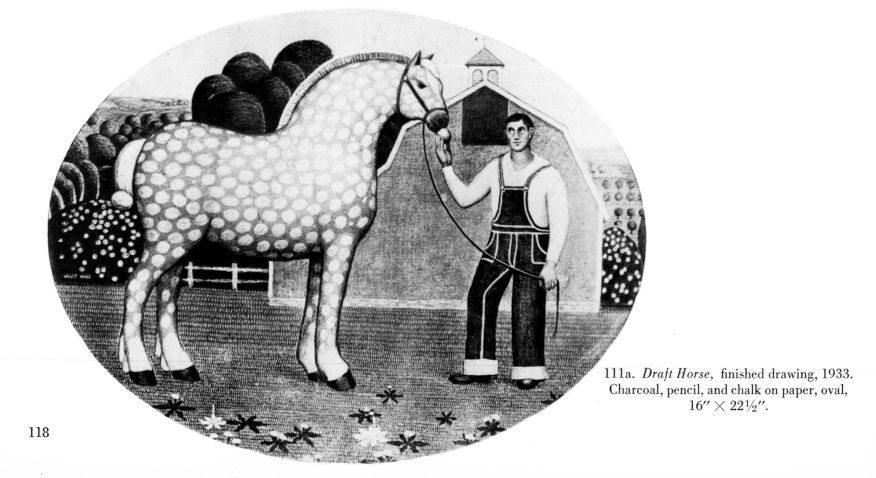

111a. *Draft Horse*, finished drawing, 1933.
Charcoal, pencil, and chalk on paper, oval,
16″ × 22½″.

118

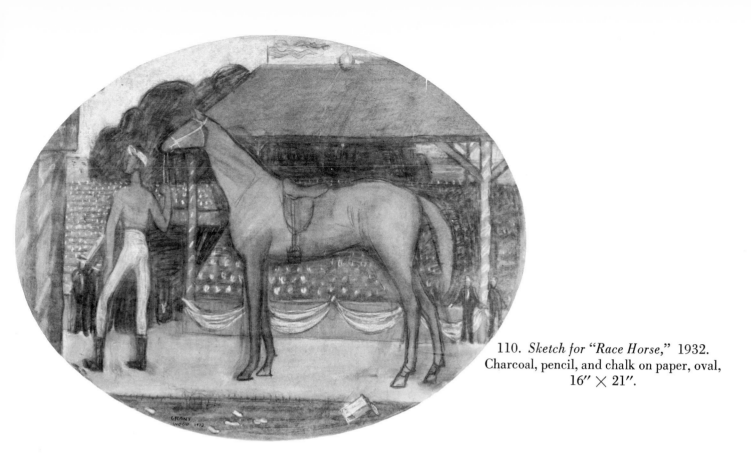

110. *Sketch for "Race Horse,"* 1932.
Charcoal, pencil, and chalk on paper, oval,
16″ × 21″.

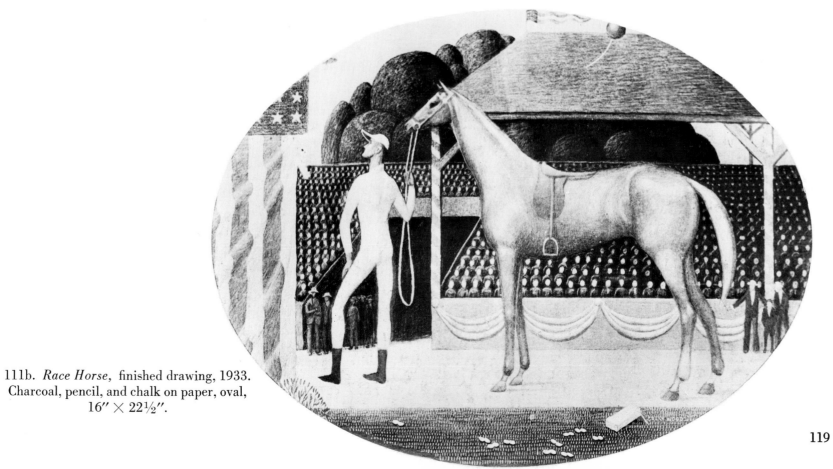

111b. *Race Horse,* finished drawing, 1933.
Charcoal, pencil, and chalk on paper, oval,
16″ × 22½″.

119

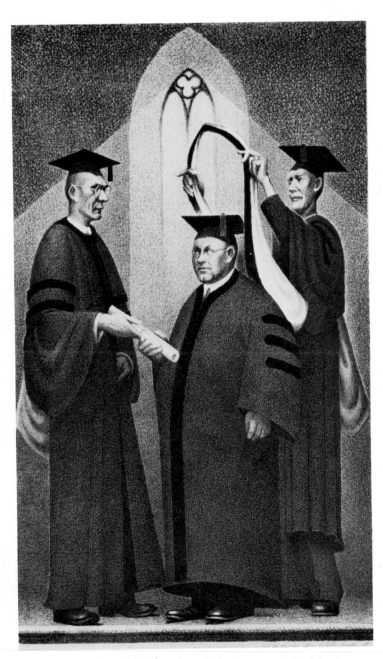

112. *Honorary Degree*, 1937.
Lithograph, 11¾″ × 7″.

Wisely resisting any specific interpretation, and reluctant even to categorize the picture as satire, Wood would only confess that *American Gothic* represented "types" he had known all his life and that he intended no ridicule by including their "faults," which he summed up as "fanaticism and false taste." His representation of conservative rural people living a prim, fastidious, unvarying existence in a relatively confined world could be interpreted as a simple example of the Regionalist ideal whereby the artist accepts the given in his native sector without changing it. However, the work defies such easy analysis, and a satiric interpretation of complacent narrow-mindedness is encouraged by the Gothic attenuation of the figures. Despite Wood's insistence that he aimed for no more satire here "than there is satire in any realistic statement,"[16] the public argued to the contrary. The comic element in his caricatured couple enjoys expanding appreciation from an increasingly city-bred, cosmopolitan public.[17]

The tenacity with which the elderly cling to their own world in face of a new generation invited Wood's satirical comment in two unconventional pictures from the early thirties in which he again employed female figures. The first of these, *Victorian Survival* (Figure 108), again uses the visual pun of elongation from *American Gothic* while in form and content it anticipates the *Daughters of Revolution* of the following year. It is a portrait of the artist's Aunt Matilda, who had occasionally looked after the Wood children, and she is pictured here as an enlarged daguerreotype, painted in a yellow-gray tone as if stained by time. Her black dress, neckband, and small round head accentuate her resemblance to the upright telephone that stands beside her. As she ignores the beckoning appliance, she stares forward through shadowy, glazed eyes with her thin lips pursed in silence. Playing with images, Wood has juxtaposed a living remnant of a waning age of privacy with a technological intruder from the electronic era. Her quiet, unassuming existence lingers on the verge of destruction by the advance of communication.

Matronly concern for vulnerable youth provides the theme for *Adolescence* (Plate 27), a vertical picture of three decorative chickens. This was conceived as a full-scale sketch in 1933, which Wood carefully redrew in 1935 and finally completed as a painting in 1940. Two fat hens, one red, the other barred gray, sit scowling through the night as they keep watch over a fledgling rooster pecked down to his pinfeathers. In giddy defiance of their rooftop perch, the rooster rises between them, stretching an extra-long, perfectly erect neck straight into the dark sky. Unable to try out his wings, he

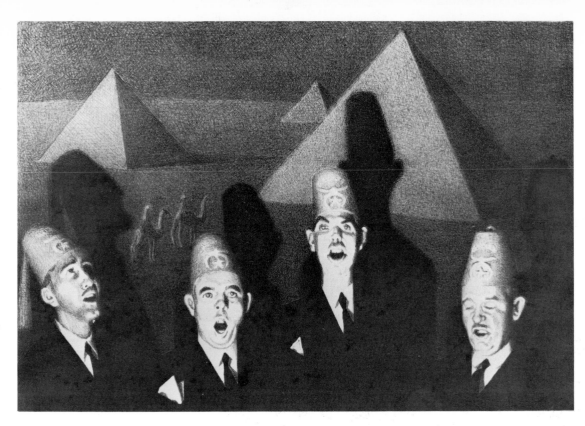

113. *Shriners' Quartet*, 1939.
Lithograph, 9" × 12".

nevertheless lifts his head to the stars, his adolescent dreams soaring. Nakedness converts the ludicrous young fowl into a universally recognized caricature of pubescent uncertainty. As a possible metaphor of male indignity, the youthful cock stripped of his plumage might also represent female revenge for indiscretion in the hen house.[18]

An urban-rural division of tastes and manners furnished Wood a base for graphic humor. In his decorative drawings *Two Horses* of 1932–1933 he set up a play of contrasting shapes and sizes that alternates between the barnyard and the racetrack (Figures 109–111). In a comic mode counter proportions distinguish the wholesome virtues of farm life set in a lush landscape, from the acquiescence of jockey and sleek mount to the pleasure of a grandstand crowd. Flowers grow at the feet of the farmer and his dappled draft horse, while a spilled box of peanuts litters the setting of star-spangled banner and bunting.[19]

Reversing the relationship in *Adolescence* of thin figure to fat and tall to short, Grant Wood placed a squat caricature of himself between two gaunt academic giants in the lithograph *Honorary Degree* (Figure 112).[20] Having received such an institutional honor from the University of Wisconsin in 1936, he could not resist the temptation to poke fun at the affected solemnity of the ritualized custom, and once more a Gothic reference serves as the satiric device. An auspicious ray of sunlight beams through a collegiate Gothic window just at the moment when a Gothic-arched mantle descends from the hands of a towering dean. Peering up at the

severe, steel-rimmed visage of the second academician, the plump little farm boy from Anamosa, his shoes shined bright for the occasion, accepts the diploma, bewildered by the dark-robed mystery of it all.

The incongruity of ordinary, middle-class, Anglo-Saxon Americans play-acting in pseudomystical roles, with exotic apparel borrowed from distant religious rituals and stage-set allusions to the faraway Orient, constitutes the satiric focus of *Shriners' Quartet* (Figure 113). Four local members of the Ancient Order of Nobles of the Mystic Shrine, founded in the United States in 1872, celebrate their exalted status with eyes, ears, and mouths straining for barbershop harmony. White collars, handkerchiefs, and flat shadows summon the observer back from the beckoning illusion of pyramids on the Nile.

The artless life of a provincial parvenu existence affectionately satirized in the *Shriners' Quartet* had been under more strenuous attack from social critics and novelists, notably Sinclair Lewis, for at least two decades. Lewis' lampoons of Midwestern town life occupied much of Wood's talent and imagination from late 1935 to the spring of 1937, when the painter created nine large drawings to be reproduced as full-page illustrations for a Limited Editions publication of *Main Street*.[21] In his first successful novel as well as in the slightly later *Babbitt*, Lewis had avoided compromising his personal social realism with the disparaging cynicisms popularized by H. L. Mencken,[22] and in both books he had refrained from overcoloring his characters with a uniform intensity of satire. Personalities

121

marked by fixed attitudes and opinions encounter each other in drawn-out plots, indulge in detailed, often introspective observations about life around them, and engage in repetitious conversations. Lewis' satire occurs primarily in the background figures of the community, who remain essentially one-dimensional as the leading characters develop. For example, in *Main Street*, Will Kennicott's Uncle Whittier and Aunt Bessie, an "American Gothic" couple, have retired to town after years on the land and become immediately cantankerous about new "notions" on marriage, children, religion, economics, morals, and politics which elude the confined contours of their tunnel vision.[23]

In visualizing single-figure portrayals for the book, Grant Wood applied satirical generalization in five out of seven portraits, tersely summarizing the fictional personalities and conveying through them Lewis' basic skepticism toward any fanatic dedication to a singular cause. The perfectionist heroine, the religious bigot, the booster, the revolutionary radical, and the reactionary sentimentalist all manifest symptoms of monomania regardless of their different motivations. Any obsession stemming from an axiomatic set of moral principles was enough to guarantee suspicion. But in one of the two remaining character illustrations Wood paid tribute to a noble humanitarian act, and in the other he objectively portrayed a liberal position of "practical idealism." Each of these represents a pragmatic point of view to which both Sinclair Lewis and Grant Wood would have submitted in confronting issues of social change and reform.

Between the frontispiece, a carefully composed close-up view of a deeply shaded, boxy Main Street mansion (Figure 114), and the last illustration, which pictures the winterbound village slum with its outhouses path-linked through the snow (Figure 115), Wood chose to represent a cross section of Gopher Prairie's more conspicuous inhabitants. Although each portrait appears with a simple label indicating only personality type, individual attributes of dress, features, expressions, and gestures make specific identification possible. In order to enliven the descriptions provided in the novel, Wood continued his practice of studying and selecting actual friends and acquaintances from his own community as models for various roles.[24] This photographic technique gives the portraits a snapshot spontaneity enhanced by oblique, low-level views, instinctive hand gestures, and dramatic eye action. In no case does a specific event intrude upon a composite characterization. Carol Kennicott's neighbor Mrs. Bogart, the black-shrouded sanctimonious widow and mother of the town bully, leers down at the spectator as she descends from the Baptist church (Figure 116). A thick, large-knuckled hand, caught in the motion of slipping on a glove, repeats the awesome shape of her hat and veil. The irony evoked by the patronizing smile beneath her mean, narrow eyes climaxes with the title *The Good Influence*, a direct quotation from the text, which conceives the woman as a grotesque as well: "Her large face, with its disturbing collection of moles and lone black hairs, wrinkled cunningly. She showed her decayed teeth in a reproving smile . . ."[25]

Equally opaque if more comical, the *Booster* emerges as an easily satirized middle-American stereotype (Figure 117). An evangelist buffoon of the business world, Honest Jim Blausser hustles local support as a folksy advance man for converting Main Street into a "White Way" and for building a new factory in the town: "He was a bulky, gauche, noisy, humorous man, with narrow eyes, a rustic complexion, large red hands, and brilliant clothes."[26] Grant Wood had only to add a few details to round out the image: a Masonic ring, a Moose pin, and the Stars and Stripes.

Wood endowed the more complex, more thoroughly conceived characters in the story with pictorial exaggerations, such as the close-set, bulging eyes of the *Booster*. *Sentimental Yearner* (Figure 118), Wood's interpretation of Guy Pollock, a timid recluse who dreams in T. S. Eliot fashion of going back to an age of tranquility, charming manners, and good taste, tends toward the ludicrous.[27] In place of a cloisonné vase, which in the novel he fondles as he confesses to Carol of suffering from the Village Virus, the prematurely aged lawyer sniffs a pink carnation. Shorn of his "silky indecisive brown mustache," with handkerchief and miniature bow tie anticipating the upturn of his wistful eyes, he displays a far more delicate disposition than Lewis had imagined. In contrast to that languishing, antidemocratic aesthete, *The Radical* Miles Bjornstam looks askance, sneering ineffectively at the Main Street bourgeoisie (Figure 119). While his cap, tools, and dogskin coat comply with the Lewis image of the outcast "Red Swede," the foxy red mustache is certainly more villainous than picaresque. Though initially moved by the pathos surrounding Bjornstam, the most convincingly tragic character of the book, Wood finally decided to discard his first compassionate treatment of the handyman, in which raised brows and untrimmed mustache endowed the face with a melancholy, timid aspect. In the published version he satirized instead the banker's-eye view of the opinionated atheist-anarchist as the slightly insane badman of the town.

The most complicated and, in the end, the least resolved personality of the novel, long-suffering heroine Carol Kennicott presented the greatest difficulties for a portrait characterization.

114. *Main Street Mansion,*
*frontispiece.*

114–122.  Illustrations for *Main Street*
by Sinclair Lewis, 1936–1937.
All except 116, original drawings, charcoal pencil
and chalk on paper, 20½″ × 16″.

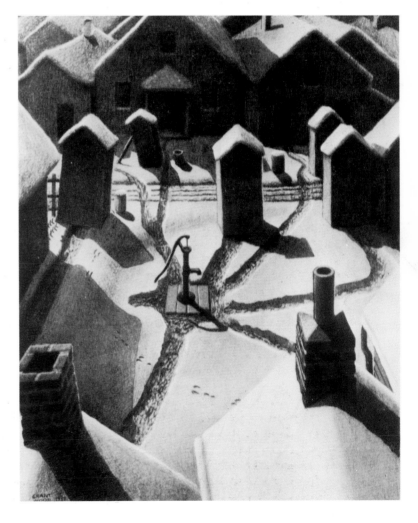

115. *Village Slums.*

116. *The Good Influence.*
Pencil and gouache on masonite, 20½″ × 16″.

117. *Booster.*

Discontent prevails as her one singular trait and surfaces in a myriad of grievances, some provoked by a frustrated aesthetic sensibility and others excusably egocentric. In her inept attempts to alleviate the severe ugliness and lack of good taste in the town, she stands accused of being an unreasonable *Perfectionist* (Figure 120). Unable to penetrate the dull complacency of the paranoid Gopher Prairie citizenry, she follows her romantic inclinations from a fantasy world of princes and palaces into a near love affair with a young poetic provincial named Erik. He lacks resolution, however, a failing she detects only sporadically in her husband, the oafish but courageous Dr. Kennicott. She seeks in both men a tragic dimension, which is apparently contained only in books, and it eludes her forever as this quality constantly disappears into blustery complications. Thereupon Lewis exclaims in her behalf: "No one big enough

124

118. *Sentimental Yearner.*

119. *The Radical.*

or pitiful enough to sacrifice for. Tragedy in neat blouses; the eternal flame all nice and safe in a kerosene stove. Neither heroic faith nor heroic guilt. Peeping at love from behind lace curtains—on Main Street!"[28]

The other window allusion to which the artist might have referred for his accurate if slightly melodramatic visualization of Carol's tortured and trapped attitude points to her most immediate

means of escape. Witnessing the amiable relationship between Bjornstam and her Swedish maid, Bea, she sits alone and lonely at the window above, "envious of their pastoral."[29] This attraction to the bucolic recurs throughout the book and locates the one consolation from her boredom in the agrarian landscape surrounding the town. While Kennicott sees the countryside as a hunting preserve or as potential real estate, his wife envisions the half-settled prairies of

120. *The Perfectionist.*

121. *Practical Idealist.*

122. *General Practitioner*.

Minnesota as a peaceful Arcadia occupied by unspoiled Scandinavian and German rustics. With this idyllic perspective Carol walks during a spring outing from a "Corot arbor" into a wood and out onto the prairie, "dipping rolling fields bright with wheat": "Above a marsh red-winged blackbirds chased a crow in a swift melodrama of the air. On a hill was silhouetted a man following a drag. His horse bent its neck and plodded, content."[30] After Carol abandons Gopher Prairie for Washington, D.C., her eventual return and renewed tolerance for the shabby Midwestern settlement rest on her transcending vision of an elemental agrarian existence: "With the world a possible volcano, the husbandmen were plowing at the base of the mountain."[31]

Though Carol's romance with the virtues of the soil helps her to rationalize her hopeless "struggle against inertia," the final victory in the novel belongs to the liberal reformer of the town, Vida Sherwin. With God on her side, she acts the part of enthusiastic soothsayer, cautioning Carol from the beginning to persevere with the town's existing agencies and to avoid the introduction of any advanced, cosmopolitan ideas of cultural improvement. In her energetic eagerness to keep peace among her neighbors, Vida moves constantly, sitting on the edge of her chair, fluttering her fingers. Difficult to capture in a detailed image, her personality is summarized by Lewis as a force revealed through her lively blue eyes, which "indicated her faith in the goodness and purpose of everything."[32] Following this emphasis, Wood appropriately portrayed Vida as the *Practical Idealist* (Figure 121). Vida, balancing the idealistic with the practical, serves as the gentle persuader of a measured, conservative reform. Secretly resenting Carol as an outside agitator, as a radical "impossibilist" who demands perfection all at once, Miss Sherwin advocates a slow, "practical" process of progressive change. As a schoolteacher, she wants to see the town build a new high school, and for years she patiently prods the moneyed men until at last they acquiesce and give their approval to the appropriate bonds. Such perennial concerns as mediocrity in architectural design, Main Street standardization, the exploitation of farmers by the town, and women's rights fail to distract the Practical Idealist from her ingrained belief that only the details of a basically immutable and essentially benevolent system can be safely altered.

In devising a picture of Will Kennicott, Grant Wood adroitly singled out the working hands of the *General Practitioner* (Figure 122). The most ambiguous character in the novel, Doc Kennicott unquestionably belongs to Main Street and to its chauvinistic standards and lackluster self-satisfaction. His wife's "high-brow" behavior constantly tests his stolid patience, and perhaps it is his complacency alone that sees him through her rebelliousness. Most praiseworthy is his willing ability to rise above the prevailing prejudice against the working poor. He courageously answers their calls for help through the winter nights and compassionately cares for their injuries and diseases with no demand of payment. This heroic image, originating with Lewis' admiration for his father's career as a rural doctor, suggests itself in the illustration: The conscientious Will ministers to the ailments of a burly and soiled farmer. However, the author's comparison of Will's "thick capable hands" with those of the laboring yeoman diminishes in the slender fingers of the artist's interpretation.[33]

The practical "nobility of good sense" and an old-fashioned pride in craft or in a job well done apparently appealed to Lewis in spite of his criticism of life in the Midwestern town. As revealed in his affectionate descriptions of the prairie farmland and in his sympathy for the individual farmers, Lewis' "revolt from the village" was not to be mistaken for a revolt from his native rural region, for which he demonstrated a genuine attachment. On this point Wood and Lewis reached common ground. The Iowa painter produced astute satiric portraits aimed at the personality traits of his neighbors in town and a few scenes that gently reproved them for their narrow viewpoints, nouveau-riche tastes, and patriotic chauvinism. In keeping with this purpose, the Main Street illustrations, while necessarily simplified as single-picture characterizations, tended more toward satire than Lewis had conceived.[34] Therein lies a degree of profundity which clearly distinguishes them from the low-corn comedy of contemporary magazine illustrations, such as those of the popular *Liberty* magazine.

In evaluating the contributions of Sinclair Lewis to modern American literature, the critic Alfred Kazin emphasized two ironical qualities which Grant Wood's satiric figure pictures of the 1930s also share. First, as a mimetic writer who had the uncanny ability to reproduce in vivid detail the surface aspects of the life he interpreted, Lewis created character types which came so close to a "native average" that they eventually became popular public symbols. Thus, while George F. Babbitt might have been intended as a caustic satire of provincial smugness, ignorance, hypocrisy, and cruel bigotry, he gradually entered the national consciousness as something of a delight, a comical figure comparable to Bumstead or Jiggs in the daily funnies. Secondly, since Lewis experienced the

common life he satirized, and affectionately identified with the raucous good fellowship represented by the manly Main Street pastimes of poker, hunting, and fishing, he not only empathized with his archetypal characters but he could also turn defensive about their boyish behavior.[35]

The minutely detailed characterizations of *American Gothic*, *Daughters of Revolution*, or *Shriners' Quartet* mimic the attitudes and actions of their real-life subjects, yet at the same time reveal the artist's genuine affection and neighborly amusement. Even the executive secretary of the Cedar Rapids Chamber of Commerce could appear in a Grant Wood drawing as a naked Silenus (see Figure 63), perched atop a basket of grapes and overflowing champagne, without raising too much local ire.[36] Furthermore, as with Babbitt, Wood's satirical figures feed into an ongoing, self-identifying national mythology. They contribute unforgettable images to basic if somewhat blasé notions of what Americans visualize themselves to be. *Fortune* magazine therefore could quite confidently ignore the initial negative reactions to *American Gothic* when it proposed in 1941 that the village pair serve the war effort as a propaganda poster symbolizing American independence.[37]

The results of Grant Wood's portrait realism in freely interpreting *Main Street* elicited enthusiastic praise from Sinclair Lewis and George Macy, the director of Limited Editions. Not only did the latter register his total delight in the precisely finished illustrations but he also immediately asked Wood to illustrate a new deluxe edition of Edgar Lee Masters' *Spoon River Anthology*. For over two years he pleaded with the artist, urged on by Masters himself, who had previously refused to allow his poems to be illustrated. Although Wood expressed interest in the possibility, he finally declined in early 1941, not wishing to interrupt an active period of painting.[38]

# 6. Success Turned Cosmopolitan

It seems rather ironic and even slightly hypocritical that Wood, a leading regionalist artist who had published a long essay entitled *Revolt Against the City*, would even consider illustrating Masters' poem of protest against village life. However, as one can clearly see in Wood's satiric pictures of the 1930s and in other sophisticated aspects of his life and career during this decade of his success, the painter in bibbed overalls, the genial, unassuming artist of eastern Iowa, could never maintain an unequivocal image of pure provincialism in spite of his self-styled rural Midwestern identification (Figure 123). His extensive travels through America and in Europe, his astute powers of perception, his antique collecting, his friendships with prominent figures in the arts who became his patrons, and his ambition to found a national school of American regionalist painting indicate no less than a cosmopolitan perspective.

Many people assume that Grant Wood lived all his life within a twenty-five-mile radius of Cedar Rapids, Iowa. He left the family farm near Anamosa at the age of ten when his father died, moved with his mother, sister, and two brothers to nearby Cedar Rapids where he grew up, and eventually settled twenty-one miles away in Iowa City where he taught at the University of Iowa from 1934 to 1941. Nevertheless, he traveled very widely, almost compulsively, spending months on end in big cities and absorbing varied cross-cultural experiences for much of his life. Study trips had taken Wood first to Minneapolis, then to Chicago, and later, on four different excursions abroad, to extended stays in Paris, Naples, and Munich.

His final trip abroad to Munich in late 1928 did not bring his wanderlust to an end. Quite the contrary. Once his success was granted by the overnight fame of *American Gothic*, Wood began to concentrate on the promotion of regionalism, and speaking tours became a major part of his professional life.[1] After several years of giving lectures on a casual basis, he placed himself under the management of Lee Keedick, a New York agent, who booked his engagements from year to year throughout the Midwest, the South, and California.[2] He also made trips to Chicago, Philadelphia, and New York to serve on exhibition juries, a role that testifies to his prominence among contemporary American artists. Finally, as part of a publicity stunt, he and eight other leading painters, under the auspices of the Associated American Artists, flew to Hollywood in 1940 to paint pictures based on scenes from a Walter Wanger–John Ford movie of Eugene O'Neill's *The Long Voyage Home*. Wood's contribution, *Sentimental Ballad* (Figure 124), was a group portrait, painted in the style of a photographic still, of the star performers drinking beer and singing in harmony at a Limehouse pub.[3]

Similar in purpose though far less grandiose in scale and cost were five commissions Wood received to design book jackets, which effectively tested his knack for summarizing plot and theme in a succinct yet intriguing way. In 1933 Wood's cover for Vardis Fisher's tedious novel *In Tragic Life* (Figure 125) tantalized the prospective reader with the nightmarish memories of adolescence that tortured the mind of the young protagonist Vridar. Suspended in a dark, abstract space are caricatured heads, both human and animal, which resemble, perhaps coincidentally, the Surrealist style then fashionable among a small group of American painters.[4] For the sequel to *In Tragic Life*, entitled *Passion Spins the Plot* (Figure 126), Wood created an equally peculiar abstraction of two heads attached cheek to shoulder in a single bust. The paired faces, large-eyed and vaguely classical in feature, represent the two personalities that Vridar, in his unjustified jealousy, saw in his fiancée, Neloa. One face glows with unspoiled innocence, while the other shows signs of immoral dissipation.[5]

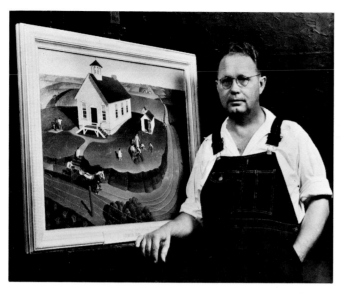

123. Photograph of Grant Wood with
*Arbor Day,* 1932.

124. *Sentimental Ballad,* scene from film version
of Eugene O'Neill's *The Long Voyage Home,*
1940. Oil on masonite, 24″ × 51″.

125. *In Tragic Life,*
book jacket for novel by Vardis Fisher, 1934.

The three later novels for which Grant Wood agreed to illustrate dust jackets overlap his regionalist preoccupation with rural subjects. For Sterling North's *Plowing on Sunday* (Figure 127), the story of a self-sufficient Wisconsin farmer living on the land immediately before World War I, Wood executed in pencil and wash a close-up of a sun-blurred plowman gripping the reins and drinking from an earthen jug. In the cover illustration for *O, Chautauqua* (Figure 128) by Thomas Duncan, the artist superimposed a village church steeple on a bird's-eye view of a Chautauqua tent. Wood's last jacket design was done for Kenneth Roberts' historical novel of the American Revolution, *Oliver Wiswell* (Figure 129). As the basis for this portrayal of the distraught pacifist hero, Wood used a painted costume portrait he had made of his secretary-assistant and official biographer, Park Rinard, wearing the wig and robe of an eighteenth-century barrister. Silhouetted redcoats and colonial militiamen face off in receding battle lines to fill out the rectangular format.

As World War II approached, Wood momentarily interrupted his personal engrossment in isolated American themes with a few minor political drawings in reaction to the Nazi invasions in Europe. He developed only one of these drawings into a finished picture for public viewing, to aid the Bundles-for-Britain campaign. It depicts a melodramatic war scene for a poster emblazoned with the legend "Blitzkrieg!" and features a young mother sheltering her little boy while the R.A.F. counterattacks German bombers (Figure 130).[6]

During his last years Wood sought solitary pleasure and diversion from the wearisome process of picture-making in reading, antique collecting, and entertaining friends (Figure 131). Though he read much casual fiction of the kind for which he had designed book covers, he claimed, in responding to the request of a Boston newspaper,[7] to have been greatly influenced by such books as Sinclair Lewis' *Main Street*, John Steinbeck's *The Grapes of Wrath*, Erich Maria Remarque's *All Quiet on the Western Front*, Lincoln Steffens' *Autobiography*, and John Dos Passos' *Manhattan Transfer*, the last two of which deal with New York life. In his collection of first editions he had autographed volumes by John Dewey, Robert Penn Warren, Carl Sandburg, William Allen White, Christopher Morley, and fellow Iowans Ruth Suckow and MacKinlay Kantor. Wood also enjoyed the company of Eric Knight, the English author best known for *This Above All*, when Knight lived in the second-floor apartment of Wood's house during his teaching stint at the University of Iowa's writers workshop.

Wood's house in Iowa City contained as well a fine collection of antiques. Pieces of ironstone ware, amber and flint glass, majolica, and silver were on display as companion pieces for his examples of early nineteenth-century American furniture, which in turn complemented furnishings of his own design, such as an elegant overshoes bin and an overstuffed armchair. The house itself became well known in the community as a model of restoration.[8] The plain, red brick, gable-roof structure, which still stands, was built in 1858 by one Nicholas Oakes, the owner of a brick yard. Its tall arched windows and shutters give it the general appearance of Gothic Revival, and the ornamental brackets under the eaves identify it as early Victorian.

A few months before he moved into this house in the fall of 1935, Wood married an Iowan, Sara Sherman Maxon, but remained with her for only three and a half years.[9] Also raised in Cedar Rapids, Sara had studied voice in Chicago and performed as a lead contralto in light opera in New York. She married Wood after touring the East singing lieder and working across the country as a soloist in Reginald De Koven's operetta *Robin Hood*. In Iowa City Mrs. Wood specialized in giving elegant dinner parties, and her abilities as a voluble conversationalist were undeniable. Celebrities in American arts and letters who visited the university or came into town to see Wood often joined Grant and Sara around an enormous formal dining table that the artist had built for such occasions. Those who came to speak or lecture were invariably encouraged to join the Society to Prevent Cruelty to Speakers. Founded in 1934 by journalism professor Frank Luther Mott at Wood's urging, this tongue-in-cheek club was designed to furnish an entertaining retreat for visiting speakers so that they might escape from superfluous social demands. Wood decorated the Society's apartment with ornate late nineteenth-century furniture, bric-a-brac, and obtrusive flowered wallpaper as a whimsical reminder of Victorian-era interiors.[10] Carl Sandburg, Lawrence Tibbett, Thomas Hart Benton, and the New York painters Arnold Blanch, Adolph Dehn, and Yasuo Kuniyoshi were some of its overnight guests.

During this period the patronage and critical acclaim that Wood attracted outside Iowa and beyond the Midwest increased impressively. One year before his move to Iowa City from Cedar Rapids, he had spent a triumphant week in New York City. In May 1934 the *New York Times* art critic Edward Alden Jewell, demonstrating his conservative taste for current American regionalist painting in an article on mural projects, dwelt enthusiastically and

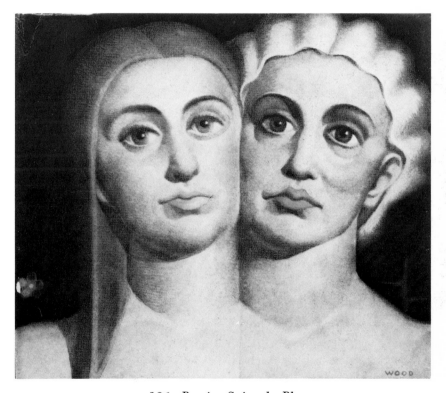

126. *Passion Spins the Plot,*
book jacket for novel by Vardis Fisher, 1934.

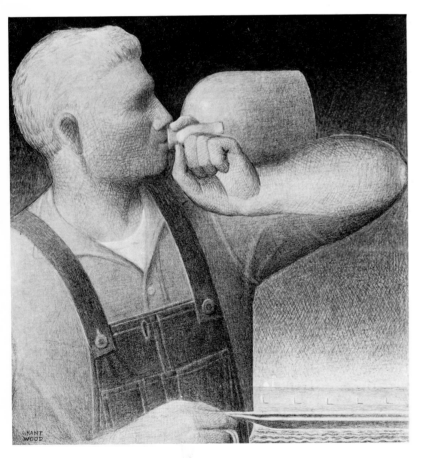

127. *Plowing on Sunday,*
drawing for book jacket of novel by Sterling
North, 1938. Pencil, ink, and gouache,
23″ × 21″.

at length on the work of Grant Wood. The full-color cartoon for *Dinner for Threshers* had recently been sold by Ferargil Galleries to Stanley R. Resor, and Jewell, prompted by a letter from Wood, described the drawing as a mural design waiting for the proper wall. Its understated theme of virtuous labor close to the soil excited the big-city critic to such a degree that he compared what he viewed as Wood's monumental simplicity to the impact of Giotto's murals. The Iowa artist's paintings since *American Gothic* merited Jewell's prize cliché, "a definite milestone in American art," and two long columns of the article were devoted to Wood's own account of the Public Works of Art Project mural project headquartered at Iowa State University.[11]

A few months later, in October of 1934, after quickly completing the first unit of murals for the Iowa State University Library in Ames and the oil painting *Dinner for Threshers* (Plate 32), Wood returned to New York to a virtual flood of ovations. Stephen Clark, chairman of the acquisitions committee of the Metropolitan Museum of Art, had already bought the new painting which had been on display at the Carnegie International in Pittsburgh. The artist had come to New York via Philadelphia to serve as a judge for simultaneous Wanamaker department store exhibitions in those two cities, along with Robert Harshe, director of the Chicago Art Institute, and Lloyd Goodrich, the future director of the Whitney Museum. Frederick Price and Maynard Walker, co-directors of the Ferargil Galleries, had planned a full schedule for Wood's stay in New York, including a luncheon given by Christopher Morley, who continued to champion Wood in *The Saturday Review of Literature*, and a dinner by Mrs. Ann Hardin, sister of New York humorist Ring Lardner. At both events he met leading art editors, critics, painters, writers, and prominent patrons, including Mrs. Juliana Force, director of the Whitney Museum and a beleaguered PWAP regional chairman. Promises of future articles, exhibitions, catalogues, commissions, and purchases buzzed around him.[12]

Gradually, Grant Wood's mature paintings discovered an active market of sophisticated collectors throughout the country.[13] *Stone City* and *American Gothic* had gone almost immediately into Midwestern museums; his *Midnight Ride of Paul Revere* was sold to a private collector in Memphis. The Dubuque Art Association eventually bargained for *The Appraisal* and *Victorian Survival*, and *The*

*Birthplace of Herbert Hoover* found a private owner in Des Moines. By 1935 the distribution of Wood's dwindling production of easel paintings had been expanded through the efforts of Maynard Walker, his first and most significant agent in New York. From him Marshall Field III purchased *Fall Plowing,* and *Daughters of Revolution* was bought by Edward G. Robinson, the first of several Hollywood and New York celebrities who became patrons of Wood. Movie director King Vidor added two Wood landscapes to his selective collection; Katharine Hepburn bought *Near Sundown,* which later entered the large collection of director George Cukor; and Cole Porter chose the unique *Death on the Ridge Road.* Alexander Woollcott was the first to own *Spring Turning* in the fall of 1936, while John P. Marquand acquired *Parson Weems' Fable.*[14] At the end of Wood's career his work sparked interest among wealthy collectors in the East, such as Cornelius Vanderbilt Whitney, who purchased *Spring in the Country.* Ultimately, as the American art market continued to inflate after World War II, the few major works that became available for purchase either vanished into the parlors of the very rich or, as in the case of *Daughters of Revolution,* ended up in large museums.[15]

As if to affirm his widening intellectual and social perceptions, Grant Wood reflected upon the surge of metropolitan adulation he had received. At the time of his New York success in 1934, he explained the appeal of the rural Midwestern image to an urban audience as a kind of wistfulness and envy for what appeared to be a simple, elemental existence, free of complications.[16] His urbane public of 57th Street and Madison Avenue obviously yearned for vicarious sensations of the barnyard and field, so long as the stage-set substitutes eliminated the life-to-death discomforts of working a farm and portrayed instead an orderly and sanitized nostalgia of quiet repose on the bountiful land. Edward Alden Jewell, overcome with a city-dweller's enthusiasm for a beautiful agrarian setting, went into ecstasies over *Dinner for Threshers:* "Here we have, noble alike in sentiment and in presentation, a portrait of rural America . . . The spirit of honest labor, close to the soil . . ."[17] A Miss Treacy, art editor of *Fortune* magazine and a guest at Christopher Morley's reception for Wood at the Sherlock Holmes Club, extravagantly proposed an outlandish plan for expanding *Dinner for Threshers* into a multiple work of art. Wood's Iowa City mural

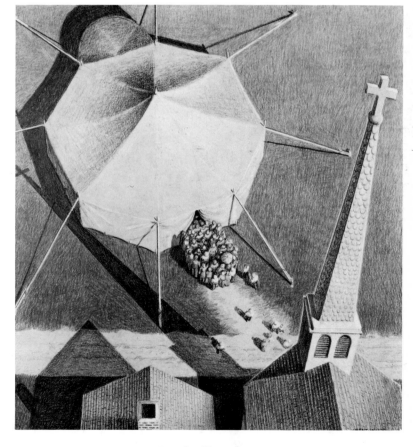

128. *O, Chautauqua,*
book jacket for novel by Thomas Duncan, 1935.
Pencil and crayon, 15½″ × 14¼″.

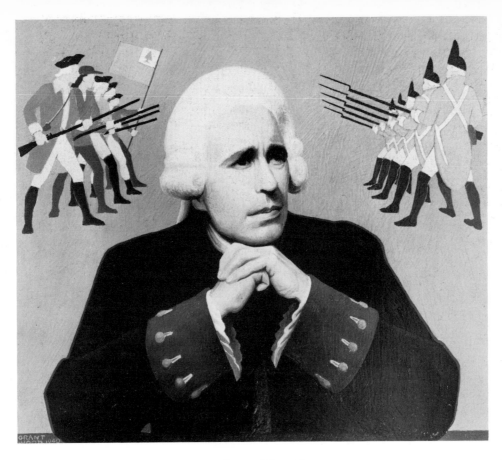

129. *Oliver Wiswell,*
book jacket for novel by Kenneth Roberts, 1940.

painters, she thought, might take each "character" out of the picture and paint him or her into "other surroundings" to illustrate a series of articles on the Middle West in *Fortune,* climaxed by the composite painting.[18]

As Adeline Taylor of the *Cedar Rapids Gazette* concluded (probably paraphrasing Wood himself), this overreaction to his work in 1934 undoubtedly reflected the futility and despair of living in a big city, a conjecture that was confirmed by the fact that a new respect for Midwestern regional writers was suddenly developing in the current New York book market. The popularity of Ruth Suckow's new book about an Iowa family called *Home Folks,* of Paul Engle's poetry in his latest volume *American Song,* and of MacKinlay Kantor's rural-based historical stories seemed to prove that "the eastern attitude toward Iowa had definitely passed through the scorn, ridicule, sympathy, appreciation and admiration stages and has now entered the status of envy."[19] It is little wonder that Grant Wood, following his New York conquest, could confidently state in his own modest contribution to regional letters—the essay *Revolt Against the City*—that the Depression was actually serving a good socio-cultural purpose. Apart from the economic hardships it created, the Depression sent disoriented people living in the city back home, mentally at least if not physically, and it was the spiri-

tual countermigration that prompted a true American art of regional expression.[20]

The ultimate objective of regional art institutions and their individual programs was to create a national school of American painting, and this was much on Wood's mind during his 1934 visits to New York and afterward. His first dreams for such a grand scheme of unification more than likely originated in his knowledge of the origins and aims of the English Arts and Crafts Movement of William Morris through the teachings of Ernest Batchelder. The Morris vision of a brotherhood of contented art workers, plying their respective crafts within an aesthetically generated cooperative community, undoubtedly provided an inspiring standard for Wood as he set about to create an art colony in Cedar Rapids. His first opportunity to explore such a possibility had occurred in 1926 through the Fine Arts Studios, a group organized by a local soprano named Edna Barrett Jackson who credited the painter with the original concept of a colony and referred to its members as "workers in the arts." Close to Wood's carriage-house studio apartment stood several empty two-story barns which he thought might be converted into studios for art, music, drama, and dance. A new building at the same end of Turner Alley was also proposed, though never built, and was to have contained an art gallery, recital hall, studios, and

130. *Bundles for Britain Poster*, 1940.
Photo-lithograph in four colors, 25½″ × 20½″.

clubrooms. It was to have been designed with steep sloping roofs and overhanging balconies in order to heighten the picturesque "Old World" potential of the narrow passageway behind the Turner Mortuary (originally the George B. Douglas residence).[21] Predictably, the dream plans faded into a short-lived compromise known as the "Studio House," a roomy old house in town which contained three floors of living and working space occupied by two musicians, a journalist, one painter, and a gift shop.[22]

In 1928 Wood's hopes for an art colony mounted once again when the Little Gallery opened its doors in downtown Cedar Rapids. Financed by the Carnegie Corporation as a three-year experimental project, the gallery materialized under the auspices of the American Federation of Arts. Its director, Edward Rowan, a Chicago-born, Harvard-trained museum man, set out to stir up a greater appreciation for the visual arts in this relatively isolated Midwestern community. He complemented a schedule of traveling exhibitions with a series of art lectures from the East and displays of the work of local artists, and in general attempted to create a temporary cultural center accessible to all kinds of relevant interests including the Community Players.[23] A qualified cultural jack-of-all-trades, Rowan also helped to organize and advise groups or clubs with programs that might, if only in some tangential way, relate to the arts.

Due to Rowan's well-applied energy, the experiment proved so successful that the Carnegie Corporation appropriated additional funds in the spring of 1932 for its continuation. Mrs. Austin Palmer, widow of the originator of the Palmer penmanship method, also wished to perpetuate the Little Gallery, and she presented it with a large house on First Avenue, Cedar Rapids' main street. In turn, the American Federation of Arts entrusted its administration to the Cedar Rapids Art Association.[24] The gallery's star associate, Grant Wood, although in the midst of his most productive period of mature painting, found time to aid in supervising the multiple offerings of the Little Gallery. Generous rooms for classes in painting, sculpture, ceramics, children's art training, weaving, metal craft, and home furnishings and a workshop for writers not only invited open participation on the part of the community but also contained the nucleus of Wood's dream for an art colony. But even this was not enough.

Twenty-six miles north of Cedar Rapids, Stone City, a once prosperous quarry town, offered picturesque shelter in a beautiful valley formed by the Wapsipinicon River and an ideal setting for a summer art colony and school. J. A. Green, a culture-bent Irish pioneer, had come to quarry limestone there soon after the Civil War, and in the 1880s he constructed a twenty-room stone mansion

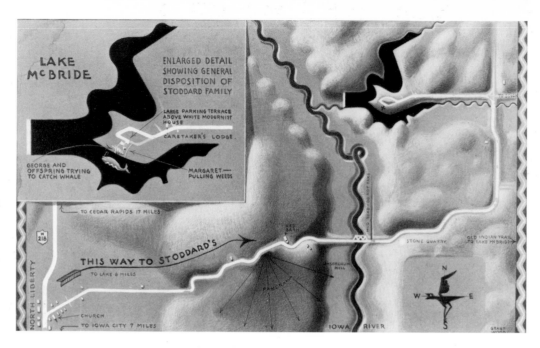

131. *Comic Relief Map of Lake McBride,*
*Iowa, Area,* 1935–1940.
Pencil, ink, and chalk on paper, 10½″ × 17½″.

high on a hill, attended by a stone church, school, depot, post office, workers' cottages, and an "opera house–hotel." The introduction of Portland cement soon closed down the quarry, and by 1932 the town consisted only of a general store and about fifty inhabitants. By May of that year a faculty and staff under Wood's direction had begun preparations for a six-week term to start on June 26th (Figure 132).[25] Sponsorship, endorsement, and accreditation for the school came, respectively, from the liberal, anti-academic Iowa Artists Club, the Little Gallery, and Coe College. The curriculum offered figure drawing, composition, portraiture, landscape painting, color theory, sculpture, lithography, metal craft, picture framing, and "lecture-conferences dealing with a mid-western expression."[26] The makeshift sleeping and eating accommodations in separate stone structures, as well as the opportunity for camping, shortly induced an informal communal spirit within the group of approximately two hundred (Figure 133).[27] After a critique each Saturday, the students would exhibit their works for sale in the opera house–hotel during Sunday's public open-house hours. For the two summers that it lasted, the colony kept up a close alliance with the local people in accordance with one of its basic principles.[28]

It was not the difficulty of teaching young students to understand and accept the regionalist creed or the fifteen hundred dollars it owed that closed down the Stone City Colony and Art School.[29] On the contrary. Though Wood had conceived the colony as a per-

manent Midwestern art center, his expanding world in 1934, which included New York, the University of Iowa, and the newly formed Public Works of Art Project, raised his regionalist sights to a national level, and both the Little Gallery and the Stone City Colony faded into the background.[30]

When an Iowa group of twenty-two PWAP artists transferred its original base of operations from Cedar Rapids to the University of Iowa campus in Iowa City, Grant Wood, as its supervisor, automatically became a member of the university's Department of Graphic and Plastic Arts. He thus inadvertently helped to break up the monopoly held by conservative academics in the department since 1909 and opened the way for modern art, beginning with nineteenth-century realism, to enter the curriculum.[31] A series of "cooperative murals" for the Iowa State University Library in Ames, designed by the novice professor and executed by his student assistants, soon began to issue steadily forth from their workshop, a former swimming pool inside what was originally the old campus armory.[32] Threatened at one point by a sudden cessation of government funds, the group made emergency plans to live in tents, work part-time for expense money, and eat common meals cooked by members' wives.[33]

Such solidarity furnished a useful example of dedicated group action for Wood as he proceeded to campaign for a government-sponsored system of regional art schools. Indeed, he contended that

132. Photo of faculty, Stone City Colony and Art School, Stone City, Iowa, summer 1932. Left to right: Grant Wood, Adrian Dornbush, Edward Rowan, Arnold Pyle, Marvin Cone, David McCosh.

133. Photo of Grant Wood painting Rocky Mountain mural on side of his ice-wagon residence at Stone City Colony and Art School, Stone City, Iowa, summer 1932.

the short-lived PWAP was what gave him the idea for a viable nationwide system. The federal government, he said, should take advantage of that sudden and brief experience and establish regional centers for art instruction within appropriately divided cultural and geographic districts. These centers or schools should ideally be allied with universities, where gifted art students might profit from liberal-arts courses, for example in the natural sciences, without committing themselves to strict academic requirements.

While mural paintings enabled students to work in groups to develop originality "under proper guidance," and to enjoy a definite purpose, the program should also stage competitive exhibitions. Organized and judged regionally, these events would help foster "the peculiar local spirit" and promote "sectional rivalries," and federally sponsored awards and opportunities should be given to artists recognized among the local centers as the most talented.[34] On a grass-roots level, the town boosters should be urged to join the American art public and pay heed to the possibilities of regional schools. Annual exhibitions, Wood promised, could arouse "hard-headed business men and the community in general" to boost their local art with the same enthusiasm that they showed for a local baseball team or other home enterprise.[35] "There is nothing ridiculous about such support; it would be only a by-product of a form of public art education which, when extended over a long period of time would make us a great art-loving nation."[36]

Wood's self-assigned mission to encourage a locally based national art worthy of future audiences was not unlike the equally ambitious goals of his American predecessors. From John Singleton Copley, Washington Allston, and Thomas Cole through Winslow Homer, Thomas Eakins, and Robert Henri, he inherited a persistent dream that the United States could not only declare its artistic independence from Europe but also might ultimately produce innovative and distinctly American painters free, as Eakins exclaimed, from any "foreign superficialities."[37]

While the Americans of the nineteenth century occasionally deviated from the prescribed subjects and styles of the academic tradition, most often as an accidental result of their marginal training, they aspired to learn the fine art of painting: "correct forms" of portraiture, history painting, landscape, and genre. Emancipation from the "schools" came with the decline of the academy and the ascension of progressively abstract deviations from prescribed naturalism beginning in the late nineteenth century. While avoiding extremes of either academic tradition or modern abstraction, Wood in the 1920s permitted himself to choose freely from among a wide range of stylistic alternatives, both traditional and modern. No longer constrained by aspirations toward a formally schooled propriety or thwarted by a sense of cultural isolation that burdened his American precursors, he was free to apply his imagination to the rural life and setting of his native locale.

# III

# The Regionalist Revolts
# Against the City

# 7. Regionalism Precipitated

Of all the art-historical terms applied to twentieth-century American painting, the term "regionalism" knows no equal for ambiguity. By way of contrast, the nickname "ashcan school" for Robert Henri's circle of painters clearly indicates their preference for urban scenes picturing the streets of working-class neighborhoods. In avant-garde painting, the labels "synchromism," "precisionism," "abstract expressionism," "pop art," and "minimal art" all reflect the stylistic nature of the respective schools. "Regionalism," on the other hand, though a widely used generic term in the art history of the United States, is far less explicit in identifying form, subject matter, or content. Paintings classified as regionalist could conceivably comprise landscapes and city views, genre scenes, critical commentary on social conditions, patriotic refrains, murals of historical events, and folklore. As it was applied to the prolific output of painting in the late 1920s and 1930s, which took many directions in subject matter and thematic intention, no such one-word description could avoid being relatively meaningless.

Nevertheless, by the 1940s the term "regionalism" had settled into persistent use. It assumed the dubious authority of an art-historical category with little clarification by means of study and scholarship to substantiate its accuracy or appropriateness. When critics of the 1930s first viewed the paintings to which the term now boldly alludes, they readily exchanged it for other labels just as adroit and seldom any more to the point. For instance, one substitute, "American Scene," was even broader in designation; it originated in New York City during the 1920s referring primarily to paintings of urban life and settings. Another alternative, "localism," was used to imply an intimate knowledge and understanding of any given environment presumably anywhere in the world. On the other hand, the label "nationalist school" censured all American realists because they shunned abstract styles. Painters themselves were plagued by the question of labeling their art. Of the painters who gained lasting fame under the regionalist banner, only Grant Wood worked to organize a self-perpetuating movement dedicated to the prospect of establishing an internationally recognized American school. He alone formulated concrete principles and theories to validate "regionalism" as a term applicable to his art, a programmatic approach that corresponded in substance, if not in method, to the regionalist position adopted by a group of contemporary American writers known as the Southern Agrarians. Less articulate than Wood, the painter John Steuart Curry quietly permitted himself to be recruited into the movement regardless of its terminology or concepts. Thomas Hart Benton, who elaborated endlessly about his aspirations and accomplishments, soon appropriated the name "regionalist" for his personal polemics. In keeping with their comparative nonchalance, neither created major works as unquestionably identified with the term, theory, or movement as *American Gothic* and *Stone City*, the standard-bearers of Grant Wood's decade of brief stardom.

In the spring of 1931 Grant Wood began to speak publicly about a "new movement" of Midwestern painting. Addressing the Fourth Annual Regional Conference of the American Federation of Arts held in Kansas City, he acknowledged that painting American subject matter in the name of an American art was not new but dated back to the colonial period. Nevertheless, earlier American painters had generally derived their styles and even their themes from European sources, and it was this deficiency for which Wood sought a remedy based on a representational manner of painting. Without being either primitive or provincial, the contemporary American artist, he maintained, could achieve an independent style by devising a personal "convention" of composition and design applicable to "literary, story-telling, illustrational pictures." In reaction to "the abstractions of the modernists" in Europe and New York, such conservative experiments were under way in the conservative Midwest, where, Wood announced, a new movement known as regionalism was arising.

By the end of 1934 the growing prominence of several American painters from the Midwest had attracted notice from the popular press in the East, which, in response to a current national impulse to idealize rural life, promoted them to leadership roles in what it claimed was a genuine indigenous art. This promotion climaxed on Christmas Eve of 1934 when *Time* magazine issued its cover story on American painting entitled "U.S. Scene."[1] The article made the most of the American public's misunderstanding and intolerance of modern European abstract painting by dismissing its "arbitrary distortions" in "screaming colors" as "crazy" and "outlandish." Only a lack of market for traditional paintings, according to *Time*'s distortion of facts, had forced American painters to copy Cubism, Futurism, Dadaism, or Surrealism after World War I. Then, at the end of the 1920s, help rode in from the West. A small band of native painters from Missouri, Kansas, Iowa, and Ohio arrived in time to challenge "introspective abstractions" with direct representations of familiar environments and their inhabitants.

The article's standards for content were few. American paintings praised by *Time* were devoted to any politically neutral subject, rural or urban, and from the magazine's nationalist point of view it seemed of no consequence whether a painter depicted a quality of the local life he knew best or gathered his material far from home in some other area of the country. An exhibition of "typical Americana" could be considered sufficiently entertaining if it presented a montage of fields, barnyards, streets, railroad yards, amusement parks, factories, and appropriate human figures. Thomas Hart Benton, who by this time had completed three of his four most prominent popular-history murals, was featured on the cover with a self-portrait and was discussed first in the article as "the most virile of the earthy midwesterners." Charles Burchfield, John Steuart Curry, Grant Wood, and Reginald Marsh trailed behind, while Edward Hopper conspicuously failed to win any mention at all.

Grant Wood's popularity was at its peak in 1934, by which time, on the basis of his activities as an educator and art-school promoter, he had made a reputation as an artist who wished to activate a movement. The *Time* article discussed Wood in his leadership capacity, maintaining that no man was "a more fervid believer" in developing "regional art." He had founded and directed his own summer art school in Stone City, Iowa, dedicated in theory to local life as the subject and content of a native art form. The Public Works Art Project (PWAP), which was the first federally funded relief program for artists, had given him the opportunity to oversee a group of young artists in a university mural project. And more recently he had been actively proposing competition within a nationwide system of art schools to encourage the selective growth of an American regionalism centered in the Midwest. Bolstered by accolades from the East, the ambitious Wood strove to live up to his fame. His hopes for implementing his proposed program rested with those Midwestern-born painters who shared his rebellious attitude toward the European influences of academicism and modernism. To launch the movement, Wood implored them to become full-fledged regionalists and to join him in teaching its regional-indigenous-national expression.[2]

Except for an eight-month stay abroad, John Steuart Curry had been living and working since 1921 on the East Coast, first in New Jersey and then in Westport, Connecticut. He and Grant Wood had first met in Stone City when Curry, a native of Kansas, visited Wood's art school in the summer of 1932 (Figure 134). Dressed up in bibbed overalls, the two artists predicted that the cultural center of the United States would evolve from this beginning and vowed that they would be back together the following year to help it along. Four years later Wood, continuing his campaign to persuade the still-absent Curry to return to the Midwest, searched for a teaching position at various colleges and universities that would please the Kansan. An appealing offer to become the nation's first artist-in-residence at the University of Wisconsin finally brought Curry back to the Midwest in the fall of 1936.[3]

In the meantime, both Wood and Benton had begun to teach, at the University of Iowa in Iowa City and at the Kansas City Art Institute respectively. They had become acquainted in New York City during the autumn of 1934 and met again the following January in Iowa, where Benton had come to lecture. Accepting Wood's advice to leave the East and live where he belonged, Benton soon accepted a commission from the Missouri legislature to paint a large history composition for the state capitol building in Jefferson City.[4] From that point on into the early forties, Wood, Curry, and Benton, the "triumvirate" of American regionalism, aided by the powers of the press, came to be overwhelmingly equated in the public eye with the Midwestern movement that Wood had dreamed of.

Though regionalist artists would continue to acknowledge and support each other, regionalism as a movement rapidly waned and eventually failed as its three titular leaders in the Midwest grew

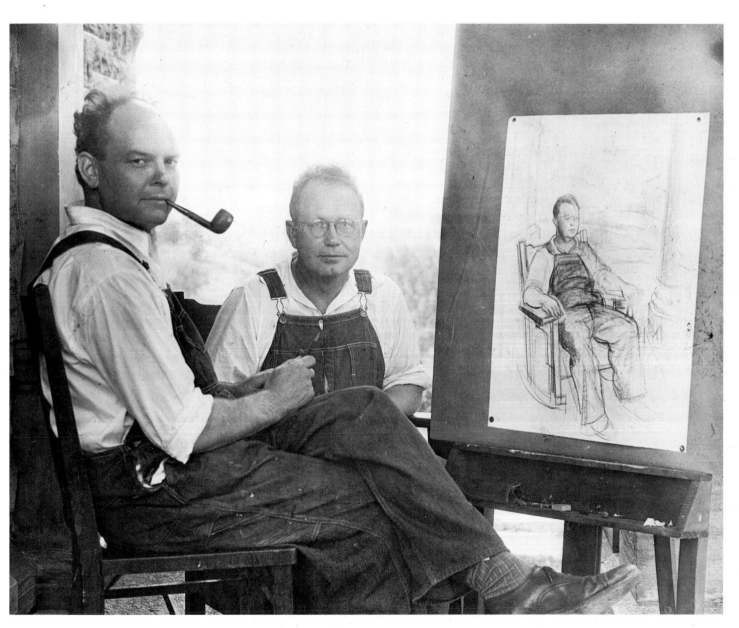

134. Photo of John Steuart Curry visiting Grant
Wood at Stone City Colony and Art School, Stone
City, Iowa, summer 1932.

increasingly skeptical about its initial premise and ultimate destiny. Predictably perhaps, their interest in sustaining a movement or school in order to establish a collective identification with a given region soon gave way to an awareness of individual aesthetics. In 1937 Curry warned artists against overvaluing the role of a specific region in the formation of a native art; using Grant Wood as an example, he stressed the importance of a personal absorption in subject and content through which artists could "express a more direct reaction to the physical environment in which they find themselves."[5] Wood became concerned about the inevitability of imitators, as his style was more vulnerable than most to such trespassing, and grew progressively cautious about treating the regionalist movement as a prescribed program of painting—in short, as a new academy. In a 1940 article on Curry he emphasized the fundamental need for personal experience as the exclusive source of regional identity:

> It is the depth and intensity of the artist's experience that are of the first importance in art. More often than not, however, a preponderance of a man's significant experience is rooted to a certain region. In this way, a particular environment becomes important to his art.[6]

Benton, the least committed of the three to any formal concept of regionalism, went so far as to object to the term itself. He believed in retrospect that "regionalism" implied too narrow a range of subject matter, especially in his case since he "was after a picture of America in its entirety (Figure 135)."[7] He tended to value his relationship with Curry and Wood in this "Americanist" context and, without intentional disrespect for Wood's efforts to bring them together, he took pleasure in suggesting that regionalism as a movement was primarily an invention of the mass media.[8]

As previewed in the *Time* "U.S. Scene" article, promotional press on behalf of regionalism proved of little worth or merit. The publicity initiated by Time, Inc. publications, the Hearst press, critic Thomas Craven, the American Federation of Arts, and Peyton Boswell, the editor of *Art Digest,* reached its apex by mid-decade. Its main thrust, as indicated in the 1934 Christmas Eve issue of *Time,* was to denigrate modernist artists and their limited American support as subversive to nationalist cultural interests. Unfortunately, the vulgar promotion that took the form of vicious attack or chauvi-

nistic display detracted from sincere and sensitive efforts on the part of such critics as Edward Alden Jewell of *The New York Times,* Marquis W. Childs, Lewis Mumford, and Constance Rourke to evaluate the individual achievements of the artists. By arousing resentment within the art world, contentious publicists ultimately damaged and downgraded the prestige of the regionalists as a group.[9]

Whatever the faults of promotion, the popular appeal of the rural aspects of regionalism insured the critical recognition, pro and con, of its social implications. Not only did the image of life on the land satisfy an urban nostalgia for the countryside, but it also offered welcome distraction and escape from the hard times and frustrations of the Depression, as many critics noted. The American people, wracked by insecurity, desired a stabilizing national identity, and a rural regionalism spoke to this need.

At the end of the decade, art historian Milton Brown considered rural-oriented regionalism to be a means of coping with social crisis through a search for cultural roots and "basic principles." Accordingly, any exploitation of nostalgia for less troubled times or preoccupation with sectional mythology and history represented a revolt against the evils of twentieth-century industrialization as intensified by the Depression.[10]

During World War II, which brought a renewed international outlook, critics and art historians regarded the national need for rural regionalism with growing disdain. Art historian H. W. Janson maintained that regionalism actually derived, in Wood's case at least, from European sources rather than from the unique qualities of a particular American locale. By comparing the regionalist painting of Germany during the 1920s, called *Neue Sachlichkeit,* with nineteenth-century German romantic painting of the Biedermeier period, Janson concluded that Wood must be an American "Neo-Biedermeier" who appealed to the public through a vision of stability and "substitute reality."[11] Samuel Kootz, a devotee of Cubism, expanded his broad attack on all conservative realist painting and condemned regionalism as nationalist, chauvinistic, and, by inference, "an innocent approximation of the Fascist attitude." Despite his differences with them, however, he concisely summarized the social significance of their popularity in the preceding decade. He believed that regionalism had endowed the country with a concrete sense of security, "something with a body and an existence to inspire confidence . . . security compounded of familiar homely scenes . . . an America of insistent actuality." Kootz speculated that a large

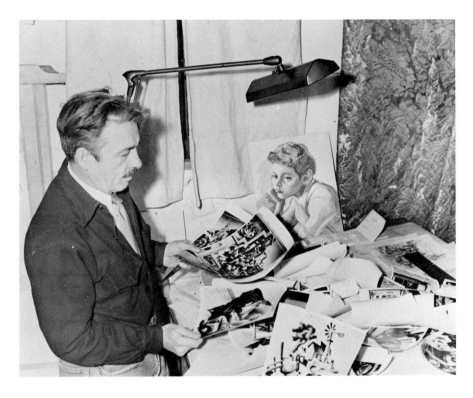

135. Photo of Thomas Hart Benton, 1935.

middle class found reassurance in lyrical canvases of rich farm lands, as well as in Charles Sheeler's views of vast industries—"the whole colossal evidence of self sufficiency."[12]

While the critical and popular reactions to regionalism in the 1930s may have been strongly affected by the influence it had on the social stability of a nation shaken by economic depression, the movement actually came out of pre-Depression efforts in the American art world to establish a native identity. During the 1920s there was an increase of published attention paid to American antiques and folk art, Currier & Ives prints, and American Indian art, as well as to contemporary Mexican art and the German *Neue Sachlichkeit*. In the bimonthly *Art Digest*, articles and reviews, which were often collected and condensed from newspapers and specialized periodicals, provide a good cross-section of the achievements and expectations of artists and critics during the period. Its editorial stance,

under the direction of Peyton Boswell, a fervent art nationalist, reiterated the hopes of American artists of the Federal Period who had also prophesied an "imperial period" for the United States and predicted that a "renaissance" of art would provide the nation with appropriate glorification.[13]

In the fall of 1927 the critic-historian Lewis Mumford, despairing of eclectic tastes among his countrymen, foreshadowed a regionalist grievance against influences from abroad, which had impaired the development of native art forms. The seventeenth-century American farmhouse, he complained, stood as "the last consistent example in America of a healthy tradition, untainted by foreign modes and meaningless precedents."[14] Inspired by such models of efficiency from the past, functional machine-related designs could supply a basis from which a national art of building would properly develop. In contrast to Mumford's up-to-date conten-

147

tions, other references to early American art and design in *Art Digest* of this period were mostly limited to an antiquarian enthusiasm for past achievements. The preservation and restoration of colonial interiors by museums and other organizations, such as the Williamsburg project, and the upsurge of private antique collecting were treated as signs of an improved taste suddenly surfacing in the wake of an extended commercial and industrial growth. "The so-called 'craze' for American antiques should be regarded as an important step in the aesthetic development of modern America and as a sign of the nation's emergence from the long period of materialism and disregard of beauty which characterized a whole century."[15]

Folk art, then popular as a category of antiques, was held up by the critics as an object lesson in good craftsmanship. To stave off what appeared to be a careless lack of technique in modern art, they admonished the artists to learn their craft thoroughly. It was not necessary to return to academicism or even to pre-Impressionist masters, since many examples of excellent craftsmanship existed outside the mainstream of art history. Holger Cahill, for one, later in charge of the WPA Index of American Design, preferred the direct personal handling of tools and materials that he saw in American folk art to the standardized practices provided by formal training. An ancient tradition of craftsmanship that all artists in the United States could follow lay close at hand in the arts of the American Indians. This new appreciation of America's vanquished aboriginal culture, however, was motivated less by a desire to help the tribes maintain their craft traditions than by an attempt to assess their past accomplishments within an art-historical context. An article about an exhibition of Indian art directed by John Sloan at the Grand Central Galleries betrays this scholarly purpose with the headline "Great Tribal Exhibition Will Reveal the Indian's True Place in Art."[16]

Ignoring the critical denouncements of modern industrial society for which the Mexican muralists José Clemente Orozco, David Alfaro Siqueiros, and Diego Rivera and *Neue Sachlichkeit* artists enjoyed notoriety, *Art Digest* chose to dwell upon their national stylistic identities. It was their general identification with an international backlash against avant-garde abstractionists rather than their specific intentions that attracted conservative American observers. *Art Digest* stated in late 1926, "the New Objectivity

(*Neue Sachlichkeit*) is but a symptom of the thorough-going reaction which is repressing rather vigorously the revolutionary wave of the post-war years."[17]

In 1951, a decade after the demise of regionalism, Thomas Hart Benton, in writing his personal history of the movement, began by acknowledging the early importance of "American Scene" painting, particularly in the town and city scenes of Charles Burchfield, Edward Hopper, and Reginald Marsh. "An Americanist movement," he wrote, "though it was not clearly defined, was in the air."[18] Among the leading Americans of the period, Hopper and Burchfield most often satisfied the general requirements agreed upon by critics, but, so long as painters concentrated on local material rendered in a realist style, be it an urban or landscape subject, genre, or social criticism, they qualified as "American Scene" artists. An exhibition of "Summer Landscapes" at the New York City Downtown Gallery in October 1930 elicited praise for painters who preferred to "paint America first" rather than to spend their summer abroad.[19] Marguerite Williams of *The Chicago Daily News*, in writing about the Art Institute exhibition in which *American Gothic* won a three-hundred-dollar purchase prize, exulted over the "new life" sweeping through American painting in topics ranging from chorus girls to farmers, from fruits and flowers to satires on prohibition. With a rush of patriotic pride, she remarked on the absence of Cubist paintings and on the fact that European conventions had now been seasoned with the American temperament.[20]

During the same season Margaret Breuning of *The New York Post* preferred the prosaic subjects of industry at the Water Color Annual sponsored by the American Water Color Society and the New York Water Color Club.

> It is the use not only of the American subject, but of the thing at hand, the obvious and not the pictorial or unusual aspect of the American environment that makes the deepest impression. Factories and sawmills, drab city streets and docksides, quarries, ordinary placid bits of farming country are transmuted by creative vision. . . .[21]

"American Scene" painting even won aesthetic sanction from Princeton's famous art historian Dr. Frank Jewett Mather, who pro-

nounced the ultimate distinction between the modern artist and the modernist. The former was a painter who made pictures closely related to the actual world in which he lived, as for example John Sloan. The modernist, on the other hand, isolated himself as superior to actual life so that "he is prone to have less and less meaning as his personality wanes and his work is obliged to speak for itself."[22]

While "American Scene" prevailed as an all-encompassing category riddled with conceptual ambiguities, there arose during this period certain attitudes that consistently observed the local boundaries of subject and theme that would eventually be charted as regionalism. A call for expatriate artists to return home had gone out in the late twenties, not surprisingly from the South, where the Agrarians of Vanderbilt University exercised their literary talents and promoted a regionalist cause of cultural preservation. As if at the bidding of the Nashville writers, the Southern States Art League urged painters and sculptors as well to extol rural traditions and a "neighborly life" with subjects related to the soil.[23] A nationalist emphasis, no matter what it implied in terms of subject matter and style, dominated the pages of *Art Digest*, subsuming by 1932 all other considerations. In order to protect American art against foreign influences of both modernism and academicism, one popular critic proposed that a new tariff be legislated to give the "infant industry" of American art a better growth potential.[24] The Mid-western regionalists and their publicists were to sustain this defensive position throughout the thirties:

> The stock rebuttal of any criticism of the foreign invasion of art is that art, after all, has no nationality. I insist that it is the very nationality of French art that is being forced down our throats, and we are told to accept anything as fine just because it is French.
>
> The rampant invasion of foreign art, fashionable at the moment, has little to do with the cultural program so desired by and necessary to us. The work of leading French contemporaries does not reflect the temper or character of our people—is alien and at bottom quite as foreign as its source to our natural inspiration.[25]

Some Americans, taking the pose of "rugged individualism" so dear to Thomas Hart Benton, found their own reasons for rejecting European influence. A little-known artist, Joseph Pallit, after a visit abroad berated European artists for being too effete, aesthetic, and theoretical, for lacking in "brute vitality." Artists in the United States, on the contrary, must live up to a masculine mystique and lead the country to supreme artistic power. "We are farmers and roughnecks," he said. "Our maturity is upon us and we shall do things as great as the world has ever seen"[26]

# 8. Regionalism *vs.* the Industrial City

Even as American artists in the late 1920s were seeking a national identity through a purebred native art employing local subject matter and themes, there was at the same time in American literature a similar movement toward cultural self-discovery, which also espoused regionalist sentiment. American writers of the twenties, despite their attacks on the puritanical parochialism of the middle class and on provincial sentimentality, had retained the traditional subject matter and themes essential to regionalist art. An outspoken group of Southern poets and critics led by John Crowe Ransom and Allen Tate at Vanderbilt University, who called themselves Southern Agrarians, undoubtedly came closest in attitude to that of the Midwestern regionalists. Their criticism of industrial capitalism, urbanism, machine technology, and formal abstraction in modern art and science exhibited a pronounced bias against the Northeast and the cosmopolitan progress it represented. As prescribed in their 1930 publication *I'll Take My Stand,* the single solution for an ailing South, if its identifying regional traditions were to be saved in the face of alien inroads, was agrarianism.[1] This advocacy of a local rural life as the alternative to industrial urbanization suggests that the Southern Agrarians would have provided the artists of the Midwest with welcome assistance in formulating and advancing their artistic application of an anti-urban regionalism.

And such was the case. Grant Wood and Thomas Hart Benton both credited the aesthetically induced social opinions of the polemical Vanderbilt writers with stimulating their own regionalist theories. In his personal history of regionalism, Benton indicated that the term "regionalism," as applied to Midwestern subject matter in painting, was borrowed directly from the Southerners.[2] Grant Wood too as early as 1935 acknowledged the same literary circle for enlightening regionalist ideas. In his essay *Revolt Against the City* he shared the antipathy of the Southern Agrarians toward the urbanized Northeast, and at one conclusive point he cited Ralph Borsodi, a favorite hero of the Southerners, for his agrarian practices as a subsistence farmer.[3]

The notorious 1925 Scopes trial, which called into question the propriety of teaching evolution in public schools, was one of the events that triggered the formation of the Southern Agrarians. The attacks leveled against the South by H. L. Mencken and Northern newspaper reporters during and after that histrionic debate between Clarence Darrow and William Jennings Bryan aroused the loyalty of the Southern writers, who had previously been indifferent to and even critical of their region in articles they had contributed to the now-defunct literary magazine *The Fugitive.* Now collectively defensive of the relative backwardness of their impoverished agricultural states, they chose to rationalize the South's economic and social conditions as a positive cultural advantage superior to that of industrialization and urban development. From this initial position, these Southern writers evolved their ideal of agrarian economics and socio-aesthetic theories of regionalism to counter the way of life proposed by the urban-industrial progression.

The group's criticism of the modern city had its roots in attitudes that had existed for well over a hundred years. Thomas Jefferson in Virginia and Thomas Carlyle of England, at the beginning of the nineteenth century, both dreaded the machine age and the drastic changes its industrial order would deliver to a world economy still based on agriculture and for the most part restricted to a "domestic" system of home production. A century later an organized struggle to protect rural life from industrial urbanization was advocated by Harvard philosophy professor Josiah Royce. A region, he advised, must consciously perpetuate its own customs and ideals and cherish its traditions, legends, and local aspirations. Conformity and coercion accompanied the growth of big business, big cities, and

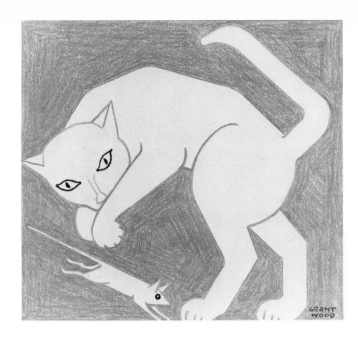

136. *Cat and Mouse.*

136–140. Drawings for endpapers of
*Farm on the Hill* by Madeline Darrough Horn,
1936. Each drawing crayon on paper,
5¾″ × 6½″.

centralized government, while individual freedom thrived in a small provincial community.[4]

The preference of the Southern writers for life in the country, confined to a village or a farm rather than an estranged existence in a chaotic city, originated in an ancient pastoral tradition coupled with a Romantic attraction for the Middle Ages. The belief that a local life deeply rooted in local tradition could produce a flourishing art won the adamant endorsement of the nineteenth-century English critic and theorist John Ruskin, who served as an inspiration to the Agrarian anti-urban bias. Ruskin had predicted that great art would become extinct as a result of unchecked capitalist industrialism, which would eventually destroy local loyalties and turn the art object into a commodity.[5] From an antiprogressive position, T. S. Eliot contributed to regionalist-agrarian concepts through his theory of a homogeneous community, which he viewed as the most accommodating of aesthetic environments. The great artist working in a racially and spiritually unified society attached to the soil, his interests centered in a particular place, would be better equipped to create a masterpiece, with subject matter emanating from a self-contained tradition.[6]

For the most part, the less systematized beliefs and practices of the Midwestern regionalist painters paralleled the basic ideas of the Southern Agrarians. Both movements rejected the urban life created by the large-scale industrialization of the twentieth century at the expense of the individual and his autonomy. Both espoused rural living in close touch with nature and local customs and traditions. Art, therefore, was to be a product of extended living experience in such a locale, expressive of a deep emotional attachment to a particular region. While devoted to these basic principles, Grant Wood nevertheless took exception in his art to the region-bound orientation of the agrarian vision. He insisted upon a certain amount of

license in depicting his region because he believed his art should have universal appeal, and he desired that regionalism be expanded as a league of cooperative art centers and a program of competitions. Thus, at the height of his success, whether in his theories or in his works (Figures 136–140), Wood was much more of a cosmopolitan artist than the rustic painter many believed him to be.

Both the Southern Agrarians and the Midwestern regionalists, in rebelling against the city, concentrated their attacks on the effect that urban civilization had on the artist and his work. The big city, they argued, spawned an artless cosmopolitanism and an affected bohemianism in place of the genuine culture produced by a rural society. As stated in 1935 by Donald Davidson, "Urban civilization produces an art without roots when it produces any art at all. Some of its artists tend to be dissociated from place, experimental, absolute, sophisticated; this is the art of the expatriates and cosmopolitans."[7] Though Wood, Benton, and Curry had lived and worked in cities and were never able to break away from cosmopolitan institutions and individuals commercially necessary for their success, they too in principle rejected the modern art and artist nurtured by the city, especially Paris and, to a lesser extent, New York. Personal experiments with bohemian life in both cities had proved particularly disillusioning for Wood and Benton, to whom a rejection of direct European influence marked the turning point in their respective careers.

Throughout the 1930s Wood dismissed the big city on the East Coast or abroad as inconsequential, for that matter harmful, to the new regional painter of the rural Middle West. He noted that painting was retreating to the "more American village and country life,"[8] moving into the great central areas that no longer should be abandoned as a culturally barbaric hinterland.[9] And quoting Christopher Morley's prophecy that future artists would originate from remoter

151

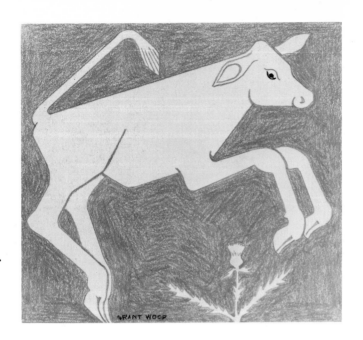

137. *Calf and Thistle.*

areas, "farther from the claims and distractions of an accelerating civilization,"[10] Grant Wood forecast that the ideal artist would remain at home, altogether untainted by an elitist metropolitan cultivation of the fine arts:

> Because of this new emphasis upon native materials, the artist no longer finds it necessary to migrate even to New York, or to seek any great metropolis. No longer is it necessary for him to suffer the confusing cosmopolitanism, the noise, the too intimate gregariousness of the large city.[11]

In early 1931, enjoying sudden fame from the recent success of *American Gothic,* Wood acted as a confident spokesman for Midwestern regionalism, though he reproached the cosmopolitan, bohemian, and abstractionist elements of modern art much less vehemently than had the Southern Agrarians. He advised that any Midwestern artist wary of abstractions derived from French modernism and preferring well-composed "story-telling pictures" would be better off living and working in his own home town. Although at the time benefiting from favorable criticism, and a prize-winning sensation at the Chicago Art Institute, Wood held that the local artist need not even go to Chicago in order to seek publicity, cultivate friends, or make important contacts in the art world. Not only were living expenses cheaper and models free at home, but friends and acquaintances also offered more constructive advice than that of artist colleagues. The local townspeople, varying in their interests and understanding of art, could respond intuitively to a painting and provide frank opinions.[12]

A few years later, in reminiscing about his visits abroad, the Iowa artist directed his anticosmopolitan, antibohemian aversions to the American "exiles" of the 1920s, whom he had observed from the safe distance of his sketching tours through Parisian parks and suburbs. By the mid-thirties he was convinced that Europe had rightfully lost much of its magic for artists in the United States and concluded that "expatriates do not fit in with the newer America."[13] For this reason he disparaged his fellow townsman Carl Van Vechten, a fashionable critic and novelist in exile from Cedar Rapids. When Gertrude Stein made her lecture tour of the United States in 1935, conducted by Van Vechten, Wood dismissed her performance as "only a seven days' wonder."[14]

Wood's equation of a bohemian existence with rootless dissociation from a familiar community—termed by the Agrarians a "region of memory"—is documented in his pastel drawing of 1935, *Return from Bohemia* (Figure 141). The artist depicted himself with brush in hand and palette poised, in front of a red barn. A circle of friends and neighbors, including his patron David Turner, are gathered to welcome him back to Iowa. The picture was intended as a jacket for his projected autobiography, which was to bear the same title. The central message of that unwritten book was repeatedly given in condensed form to the press as an anecdotal account later to be dubbed the "whiskers" story. In it Wood dramatized his conversion from the bohemian diversions in Paris to the solid ground of a personal regionalism. He had grown an uncomely red beard for the duration of his year abroad (Figure 142) and now characterized its incongruous appearance as a symbol of his attempt to adopt a French manner of painting. Though Wood in Europe had shared H. L. Mencken's belief that the Middle West was indeed "inhibited

152

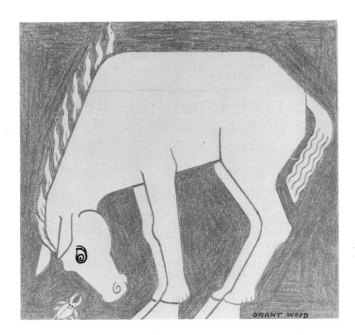

138. *Horse and Beetle.*

and barren," he finally decided, after a small, unsuccessful exhibition of his picturesque views of French architecture in Paris in 1926, that French painting, while fine for French artists, was not for him. In analyzing his painting to date, he concluded that only in Iowa could he realize his potential as an American artist. The most authentically agrarian aspect of this testimony of conversion pitted bohemia against the barnyard, much to the delight of the newspapers:

> I'd found the answer when I joined a school of painters in Paris after the war who called themselves neo-meditationists. They believed an artist had to wait for inspiration, very quietly, and they did most of their waiting at the Café du Dome or the Rotonde with brandy. It was then that I realized that all the really good ideas I'd ever had came to me while I was milking a cow. So I went back to Iowa.[15]

In 1935, the same year that Wood published his personal manifesto, *Revolt Against the City*, Thomas Hart Benton decided to depart for Missouri after almost twenty-five years in New York City. More verbose than any other painter of regionalist persuasion, Benton marked the grand occasion by writing his own book, *An Artist in America*, which included a lengthy reflection upon the evils of the metropolis.[16] His opening complaints against the city are hardly original: too many people crowded together to live in comfort, their outlook restricted by the city's confining walls; Manhattan was actually a highly provincial place which demanded all the attention of its inhabitants and locked out the rest of the country; in

league with a group of young bohemians, its large parvenu class looked to Europe for ideas, tastes, and values, "the paraphernalia of their pretensions."[17]

In airing his personal prejudices against the city, Benton expanded upon his earlier fear and distrust of the bohemian artists of the prewar period to condemn indiscriminately a wide assortment of people he referred to vaguely as intellectuals, academicians, radicals, and aesthetes. "Careerist intellectuals" and Marxist radicals were, he warned, intent on ridding art of all meaning in favor of either pure abstraction or stereotyped propaganda. Equally offensive were the conservative academicians "bound up in the negative refinements of conformity" and limited by "a narrow naturalism," because they held positions of power that allowed them to impose their taste on public art affairs, commissions, and projects. Perhaps most disturbing to Benton were the attitudes that he believed prevailed in the management of galleries and museums—an aestheticism which he disparaged at length as homosexual. "Withdrawn from the temper of America," these individuals thrived on "urban isolation" so that the dictates of fashion rather than innovation governed the selection of pictures to be judged, exhibited, and purchased. In addition to infiltrating the museums and galleries of the cities, this insidious force also endangered cultural institutions throughout the country. If unchecked, he predicted, it would eventually destroy the growth of art in the West, where people "are highly intolerant of aberration."[18]

Benton's anti-intellectual rancor, reinforced by his long-time friend and faithful promoter Thomas Craven, probably originated during his bohemian period, when, uncertain but ambitious, he was seeking an artistic identity. Having had a taste of academic train-

153

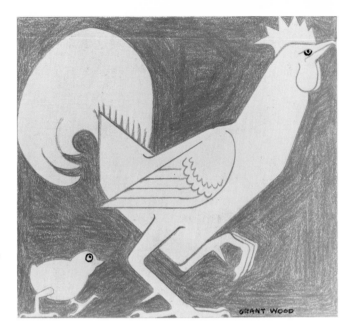

139. *Rooster and Chick.*

ing at the Art Institute in Chicago, and three inconclusive years in Paris, he was susceptible to any new doctrine convincingly presented. The void was filled temporarily by Stanton MacDonald-Wright, who had arrived from France in 1914 to introduce Synchromism, his version of color cubism, to New York. Benton proceeded to apply Synchromist color schemes to compositions of male figures borrowed from Michelangelo; and through Wright's brother, the iconoclastic critic Willard Huntington Wright, Benton participated in the first exhibition of American modernists, the Forum Exhibition of 1916. Despite success, a dissatisfied Benton soon recoiled from any theoretical art of absolute principles and abstract purity cultivated within an isolated bohemia of "romantic and esoteric notions and beliefs."[19] His conversion from an abstract art determined by inner "genius" to an art descriptive of the external world took place during World War I when he served in the Navy as an architectural draftsman. After the war he made his separation from "the bohemias of art" final during the first of many summers on Martha's Vineyard. Here he sketched and painted landscapes and natives, "plain American people and their environment," an experience that, he contended in 1935, had freed his art "from the dominance of narrow urban conceptions."[20] Yet, for the homeward-bound Missourian, halfway through four series of anecdotal murals, his celebration of the turbulent transformation of the United States from a rural to an industrial society was to fulfill the "great promise" for American painting. And though Benton would always relish the street sights of lower Manhattan, the "outlying places of the great rivers and fields" represented an untapped region ready to furnish his work with new themes as the indigenous art of the future. He failed to mention, however, that other painters native to the Midwest

had never left home or had already begun again to depict the reserve of material that still awaited Benton.

It was as a symbol of industrialism that the impersonal city bore the brunt of the attack launched by the Southern Agrarians in their publication *I'll Take My Stand,* a view that the regionalist painters of the Midwest supported and shared. The Agrarians' concern for problems that industry had inflicted on human existence are unequivocally stated in the book, which contains several denouncements of industrialism in the introduction and in a number of the essays. Industrialism evicts people from the soil and crowds them into factories, warehouses, and stores, where they sacrifice their individuality to drudgery and are victimized by economic insecurity and the threat of sudden unemployment. Industrialism deadens aesthetic sensibility by denying the worker leisurely daily contact with external nature, while art itself is reduced to the function of advertising or becomes a mere commodity. With the aid of applied science and machine technology, industry feeds on natural resources and ravages the landscape in order to expand itself in the name of progress. Worst of all, from an agrarian point of view, industry renders obsolete that last stronghold of self-sufficiency, the family farm, since the progressive industrialists believe that farming should be integrated into large industrial units. The farmer accordingly must alert himself to the fact that industrialism can translate his farm into mere economic intangibles, rob him of his native homestead, and steadily dehumanize his life.[21] The Southern writers clearly recognized that the purpose of unlimited mechanization was to accelerate industrial growth. To stem its advance they offered a single reactionary solution: the creation of an agrarian society based on an early stage of mechanization in which agriculture,

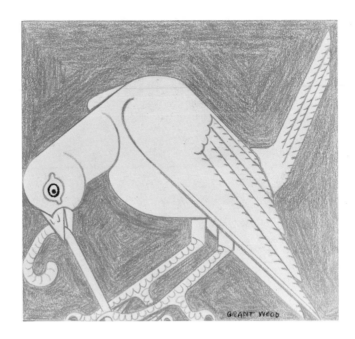

140. *Bird and Worm.*

preferably subsistence farming, would safeguard private dignity and guarantee a personal pursuit of happiness.

In spite of this unconditional war in print against heavy industry and mass production, however, the Agrarians displayed a certain ambivalence toward the machine because of the necessity of accepting some measure of mechanical development in cultivating the soil; and this ambivalence can be seen in the attitudes of Benton and Wood as well. They obviously found it difficult to fix a precise standard of acceptable tool-assisted manual labor which did not compromise its purported moral and creative benefits for the worker. Even subsistence cultivation, if it were not to revert to sheer primitivism, needed to accept in a limited way the progressive evolution of machinery and industry. Presumably, the limit would be reached when the mechanical device, remotely controlled and motor-driven, got out of hand and abandoned the individual and his craft skills for large-scale agricultural methods, sacrificing human autonomy to a growing reliance upon automation. The Southern Agrarians and the regionalists begged the question in their anti-industrial rhetoric or evaded it altogether in their aesthetic reverence for handicraft. Another cause for ambivalence, at least in the case of Benton, was that a mechanical device, when viewed in isolation, might fascinate the individual with its functioning parts and its power, despite the disturbing prospect of an urban environment and dehumanized workers.

Benton himself never took a definite stand in accepting or rejecting machine technology, and he alternated at will between celebration and doubt. Although dubious about the machine's benefit to society, he loved engines and used them as featured details in his paintings, alternating them with scenes of physical labor. Yet in the early twenties he had defied the traditional conventions of historical mural painting by proposing to paint a "people's history" of the United States emphasizing human "processes" over idealizing great men and events of the past. His primary purpose, he said, would be to demonstrate the expanding hiatus between the working people and the complexities of mechanized civilization. He later explained more precisely that history would progress from the frontiers, "where the people controlled operations, to the labor lines of the machine age, where they decidedly did not."[22]

In a cycle of murals that he called *The American Scene*, painted during the early years of the Depression, Benton chose to depict the struggle between the past and the advancing machine technology in the rural South and West in accompaniment with scenes of city life and heavy industry. These murals were painted on the board-room walls of the New School for Social Research in New York City in 1930 and 1931. In the panel "The South" (Figure 143) the Negro labors by hand in the cotton field while the white farmer works his land with a horse-drawn harrow. The tractor and other modern field equipment stand by, relegated for the time being to a small area above the dominant figures. Another rural scene records a step forward in the application of modern technology to Midwestern agriculture. The farmer hand-picking his corn competes for attention with shiny harvesting machinery. Not far away the sleek white grain elevator looms above the horizon, announcing the arrival of the machine age to the land. In the panel entitled "The Changing West" mechanization has all but triumphed as oil wells, refineries, motors, and airplanes fill the partitioned areas. A surveyor and a welder dwarf the cowboy and shepherd on the Western plain.

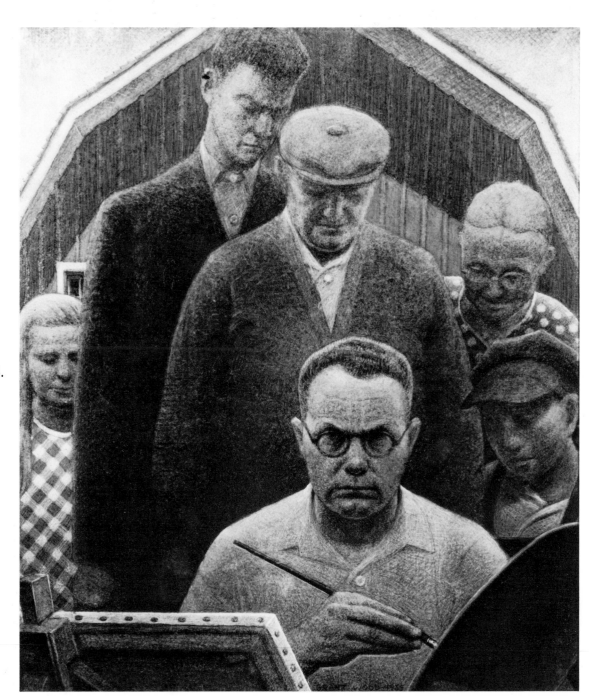

141. *Return from Bohemia*, 1935.
Pastel on paper, 24″ × 21″.

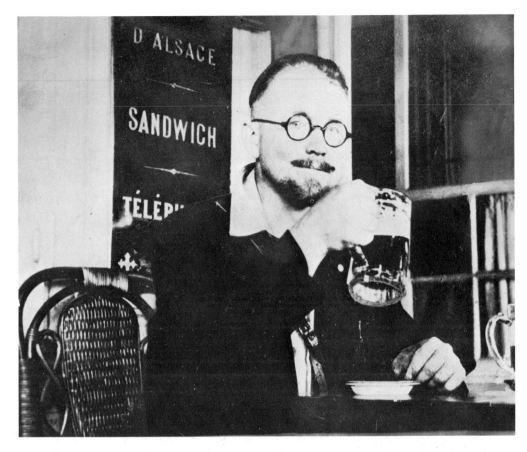

142. Photograph of Grant Wood
in France, 1924.

Two irregularly shaped panels called "City Activities" and "Civilization" pulsate with the frantic pace of melancholy people jammed into narrow spaces, where they engage in sensual experiences. "Coal," "Steel," and "Construction" dramatize the trials of the industrial worker contorted by his manipulation of pneumatic tools. The man-made settings of mines, mills, and harbors replete with the massive forms of heavy industry obliterate all elements of nature. Benton's desire to estimate the tension between man and mechanization climaxes in a tribute to mechanical energy. In "Power" (Figure 144) he used a combination of cutaway views of machines and segmented details to apotheosize the internal-combustion engine and the dynamo. Locomotion and flight radiate from a firing cylinder head.

In spite of the disruption wrought by machine technology, its raucous energy continued to captivate Benton's self-possessed, masculine temperament as it had since before the war. When he first went to Chicago early in the century he reveled in the city's upward expansion, "watching the donkey engines manipulate the great steel beams."[23] Though generally aware of ruthless commercial enterprise and the sacrifice of aesthetic considerations to "crass parvenuism," he could not help voicing a boyish delight at the sight of such unrestrained growth. The skyscraper, rising at the convergence of railroad lines, bridges, engines, and ships, stood as the mightiest achievement of all. Overlooking all the financial manipulation that built it, Benton rejoiced in the skyscraper as "the first effort of the American spirit to give itself an original monumental expression."[24]

Benton's dramatization of America's frenzied transformation into an urban-industrial, engine-paced society had little in common with Grant Wood's stolid and perhaps naïve aversion to the advancement of industrial mechanization onto the roads and fields of his ideal farmscapes. In an isolated painting of a highway disaster, Wood exposed his apparent skepticism regarding the expansion of motorization into local life on the open land. *Death on the Ridge Road* (Plate 33) hurtles the viewer over an innocent passenger car into the midst of impending collision. Alternating planes of contorted space, deep shadow, and flashing light vibrate with the sickening sensation of a crash. Although time stands still in the picture, the distortion and exaggeration of the guilty vehicles animate the scene with a sense of speed. The villainous black limousine stretches out to regain the right side of the road after illegally passing the slower car. The oncoming red truck dives over the hilltop, bent on destruction and fatality. Wood had never reconciled himself

143. Thomas Hart Benton:
*The South*, 1930.
Egg tempera and distemper mural, 91″ × 96″.

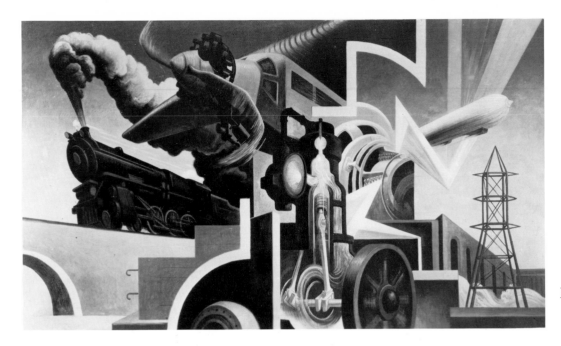

144. Thomas Hart Benton: *Power*, 1930.
Egg tempera and distemper mural, 7′7″ × 13′4″.

to the automobile age, and he distrusted cars and avoided driving as much as possible. His suspicions about automobiles had been confirmed by an accident that took place on the Ridge Road, north of Stone City, Iowa, in 1934, and left his poet friend Jay Sigmund seriously injured. Five years after *Death on the Ridge Road* his landscape painting of the new gravel road to Solon (Plate 36), south of Cedar Rapids, excludes any sign of the automobile for which the graded curve and the intersection at the bottom of the hill had been expressly engineered.

As Benton documented in his panel paintings of field work, trucks and large tractors had joined steam engines in the harvest by 1930, and toward the end of the decade many farmers of eastern Iowa were retiring their teams of draught horses in favor of the light tractors manufactured by several Midwestern firms. Nevertheless, even this fact did not induce Wood to introduce the industrial age into his farmscapes, and motorized farm machinery remained conspicuously absent in his interpretations of farming. The foreground slopes and distant hillsides in *Stone City* (Plate 12), *Fall Plowing* (Plate 21), *Young Corn* (Plate 22), and *Spring in the Country* (Figure 97), though uniformly planted, reveal no signs of a tractor. Presumably it is all the result of hand and leg work by the farmer and his team, the farm wife and her children, working in direct contact with sod and soil. In *Arbor Day* of 1932 (Plate 25) the farmer slows his horses in front of the schoolhouse, and in *Dinner for Threshers* (Plate 32) two years later, the unharnessed team eating oats in the barnyard can expect shortly to return to the fields to help with threshing. Even in the agricultural murals that Wood designed and directed for the Iowa State University library in Ames,

the faithful horse prevails in spite of the scientific experimentation and advanced technology to which the institution is dedicated.

*Death on the Ridge Road*, flanked as it is by landscapes free of vehicles and tractors, seems on the surface to signify a determined refusal to recognize the ongoing integration of rural life and farming into an industrial society. However, in *Fall Plowing*, a major farm view painted immediately after the more famous *Stone City*, two ages of the machine confront each other in the image of a bulltongue plow, whose blades, beam, and handles form a graceful linear composition in the immediate foreground. The plow's prized status as an object of reverence reveals something of Wood's ambivalent attitude toward industry. The plow stands either as the epitome of machine-wrought tools at the service of the agrarian worker or as the ultimate transition from hand labor to motorized mechanization, announcing the arrival of industrial mass production in the field. A symbolic stalemate thus results from Wood's willingness to accept and indeed celebrate the continuous advancement of factory-produced farm machinery without reaching a decision as to whether the traditional handwork of the farmer should give way to a motor-driven substitute for the horse-drawn plow, an inevitability that Grant Wood's farmscapes never accept. The dirt-polished steel share has bitten deeply into the sod crust to dislodge a thick roll of turf over the moldboard from which the upturned soil falls ready for the harrow. This exemplifies direct contact between man and earth as extolled by the Agrarians, here sanctified by the artist in tangible form. The hand plow asserts its functional beauty in tribute to man's inventiveness and guiding mind while it waits at mid-furrow for either the return of the team or its tractor replacement.

159

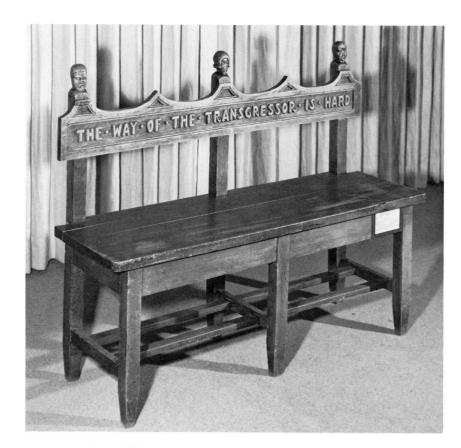

146. "The Mourner's Bench," 1923. Oak, 37" × 49" × 16".

145. Chair and ottoman designed by Grant Wood and *Portrait of Nan* in living room of his home, Iowa City, Iowa, 1935–1942.

Like Wood, the Southern Agrarians were drawn to the romance of the plow. Any plow that was horse-drawn and in the grip of a farmer represented a part of tradition. The plow had been sung and written about for centuries as an eternal symbol of mankind's ability to thrive, and the act of plowing continued to be honored as a selfless deed. The blade in hand descended directly into the earth with a poetic edge unknown to the tractor or combine, to the steam or internal-combustion engine. These machines may have arrived equipped with a noisy sublimity, but their interruption of man's immediate encounter with the earth lost them the poetic potential of the myth-charged plow.

Grant Wood's devotion to handicraft, dating from his early studies with Ernest Batchelder, also contributed to his ambivalent view of the machine and industry, which can be seen in a 1937 letter that he wrote in response to a tentative definition of regionalism sent him by a Cedar Rapids high-school English class.[25] The students, obviously well versed in the Southern Agrarian position, had emphasized regionalism's revolt from city domination, its anticosmopolitanism, and its stand against industrial civilization in defense of the cultural life of a particular area. In his hand-written reply Wood agreed that regionalism had taken the form of a revolt against the cultural domination of the city and against "the tendency of artists to ignore or deny the fact that there are important differences, psychologically and otherwise, among the various regions of America."[26] But, he went on, "It is not, to my knowledge, a revolt against industrial civilization (in the William Morris sense), though it has re-emphasized the fact that America is agrarian as well as industrial."[27] In other words, Wood believed that it was more important to revive the traditional image of the United States as an agrarian society in the face of its dwindling farm population than to enter the century-old debate as to the ultimate good or evil of industrialization. Unfortunately, by inaccurately implying that William Morris had rebelled against industry, Wood complicated the issue of advancing machine technology by suggesting that the Englishman required a black-white choice between absolute approval or total resistance.

Wood's misunderstanding of Morris may be attributed to his participation in an American version of the English Arts and Crafts Movement as it was disseminated through the publications and missionary teaching of Ernest Batchelder, with whom Wood had studied during the summer of 1910. William Morris, the English master of craft and ornament, recognized the inevitable development

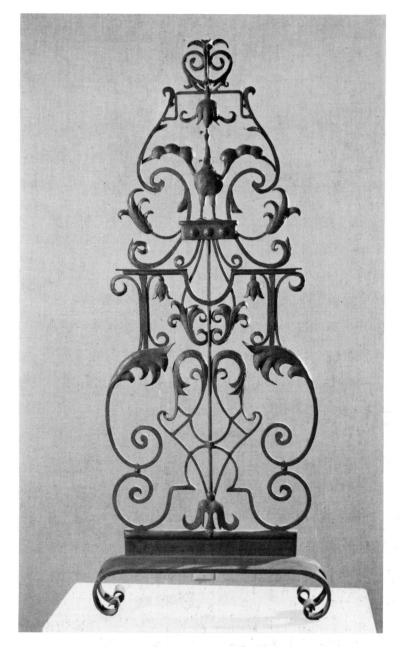

147. Candleholder, c. 1924. Wrought iron, 42″. Designed by Grant Wood and made by George Keeler.

161

148. *Turret Lathe Operator,* 1925.
    Oil on canvas, 18″ × 24″.

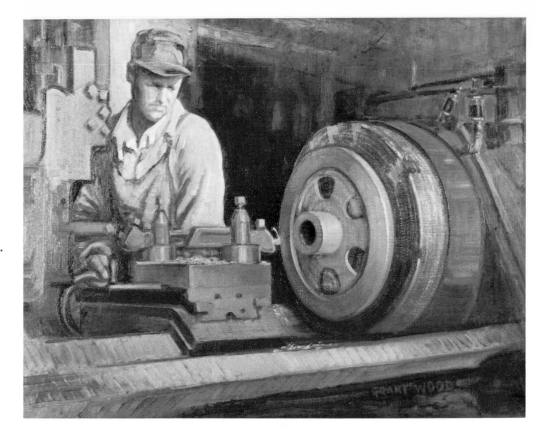

149. *Ten Tons of Accuracy,* 1925.
    Oil on canvas, 22″ × 36″.

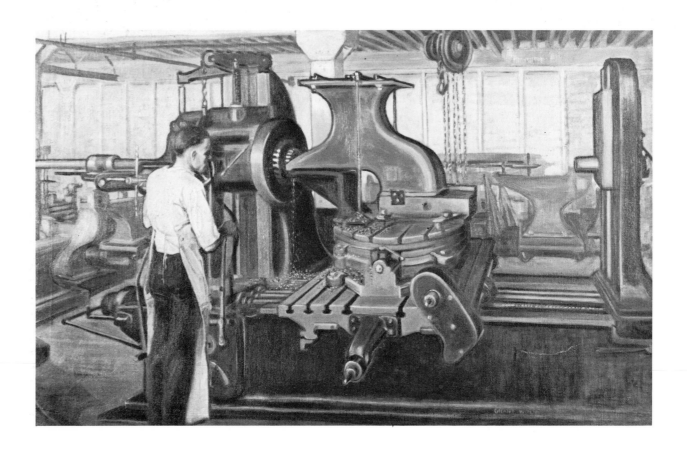

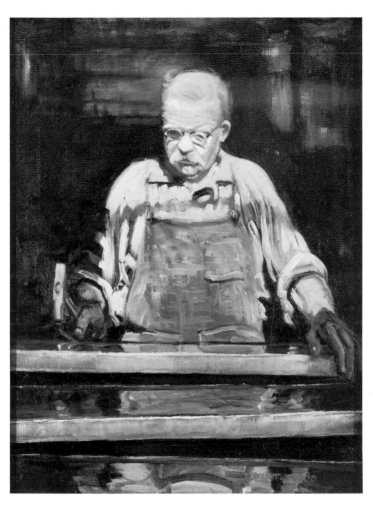

150. *The Covermaker*, 1925.
Oil on canvas, 24″ × 18″.

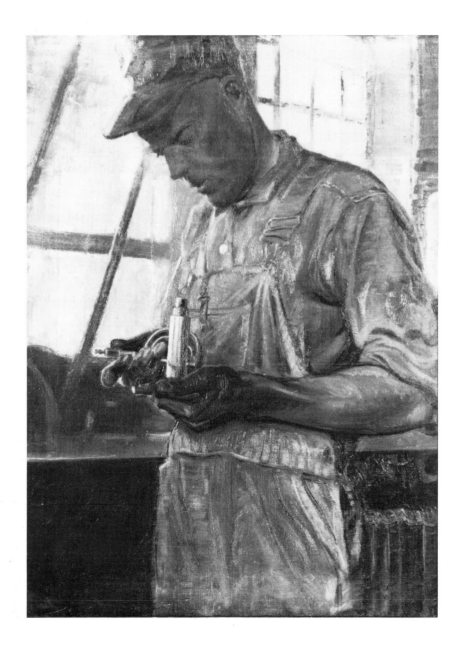

151. *The Shop Inspector*, 1925.
Oil on canvas, 24″ × 18″.

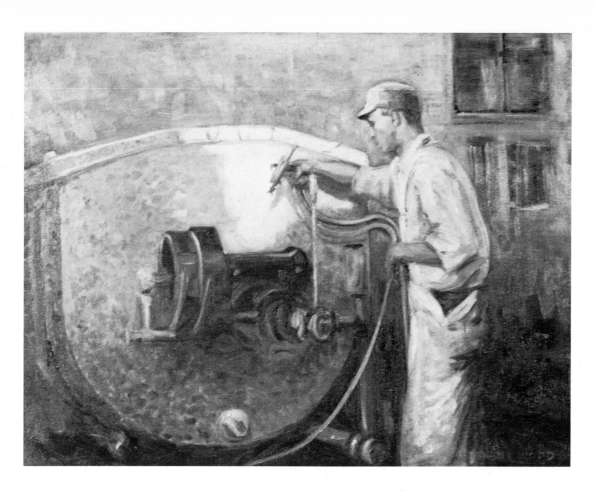

152. *The Painter*, 1925.
Oil on canvas, 18″ × 24″.

of machines and wished to turn their use away from a large-scale, profit-oriented industrial complex toward an enlightened factory system. His American disciple, on the other hand, leaned more toward the rigid anti-industrial position shared by Thomas Carlyle and John Ruskin and would entertain no compromise use of the machine, concentrating exclusively on hand-crafted design. Consequently, throughout most of his book *Design in Theory and Practice,* Batchelder religiously avoided any consideration of design possibilities that machines might offer. Examples drawn from the past, the Orient, and primitive cultures illustrated his basic principles of harmony, balance, and rhythm; and he discussed at length old craftsman techniques, guild apprenticeships, and the medieval application of ornament. Though he discouraged historicism in design in favor of originality and innovation, at no point in the text did he instruct or encourage the student to design for machine manufacture. Only in the conclusion did he pessimistically broach the subject of mechanized production, implying that an inherent lack of sympathy and communication between art and industry, between the studio-trained man and the shop-trained man, completely defied resolution. Because of their conspiracy in an artless system of commercial mass production, in Batchelder's opinion science, mechanical invention, and material progress "consistently

contributed toward a lowering of artistic standards and the degradation of the skilled craftsman to the position of an unskilled operative."[28]

Anticipating the Southern Agrarian position, Batchelder, who insisted that a permanent rift existed between art and industry, doubtlessly left on the young Wood an impression that would later temper any inclination to operate automotive machines, to design for industry, or to paint pictures of industrial subject matter. Only the chair he designed in the 1930s approached the mass production of a functional object. Overstuffed and tufted to complement the billowing hillsides of his mature landscapes, the chair conveyed a distinct feeling of self-contentment (Figure 145). He built it to his own specifications for his own comfort but added an enormous ottoman which, when shoved against the seat, was designed to accommodate the legs of a man considerably taller than he was. Although it was built by machine, the chair did not go far beyond craft in its localized production and marketing: An area manufacturer produced the chair, and a Cedar Rapids furniture store sold it in a variety of upholstery materials, with or without tasseled fringe. Other than this single venture, Wood indicated no particular interest in the prospects of an industrial art based on functional design. The Bauhaus generation of designers working in Europe after World

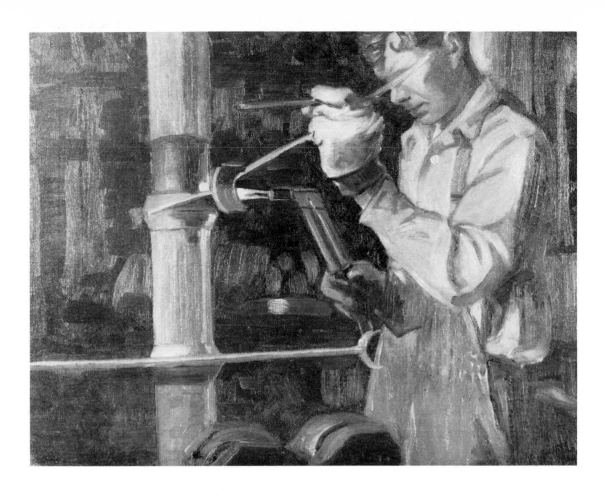

153. *Coppersmith,* 1925.
Oil on canvas, 18″ × 24″.

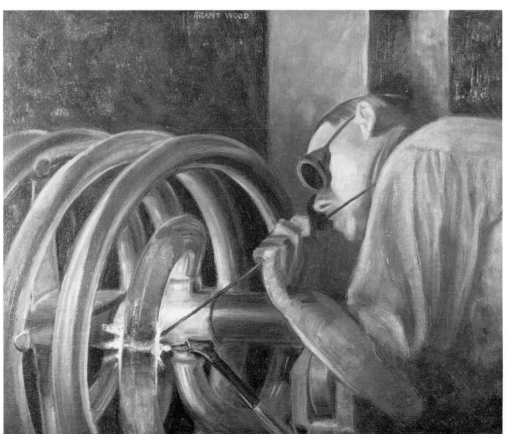

154. *Coil Welder,* 1925.
Oil on canvas, 18″ × 24″.

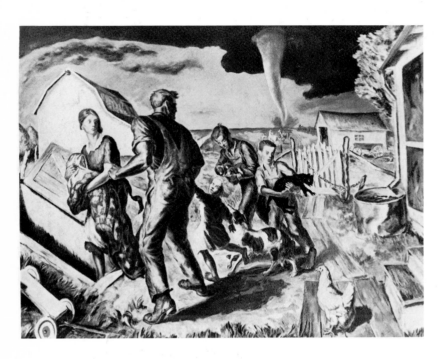

155. John Steuart Curry:
*Tornado Over Kansas*, 1929.
Oil on canvas, 46½″ × 60¾″.

War I had no more direct influence on his craft projects than their counterparts in pictorial abstraction had on his changing style of painting. A genuine lover of handiwork, Wood relished his materials and tools as much as he did making the actual design. His enthusiasm for carpentry, interior design, metalworking, and stained glass reflected the personal work ethic of William Morris as well as the updated medieval styles identified with the Arts and Crafts Movement (Figures 146 and 147).[29]

Wood did once enter the industrial scene to do a series of commissioned works in 1925, but again it was the individual craftsmanship of the workers that inspired his portrayal of the manufacture of modern dairy equipment. Shortly before accepting the commission from the J. G. Cherry Company, he had turned full-time artist and needed whatever income the project might provide. The series, which shows seven workers at their jobs in a local factory, was dedicated to skilled labor and was to be used for a temporary window display in Indianapolis to promote the patron's dairy machinery at a fall exhibition in that city (Figures 148–154). The theme of quality through craftsmanship guided the artist's choice of worker, task, and tool. The men Wood selected to picture were all long-term employees in the factory: an elderly sheet-metal worker hand-fabricating tinned copper covers for cooling machines, a machinist operating a turret lathe, a tinsmith welding a coil, a coppersmith soldering coil arms to a shaft, a painter spraying a completed coil machine, and the shop inspector checking a part with a micrometer. The last figure (Figure 151) is depicted in a close-up portrait which focuses on skillful hands in motion and is accentuated with back lighting to demonstrate the extreme accuracy required in the manufacture of close-fitting moving parts. The only painting of the series that reduces the worker to a mere operative advertises a huge milling machine used for the production of large freezer bases.[30]

Although the Southern Agrarians held that subsistence farming promised an escape from the drudgery of a factory and from the horrors of an industrialized city, they did not believe that life in nature was one of bucolic tranquility. Unlike the morally good earth conceived by Henri Rousseau, nature's mysteries and terrifying forces as envisioned by John Crowe Ransom and Allen Tate were expressive of a wrathful and indifferent God. They emphasized the use of wilderness imagery to remind mankind of its precarious position in the universe. Instead of waging an unrelenting and self-destructive exploitation of nature, man must once again learn to respect her awful grandeur. This view served the Agrarians' desire to activate the poetic imagination as an aggressive force against the

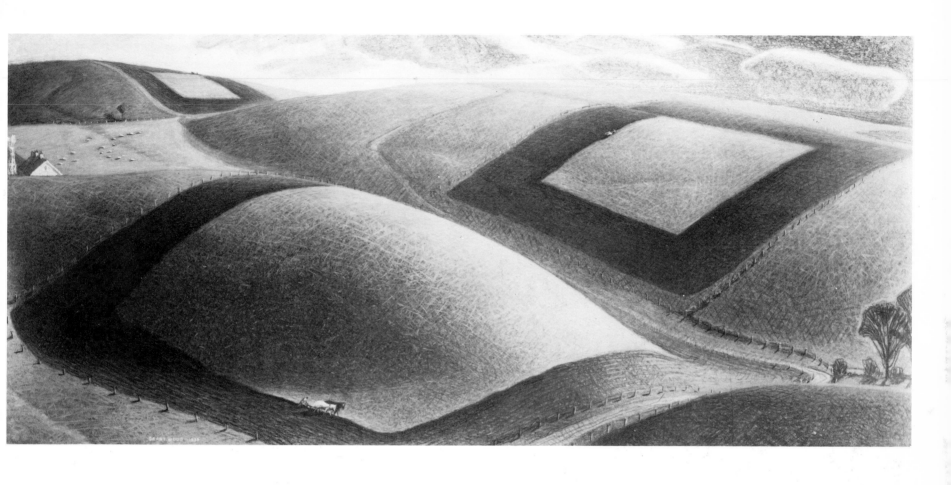

156. *Sketch for "Spring Turning,"* 1936.
Pencil, charcoal, and chalk on paper,
17½" × 39¾".

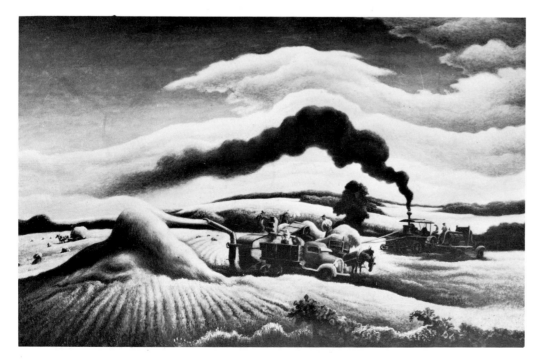

157. Thomas Hart Benton:
*Threshing Wheat,* 1939.
Tempera and oil on panel, 26" × 42".

leveling agents of standardization produced by science and industry. Everyone must divest himself of the illusion that practical rationalism could control nature through empirical knowledge and machine technology, and return to the land and a primal relationship with nature.

However protective Grant Wood felt toward his own farmer figures peacefully plowing their eternally productive fields, he understood that the man cultivating a field "is almost wholly preoccupied with his struggle against the elements, with the fundamental things of life."[31] This awareness enhanced his respect for paintings by John Steuart Curry which, unlike his own, came close to the Southern Agrarian vision of nature sublime and man's humble status within it. In his appreciation of such pictures as Curry's *Hogs Killing a Rattlesnake* and *The Line Storm,* or in response to the farmer's contest with nature in *Tornado over Kansas* (Figure 155) and *The Mississippi,* Wood commended his fellow regionalist for a "special susceptibility" to the dramatic aspects of his environment. "The violent extremes of the weather, the primitive conflicts between beasts, the religious fanaticism of the Kansas farm people" occupied this personal realm of perception. "He painted, from memory, the elemental terror of storms sweeping the prairie, the magnificence of the grain harvest, the brute struggle for survival. It was action he loved most to interpret: the lunge through space, the split second before the kill, the suspended moment before the storm strikes."[32]

The bucolic vision of nature that the Southern Agrarians had de-emphasized finds full expression in the landscapes of Grant Wood. In his mature landscapes beginning in 1930, such as *Young Corn* (Plate 22) and *Spring Turning* (Figure 156 and Plate 34), wide vistas of cultivated nature predominate, speckled only occasionally with small-scale figures or clustered buildings. These literal signs of man's residence verge on the redundant, so strongly is the human presence sensed in the domesticated terrain. Man's will reigns supreme in the docile farm land, where no natural disasters, weather, or even atmosphere dare disturb the pristine, geometricized order of field rows, pastures, trees, and roads. The generous curves of enfolding hills and the quiltlike cover of lush vegetation evince a beneficent Nature ensuring its human custodians an eternity of bumper crops. A curious dreamland reality descends upon nature, silencing the thunder and fury of natural forces lauded by the Southern Agrarians and by Curry, yet retaining a closer contact with reality than Benton's art-historical artifice of nature.

In Benton's pictorial adventures nature and its elements contribute little more than extra compositional energy. Though he resumed representational painting after experimenting with nonfigurative abstraction and eventually assimilated landscape elements into his major works, he denied nature a leading role in the process. "To see nature is never in any sense of the word to construct a picture," he wrote.[33] Rather than relying on studies from nature or immediate perceptions of reality, he would draw "people and landscapes, even fruits and flowers, much like sculptural carvings" from a preliminary relief model of clay.[34] No textural distinction between clouds and smoke, trees and rocks, detract from their "flow" as abstract compositional devices (Figure 157). Theoretically a given form would evolve, independent of nature, as a "function" of the subject matter, guided by the artist's will imposed upon raw experience. Thus Benton's form and its constructive elements of line, color, and plane never derive directly or spontaneously from nature but from a conscious analytical act in which they are abstracted, controlled, and isolated in their order of importance to the composition. The artist constructs "this new thing" with no parallel in nature: "It is experience and emotion which have by accumulation formed the temper of his mind."[35]

168

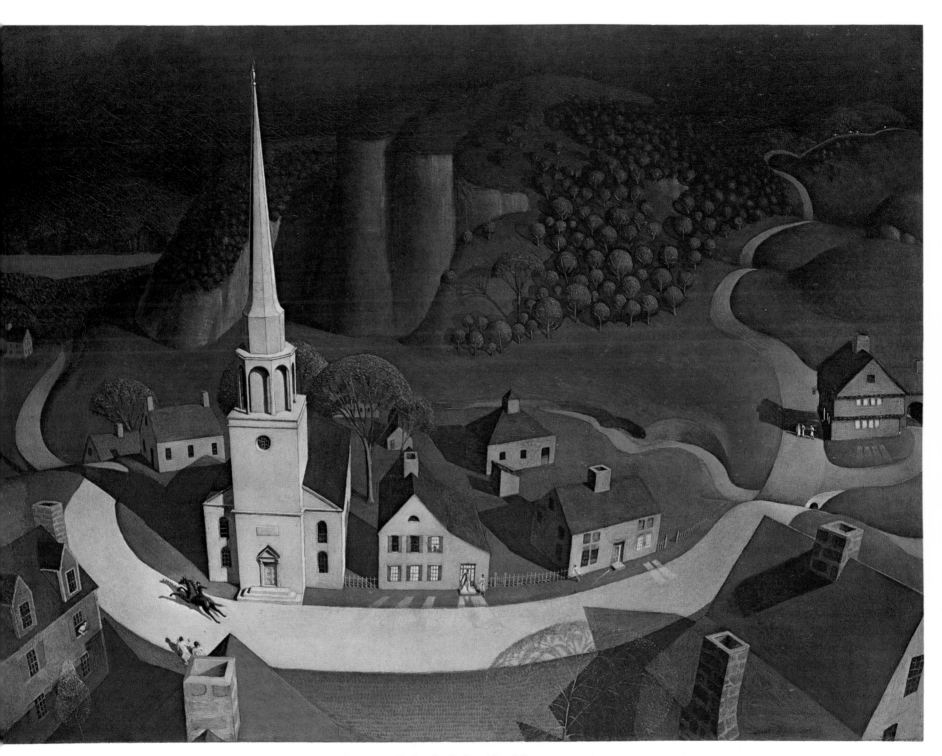

Plate 14. *Midnight Ride of Paul Revere,* 1931.
Oil on composition board, 30″ × 40″.

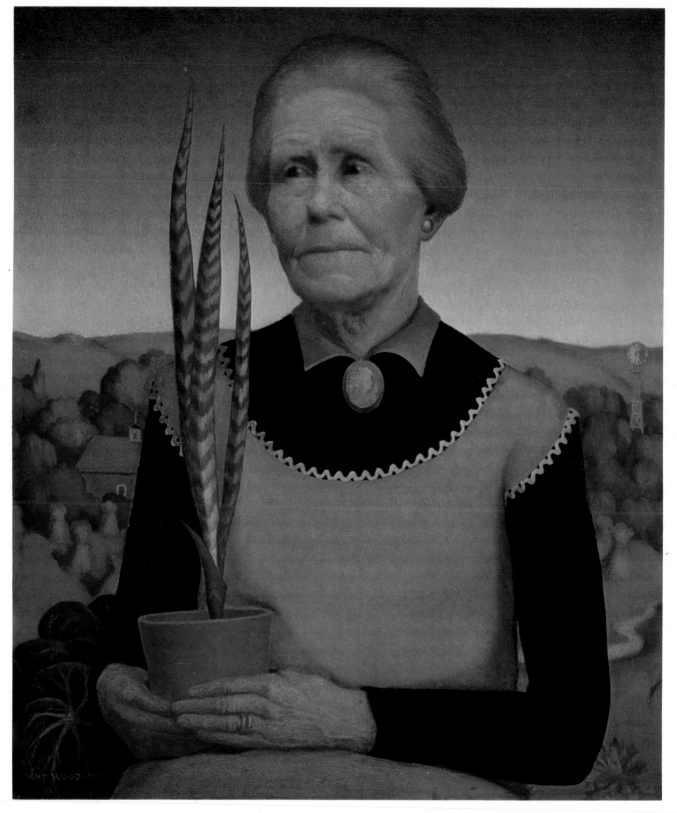

Plate 15. *Woman with Plants,* 1929.
Oil on composition board, 20½″ × 18″.

170

Plate 16. *American Gothic.*
Oil on composition board, 30″ × 25″.

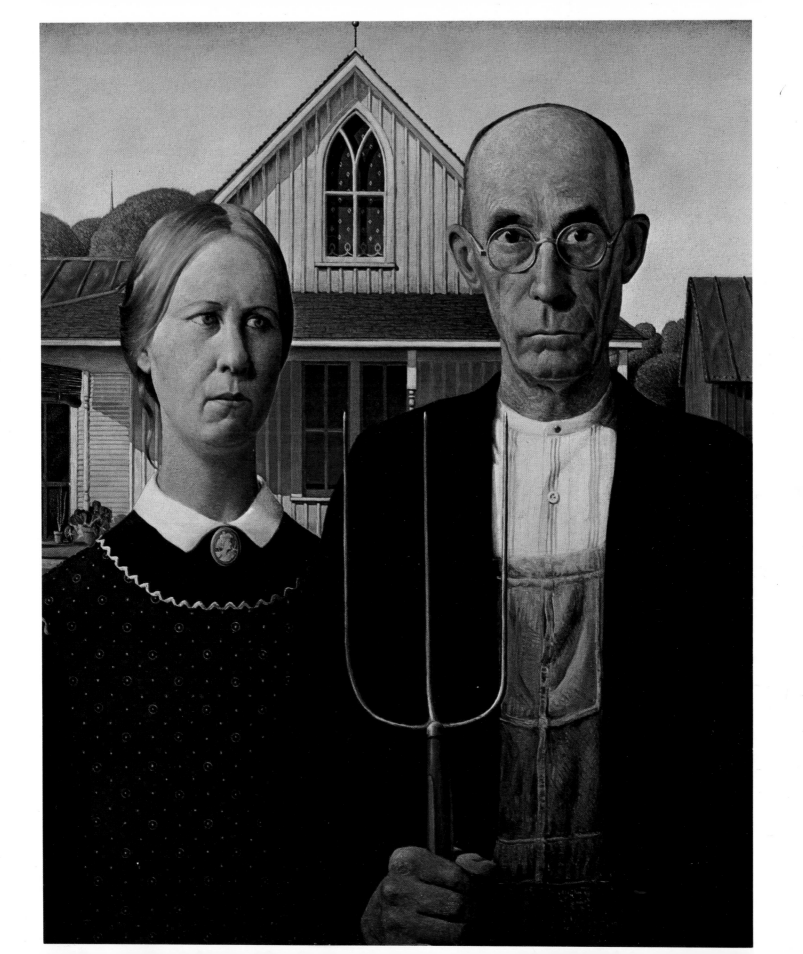

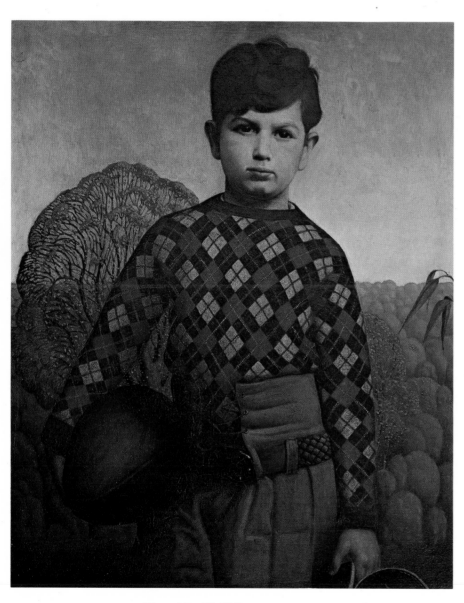

Plate 17. *Plaid Sweater,* 1931.
Oil on composition board, 30″ × 25″.

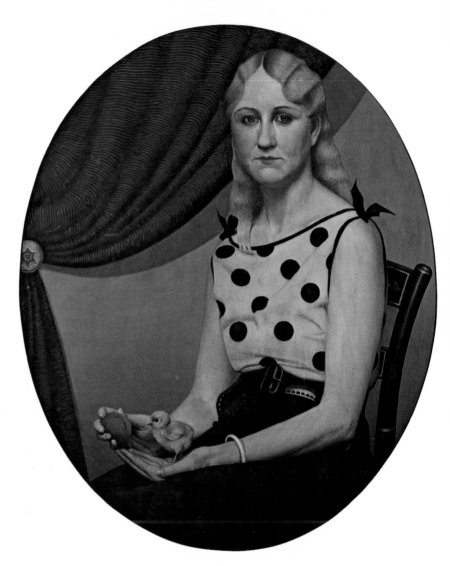

Plate 18. *Portrait of Nan,* 1933.
Oil on masonite board, 40″ × 30″.

Plate 19. *The Birthplace of Herbert Hoover,* 1931.
Oil on composition board, 30″ × 40″.

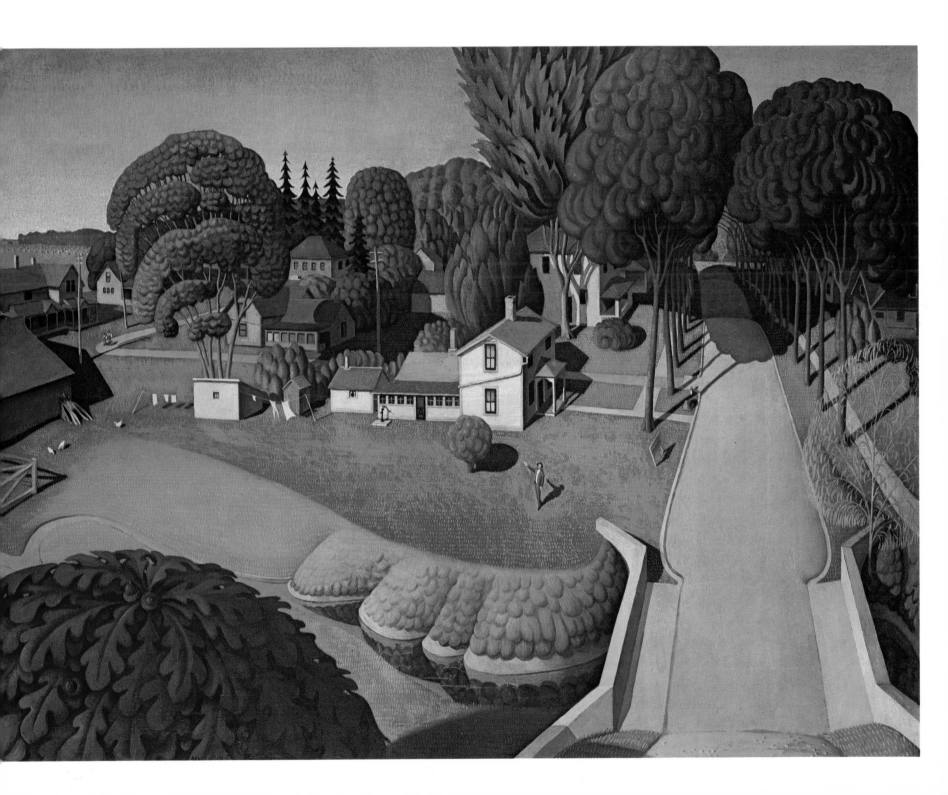

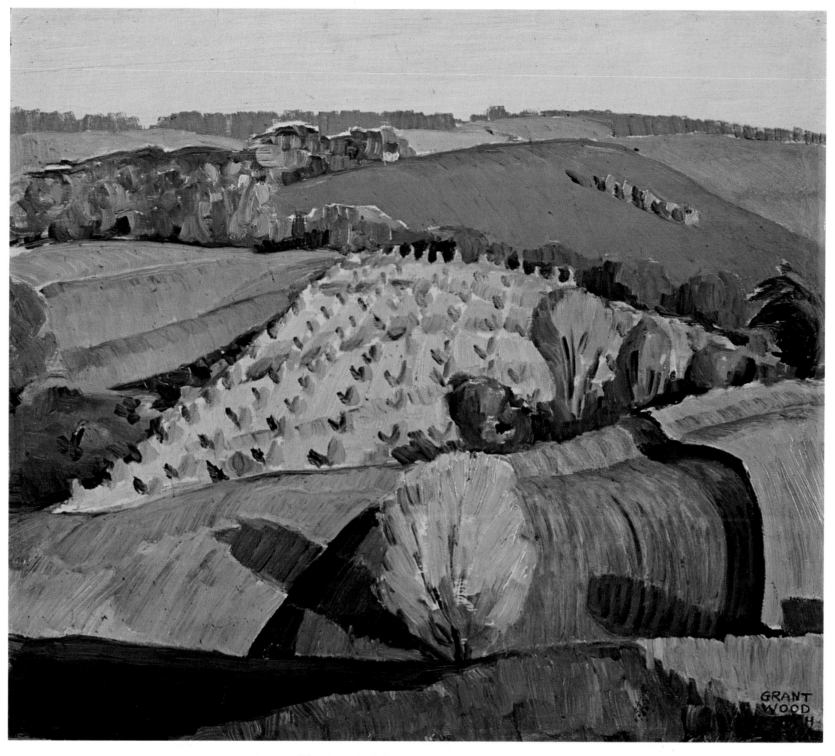

Plate 20. *Fall Plowing* (sketch), 1931.
Oil on composition board, 13″ × 15″.

Plate 21. *Fall Plowing*, 1931.
Oil on canvas, 30″ × 40¾″.

174

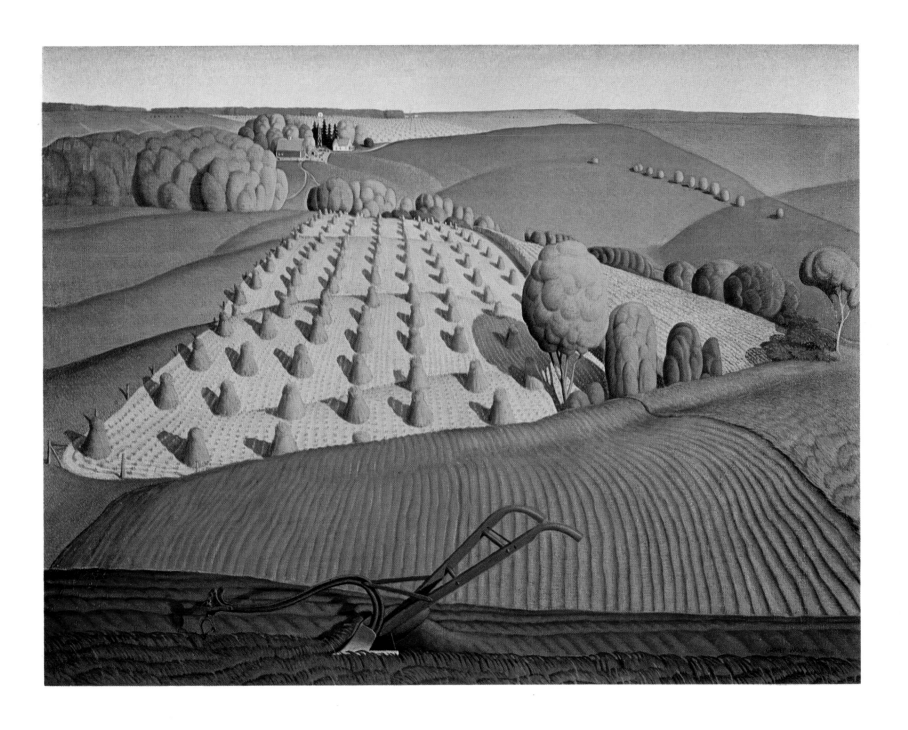

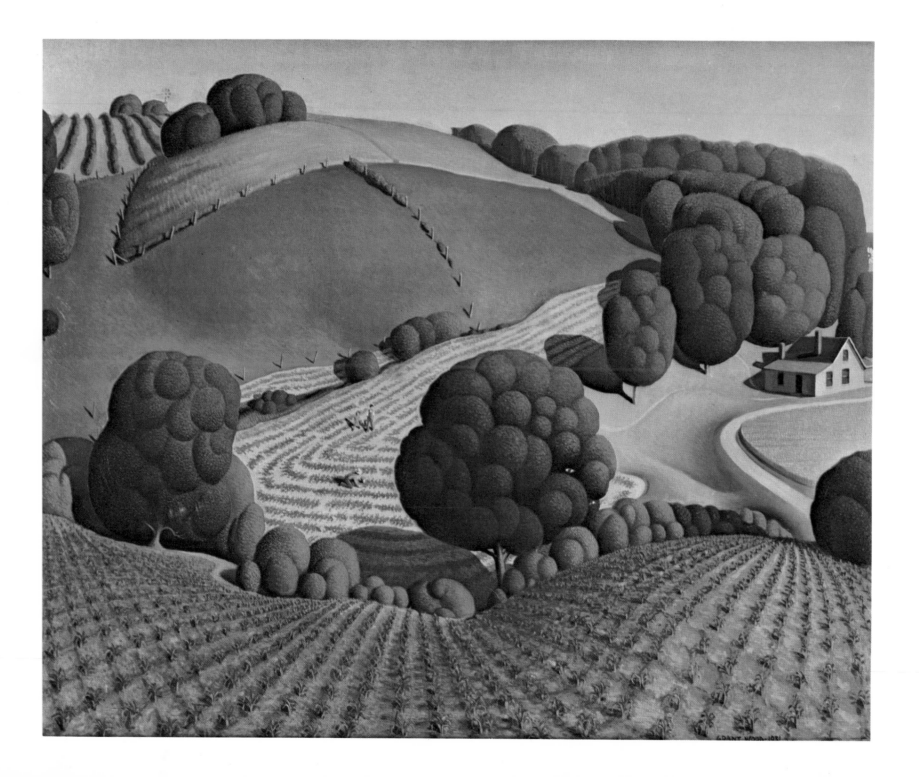

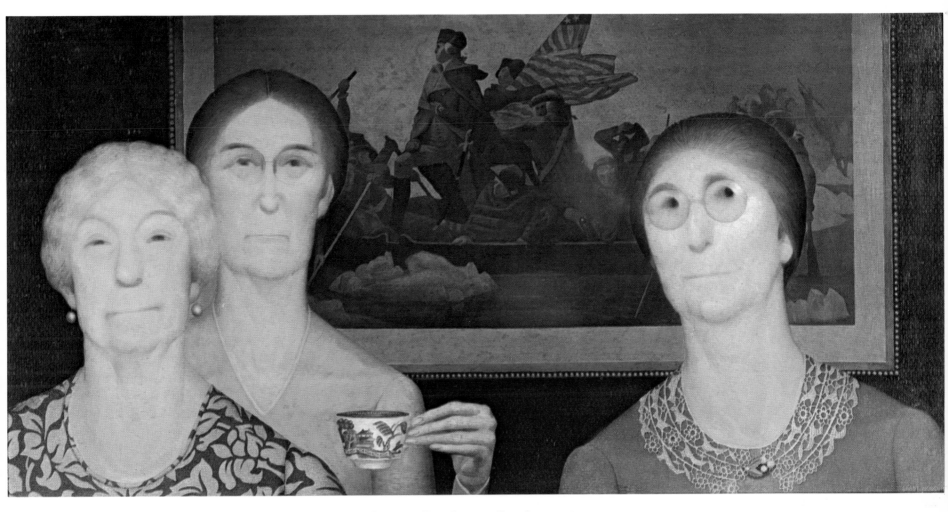

Plate 23. *Daughters of Revolution,* 1932.
Oil on masonite panel, 20″ × 40″.

Plate 22. *Young Corn,* 1931.
Oil on composition board, 24⅛″ × 30″.

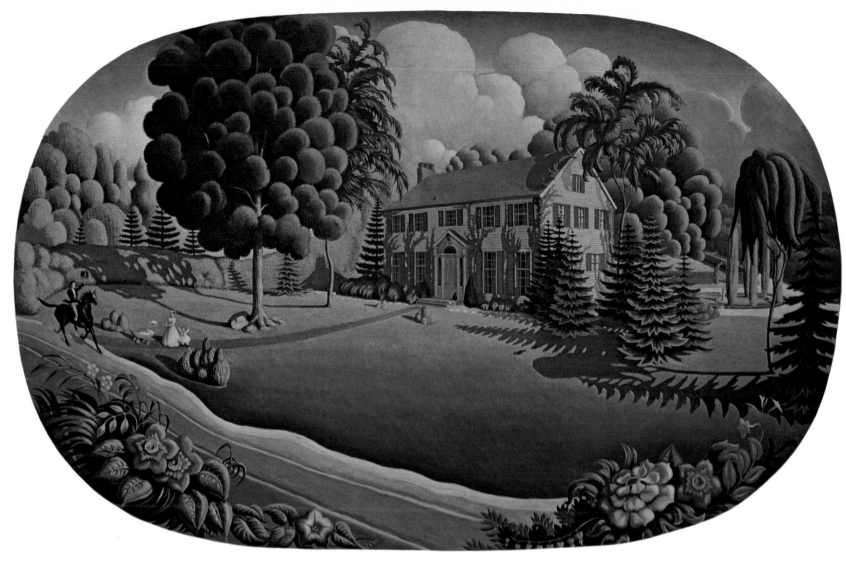

Plate 24. *Overmantel Painting,* 1930.
Oil on composition board, 42″ × 65″ (oval).

Plate 25. *Arbor Day,* 1932.
Oil on masonite panel, 25″ × 30″.

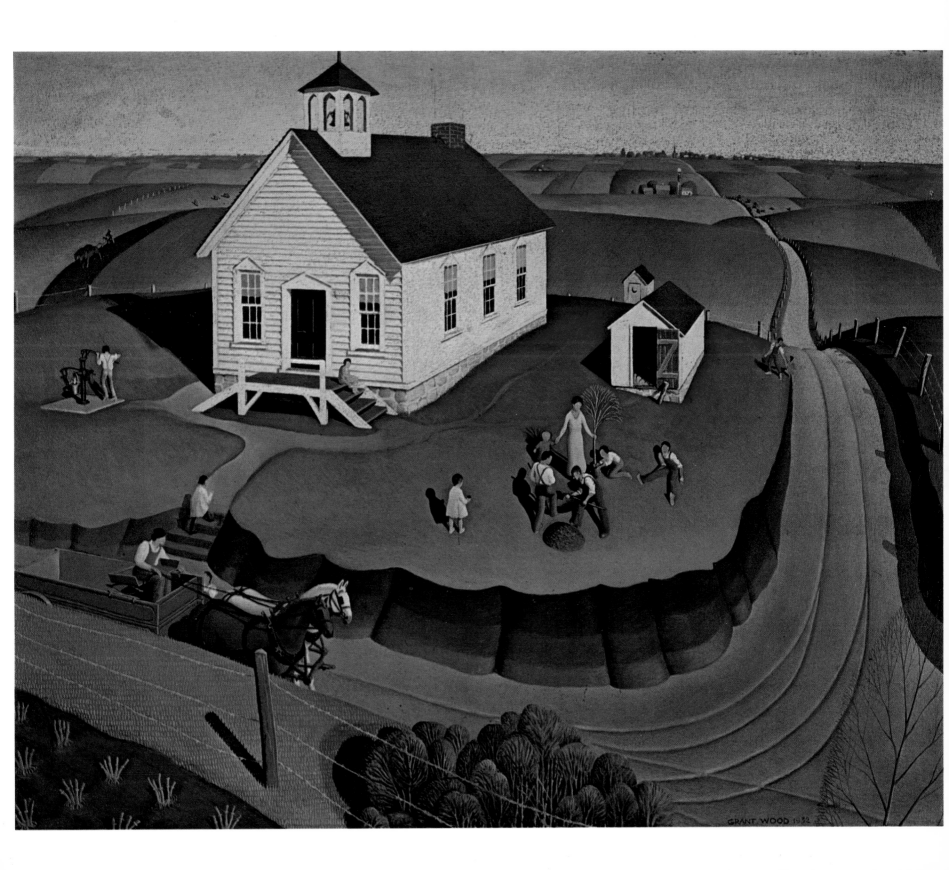

GRANT WOOD 1932

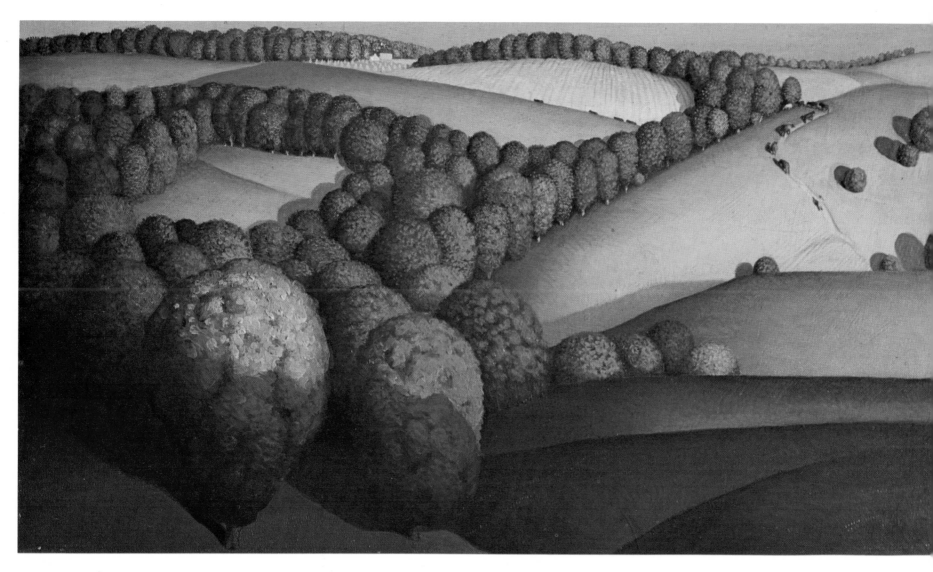

Plate 26. *Near Sundown*, 1933.
Oil on masonite panel, 15″ × 26½″.

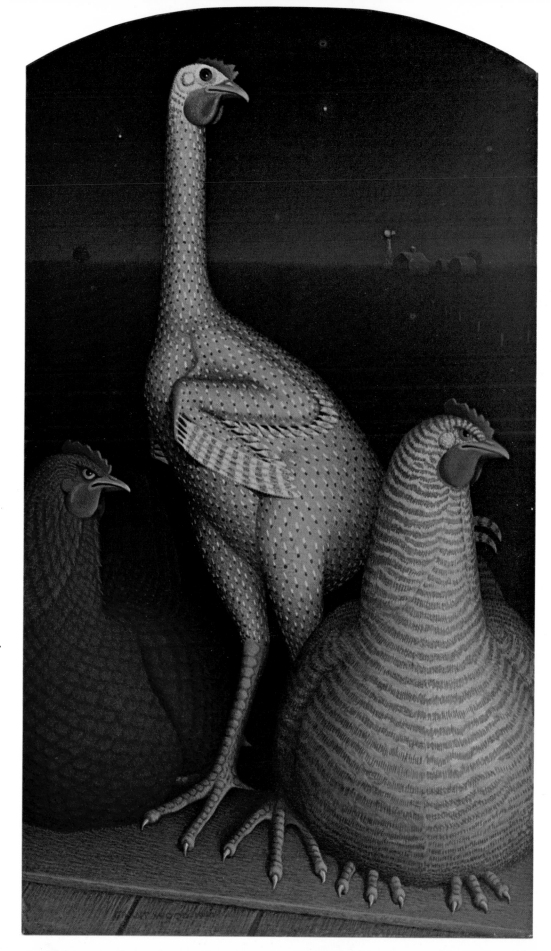

Plate 27. *Adolescence*, 1933–1940.
Oil on masonite panel, 20⅜″ × 11¾″.

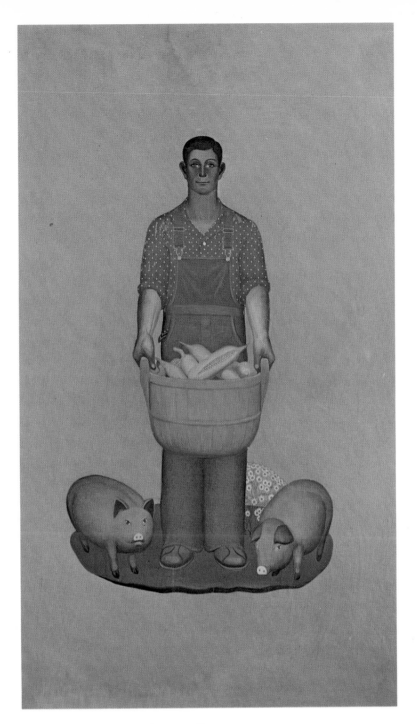

28. *Farmer.*

Plates 28–31. *Fruits of Iowa,* 1932.
Oil on canvas glued to panels, 4 feet high.
Originally in Montrose Hotel Dining Room,
now in Coe College Library, Cedar Rapids, Iowa.

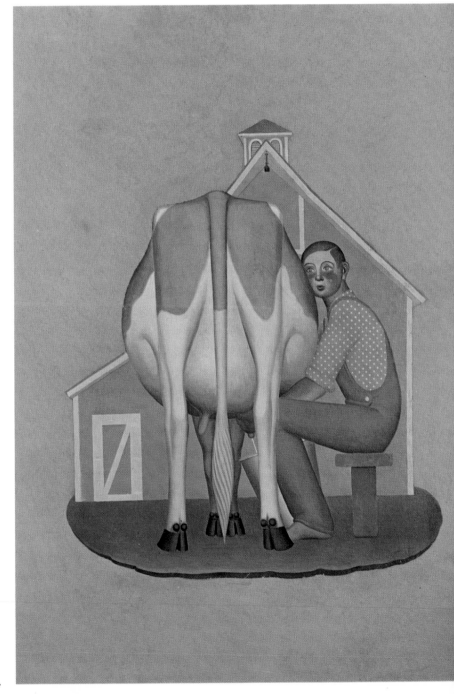

29. *Boy Milking Cow.*

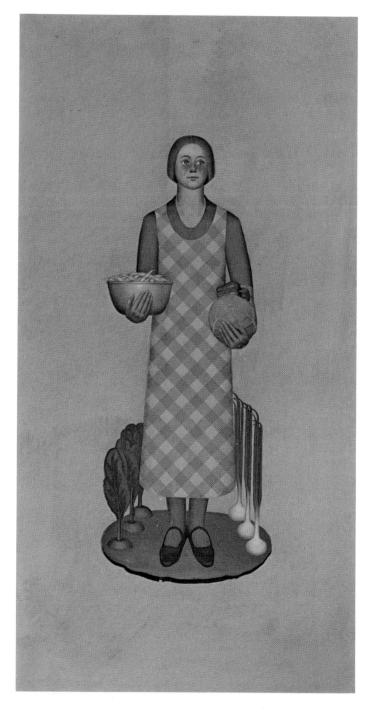

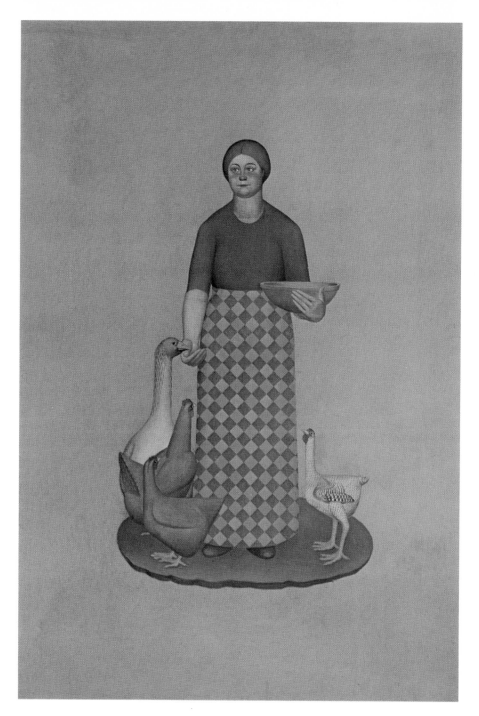

31. *Farmer's Wife with Chickens.*

30. *Farmer's Daughter.*

183

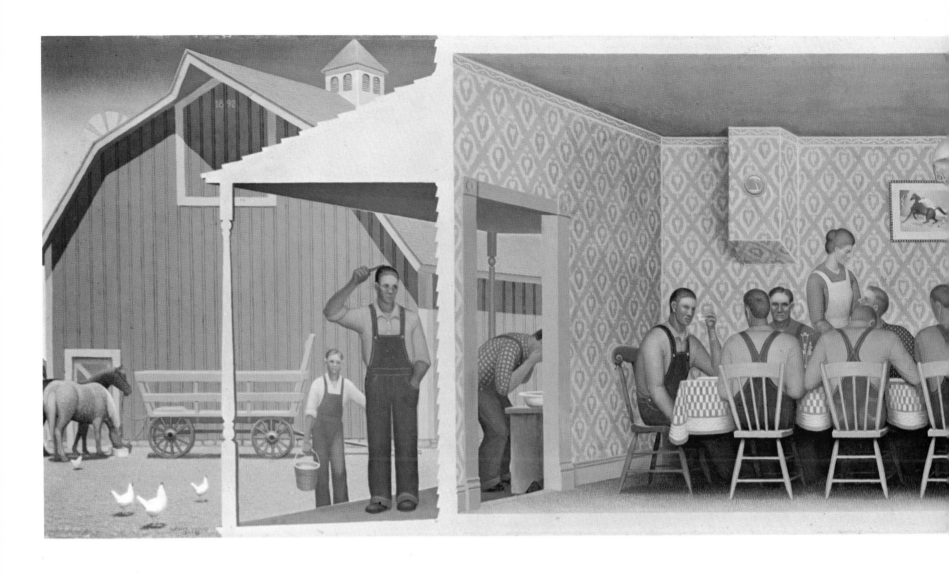

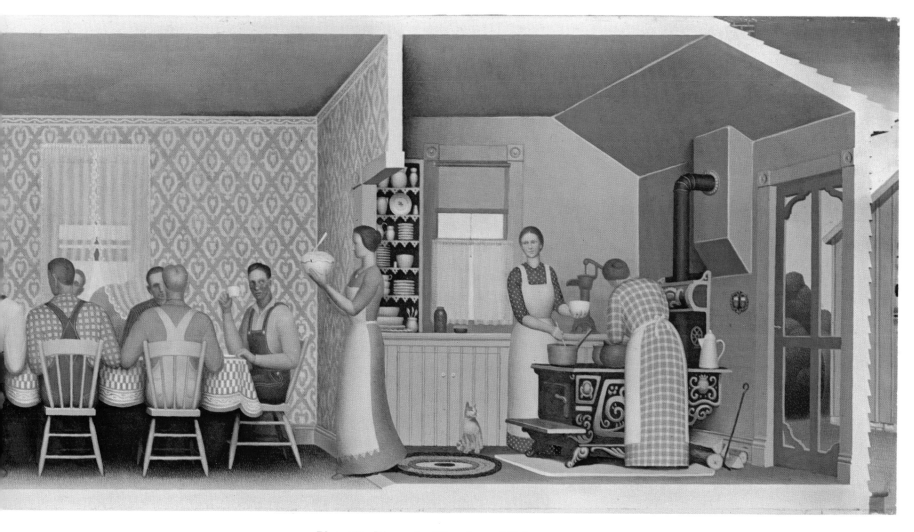

Plate 32. *Dinner for Threshers,* 1934.
Oil on masonite panel, 20″ × 80″.

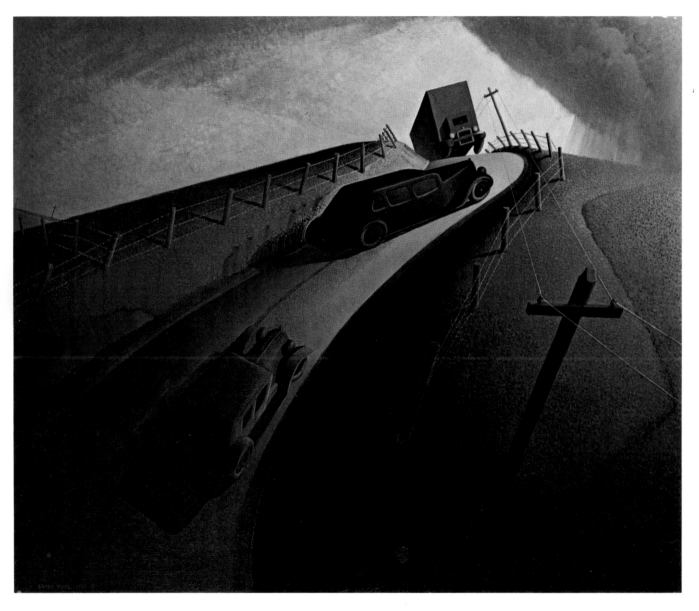

Plate 33. *Death on the Ridge Road*, 1934.
Oil on masonite panel, 32″ × 39″.

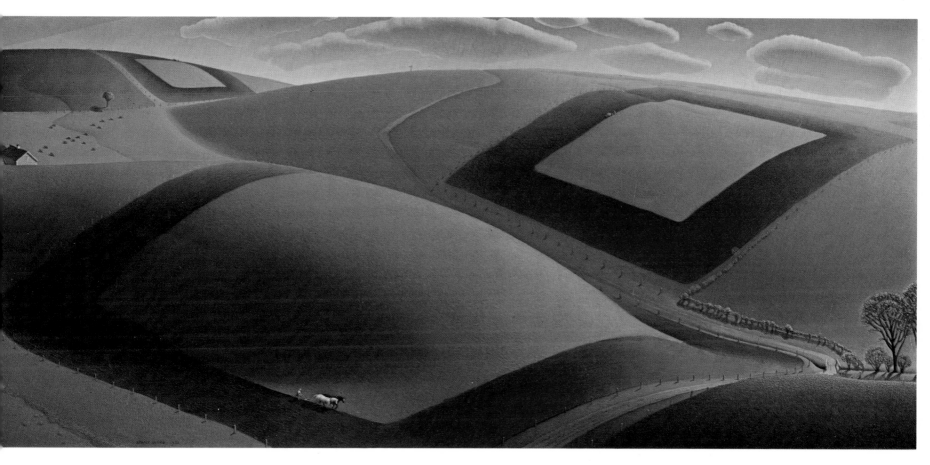

Plate 34. *Spring Turning*, 1936.
Oil on masonite panel, 18⅛″ × 40″.

Plate 35. *Haying*, 1939.
Oil on masonite panel, 14⅞″ × 16¾″.

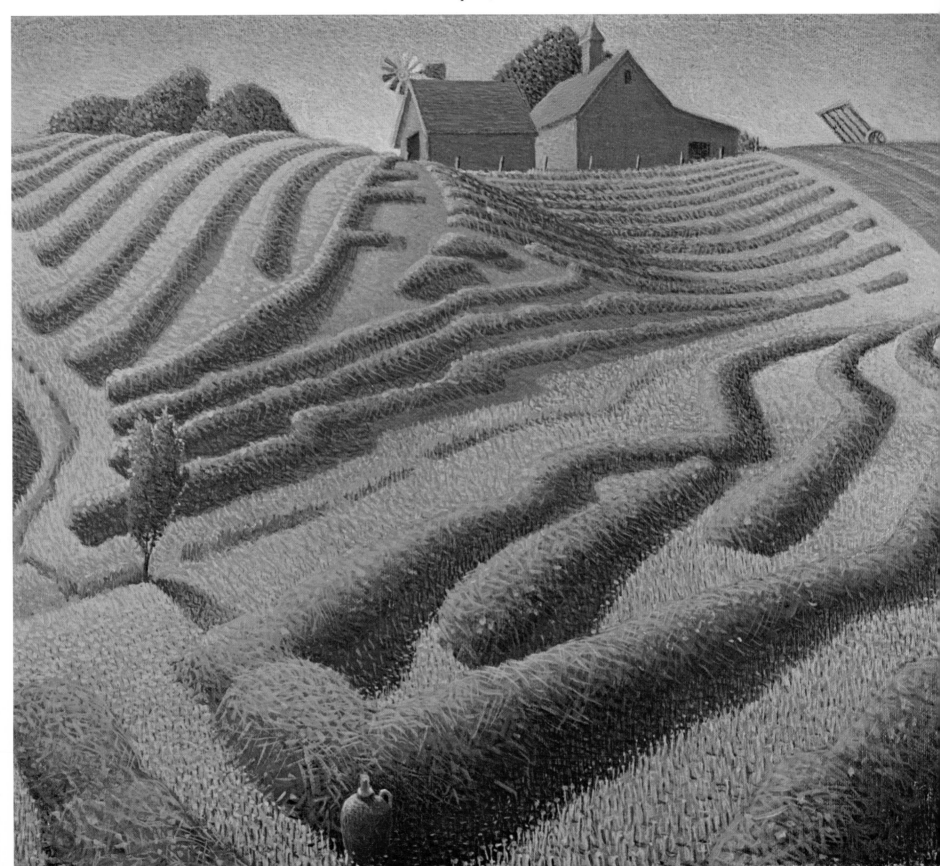

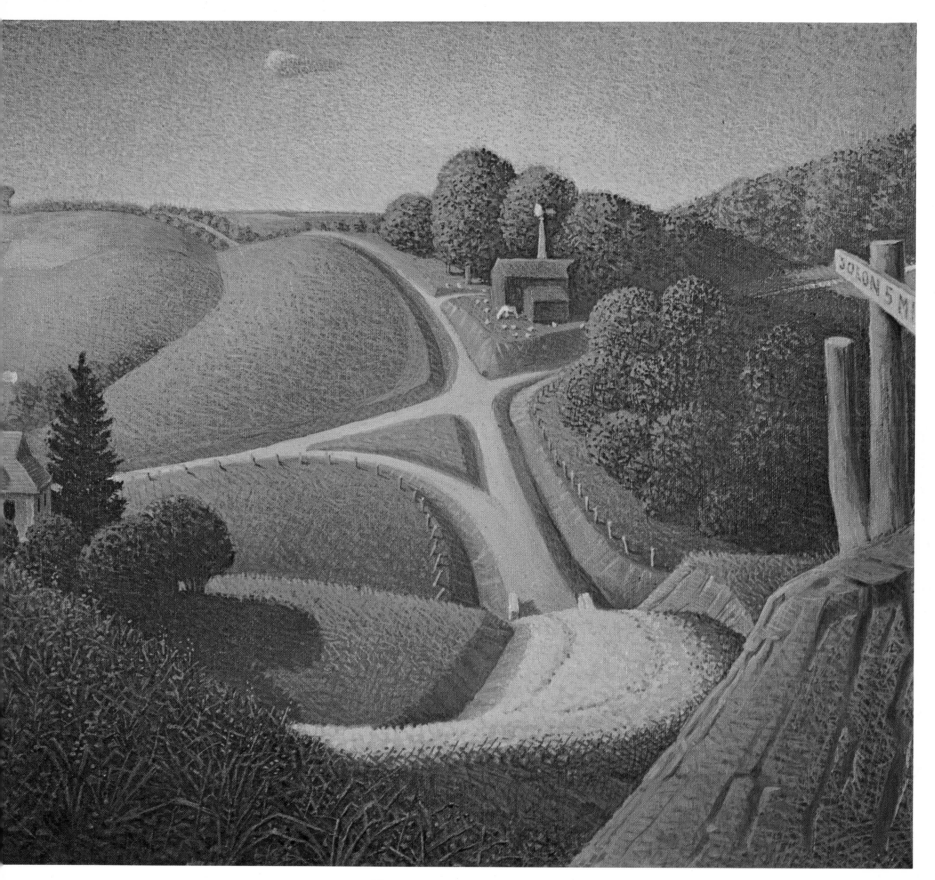

Plate 36. *New Road*, 1939.
Oil on masonite panel, 15″ × 16⅞″.

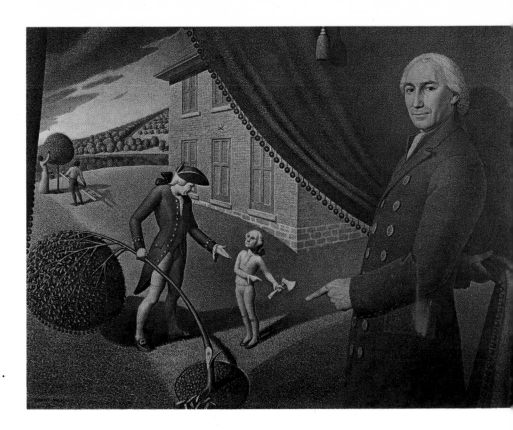

Plate 37. *Parson Weems' Fable* (cartoon).
Charcoal, pencil, and chalk on paper,
38⅜″ × 50″.

Plate 38. *January*, 1940.
Oil on masonite panel, 18″ × 24″.

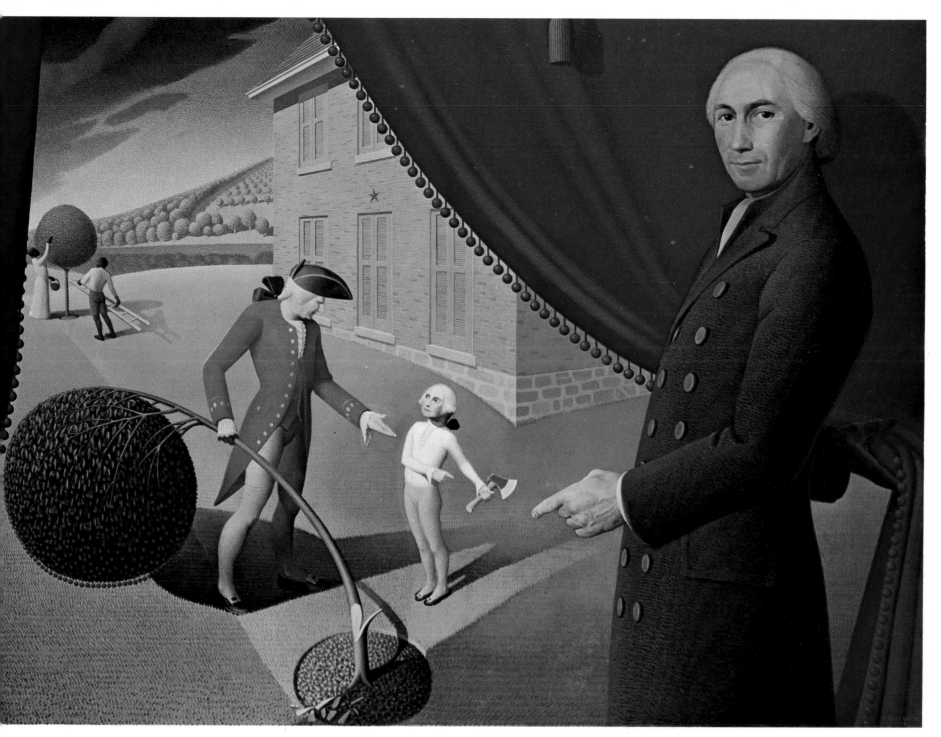

Plate 39. *Parson Weems' Fable*, 1939.
Oil on masonite panel, 38⅜″ × 50⅛″.

# 9. Art Theory for Rural Regionalism

The Southern Agrarian writers and the regionalist painters believed, in spite of their differences, that the literary and pictorial arts should be statements of an intimate attachment to a particular area. The arts were to be inspired from the same natural sense of life that had produced rural society. If the artist responded intuitively to his native ground, he would avoid the temptation either to produce self-conscious social criticism or to exploit the popular taste for anecdotal "local color." Thomas Hart Benton and Grant Wood, however, escaped neither of these consistently, Benton pursuing an exploitative variation on regionalism and Wood permitting himself both critical comment in his subject matter and national implication in his regional orientation.

In the opinion of the Southern Agrarians, an artist's deep involvement with his region should not embroil him in the area's social and economic problems. An aesthetic aloofness from "problems," the Agrarians argued, would encourage the artist to represent concrete experience and in so doing reach a universal level of meaning. Their dismissal of liberal "projects of reform" as the responsibility of artists further demonstrated their unswerving commitment to the act of art as a spontaneous insight into home-grown subjects. The reformer, in writing a propaganda novel or painting a political picture, burdened himself with sociological facts. His art served as "the agent of the social conception out of which it grows."[1] His mind overloaded itself with a system of abstractions and preconceived notions that precluded any intimate involvement with a subject. A proper regionalism, according to Allen Tate, permitted the artist "an honest inner response to an inherited environment that he regards traditionally, accepting it for what it is." Tradition as a creative means should function unimpaired by ulterior social motives and should triumph as "the knowledge of life that we have not had to learn for ourselves, but have absorbed out of the life around us."[2]

Consequently, the regionalist artist's responses to life around him were to be habitual, instinctive, and free of moral judgments or reformist impulses. He must also eschew any deliberate efforts to "express" a region or to search methodically for local color, as Robert Penn Warren advised in a 1936 summary checklist for writers desiring to practice a genuine form of regionalism. Entitled "Some Don'ts for Literary Regionalists," his advice is set forth in six maxims, the first of which emphasizes the tendency of local color or folklore to become sentimental or even snobbish, especially when such easily gathered material limited itself to quaintness. "Touristic regionalism," such as that practiced by a white artist enamored with Indian culture, must be avoided; true regionalism should entail only a familiar native locale and culture, and thus the artistic exploitation of a strange or exotic society has no place. As for the methods, purposes, and appreciation of regionalism, Warren saw an intimate connection between familiarity with a locale and universality of meaning. Regionalism, he insisted, was not provincialism; therefore, an artist should not be expected to relinquish any form of expression that he had acquired beforehand in developing his style.[3]

The Southern Agrarian rule of thumb for the regionalist artist —to maintain an objective distance from social and economic problems and to shun ideology and liberal reform in responding to the life of his locale—provided a convenient declaration of principle for Benton upon his return to Missouri in 1935. The Depression had reached its lowest ebb during his last months of work on the multi-paneled *Arts of Life* mural cycle for the Whitney Museum library in the fall of 1932. By that time Benton had not only become disheartened by parvenu exploitation, which was his sole explanation for the economic collapse, but also increasingly disillusioned with the urban East in general. The themes of cosmopolitan culture, highbrow intellectualism, class conflict, crime, and degeneracy fill the large three-part section called "Arts of the City." Even the machine itself

becomes a mockery of rapid transportation in the panel that incongruously combines death from starvation, violent protest, and a reckless driver behind the wheel of a speeding automobile. "Political Business and Intellectual Ballyhoo" (Figure 158) caps this series of murals with an unconditional negation of reform. Benton here symbolized political corruption with a spread eagle perched upon a megaphone. In the foreground three caricature figures of the liberal journals *The New Republic* and *The Nation* and the radical paper *New Masses* constitute a vicious ridicule of reform whatever its political complexion. These figures spout rhetorical fragments that register Benton's cynicism toward progressivism, Marxism, and all other formalized ideologies.[4] In the years to come, though vacillating among contradictions of theory, intention, and practice, Kansas City's prodigal painter would continue to claim an objective mind free, he said, of rigid political viewpoints or moral convictions.[5]

More consistent with the regionalist concept of total objectivity and open-mindedness to the conditions of a given time and place was John Steuart Curry's tolerance of any political or partisan pictures so long as they resulted from direct personal experience. In a brief essay of 1935 entitled "What Should the American Paint" he endorsed American-Scene subject matter in general and followed with friendly advice for the "propaganda" painter: "We are glorifying landscapes, elevated stations, subways, butcher shops, 14th Street, midwestern farmers, and we are one and all painting out of the fullness of our life and experience." The artist, in order to be part of his civilization, never paints mere facts, and he avoids stereotypes, stock mannerisms, and symbols. Radical painters, such as those associated with the John Reed Club, were particularly guilty of having indulged in the latter and violating the directive of direct experience.[6]

In the eyes of the Agrarians, an artist's instinctive responses to a native environment were likely to weaken under increased cosmopolitanism, and after three decades of intermittent travel and city living Benton had been carried by his objectivity and his aesthetic detachment far afield from a local life rooted in local tradition. At the same time, characteristics of what Robert Penn Warren termed "touristic regionalism" had multiplied in Benton's paintings from the moment he planned his first murals. Since the early 1920s main streets, highways, and back roads had led him through a nationwide miscellany of subject matter, from which he selected "a conglomerate of things"[7] calculated to show "the energy, rush, and confusion of American life."[8] Contradicting regionalist principles, Benton

rationalized the crowded condition of his murals as symptomatic of his insatiable interest in the nation as a whole: "I would like to enclose it all. The mural can carry more aspects within itself than any small painting. It can therefore be more expressive of society, of the panorama."[9]

His family background in American political history and his personal excursions throughout the country, he boasted, gave him license to lay claim on the entire land as his region of artistic exploration. In lieu of familiar aspects of daily existence within a particular locale, or of events immediately observed and drawn upon from memory, Benton favored remnants of the legendary past. As a result, his outworn fantasies of a largely make-believe frontier culture transformed popular dime-novel images and stereotype characters into progressively overrefined figure forms. Beginning in the early 1920s with a *History of America*, which he painted in "chapters" of five large paintings each, and culminating forty years later in the Truman Library mural *Independence and the Opening of the West*, Indians and settlers coexist in Benton's imagination with stylized cotton pickers, a variety of threshers, rural adaptations of ancient erotica, and folksong illustrations. Benton's life work increasingly descends to a repetitive display of chauvinism which the Southern Agrarian critic Donald Davidson termed "picnic regionalism" and denounced as "a simplified and condescending urban idea of regional culture."[10] In view of Benton's preference for the dramatic subject matter of a turbulent "frontier" society being transformed into an urbanized nation, his regionalist statements ring falsely of rhetoric, especially when he defined art as a local phenomenon: "the mirror held up to life, capable of being emotionally participated in by the locality."[11]

But Benton was not alone in this superficial interpretation of regionalism. The federally sponsored art projects initiated by the first artists'-relief measure of 1933–1934 were also urged to seek out national identity among assorted regional phenomena—contemporaneous, historical, or legendary. As district director of the Public Works of Art Project in Iowa, Grant Wood relayed these government specifications from the regional chairman in St. Louis to his local fellow participants. In order to earn their $26.50 a week, artists were above all to concern themselves with "the contemporaneous American scene," while "experiments in abstractions" and "transcripts of still life" lay outside official expectations. Beyond this, few standards were formulated: "any type of landscape, urban or rural; any industrial activity, in the field or in the factory; or any

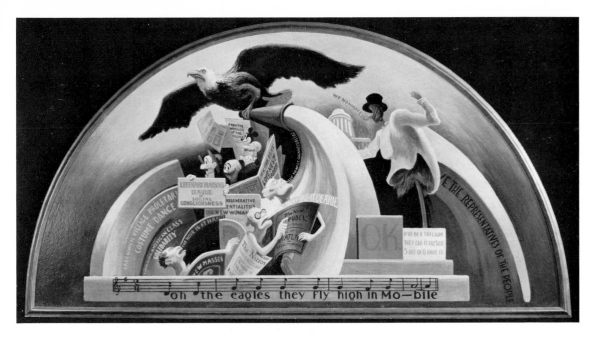

158. Thomas Hart Benton: *Political Business and Intellectual Ballyhoo,* 1932. Tempera and oil glaze, 56½″ × 9′5″.

interpretive work having social significance" would enjoy government sanction.[12] Mural projects carried out by urban painters traveling under the auspices of the Treasury Department Section of Fine Arts or the Federal Art Project of the WPA thus distributed anecdotes of economic expansion, pioneer settlement, Indian life, urban construction, and heroic legends on walls throughout the country (Figure 159). In doing so these artists too ran counter to the regionalist premise of recording a living experience witnessed in one's native region.[13]

Second only to foreign-born abstraction, official government-sponsored touristic regionalism, most often labeled "American Scene," so offended Grant Wood's regionalist theories that he willingly risked the accusation of "cultural nationalism" to propose a regionalist program on a national scale. This departure from the Southern Agrarian prohibition on all practical responsibility, especially on progressive reformist actions, resulted in the establishment of Wood's short-lived art colony and school. The Stone City endeavor was predicated on a hoped-for alliance among regionalist art schools in various parts of the country. Wood's brochure for the summer of 1933 outlining the aims of the colony amounted to a manifesto. Its cardinal purpose was to contribute to an American art of national expression from a regional—an explicitly designated Midwestern—point of view. Under the direction of Wood and a fellow painter, Adrian Dornbush, the colony welcomed "all midwestern painters" to work together "toward the development of an indigenous expression." American art, in order to ascend to the stature of a "true cultural expression," could not remain "a mere reflection of foreign painting." Nor should it succumb to an artistic

elite, languishing in either "a few tourist-ridden localities or metropolitan centers":

It must take group form from the more genuine and less spectacular regions.

It is our belief that a true art expression must grow up from the environment itself. Then an American art will arrive through the fusion of various regional expressions based on a thorough analysis of what is significant to these regions.[14]

Foreign painting, that is, twentieth-century European painting, suffered, in the colony's opinion, either from technique-dominated, antiquated academicism, from expressionistic distortion, or from nonfigurative abstraction, any of which worked against a dedicated, place-oriented, democratic ideal of picture-making.[15] And other regions of the United States, such as Taos, Cape Cod, and the northern Rockies, suffered at the hands of touristic American traditionalists who turned spectacular scenery into pretty pictures devoid of meaningful content.[16] In theory, a regionalist expression should convey an insight into the life of a given locality and communicate it clearly and unequivocally to the people who live it. Abstractions, whether in content or form, ran counter to popular understanding and held no appeal for local identification. They had no place in a school dedicated to interpretations of a region, especially when the school intended to combine its regional output with that of other regions to produce a composite national art of interregional subject matter and styles.

In order to implement this potentially sophisticated scheme, Grant Wood proposed a network of art centers and annual exhibitions which would correspond in structure to the progressive regionalism advocated by the non-Agrarian regionalist, Southern sociologist Howard W. Odum of Chapel Hill. Odum, a New South realist, opposed reactionary attempts to restore preindustrial farming, Old South culture, and a social structure determined by classes and geographic sections; and he embraced urbanization, science, and industrialization as a means of reversing the "backwardness" in economically distressed areas. What is more, he believed that the federal government, in the spirit of President Roosevelt's New Deal planning programs, could assist various regional developments to avoid sectional "inbreeding" and could serve as bases for "line-breeding," a nationwide cooperative process of cultural maturation. Wayward individualism, which he identified with Southern Agrarian sectionalism, could only provoke coercive centrism, while a cooperative harmony of regionalism would benefit the country at large in accord with its ideals of democracy.[17] On a less ambitious scale than Odum's, Wood's specialized program sought to utilize regional possibilities at a national level to create an indigenous art expression whose quality was compromised neither by the provincial nor by the foreign derivative. A flexible but homogeneous American art identity, rendered impossible by reactionary, inbred sectionalism, could thrive and prosper through organized cultivation of regional distinctions. Wood's basic ideas for a reformed regionalist movement reached their full expression in 1935 when he wrote:

> Each section has a personality of its own, in physiography, industry, psychology. Thinking painters and writers who have passed their formative years in these regions, will, by care-taking analysis, work out and interpret in their productions those varying personalities. When the different regions develop characteristics of their own, they will come into competition with each other; and out of this competition a rich American culture will grow.[18]

Within this national superstructure Wood's artist would function in much the same capacity as described by the Southern Agrarians. The duty of this native artist who had lived his formative, impressionable years in a given locale was to interpret the personality of the region. Stated aphoristically, this fundamental requirement demanded "the sincere use of native material by the artist who has command of it."[19] Wood's formulation of rural regionalism

reserved "the farm and village matter" of a region for those home-grown painters who could demonstrate their complete apprehension and understanding of the subject.[20] In short, Wood posted the area against any trespassing from Warren's *bêtes noires*—the "touristic regionalists" and the big-city picnickers. To Eastern artists, some of whom he had met during a trip to New York City in the autumn of 1934, Grant Wood sounded a special warning. None were to visit the Middle West for the express purpose of mining "the rich funds of creative material which this region holds."[21] Such a procedure would be as "false" as the old one of traveling to Europe in search of subject matter or as the fashionable forays to New England fishing villages, Mexican cities, or the mountains of the Southwest for material. In true regionalist spirit he wrote: "I feel that whatever virtue this new movement has lies in the necessity the painter (and the writer, too) is under, to use material which is really a part of himself."[22] Because regionalism was constantly endangered by false cultism, even its own artists must beware of employing Midwestern materials as faddish interludes, as outsiders were prone to do. What could be worse, Wood asked a *New York Herald Tribune* reporter in early 1936, than to have artists "who did fake Impressionist pictures in Paris a few years ago now busy with the American scene"?[23] He referred to that caravan of estranged, rootless artists on the trail of the most fashionable, most marketable style of the season. He excluded from the caravan, of course, his own self-aggrandizing *Return from Bohemia*, which saw him home safe in Iowa, secure from the passing temptations of France.

Other threats to Wood's contemplated movement of locally based but nationally endemic art lurked close at hand in the form of local-color painting and sentimentality, so he granted the "true regionalist" free rein to paint as "a severe critic" in order that he might avoid ending up "a mere eulogist."[24] Anyone painting "typical" surface impressions of an arbitrary geographical or governmental location, for instance a particular state in the union, would miss the regionalist mark and further American provincialism.[25] Sentimentality, a lingering ailment to which Southern Agrarian nostalgia for the Cotton Kingdom allowed no ready immunity, apparently did not afflict Grant Wood. In a letter to Cyril Clemens of the Mark Twain Society Wood credited the wit and humor of Tom Sawyer and Huckleberry Finn with curing him of emotional excesses at an early age. Particularly remedial was Twain's satire of popular nineteenth-century bathos as expressed in Huck's skeptical evaluation of the saccharine "crayons" by Emmeline Grangerford, one of which depicted a distressed maiden preparing to leap from a bridge. Having provided the figure with three pairs of arms, the

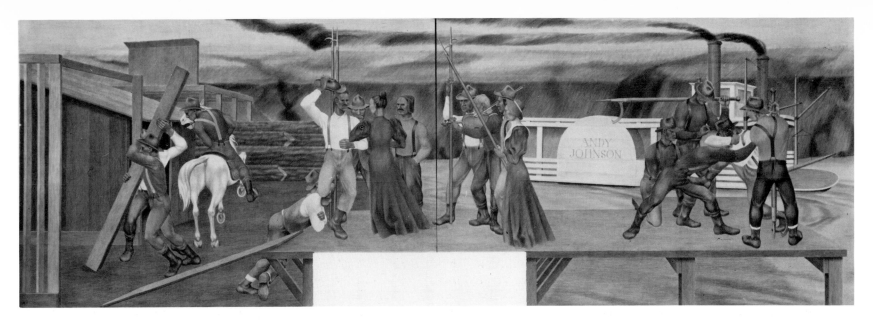

159. James Watrous: *Lumberjacks Returning to Grand Rapids on a Mississippi River Packet Boat and the Building of the Town of Grand Rapids*, 1939–1941.
Egg tempera mural on panels, 7' × 20'.

young artist herself had died before choosing which would be the most dramatic. With regard to the permanent effect this scene had on his taste, the Iowa artist commented:

> As I look back on it now, I realize that my response to this passage was a revelation. Having been born into a world of Victorian standards, I had accepted and admired the ornate, the lugubrious and the excessively sentimental naturally and without question. And this was my first intimation that there was something ridiculous about sentimentality.[26]

In a speech given at the American Federation of Arts Wood dismissed "Modernism" as a "clearing-away period" and cautioned against the subsequent tendency toward superficial "story-telling pictures." The general public, bored with abstractions and theories, would favor the simplistic illustration and, if it had its way, lead painting back to the anecdotal pictures *Yard of Puppies* and *The Spirit of '76*.[27] This sort of taste for illustration would severely hinder the development of a native art of historical significance. The antidote to such detail-laden pictorial sentiments lay in the establishment of what Wood termed a convention of the decorative. By this he meant an adherence to well-crafted design over and above the capricious demands of subject matter or thematic purpose; the artist's maintenance of high standards of aesthetic excellence can withstand the whim of time or place and guarantee the work of art a lasting universality:

> The religious paintings of the Old Masters escaped being buckeyes because they were painted within limitations.

They are decorations first and story-telling pictures afterwards, and the story is in no wise weakened by the decorative qualities. The story of American life of this period can be told in a very realistic manner, employing sympathy, humor, irony or caustic criticism at the will of the painter, and yet have decorative qualities that will make it classify, not as an illustration, but as a work of fine art with the possibilities of living through the ages—if the decorative side is finely considered.[28]

Whatever his differences with the Vanderbilt writers, Grant Wood never strayed from the fundamental Southern Agrarian concept of regionalist art as an instinctive urge to express the state of mind produced by an intimate relationship with a rural home environment. He would have agreed that the artist, to attain regionalist content, would never set out deliberately to "express" a region or to search with antiquarian zeal for local color as a revelation of one's past. A self-conscious effort to discover tradition was destructive in that it thereby dislodged the tradition from its natural location in the social order of a community.[29] As for the artist's evaluation of local life, individual actions, and social behavior, Grant Wood blithely evaded the Southern Agrarian ultimatum demanding strict abstinence from commentary or criticism. To Wood, the painter enjoyed full editorial rights, as long as he proved intimately knowledgeable of his native subject matter. He should be under no obligation to assume wholesale attitudes and standards certified and prescribed by any particular custom or class, especially if in exploring his world his comic sense maintained a balanced mixture of sympathy and irony.

# IV

# The Painter of the Agrarian Myth

# 10. Social Background: The Noble Yeoman

From his early attempts at academic allegory, which culminated in the Memorial Window (Figure 68), to his later portraits, topographical views, and patriotic fables interpreted through whimsical satire, Grant Wood consistently strived for a universality of meaning as well as a distinctive style. This objective found its fullest realization through Wood's loyalty to the regionalist principle of interpreting his immediate environment and the life of its people. Out of his devoted depictions of surrounding farm land and farm life arose an idealistic vision of the landscape that poeticized an agrarian myth as no other American paintings had done before.

In the last few years of his life Wood produced a series of pictorial inventions of "farmer material" based on his extensive acquaintance with the rich farmland of Iowa. Wood transformed this region into a world of well-being, a metamorphosis of nature that gave no hint of the hardships of tilling the land, no sense of the arbitrary catastrophes of nature or the inconstancy of human institutions. This rural paradise is occupied by innocent farm folk, anonymous providers immunized from the harsh, impersonal realities of bad weather, pests, disease, fluctuating markets, and mortgages. In each of these works a sunlit environment of rolling fields bordered by clusters of plumed trees flows into a succession of gently tilting planes which fade into a distant horizon, leaving a narrow band of sky (Figure 160). From a position high above the landscape, the viewer peers down upon a foreground of sharply descending slopes and experiences a momentary sensation of sequestered security from occasional distant farm buildings, despite their isolation in the enormous expanse of land. There is no density of atmosphere to interfere with the crystal-clear visibility of the scene, every tree, windmill, and shock of corn detailed precisely against the distant sky.

No towns or villages appear in any of the farm-land pictures. No smokestacks protrude to reveal the presence of factories, acknowledged in the few industrial scenes of Cedar Rapids that Wood painted during the 1920s (Figures 161 and 162). No engine-driven machinery passes the plowman in the field. Miles of empty gravel roads meander in and out of the rolling countryside, vanishing behind low hills and reappearing to diminish gradually at a string's width over the horizon. The plodding horses mark a leisurely, peaceful tempo that seems to prolong their arrival at the end of a furrow or return to the house and barn beyond.

In pronounced contrast to such early landscapes as *Midsummer, Cowpath* (Figure 24) and *Cornshocks* (Figure 19) or to the various storm-ridden farm scenes of John Steuart Curry, the rough edge of unruly nature in these works has been submitted blade for blade to the grooming order of agriculture. Hand-tooled and patterned by the plow, the land has been converted into a luxurious garden, luring the gardener-painter to invent ornamental fancies as forms of intrinsic physical beauty. In comparing a Wood farm with a Wood-inspired photograph (Figure 163), one can see that in his ideal agrarian world rows of new corn contain no blank spots of irregular growth and that the shaggy overgrowth of the trees has been smoothed over by a freehand geometry.

While springtime, summer, and fall prevail in most of the farm pictures, in a few drawings and lithographs made in the late 1930s, corresponding to a period of domestic stress and departmental strife at the University of Iowa, Wood does allow the winter season—cold, dark, and barren—to enter his landscapes.[1] The raw forces of nature strip the trees and blanket the ground, sharpening the contrasts and deepening the shadows. In *December Afternoon* (Figure 164), where winter is still an entertaining novelty, a sleigh and a spirited horse are featured; but in *January* (Figure 165), *February* (Figure 166), and *March* (Figure 167) winter has grown harsh and tedious. Ponderous frozen cornshocks and rigid horses

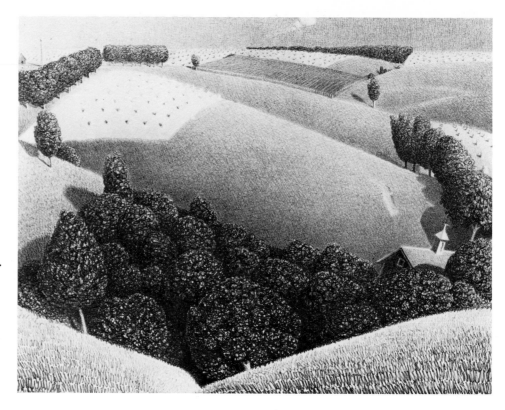

160. *July Fifteenth, Summer Landscape,* 1939.
Lithograph, 9″ × 12″.

stand planted in deep snow on bleak prairie fields under dark skies. Incessant wind and bitter cold blur the details and bend the heavy-laden tops of the shocks over into deep shadow. The increased angularity of shape and composition suggests the forceful presence of the strong, biting winds.

In *March* the road no longer winds its way gracefully over the land but slashes in a z-form, as in *Death on the Ridge Road* (Plate 33), from the foreground to the top of the picture, broken up by sharp wedges of dark gullies and ditches along the way. In the original drawing for the lithograph (Figure 168) the road elbows treacherously to the right, all but disappearing before it angles toward the farm buildings above. Bare trees and bushes lean with the wind, and the banks bristle with last year's weeds. In the finished drawing and final lithograph, however, the road and hills have been smoothed out and fence posts have replaced the trees. The house and barn and a lone tree bend in distorted animation toward a Bentonesque team of wagon and driver who strain to reach their destination at the end of the road.

In each of the rough-weather pictures, as well as in a cloud-dominated lithograph of harvest entitled *Approaching Storm* (Figure 169), the principal motifs of farmer, road, barn, animals, and crops loom at close hand in front of the broad open view characteristic of Wood's sunnier farmscapes. Nevertheless, even this brief intrusion of winter's barren fury could hardly dispel the enfolding

warmth sustained by Wood's prevailing conception of a snug Iowa farm life. By the spring of 1941, less than a year before his death, Wood pondered the severity of winter on the land with an undaunted sense of well-being in a letter to King Vidor, who had purchased the painted version of *January* (Plate 38):

> Here in Iowa, the winters are severe, Heaven knows, but even at the height of winter, one does not get the feeling of utter bleakness and desolation that is characteristic of Dakota, for example. The farmhouses are snug, the barns well-stored; it is a land of plenty here which seems to rest, rather than suffer, under the cold. In light of this, it seemed to me that nothing caught the spirit of an Iowan winter more aptly than the familiar scene of a field of cornshocks partly covered with snow. The rabbit tracks, leading into the snug shelter of the shock in the foreground, are a piece of symbolism with which I had some fun.[2]

Coming at a time of agricultural crises and amidst the wasteland of the Depression, Wood's farmscape views of uncurtailed prosperity seem painfully paradoxical. Drastic disparities existed between the Imagination Isles of Wood's make-believe farm land and

202

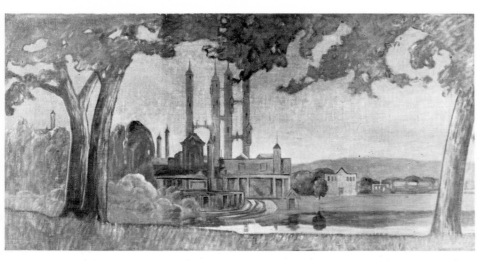

161. *Fanciful Depiction of Round-house and Power Plant, Cedar Rapids,* c. 1920–1923. Oil on canvas, 35¼″ × 72¾″.

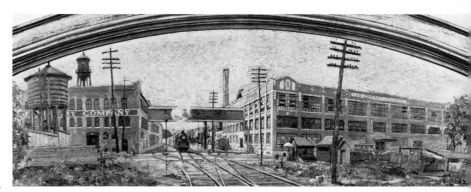

162. *The Old J. G. Cherry Plant, Cedar Rapids,* 1925. Oil on composition board, 13″ × 41″.

163. Photograph of farm in spring by Ray Barth, 1974.

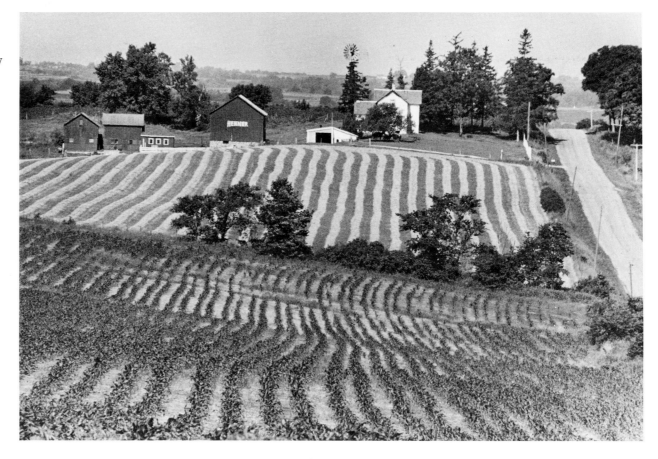

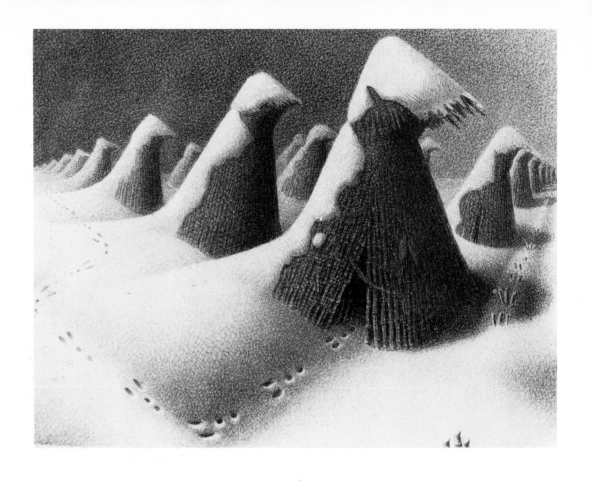

165. *January*, 1937.
Lithograph, 9″ × 11¾″.

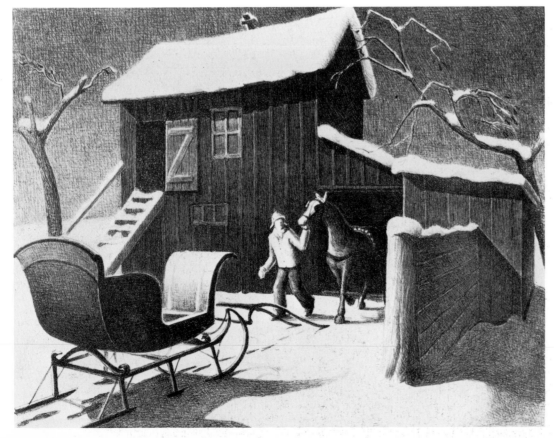

164. *December Afternoon*, 1941.
Lithograph, 8⅞″ × 11⅞″.

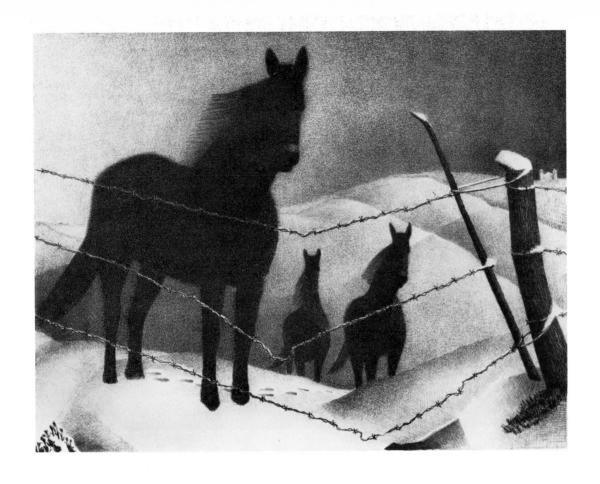

166. *February*, 1941.
Lithograph, 9″ × 11¾″.

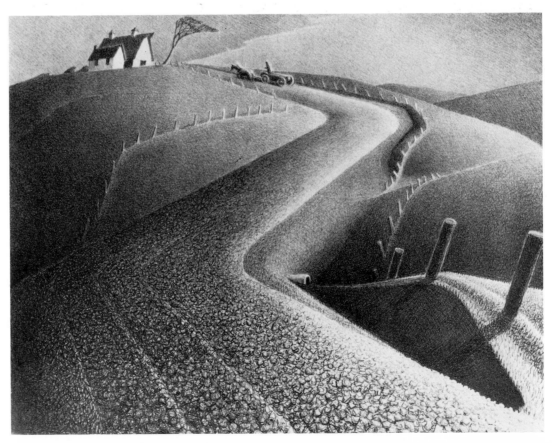

167. *March*, 1939.
Lithograph, 9″ × 12″.

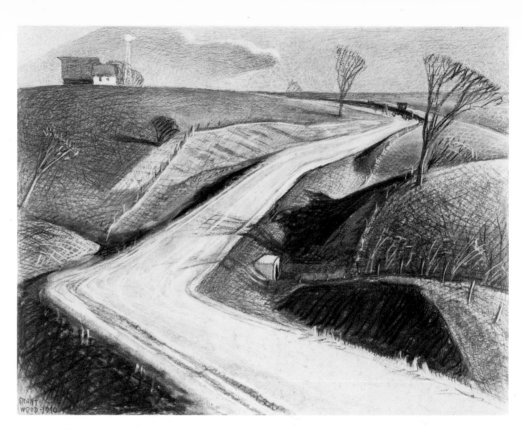

168. *March*, c. 1939.
Charcoal on paper, 18″ × 23″.

the life of the average Iowa farmer during the 1930s. In the early twenties the farm prosperity of the war years had rapidly declined, and the rural economy was already failing by the time of the Crash in late 1929. A further drop in farm prices in the early thirties intensified the crisis.[3] The devaluation of farm land, buildings, and implements followed the collapse of income, compounding the problem for thousands of farmers who had invested in land and machinery during wartime inflation. The loss of capital investment, plus rising taxes and swelling costs, caused fixed mortgage payments to go unmet, and foreclosures and forced farm auctions multiplied.

In a desperate effort to realize at least the cost of production, farmers in the western part of the Midwest decided to strike against the marketing of their products to the cities. Hoping for higher farm prices, they organized the Farm Holiday Association in 1932, headed by Milo Reno, a former president of the Iowa Farmers Union. Members refused to ship food into Sioux City for thirty days and blocked the highways with spiked logs and telephone poles, smashed windows and headlights, and punctured tires with their pitchforks. Chanting "We'll eat our wheat and ham and eggs, and let them eat their gold," farmers poured milk into ditches. The movement spread over the northern Great Plains, and strikes continued into the winter of 1933–1934. But the most violent acts occurred in Iowa. In one case, a thousand angry farmers threatened to storm the Council Bluffs jail until authorities released fifty-five pickets on bail. In another, five hundred men in the LeMars area marched on the courthouse, mauling an agent of a New York mortgage company. At Storm Lake, Iowa, a lawyer conducting a foreclosure was attacked by a group of vigilante-farmers who threatened to hang him.[4]

Although the Farm Holiday movement had little economic impact, it did dramatize the plight of the farmers. Soon after his inauguration Roosevelt began to move on the mortgage foreclosure problem through the new Farm Credit Administration, and Congress enacted emergency legislation, including the Farm Credit Act. Agriculture Secretary Henry A. Wallace of Iowa (Figure 170) instigated the Agricultural Adjustment Act, which attempted to bring about a "parity" balance between the production and consumption of farm products by paying the farmer to bank some of his fields or restrict his livestock and by lending him money for a collateral in crops.[5] Relief programs, while they aided those farmers who could afford to be aided, did little to ease hardships on the family-owned and -operated farms. The trend toward bigness, both in acreage and capitalization, had already subjected the farming business to increased concentration despite the traditional view of farming as a family enterprise. Mass production for cash crops, technologically and scientifically advanced, called for ever more efficient machines, which required capital beyond the means of many small farmers. Moreover, droughts, dust storms, and plagues of grasshoppers from 1933 to 1936 drove many families off their farms into tenancy or migrancy. While Iowa was not as hard hit by the weather as the "Dust Bowl" to the southwest, like that region it suffered great losses in its rural population.[6]

In view of Grant Wood's sympathy with liberal reforms, his approval of social criticism in painting, even regionalist painting, and his satirizing of conventional notions about past history and those who held them, it is difficult to explain the appearance of his stylized, idyllic farmscapes and farm figures in the midst of a farm

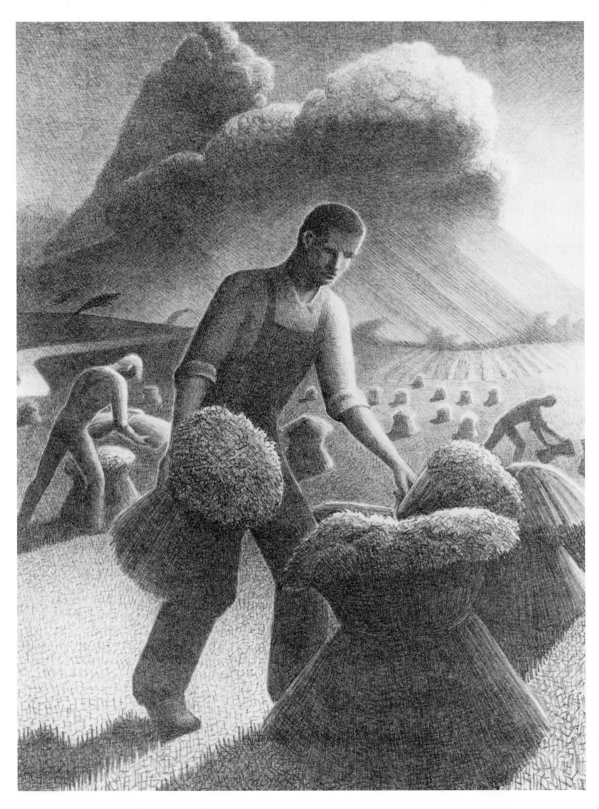

169. *Approaching Storm,* 1940.
Lithograph, 11¾″ × 9″.

170. Portrait of Henry Wallace for *Time* magazine cover, September 23, 1940. Original drawing: charcoal, pencil, and chalk on paper, 24″ × 21¼″.

171. *Fertility*, 1939. Lithograph, 9″ × 12″.

crisis in Iowa (Figure 171). The distance he maintained from the farmers' dilemma as subject matter makes a startling contrast to his publicly announced admiration for the farmers, for their courage and independence. He clearly stated that the artist—painter or writer —should speak for the farmers as "the richest kind of material."[7] Such discrepancies cannot help but arouse skepticism as to his basic motives in painting what he did, and one at first might suspect that aesthetic and commercial aspects had been his overriding concerns. Conceivably, as a visual artist Wood could have simply found himself attracted to the decorative qualities of farm land, apart from his political and social sympathies. Aiming for universality, he could have valued the farmed landscape, as he did the dress and shelter of the rural Midwest, for its ornamental possibilities: details crisp and clear-cut, an orderliness of plain craft and cultivation in reaction against his former appreciation for the old European custom of the picturesque. Alert to urban nostalgia for the bucolic, Wood, too, might have been exploiting the long-standing, ready-made market to guarantee his material success. However, neither of these purposes withstands close critical scrutiny.

From Grant Wood's first major farm pictures of 1930 and 1931 up to the summer of 1934, when *Dinner for Threshers* was sold sight unseen, this category of his work enjoyed far less popularity than his other subjects. He was best known as a satirist, and most of his

farm pictures remained in the area of Cedar Rapids; *Young Corn*, for instance, hung as a commemorative piece in the local high school.[8] What is more, even after the success of *Dinner for Threshers*, two years passed before he painted another easel picture of farming that could be peddled by an Eastern-city dealer. True to the regionalist creed and to his personal convictions about the organic relationship of the local artist to the local life he interpreted, Grant Wood only gradually appropriated "farmer material" as his own. After painting a few farm scenes, such as *Haystack and Red Barn* (Figure 172), in the 1920s, he did use a distant farm in the background landscape of the portrait of his mother (Plate 15). And in 1930 he made *Stone City* (Plate 12) to accompany *American Gothic* as the picture of a village that failed, using the high wall of the quarry, its industrial scar, as a central motif. The foreground slope of newly sprouted corn apparently pleased the artist's eye for decorative pattern to such an extent that he expanded it compositionally in *Young Corn* (Plate 22), painted the following spring, and enlarged upon it thematically by adding a family at work in the distance planting a field of their hillside farm. *Fall Plowing* (Plate 21) was painted in 1931, at the same time as he did farm figures for the mural *Fruits of Iowa* (see Plates 28–31) for a local hotel dining room. It was not until after this period that he produced a steady flow of farming pictures in various media.

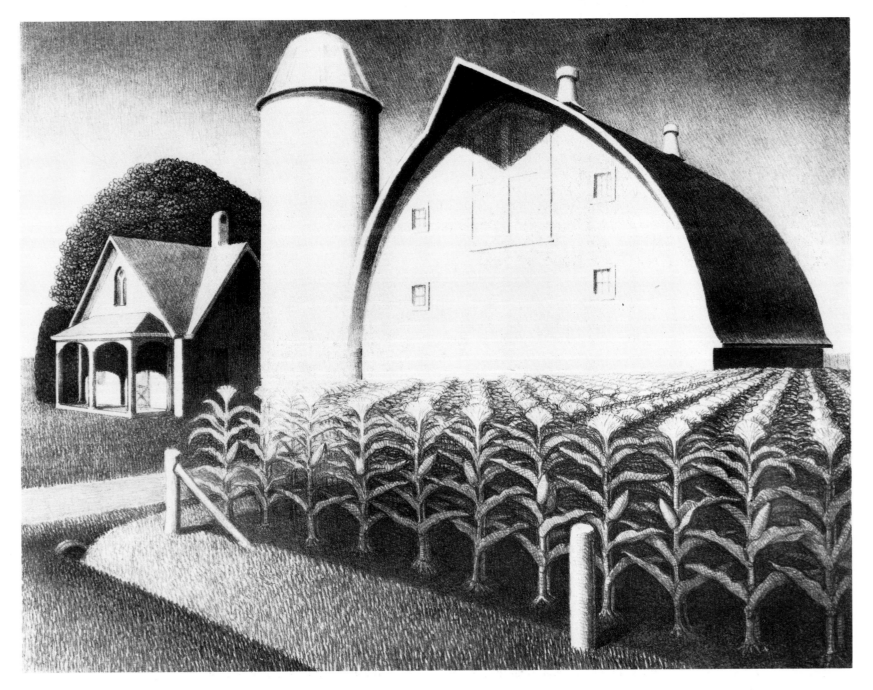

Wood's intensifying attachment to farm subjects and his gradual adaptation of them into his art militate against the charge that he was concerned solely with decorative possibilities. If design, composition, and ornamental abstraction had been the only reasons that Wood had been attracted to scenes of farms and farm life, why then did he not widen his repertoire to exploit other subjects equally promising in decorative potential? Wood's growing preoccupation with farm subject matter suggests something more than an incidental run-off from formal invention. Evidently Wood had assimilated "farmer material" in his initial search for decorative patterns, and after making it his primary regionalist subject he developed an idealized view of rural life, filtered and purified of the toil and sweat he would have recalled along with pastoral memories of his boyhood on the farm.[9] By the time he wrote *Revolt Against the City*, Wood's commitment to this subject matter rested on a deepening conviction in the traditional virtues and legendary ideals of a rural way of life in the Midwest.

Before the distraught Iowa farmers attracted national attention to their plight by means of reprisals, Wood had formulated a set of pictorial conventions idealizing the farm family and farmstead into a highly crafted and refined compositional design. He disdained storytelling paintings, and through these conventions maintained an aesthetic distance from actual events and current issues in his quest for universality. The tangible pictorial results of this effort, along with Wood's personal commitment to an anti-Eastern, anti-European regionalism, are not without historical precedent. Earlier in American history, during periods of economic distress, protective shields of agrarian ideals and imagery had traditionally been raised in support of the hard-pressed farmer. For example, the Populist movement of the 1890s had perpetuated through its rhetoric an assortment of alluring sentiments that were echoed thirty years later in Wood's proposed standards for regionalist art, as well as in the polemics of his aroused neighbors on the farm. Considering Wood's farm background, which undoubtedly contributed to his compassion and admiration for the farmer, whom he described as a virtuous, independent individual preoccupied with fundamentals and misunderstood or mistreated by the city, it is conceivable that his artistic use of idyllic images to celebrate life on the land was a kind of elaborate praise of the farmer's exalted position.[10]

American farmers, for several generations a majority of the population, inherited the belief that they had a fundamental and indeed natural right to deferential treatment from all other sectors of society, an attitude supported by a centuries-old pastoral tradition. A modern equivalent of the classical Arcadian shepherd of Virgilian

fame, the noble tiller of the soil in cultivating God's earth had acquired free title to his own plot of land in an Edenic garden of the world. Along with this incomparable privilege went the attributes of an ideal man: total honesty, perfect health, absolute virtue, and permanent happiness. This superhuman image of self-sufficiency could hardly avoid becoming increasingly fictional in the face of the economic realities with which the largely mobile, cash-crop, commercial farmers of the United States had to contend. Regardless of its flimsy credibility, the fable of the virtuous yeoman, whose natural rights deserved to be protected against all vested interests, continued to flourish undimmed at the end of the agricultural crisis that spanned the last three decades of the nineteenth century. Its persistent appeal found concentrated encouragement in the Populist movement, which had been organized by farmers as a political force to alleviate their depressed economic and social condition.

Indulging the tendency of farmers to see themselves as innocents rather than as land-speculating, mechanized small capitalists, the movement's leaders by the time of the 1890s depression switched their emphasis from practical reforms and concrete improvements in agricultural techniques to an unreserved verbal attack on "money power." They told of a city-centered, Eastern-controlled conspiracy of monopolies, great trusts, railroad corporations, and gold-gambling bankers that plotted on both sides of the Atlantic to crush the little man, whether he be husbandman, tradesman, or small-town shopkeeper. The most immediate means for him to survive this apocalyptic onslaught would have to come from a reformed and sympathetic government of the people. This government would, before all else, protect his debt-burdened livelihood from a deliberate contraction of currency, and it would legislate enforceable laws against the continuing consolidation of ever larger and increasingly impersonal corporate interests.[11]

Even after twenty intervening years of agricultural prosperity, during which commercial farmers had become a powerful, overrepresented minority of technically trained, conservative businessmen whose shrewd use of pressure politics paid off in federal assistance, populist ideas and resentments persisted. When hard times returned in the 1920s and 1930s, attacks on industrial capitalism and urban corruption were made again from that anachronistic agrarian point of view with a few revisions and additions.[12] The affirmation of an idyllic rural life still implied a simultaneous rejection of city existence. However, instead of condemning Wall Street financiers for their Crosses of Gold or railroad magnates for exorbitant freight rates, the farmer denounced Eastern capitalists for their unethical way of life, eschewing productive labor by speculating on the pro-

172. *Haystack and Red Barn,* c. 1925.
Oil on canvas, 18″ × 22⅛″.

duction of others. Investors did not work for a living as the farmers did from dawn to dusk, and yet they reaped fortunes and often fame as well.

In retaliation for the city-bred epithets of "hick" and "hayseed," the farm population hurled a steady stream of abuse straight out of the 1890s at immigration and organized labor. To the rural mind, anyone remote and alien provoked distrust, even someone from the country if he dwelt in the city.[13] In particular, urban manufacturers were blamed for the immigrant horde since their insatiable demand for cheap labor had encouraged the importation of "dangerous elements" from Eastern Europe—such as the thousands of Czechs who settled in Cedar Rapids—to work in their mills. In the opinion of many farmers, who were progressively consolidated but still independent in spirit, these immigrants brought radical, un-American ideologies with them. As a result of their corrupt, ward-healing machine politics they encouraged the rise of labor unions, which, from the distant viewpoint of a rural work ethic, made excessive demands for shorter hours at higher pay. Consequently, it was natural for the farmers to believe that these increased wages invariably contributed to the rising cost of items that farmers had to purchase in town. Thus ended the old populist appeal for a universality of all toilers, industrial as well as agricultural. As the *Elkader* (Iowa) *Register* summarized the immigrant issue, aliens shared nothing with "original stock" Americans, engaging as they did (according to the *Register*) in political radicalism, harboring foreign loyalties, and perpetuating their differences by isolating themselves in overcrowded urban ghettos.[14]

Big business, immigration, and organized labor together embodied an urban challenge to the isolationist-nationalist persuasions of a waning agrarian tradition. Henry C. Wallace, editor of *Wal-*

*lace's Farmer* and Secretary of Agriculture under Harding, candidly expressed a conventional "country" outlook from the middle border in 1930 when he referred to the cities as "the death chambers of civilization."[15]

It was in the midst of this populist climate that Grant Wood began to channel his own native-born, populist predilections into propositions for a rural Midwestern regionalist art. By 1935 he could confidently write of "the present revolt against the domination exercised over arts and letters, and over much of our thinking and living by Eastern capitals of finance and politics."[16] Just as the farmer stood his ground to preserve his agrarian ideals and to protect his long-range economic gains from outside intrusion, the self-made regional artist must resist big-city, Eastern, and European dictates of taste and style, academic or modern, for the sake of his independence and individuality. A secession from Europe and the East would in populist terms constitute a victory for American art over an economic conspiracy in the international art market: "The long domination of our own art by Europe, and especially by the French, was a deliberately cultivated commercial activity—a business, and dealers connected with the larger New York galleries played into the hands of the French promoters because they themselves found such a connection profitable."[17] The heartland artists who achieved independence from alien schools of abstraction or from the outmoded academicism of the Eastern art establishment thereby acquired a special status as a new breed of autonomous American art producers. Thus Grant Wood advocated that along with the farmer they merited public support as a national resource, one that required federally backed programs of educational and professional opportunities.

# 11. Cultural Tradition:
# The Machine and the Garden

The populist implications of Grant Wood's regionalist program on behalf of a defensive rural society, and the reinforcement that his idyllic farmscapes gave the farmer's self-image during a period of economic strife, broach a cultural source from which emanated a national agrarian myth. Beyond offering immediate comfort from economic and social hardship through pictorial escape, Wood in his farm paintings also addressed the fundamental question around which this time-honored American myth had developed: how the nation might best employ its land and natural resources for the material and spiritual benefit of its people. Recent investigations by American intellectual and literary historians agree that the promise of agrarian utopia has long been a major preoccupation of the American mind as it confronted, ignored, or rationalized the imposition of industry and urbanization upon a virgin landscape. Generations of American agrarians, from Thomas Jefferson to Ralph Waldo Emerson and Frank Lloyd Wright, have faithfully envisioned the American landscape as an agrarian garden, thereby creating and advancing a tradition of poetry, prose, and political rhetoric. Demonstrating the myth to be a determinant factor, consciously or unconsciously, in American literature, scholarly studies since World War II provide a valuable interpretive framework for analyzing Wood's fanciful views of Iowa farm country. In the content as well as in the form of his art, Grant Wood realized his aspiration of a regionalism with national relevance, transcending the bounds of an aesthetic experience to garner the broad-based appeal of a mass-culture myth.

Henry Nash Smith's pioneer study of the agrarian myth, *Virgin Land*, published in 1950, explores the various levels on which the myth manifested itself during the Westward movement.[1] His literary sources, primarily drawn from prose and rhetoric, attest to the great attraction the utopian dream of transforming a wilderness into a "Garden of the World" held for nineteenth-century America. The idealization of the frontier farmer into a virtuous, happy yeoman tilling his own quarter section perpetuated the Jeffersonian dream of a rural republic of family-size subsistence farms. Accordingly, the sponsors of the Homestead Act (1862) appealed to the mythic garden as a "fee-simple empire" and to the symbolic yeoman as one who earned a right to possess land by cultivating it. Historically, Nash observed, Americans had attempted to deal with actuality through recourse to the myth, and the results not surprisingly were less than satisfactory. The agrarian ideal, for example, invoking the legend that "rain follows the plow," had encouraged the ill-fated practice of conventional farming on the arid land beyond the 100th meridian. Another misapplication of the mythic to the actual originated from the famed frontier thesis of Frederick Jackson Turner that the experience of converting savage land into a rural civilization was basic to democratic attitudes. This hypothesis with its agrarian restrictions proved inadequate for understanding the institutions and issues of an industrial society.

Richard R. Hofstadter's critical analysis of the "agrarian myth" in *The Age of Reform* evaluates the role played by the myth in the politics of Populism.[2] He began by tracing the evolution of the yeoman image from its source in eighteenth-century literature to its exploitation by national politicians in the twentieth century. He associated the decline of the image with the coincident upswing in the commercial commitments of American agricultural life. Populist rhetoric to the contrary, the farmer was no freer of the marketplace, indeed of the international marketplace and its financial institutions, than any other businessman. Nonetheless, the "soft" side of the farmer's existence, as Hofstadter termed the agrarian ideology based on an Edenic ideal, invariably reappeared during periods of discontent, usually as a scheme of pleading for special dispensation.

Following Hofstadter's examination of political-propagandistic use of the agrarian myth for economic and social ends, Leo Marx in

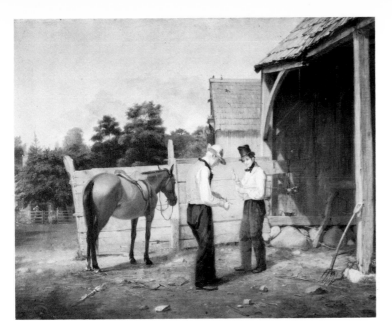

173. William Sidney Mount: *Bargaining
for a Horse*, 1835.
Oil on canvas, 24" × 30".

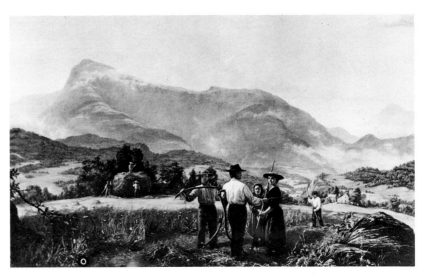

174. Jerome B. Thompson: *The Haymakers,
Mount Mansfield, Vermont,* 1859.
Oil on canvas, 30" × 50".

his essay *The Machine in the Garden* attempted to explain why an industrial society would continue to covet as well as to exploit such an anachronistic vision.[3] He redefined the image of a self-sufficient yeoman as a symbol of poetic rusticity located in the "middle landscape" of pastoralism, a bucolic paradise lying between the extremes of primitive nature and urban civilization. Since the pastoral ideal had to be responsive to the infiltration of industry into the actual landscape in order to survive, it underwent constant literary and rhetorical modification in order to accommodate machine technology in its visionary garden. These flexible attitudes toward the role of technology in a fading New World paradise upon which Marx concentrated are particularly important for understanding the composite vision of Wood's rural Iowa environment as a pastoral farm land of imaginary charm and agrarian contentment. Though machines never trespass on his decorative fields, and though his farmers resemble the symbolic yeoman of the agrarian myth, industrial technology pervades his farmscapes. His precise composition and calculated form design function as artistic equivalents of the antipastoral realities that Leo Marx termed "counterforces."[4]

Wood's attempt to withdraw from industrial-urban society was fundamental to his idealization of farm land and life. In evoking a pastoral longing to escape modern civilization by fleeing the city into a fanciful countryside, Wood reiterated the impulse of generations of Americans concerned about the social and cultural consequences of industrialization. Out of this impulse had grown a literary tradition unparalleled in the visual arts. A classic statement in this tradition is recorded in Thomas Jefferson's *Notes on the State of Virginia*, Query XIX, written in the early 1780s. Although Jefferson recognized the inevitability of native manufacturing in the new republic and reluctantly acceded to its growth following the War of 1812, he advocated, in theory at least, an agrarian society of family-size farms. Given the immensity of the American territory, a classless state of self-sufficient independent freeholders could expand indefinitely, leaving a market-regulated urban society of subservient workmen to Europe. Americans should raise raw materials to exchange for those foreign manufactures deemed necessary, creature comforts being less important to the agrarian way of life than the guarantee of "rural virtue." Jefferson had read classical pastoral poetry, and from his attachment to Virgil's first *Ecologue*, in which Tityrus the shepherd lives a virtuous life of "happy leisure" in an Arcadian valley, he identified the cultivation of Virginia landscape and the farmer's close contact with the soil as sources of high morality.

To Ralph Waldo Emerson the landscape represented an opportunity for "Man Thinking" to function on a high spiritual level of existence. Urban civilization, concentrating its energies in a utilitarian sphere of commodities, denied man any spiritual perception, while the countryside of Concord, for example, offered tranquility and pastoral beauty. It was in farm country and not amid the awful sublimity of the wilderness that man could return to the life of the mind; by living instinctively in harmony with nature he could regain his initial intimacy with the Divine. Toward this end the farmer could serve the scholar well as a working model of completeness. In the presence of nature and the processes of reproduction,

213

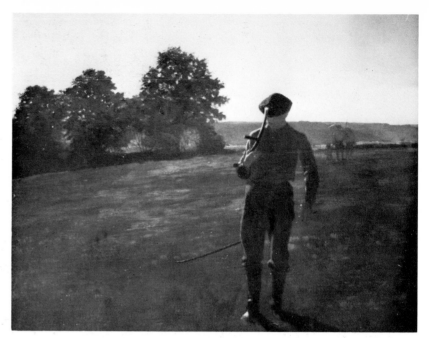

175. Winslow Homer: *Farmer in Field*, 1867.
Oil on canvas, 17⅛″ × 22″.

"the miracle of generative force," he engages in the only creative economic enterprise. Its discipline rests on self-reliance and the practical arts, which are lost to the dependent city man. Within Emerson's idealized agrarian conception, the farmer could rise to higher virtues and values. Response to his natural environment might become consciously aesthetic, and his reticence to articulate his observations of beauty would signify to Emerson their depth of sensitivity, unencumbered by intellectualization. The natural qualities of the farmer, his independence and inherent self-governing abilities, contradict theories of civilization which rank commerce, industry, and urbanization above agriculture. Progress would be of little consequence to the ideal farmer who, being in constant touch with nature, inherits the potential of knowing its divine essence.[5]

In reconstructing his summers as a youth on his grandfather's valley farm, Frank Lloyd Wright preferred to remember himself and his farmer uncles in a guise analogous to Emerson's ideal agrarian type. Attuned to the values of nature on practical and aesthetic levels, the Wisconsin farm family might also at some heightened moment reach the spiritual essence permeating the garden landscape. And Wright concluded, "Was not nature in this sense the very nature of God?"[6] He considered his creativity, his consciousness of the "internal nature" of building materials, and his principles of organic architecture to be directly traceable to his early experiences of working the soil and observing the plant and animal life of a "wild Wisconsin pasture." The strong sentiment behind this conviction undoubtedly encouraged his permanent return to the valley after twenty-five years of successful practice in Chicago.

Voluntarily exiled from the city, Wright envisaged a home, studio, and school in a pastoral paradise. A "natural house," "native in spirit," married to the brow of a hill, would overlook orchards, grain and corn fields, a "glittering decoration" of grazing cows and sheep, with a garden and "sturdy teams" plowing the fields: "There would be the changing colors of the slopes, from seeding time to harvest."[7] Moreover, "the place was to be self-sustaining if not self-sufficient, and within its domain of two hundred acres was to be shelter, food, clothes and even entertainment within itself."[8] A modern Monticello. This spacious independence, continued Wright, belongs as a natural right to all Americans living in the United States. Each person earns at birth an acre of land in a continental garden. Wright's pastoral "Broadacre City" was to be horizontally distributed throughout the land by the power of machinery and organically integrated by a network of highways, air transportation, and electronic communication. Such a plan would reverse the "aggregations and superconcentrations" which accelerate the obsolete city into a graveyard of skyscrapers: "The machine thus comprehended and controlled would succeed for the man himself and the widening margin of leisure be increasingly spent in a field or on the stream or in the public or private gardens or the wood and wild so easily reached now on great architectural roads."[9]

In the history of American art few painters before Grant Wood sought to gratify the recurrent impulse of abandoning the city in favor of the country with a body of pictures idealizing farmscapes and farm figures. A century earlier William Sidney Mount had devoted his life's work to rural genre paintings, depicting an assortment of directly observed barnyard pleasures in the vicinity of his home at Stony Brook, Long Island. The raffles, horse-trading, music, and dances of the farmers and their slaves conform in mood to seventeenth-century Netherlandish tavern scenes, though without

214

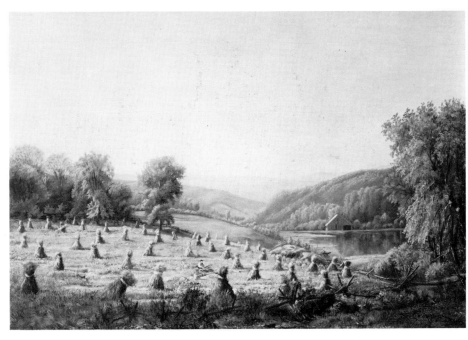

176. Jasper F. Cropsey: *Field of Cornshocks*, 1858. Oil on canvas, 16″ × 24″.

indulging in the grotesque (Figure 173). Mount's choice of pleasant events and leisurely pastimes no doubt perpetuated the well-marketed myth of an Edenic existence on the farm; but the figures, subjected as they are to confined spaces deliberately worked out through linear perspective, fail to identify with the noble yeoman in his conventional open setting, the productively worked field of agrarian fulfillment.[10]

No American painter in the nineteenth century came closer to this ideal image than Jerome Thompson, whose sketching trips to Massachusetts' Berkshires and to Vermont yielded such paintings as *The Haymakers, Mount Mansfield, Vermont* (Figure 174). A farm family poses with scythes and rakes in the foreground field before a background of mountain landscape similar to the wide-angle, panoramic views produced by the so-called Hudson River School. But aside from Thompson, only a few glimpses of the farmer occur in either landscapes or genre paintings throughout the nineteenth century. Winslow Homer's sporadic figures of anonymous brim-shaded farmers join his soldiers, black cotton-pickers, fishermen and their wives, hunters, and children as symbols of human inventiveness and endurance pitted against the prevailing forces of nature (Figure 175). But in this emblematic role they do not speak of an ideal life in a pastoral garden.

Aside from portraits, American painters of this period favored landscapes of mountain wilderness, from the Catskills to the Rockies. What little space they allocated to the farmer and his field can be seen in a scattering of paintings by Asher B. Durand, Jasper Cropsey (Figure 176), and George Inness which characteristically include peripheral details of tilled land. The sublime drama of untamed nature and its monumental landmarks overwhelmed the pas-

toral and enjoyed popular acceptance as a worthy alternative to the Grand Manner tradition of classical history-painting. Thomas Cole could thus incorporate didactic metaphysical themes into his landscapes, while his student Frederick Church would scale volcanoes to a cosmic design in accordance with the science of physical geography formulated by Alexander von Humboldt.

In spite of the scarcity of farm imagery in the painting of America's century of expansion and settlement, one might still expect to find an idealization of the farmer and his life in the articles and advertisements of the farm journals of the period. However, it was farm machinery, its proliferation and its technical progress, that monopolized the illustration space left over from close-up drawings of plants. The only depictions of the farmer as an ideal type comparable to the agrarian yeoman took verbal form in the inspirational columns dedicated to improving the standards and standing of the "agriculturist." *The Country Gentleman*, which first appeared in 1853, implored its readers to spare themselves from the degrading drudgery of farming strictly for profit. The farmer might best exert his valuable influence in leading his children and neighbors to an elevated aesthetic vision of the scenes around him: "It does not at all destroy or lessen one's skill to manage those two refractory opponents, Cost and Profit, to look up occasionally from the plowpoint before him, to the rich, varied, and magnificent panorama around him."[11] Furthermore, the farmer was to look upon his farm as a vast laboratory in which to observe the workings of nature and to study her laws: "If there is a man who should possess a vigorous and well trained intellect, a noble and generous soul, with enlarged and comprehensive views . . . that man is the American Agriculturist."[12]

# 12. Pastoral Farmscape for a Technological Society

It was Grant Wood who finally reversed the tendency in American art to ignore farm life as subject matter worthy of pictorial treatment. His farm views combine two versions of the agricultural-utopia fable. Growing out of his genuine affection for the farmer, Wood's regionalist belief in localism as the key to an independent native art form led him concurrently to the agrarian myth and to a modernized version of the pastoral ideal. The farmscapes reflect his fundamental ambivalence toward the machine and its industrial accompaniment, and issue a last tribute to the elemental agrarian life close to nature just at the time when fields were being submitted to a technological reordering.

In his farm pictures Wood not only forbade the machine but also eliminated the industrial allusions of utility poles and wires, railroad tracks and billboards. He chose to avoid the permanent signs and scars of industrial-electronic civilization as it invaded and occupied the countryside. He refused to recognize the machine or the dynamo as instruments of an advanced process of extending the garden, of furthering the pastoral ideal of the agrarian landscape, and by doing so he disregarded the argument favored by advocates of industrialization during the nineteenth century.[1] Nevertheless, the impact of the machine age, so thoroughgoing, inevitably had to be felt in his works. While Wood depicted a version of the agrarian myth that could generally be described as a popular pastoral experience, his landscape imagery and style evoke a profound form of modern pastoralism which Leo Marx termed "complex," as distinguished from the merely sentimental. This complexity results as urban civilization imposes elements of its "real world" on an idyllic vision. This intrusive agency of reality Marx referred to as a "counterforce."[2]

The "counterforce" of Grant Wood's mature landscapes assumes its most overt and melodramatic form in *Death on the Ridge Road* (Plate 33). In this picture he inadvertently combined the traditional antithesis to the pastoral ideal, that is, a sudden confrontation with death, with the relatively recent antipastoral forces of modern industrialization and machine technology.[3] The literal entrance of the machine, utility poles, and wires into his garden landscape brings disaster and tragedy, and Wood never permitted it to happen again. In fact, his next easel painting, *Spring Turning*, completed about two years later, excludes the machine altogether, offering instead an entirely appropriate nineteenth-century vision of industrial America as a mass-produced agricultural landscape, "a well-ordered green garden magnified to continental size."[4]

In *Spring Turning* the viewer surveys a panoramic landscape which represents an advanced form of massive agriculture, characterized by large fields of commercial crops raised for an international market and subsidized by the federal government. Yet tiny figures of farmers with hand plows and teams patiently labor away in the midst of a boundless counterforce of mechanized productivity, almost lost in the enormity of it all. This discrepancy between myth-turned-reality and pure myth occurs in most of Grant Wood's farm-scapes, each picture integrating a modernized pastoralism with a traditional agrarianism.[5] The agrarian myth presupposes the fixed symbol of a yeoman tending his family farm by hand on a small-scale, subsistence level in complete harmony with his natural environment. But in Wood's pictures the isolated farmer figures, which recall those noble husbandmen and perform symbolically as a vestige of the agrarian myth, are preserved in an idealized farm-scape whose pastoral dimension has acquired a twentieth-century scale through the counterforce of mechanization.[6]

Wood used three distinct types of allegory to evoke the agrarian spirit in his farm paintings of the thirties: single iconic figures bearing the fruits of their labor from the ever-productive fields and representing the unfailing generosity and bounty of nature; an assembly of farmers ritualistically celebrating the harvest, the result

216

of their cooperative efforts; and anonymous figures in the farm landscapes that labor as planters, reapers, and conservationists.

The most traditional and overtly symbolic of Wood's allegorical figures appear in his mural panels called *Fruits of Iowa* (Plates 28–31 and Figure 177) painted for the Montrose Hotel dining room in Cedar Rapids. The individual members of the farm family, physically separated in panels but unified in design, function as iconic figures in votive poses, holding their produce as an offering for the viewer. The barnyard reality and photographic realism of Wood's earlier painting *Appraisal* (see Figure 80) have diminished, and the farmer and his wife and children have undergone decorative stylization and idealization. As the *Fruits of Iowa* demonstrates Wood maintained a balance between the ornamental and the naturalistic. Working together in his allegorical abstraction, the two modes equate formally to an agrarian ideal of the earth-farmer relationship, an equal organic exchange between man and nature. Unlike the farm paintings of Benton and Curry, Wood's paintings show the farmer to be neither heroic nor histrionic but an integral, silent participant in nature. Each figure and its accessories are firmly set on a pedestal of sod as precisely edged designs on a pastel green field. Combinations of flat-patterned cloth and solid blue denim unite the figures on the surface, while their arched brows and closely cropped, obsessively groomed hair contribute to a ruddy-cheeked family resemblance. As deliberately posed figures they resemble portraits from an old-fashioned family album, each frozen in position waiting for the camera to click.

Thick-armed and heavy-shouldered, the boyish-faced farmer (Plate 28) offers a bushel basket of prize corn, coveted by the pink-nosed ceramic pigs at his feet. His ample wife (Plate 31) fattens Grant Wood's most beautiful fowl, including his favorite, the sparsely feathered "adolescent." A daughter and son stand demurely (Plate 30 and Figure 177), displaying freshly ripened vegetables and melons. Most generous of all, a Guernsey cow (Plate 29), viewed symmetrically in profile, her hind quarters squared off to a coral-pink barn, avails herself to a whistling milk hand. In keeping with the theme of plenty, the belly of the cow expands upon the shape of the udder, a sphere of liquid nutrition installed on a narrow rectangular framework. Like the farmscape itself, Wood's farmers, animals, fruits, and vegetables are fecund forms, ripe and robust. When the murals were originally installed in 1932, this display of agrarian well-being must have also been intended by Wood as a theme of sharing, for the anonymous allegorical farm family smiled

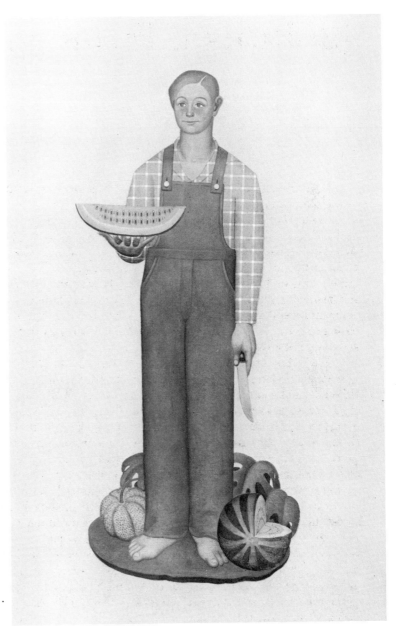

177. *Fruits of Iowa: Farmer's Son,* 1932. Oil on canvas glued to panel, 3'11½" high.

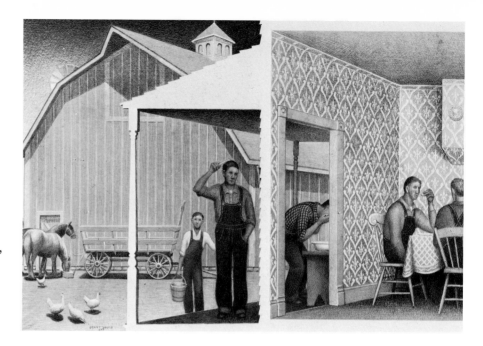

178. *Sketch for "Dinner for Threshers"* (left section), 1933. Chalk, pencil, and paint on paper, 17¾" × 26¾".

down upon the diners from high upon the restaurant walls. They do not appear to regard the foodstuff as property or commodity, nor do they seem concerned with its commercial processing or market distribution. They exist as pure source symbols, ready to bestow the produce yielded by the bountiful garden upon the world. Idealized, washed, and sorted, they present themselves as the agrarian fruits of Iowa.

Equally ceremonial though less obviously symbolic is Wood's depiction of an assembly of farmers who solemnly engage in an annual ritual of thanksgiving for their harvest within the sanctuary of the family farm. This yearly gathering, when a harvest "run" of eight or ten neighboring families would meet at the normally isolated farm to work and celebrate, furnished a fragile social base for an American rural culture which had long been threatened by the accelerated migration of most of its members to the industrial cities. Dedicated to an agrarian vision, *Dinner for Threshers* (Plate 32 and Figures 178 and 179) portrays a ritual celebration of mythical self-sufficiency and of perennial plenty gained through cooperative labor. Depicted by Wood as a quasi-religious scene, the dinner of farm workers takes place in an early-Renaissance construction of shallow space. The accumulated attributes of a farmhouse designate a sanctuary of an ever-present past. Timeless bibbed overalls and "pioneer" dresses mingle with the mementoes of homestead settlement, antedating by far the year 1892 painted on the modern barn. The newly painted images of the old present a rear-view reflection of the rapidly changing life style of an urban-oriented society. The woodstove, the gas lamp, and the hand pump commemorate the golden age of virtuous handwork and household craft that preceded rural electrification.

Outside, where no heavy threshing machinery may be seen, the pristine yeoman, after his morning of field work, symbolically cleanses himself with the holy water of the barnyard before entering the sacred interior. Once seated, he will wait for the bowl of plenty, ceremoniously carried by an archaically stylized woman in an immaculate early-American costume. The grave mood that is registered on the ten faces visible pervades the whole interior and quiets the figures. This dinner scene bears little in common with the rollicking festivals in Doris Lee's interpretations of rural existence or in George Caleb Bingham's river men. Heavy with sentiment, Wood's painting represents the sacramental last supper of an allegedly independent community of cooperative labor on the American "middle border," consecrated by the high priestesses of the family farm who tend an elaborate altar of the vanishing past.

Sharing the agrarian myth as their allegorical frame of reference *Fruits of Iowa* and *Dinner for Threshers* each focus on a different aspect of that myth. As iconic imagery of a self-perpetuating plenty within the garden of the world, the deified farm family of the mural fulfills the promise of a cornucopia as the produce from the promised land spills forth from their hands. The harvest feast of the threshers commemorates the legendary virtues of cooperative hand labor as it pays tribute to the rural work ethic of productive toil toward the fulfillment of an agrarian utopia. In his pictures of farm folk working the land, as in *Dinner for Threshers*, Grant Wood paid homage to dedicated labor, though the allegorical references in them are far less specific. Pictured in stop-action poses and surrounded with the attributes of tools and crops that denote their respective functions in maintaining the garden of the world, the figures have nothing in common with Jean François Millet's labor-

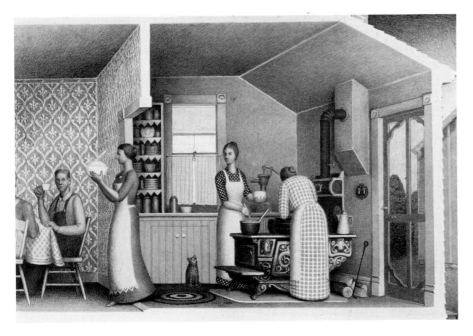

179. *Sketch for "Dinner for Threshers"*
(right section), 1933.
Chalk, pencil, and paint on
paper, 17¾″ × 26¾″.

wracked peasants (Figure 180), but perform anonymously in fields of pastoral promise. The plowmen directing their teams over the low-rising hills of *Spring Landscape, Spring Turning,* and *Spring in the Country* turn the sod of flawless fields, slowly cutting a neat and orderly edge between last year's turf and this year's furrow. No harm may come to this luxurious land of soft sounds, diffused sunlight, and quiet shadows as long as the sturdy yeoman retraces his footsteps season by season, turning his hand to the harmonious convergence of nature and man's ability to make rewarding use of it. There is no hint here that any alien force of advancing civilization or any arbitrary act of temperamental nature could tilt this perfect balance.

The figures of Wood's agrarian-prone pictures continue to work the fertile soil throughout the seasonal stages of tillage and growth, confident of their material reward, unmarked by physical strain. In *Young Corn, Spring in the Country,* and *Spring in Town* the planting takes place around the edges of the great fields, as if Wood intended a gardener's tribute to the art of hand-planting a small plot. Hoes and forked spades dig into the rich ground which already supports a lush growth of fruit trees and flowers. Adjacent to the garden landscape, the lots on the edge of town remain closer to the farmer's field than to the factory of distant smokestacks in the town itself (Plate 40). A little settlement clustered around a church on a hill awakens to springtime chores as the angular form of the man in the garden bends to a labor of love.[7] The bounty of the harvest season is represented not only by human figures at work in the fields but also by certain characteristics of the landscape that could be considered symbols both of human endeavor and of the culmination of another fruitful season. As in an early oil sketch of haystacking

made by Wood in the 1920s (see Figure 172), the fields in the later works, such as *Seed Time and Harvest* (Figure 181), are patterned with orderly diagonal rows of handmade haystacks, their presence dramatized by late-afternoon shadows. These stacks occur again in *Approaching Storm* (Figure 169), one of the few pictures in which Wood allowed the weather to play a role. Nevertheless, the threat of the ornamental thunderhead, whose angular shafts of rain drive against the distant horizon, does not appear to disturb the men at work stacking the ripe grain for the threshing run of August.[8]

Two allegorical figures, which recur in a number of different paintings, epitomize Grant Wood's treatment of the agrarian myth, embodying both the rural work ethic and its guarantee of a peaceful existence enriched by the aesthetic rewards of a lovely setting as well as the tangible fruits of the fertile soil. The woman as conservator and beautifier, as caretaker of the garden, and the yeoman as productive possessor of the land stand as the most monumental images of the Iowan's farm pictures. The first, and perhaps the more personally satisfying to the artist, appears in three of his pictures of planting scenes. *Arbor Day* (Plate 25), *Tree Planting* (Figure 182), and *Spring in the Country* (Figure 97) portray the woman in an active capacity of conservation. As a schoolteacher and mother, she guides the children in providing for the environment, in sustaining its balance of natural and cultivated beauty. The country schoolyard defines her exclusive domain in the open farmscape, and here she instructs future caretakers in the methods of preservation and landscaping that will perpetuate the agrarian garden.[9]

Dominating the lithograph *In the Spring* (Figure 183), an industrious farmer rests momentarily from digging post holes for a new fence. Feet firm on the ground and hands on his hips, he smiles

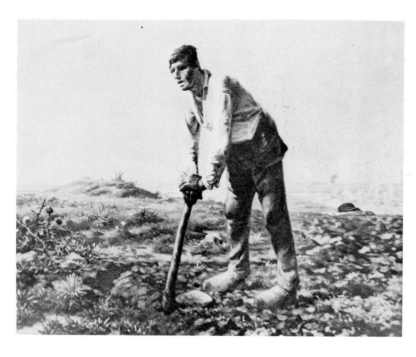

180. Jean François Millet: *Man with a Hoe*, 1859–1862. Oil on canvas, 32″ × 39½″.

confidently at the observer; behind him his partially plowed field recedes diagonally toward a barn from which a herd of cows slowly emerges. A statuesque image, he assumes a heroic posture, his form projecting above the horizon. His presence honors the natural right of possession acquired through productive labor and diligent maintenance. This son of the proud husbandman of the Jeffersonian legend bears little resemblance to the broken, hunched brute of Millet's *Man with a Hoe*, which represented to North America the decadence and decline of European peasantry, "humanity betrayed."[10] Wood's most sensitive and courageous commemoration of the noble yeoman is realized through the silhouette of a naked farmer against his midsummer field and the nocturnal sky. Entitled *Sultry Night* (Figure 184), this picture depicts what was once the common practice of bathing with sun-warmed water dipped from a tank following a day of hard work (Figure 185). As a pictorial statement, however, abstracted from the mundane act, *Sultry Night* articulates the predominant theme of Wood's farmer material, the equation of ideal agrarian life with a mythical promise of spiritual and material self-sufficiency, a rural paradise realized through devoted labor. Avoiding academic classicism as a convenient means of allegorization, the artist unveiled his American Adam as a natural man living an elemental existence. The fields of his own making testify to a partnership with nature as they spread out behind him. An old tree bent with age, a relic of the original wilderness, is effectively contrasted to a galvanized metal tank, the contribution of industrialization. Identified with the allegorical yeoman and his earthbound ethic of manual labor, the naked farmer culminates Wood's representation of the agrarian myth of plenitude. Unaware that motorized machinery and its impersonal technology of increased productivity threaten to encroach on his idyllic way of life, he celebrates himself as an independent man at home with a benevolent nature, its organic rhythms and seasonal cycles.

Accompanying these figures of agrarian imagery, a complex of counterforces, more subtly presented than in *Death on the Ridge Road*, illustrates an agrarian pastoralism in Wood's farmscape. An inherent duality exists in Wood's choice of subject matter: The farmer figure may honor a mythic acquisition of total plenty but only after he has inched across an enormous field of a scale known only to agricultural mass production. The ideal and the real combine as an ironic hybrid, a crossbreed of preindustrial agrarianism and the pastoralism of the technological present. The cultivated farm lands, whose repetitious patterns obviously inspired the artist to make his decorative refinements, have been submitted to a rather standardized design technique to create an efficient, smooth-flowing composition of abstracted forms. This thoroughly modern pictorial style may be regarded as a kind of paradoxical counterforce to the subject and content of the paintings, reflecting a contemporary machine aesthetic derived from industrial design.

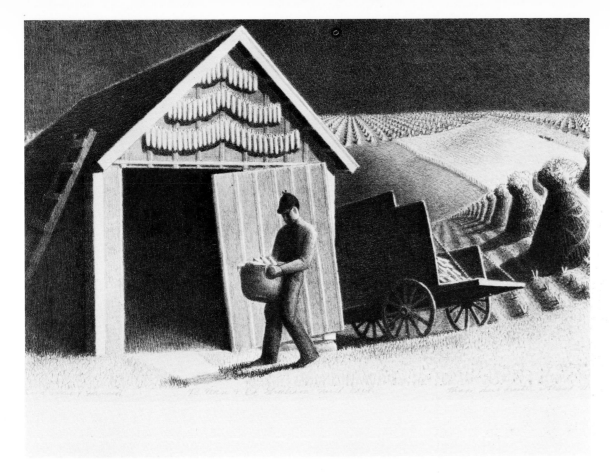

181. *Seed Time and Harvest*, 1937.
Lithograph, 7½″ × 12″.

182. *Tree Planting*, 1933.
Charcoal, pencil, and chalk on
paper, 34″ × 39″.

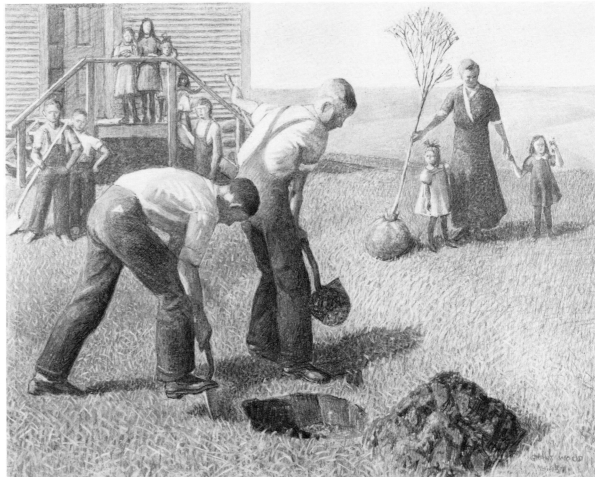

In contrast to the modest subsistence clearings of the colonial yeoman settlers east of the Appalachians which were the legendary models of the American agrarian myth, modern agriculture followed a geometric configuration of land distribution and covered the heartland with patchwork patterns, distended by rolling hills and interspersed with section roads, rivers, and streams. The ornamental promise of the Upper Mississippi corn belt must have nourished Grant Wood's innate proclivity for decorative fantasies, which had found little satisfaction in the sublime irregularity of the Rocky Mountains (see Figures 89 and 90). Using a measured system of pictorial design, he fused the reality of the observed with the ideal he visualized into an unmistakably personal form of stylization. By using this system, Wood courted the danger of redundant "external arrangement," which in lesser hands could result in a monotonous exercise or at best a standardized copy of the original.[11] But in stressing content over craft, Wood perceptively interpreted his immediate world without allowing the pattern of design to hinder his expressed purposes as a regionalist artist.

In sudden opposition to his many broadly brushed, plein-air impressions of Indian Creek (see Figures 21–23), Wood produced *Stone City*, the first landscape of his mature style. Here he inaugurated a concise craft of composition by which he arrived at the final painting through a series of calculated steps. For the remainder of his career, in developing paintings from spontaneous sketches to preparatory cartoons, Wood measured, shaped, tested, and altered in order to tailor each element to fit into the total design. His proper positioning and proportioning of every decorative form depended upon an elaborate but elementary formula of diagonals, which he later taught as "the principle of thirds." He simply divided the panel into nine equal rectangles and then drew diagonals through the perpendicular intersections as directional guides to all major contour lines (Figure 186).[12]

From the first step to the finished product, Wood proceeded in traditional craft fashion. The painting is by no means primitive, but to the contrary technically sophisticated, having resulted from a rational process from the first penciled line to the last stroke of the brush. With the aid of a predetermined formula, equivalent to a stonecutter's template, Wood modeled and carved ornamental trees and sensuous slopes into palpable existence. After the initial sketch state, he left little to accident, carefully weighing and measuring the dynamics of shape, line, light, and value. Yet the pictures do not

seem contrived to the point of losing the observer's interest. Using a subtle curved zigzag gesture that sweeps from side to side or an s-curve convolution that whirls the observer around the steeply banked valley, Grant Wood rescued his pictorial process from potential inertia. Despite the painstaking process involved, the curvilinear compositions of *Young Corn, Near Sundown,* and *Spring Turning* read as spontaneous responses to the general character of eastern Iowa countryside. The artist not only is moved by the land but moves with it, gliding over smooth hills or penetrating shadowy folds of deep space. The observer is invited to join in the exhilarating visual experience as an alternative to exploring distant houses and barns in hopes of arousing personal memories or fantasies about rural life.

Wood's intricate system of planning and executing a picture paralleled a popular concept of "streamline" design that was indiscriminately applied at this time to almost any utilitarian object and adopted as a modern style of composition. This easy approach to modernization originated in the science of hydrodynamics and its application to the design of the contours and surfaces of ships, planes, and autos to achieve minimal air resistance. Technical designers who evolved the bodies of such automobiles as the Cord or the Chrysler Air Flow had contributed to a new design aesthetic which improved machinery and new industrial materials had enabled. They transfigured the academic traditions of applied ornamentation, still prevalent in Art Deco objects of all kinds. At best, design and decoration merged, as in Marcel Breuer's and Ludwig Mies van der Rohe's tubular steel chairs. By 1930 Grant Wood referred to the decorative in his paintings as synonymous with design. At that point his farm landscapes, built on a superstructure of diagonals, matured as compositions of streamlined forms accented with geometrically patterned textures and rounded details that repeated the dominant contours.

Prefiguring the curving hoods and fenders characteristic of automotive styles of the last half of the 1930s, the sloping lines and elongated, sometimes tapered, shapes of Wood's farmscapes, aerodynamic in appearance, confirm an aesthetic analogy between his pictorial process of descriptive abstraction and current industrial design. The visual dynamics of his farmscapes are effortlessly expressive of a machine-driven speed unimaginable to nineteenth-century landscape painters. Convincingly antipicturesque, in accordance with Wood's desire to avoid sentimentality, they do not

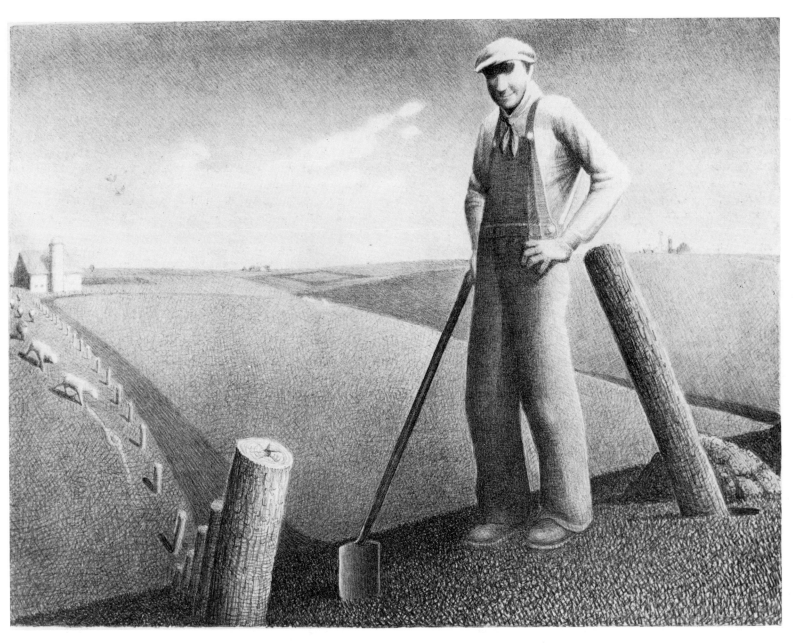

183. *In the Spring, Farmer Planting
Fence Posts*, 1939.
Lithograph, 8″ × 12″.

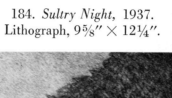

184. *Sultry Night,* 1937.
Lithograph, 9⅝″ × 12¼″.

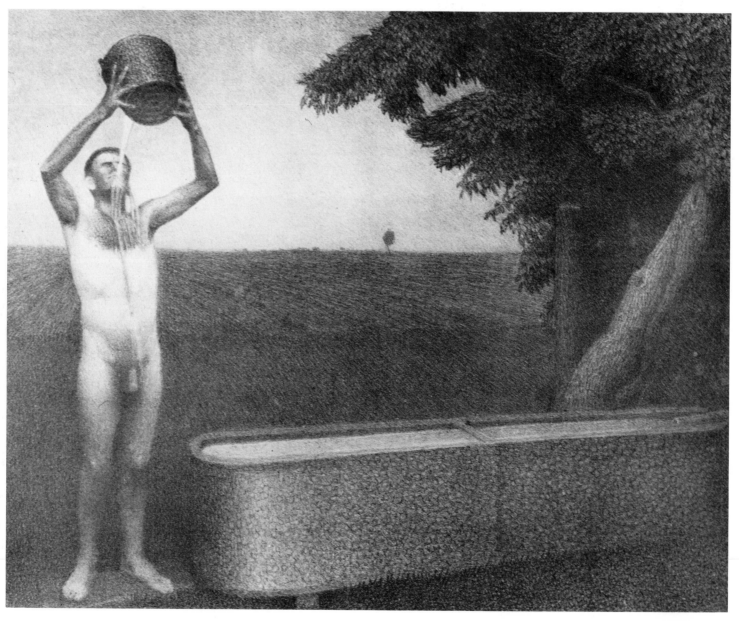

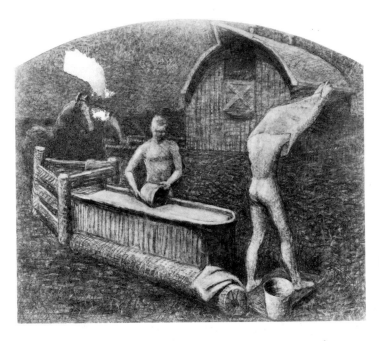

185. *Saturday Night Bath,* 1937.
Charcoal on paper, 19″ × 23″.

allow for metaphysical speculation or contemplation of an Arcadian age long past. If Wood sought a momentary resolution to the constant disruption of bucolic peace and tranquility in an industrial-urban age by eliminating machines from his paintings, he ultimately qualified the effect by acceding in his pictorial form to the artificial world of an organized technological society.[13] Viewed as compositions in the abstract, his farm pictures counter any references of subject matter to the agrarian myth. Wood's cultivated Nature is far removed from the wilderness scene of a mountain-bordered corn field as painted by Jasper Cropsey, who approached the irregular shocks at eye level across an overgrown foreground and through shaggy trees that alternate right and left into the background (Figure 176). The animated whirls and undulations of Wood's sleek landscape, despite the charm of its rustic details, instantly pull the observer into its plunging recession of space and spin him off.

That Grant Wood should entertain an unresolved ambivalence toward the machine and its technology, and that his pictures, though agrarian in theme, should betray that ambivalence in their streamlined stylization is no fault of the artist. In Wood's modernized version of the agrarian myth, the duality of pastoral mode and machine-conditioned design occurs as an inherent consequence of the technological era regardless of Wood's attempt to ignore the existence of the engine. Such involuntary susceptibility to mechanization was foreseen by a prominent social critic at the beginning of the industrial age and reaffirmed from a similar determinist point of view nearly a century and a half later. Early in the nineteenth century a search had already begun for a concept to explain a society increasingly possessed by mechanization and technology. In a critical essay of 1829 analyzing the mechanical age and the new industrial order, Thomas Carlyle feared that the "machine" by its very nature caused damage to the internal and spiritual well-being of mankind as well as altering the structure of society. Machinery, he insisted, manages every department of thought and expression, and, because of its intention to accelerate productivity, it leads to an emphasis of means over ends. This preoccupation with external arrangements operates against inner meanings: "Men are grown mechanical in head and heart, as well as in hand."[14] A utilitarian attitude would divest all thought of will, emotion, or creative power and would, Carlyle predicted, eventually result in uniformity and total fatalism, because those aspects of life which can be calculated and manipulated would overtake the spontaneous and the imaginative. As he was later cited and acknowledged by the Southern Agrarians, Carlyle foresaw abstract, invisible social forces, unrelated to man's "dynamical" inward impulses, determining all behavior.[15]

A century and a quarter later, after technology had passed from steam to nuclear power, the French social critic Jacques Ellul traced the complex ramifications of technological determinism back to a single fundamental concept. He believed that a technical system of standardized means, deliberately executed in order to reach a predetermined, utilitarian result at absolute efficiency, answered to a nearly fatalistic force which he characterized as "technique." He suspected that this autonomous force if unimpeded would eventually compel and control all acts and decisions, regardless of their aims and independent of faulty human intervention. Science, art, and individual man himself would function as mere instruments of "technique," "the consciousness of the mechanized world."[16] Had

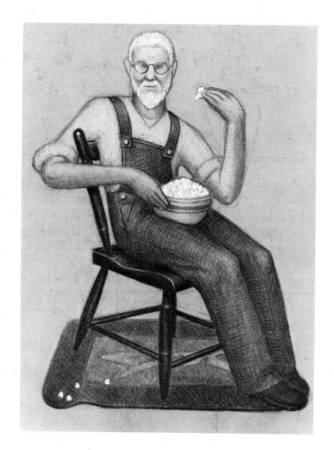

187. *Grandpa Eating Popcorn.*

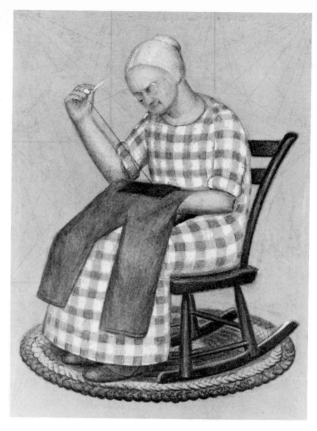

186. *Grandma Mending.*

186–188. Drawings for illustrations for *Farm on the Hill* by Madeline Darrough Horn, 1936. Each drawing crayon and gouache on paper, 9½″ × 7″.

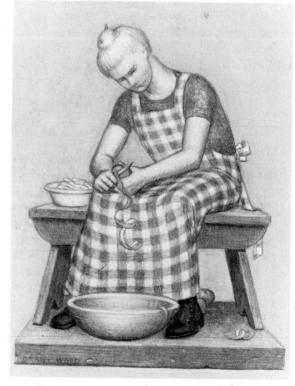

188. *Hired Girl Peeling Apples.*

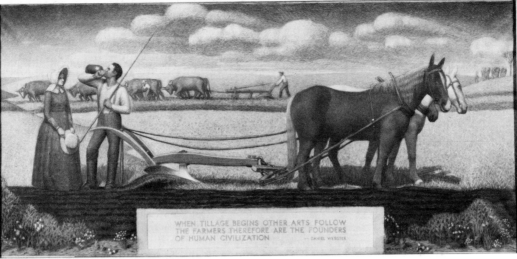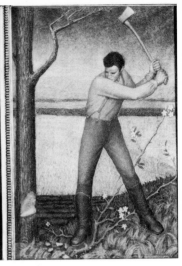

189. *When Tillage Begins,*
preparatory drawing for mural, Iowa State University Library, Ames, Iowa, 1934. Charcoal on paper, triptych, 23″ high × 16½″ + 49″ + 16½″.

he applied his concept to the transition of agriculture from hand-work to advanced machine operation, Ellul would no doubt have concluded that "technique" automatically diminishes the farmer's intuitive interaction with nature and that only unpredictable natural conditions and human fallibility can temporarily disrupt standardized procedures. "The technical absorbs the natural," he stated, and machine techniques exploit the interdependence of man and his tools until, depersonalized, man serves "technique" and labors routinely, more and more oblivious of his mechanical counterpart.[17] In Wood's *Fall Plowing* the all-steel bull-tongue plowshare poised in a furrow waits to be motorized and incorporated into an even more efficient and impersonal system.

The only pictures by Grant Wood that clearly illustrate the forces under attack by Carlyle and Ellul came about through mural commissions for the library at Iowa State University at Ames, which were made with the support of federal government relief funds (Figures 189 and 190). The assigned subject matter, in sharp contrast to the subtle agrarian-pastoralism of his farmscapes, unconditionally advocates technological development of farming through specialized research and field experiments. Only a shadow of the yeoman farmer waits in the hayloft of the barn, to be released from his hand-work discomforts by the latest agricultural methods.

In the mural in the first-floor alcove, a pair of pioneer farmers chop down trees to clear more land and flank a long central panel depicting two stages of plowing. In the background, teams of oxen pull a cumbersome plow through tough prairie grass while a farmer and his well-dressed wife rest behind a sleek plow and a team of fastidiously curried horses. Progress has been made. The inscription, particularly appropriate for boosting a university of agriculture and mechanical arts, quotes from a speech by Daniel Webster: "When tillage begins, other arts follow. The farmers therefore are the founders of human civilization." Dismissing the damages that the Northern Railroad did to Webster's own farm as mere "inconveniences," the great orator from Massachusetts had effectively represented the interests of Boston manufacturers in the Senate[18] and

continued to champion industrial development at any cost to the landscape. To promote his speculation in Western land, he paid standard rhetorical tribute to agriculture as the everlasting basis of an American economy. But when he declared farmers to be the founders of civilization, he could hardly have visualized an agrarian garden of husbandmen pursuing happiness through tillage. If the murals leading up the staircase to the reading room accurately fulfill Webster's prophecy, "the arts following tillage" include only the practical arts of applied science and engineering, the only arts essential to supplying food for the industrial city as efficiently and profitably as possible.

While technology continued to triumph as the new provider for the twentieth century, reducing the farmer to the role of a skilled operative dependent upon a massive complex of corporate merchandizing and government subsidy, the myth of the agrarian yeomen tending a pastoral garden in harmony with nature refused to vanish completely. To Grant Wood belongs credit for envisioning modern pictorial imagery for this persistent myth, through which he achieved a regionalist mode of universality. He transformed his Iowa farm land into a decorative composition of streamlined forms distinguished by pastel hues, pronounced patterns, and ornamental fauna. Idealized figures of contented farm folk work its fields without motor machines and stop to share its bounty with the world, a fantasy of human fulfillment. But no matter how imaginary his farmscapes become, they are distinctively reflective of both social and cultural realities. They touch upon the farmer's traditional self-image of innocence and at the same time embody a twentieth-century technological society and its pervasive force of "technique." In either case, Grant Wood's treatment of farmer material does not manifest the academic or reactionary in its attempt to sustain the agrarian myth in an extended pastoral setting. As a sophisticated synthesis of the old and the new, his farm pictures lie much closer to contemporary civilization and its cosmopolitan tastes than to a golden age of the Arcadian or to the lost wilderness of mid-America's brief picturesque phase.

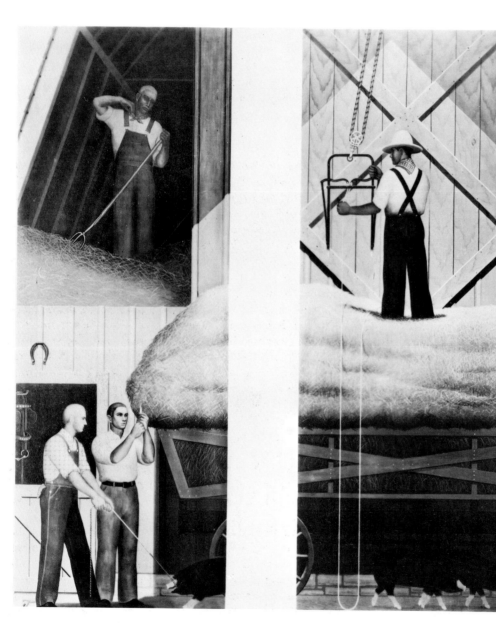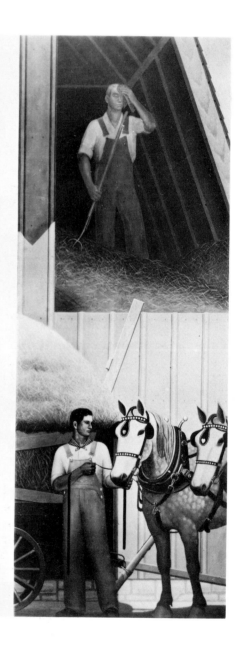

190. *Agricultural Science Murals*,
main stairway, Iowa State University Library,
Ames, Iowa, 1934–1937.
Oil on canvas.

# Appendix:
# *Revolt Against the City* by Grant Wood

[One year after joining the faculty at the University of Iowa, Grant Wood wrote a statement outlining his basic principles of art. The title of the essay, *Revolt Against the City*, underlines its rhetorical promotion of regionalism, a movement to which artists all over the United States must, according to Wood, dedicate themselves in order to avoid a "colonial" dependency on European tradition. He felt that the rural Midwest—the farmer's life, dress, and setting—would provide the richest kind of material for a truly indigenous regionalist style. *Revolt Against the City* appeared as the first of four pamphlets edited and independently published in Iowa City in 1935 by Frank Luther Mott, a renowned journalism professor and historian of the press. Following the essay by Grant Wood, the short-lived "Whirling World Series" completed its brief run with three works by regional writers: an experimental "musical play" concerning a farm family entitled *Shroud My Body Down* by Paul Green, an interpretation in verse form of Chaucer's pilgrims by Edwin Ford Piper, entitled *Canterbury Pilgrims*, and a collection of poems devoted to rural life in Iowa by Hamlin Garland called *Iowa O Iowa.*]

The present revolt against the domination exercised over art and letters and over much of our thinking and living by Eastern capitals of finance and politics brings up many considerations that, ought to be widely discussed. It is no isolated phenomenon, and it is not to be understood without consideration of its historical, social and artistic backgrounds. And though I am not setting out, in this essay, to trace and elaborate all of these backgrounds and implications, I wish to suggest a few of them in the following pages.

One reason for speaking out at this time lies in the fact that the movement I am discussing has come upon us rather gradually and without much blowing of trumpets, so that many observers are scarcely aware of its existence. It deserves, and I hope it may soon have, a much more thorough consideration than I give it here.

But if it is not vocal—at least in the sense of issuing pronuncia-

mentos, challenges, and new credos—the revolt is certainly very active. In literature, though by no means new, the exploitation of the "provinces" has increased remarkably; the South, the Middle West, the Southwest have at the moment hosts of interpreters whose Pulitzer-prize works and best sellers direct attention to their chosen regions. In drama, men like Paul Green, Lynn Riggs, and Jack Kirkland have been succeeding in something that a few years ago seemed impossible—actually interesting Broadway in something besides Broadway. In painting there has been a definite swing to a like regionalism; and this has been aided by such factors as the rejection of French domination, a growing consciousness of the art materials in the distinctively rural districts of America, and the system of PWA art work. These developments have correlations in the economic swing toward the country, in the back-to-the-land movement —that social phenomenon which Mr. Ralph Borsodi calls the "flight" from the city.

In short, America has turned introspective. Whether or not one adopts the philosophy of the "America Self-Contained" group, it is certain that the Depression Era has stimulated us to a re-evaluation of our resources in both art and economics, and that this turning of our eyes inward upon ourselves has awakened us to values which were little known before the grand crash of 1929 and which are chiefly non-urban.

Mr. Carl Van Doren has pointed out the interesting fact that America rediscovers herself every thirty years or so. About once in each generation, directed by political or economic or artistic impulses, we have re-evaluated or reinterpreted ourselves. It happened in 1776, of course, and again a generation later with the Louisiana Purchase and subsequent explorations and the beginnings of a national literature. It came again with the expansion of the Jacksonian era in the eighteen-thirties, accompanied by a literary flowering not only in New England but in various frontier regions. It was marked in the period immediately after our Civil War, when Emerson observed that a new map of America had been unrolled before us. In

the expansionist period at the turn of the century, shortly after the Spanish War when the United States found herself a full-fledged world power, we had a new discovery of resources and values. And now, with another thirty-year cycle, it comes again. It is always slightly different, always complex in its causes and phenomena; but happily it is always enlightening.

Moreover, these periods of national awakening to our own resources have always been in some degree reactions from foreign relationships. These reactions are obvious even to the casual reader of history and need not be listed here except as to their bearing on the present rediscovery. Economic and political causes have contributed in these days to turn us away from Europe—high tariff walls, repudiation of debts by European nations, the reaction against "entangling alliances" which followed upon President Wilson's effort to bring this country into the League of Nations, and the depression propaganda for "America Self-Contained."

But one does not need to be an isolationist to recognize the good which our artistic and literary secession from Europe has done us. For example, until fifteen years ago it was practically impossible for a painter to be recognized as an artist in America without having behind him the prestige of training either in Paris or Munich, while today the American artist looks upon a trip to Europe as any tourist looks upon it—not as a means of technical training or a method of winning an art reputation, but as a valid way to get perspective by foreign travel. This is a victory for American art of incalculable value. The long domination of our own art by Europe, and especially by the French, was a deliberately cultivated commercial activity—a business—and dealers connected with the larger New York galleries played into the hands of the French promoters because they themselves found such a connection profitable.

Music, too, labored under similar difficulties. Singers had to study in Germany or Italy or France; they had to sing in a foreign language, and they even had to adopt German or Italian or French names if they were to succeed in opera. In literature the language relationship made us subject especially to England. The whole of the nineteenth century was one long struggle to throw off that domination—a struggle more or less successful, but complicated in these later years by a continuation of the endless line of lionizing lecture tours of English authors and by the attempt to control our culture by the Rhodes scholarships which have been so widely granted.

This European influence has been felt most strongly in the Eastern States and particularly in the great Eastern seaport cities.

René d'Harnoncourt, the Austrian artist who took charge of the Mexican art exhibit a few years ago and circulated it throughout the United States, and who probably has a clearer understanding of American art conditions than we do who are closer to them, believes that culturally our Eastern States are still colonies of Europe. The American artist of today, thinks d'Harnoncourt, must strive not so much against the French influence, which, after all, is merely incidental, but against the whole colonial influence which is so deep-seated in the New England States. The East is nearer to Europe in more than geographical position, and certain it is that the eyes of the seaport cities have long been focussed upon the "mother" countries across the sea. But the colonial spirit is, of course, basically an imitative spirit, and we can have no hope of developing a culture of our own until that subserviency is put in its proper historical place.

Inevitable though it probably was, it seems nevertheless unfortunate that such art appreciation as developed in America in the nineteenth century had to be concentrated in the large cities. For the colonial spirit thereby was given full rein and control. The dominant factor in American social history during the latter part of that century is generally recognized as being the growth of large cities. D. R. Fox, writing an introduction to Arthur M. Schlesinger's "The Growth of the City," observes:

> The United States in the eighties and nineties was trembling between two worlds, one rural and agricultural, the other urban and industrial. In this span of years . . . traditional America gave way to a new America, one more akin to Europe than to its former self, yet retaining an authentic New World quality . . . The present volume is devoted to describing and appraising the new social force which waxed and throve while driving the pioneer culture before it: the city.

This urban growth, whose tremendous power was so effective upon the whole of American society, served, so far as art was concerned, to tighten the grip of traditional imitativeness, for the cities were far less typically American than the frontier areas whose power they usurped. Not only were they the seats of the colonial spirit, but they were inimical to whatever was new, original and alive in the truly American spirit.

Our Middle West, and indeed the "provinces" in general, have long had much the same attitude toward the East that the coastal

cities had toward Europe. Henry James's journey to Paris as a sentimental pilgrim was matched by Hamlin Garland's equally passionate pilgrimage to Boston. It was a phase of the magnetic drawing-power of the Eastern cities that the whole country, almost up to the present time, looked wistfully eastward for culture; and these seaport centers drew unto them most of the writers, musicians and artists who could not go on to Europe. And the flight of the "intelligentsia" to Paris was a striking feature of the years immediately after the World War.

The feeling that the East, and perhaps Europe, was the true goal of the seeker after culture was greatly augmented by the literary movement which Mr. Van Doren once dubbed "the revolt against the village." Such books as "Spoon River Anthology" and "Main Street" brought contempt upon the hinterland and strengthened the cityward tendency. H. L. Mencken's urban and European philosophy was exerted in the same direction.

But sweeping changes have come over American culture in the last few years. The Great Depression has taught us many things, and not the least of them is self-reliance. It has thrown down the Tower of Babel erected in the years of a false prosperity; it has sent men and women back to the land; it has caused us to rediscover some of the old frontier virtues. In cutting us off from traditional but more artificial values, it has thrown us back upon certain true and fundamental things which are distinctively ours to use and to exploit.

We still send scholars to Oxford, but it is significant that Paul Engle produced on his scholarship time one of the most American volumes of recent verse. Europe has lost much of its magic. Gertrude Stein comes to us from Paris and is only a seven days' wonder. Ezra Pound's new volume seems all compounded of echoes from a lost world. The expatriates do not fit in with the newer America, so greatly changed from the old.

The depression has also weakened the highly commercialized New York theatre; and this fact, together with the wholesome development of little theatres, may bring us at last an American drama. For years our stage has been controlled by grasping New York producers. The young playwright or actor could not succeed unless he went to New York. For commercial reasons, it was impossible to give the drama any regional feeling; it had little that was basic to go on and was consequently dominated by translations or reworkings of French plays and by productions of English drawing-room comedies, often played by imported actors. The advent of the movies changed this condition only by creating another highly urbanized center at Hollywood. But we have now a revolt against this whole system—a revolt in which we have enlisted the community theatres, local playwriting contests, some active regional playwrights, and certain important university theatres.

Music (and perhaps I am getting out of my proper territory here, for I know little of music) seems to be doing less outside of the cities than letters, the theatre, and art. One does note, however, local music festivals, as well as such promotion of community singing as that which Harry Barnhardt has led.

But painting has declared its independence from Europe, and is retreating from the cities to the more American village and country life. Paris is no longer the Mecca of the American artist. The American public, which used to be interested solely in foreign and imitative work, has readily acquired a strong interest in the distinctly indigenous art of its own land; and our buyers of paintings and patrons of art have naturally and honestly fallen in with the movement away from Paris and the American pseudo-Parisians. It all constitutes not so much a revolt against French technique as against the adoption of the French mental attitude and the use of French subject matter which he can best interpret because he knows it best. an American way of looking at things, and a utilization of the materials of our own American scene.

This is no mere chauvinism. If it is patriotic, it is so because a feeling for one's own milieu and for the validity of one's own life and its surroundings is patriotic. Certainly I prefer to think of it, not in terms of sentiment at all, but rather as a common-sense utilization for art of native materials—an honest reliance by the artist upon subject matter which he can best interpret because he knows it best.

Because of this new emphasis upon native materials, the artist no longer finds it necessary to migrate even to New York, or to seek any great metropolis. No longer is it necessary for him to suffer the confusing cosmopolitanism, the noise, the too intimate gregariousness of the large city. True, he may travel, he may observe, he may study in various environments, in order to develop his personality and achieve backgrounds and a perspective; but this need be little more than incidental to an educative process that centers in his own home region.

The great central areas of America are coming to be evaluated more and more justly as the years pass. They are not a Hinterland for New York; they are not barbaric. Thomas Benton returned to make his home in the Middle West just the other day, saying, according to the newspapers, that he was coming to live again in the

only region of the country which is not "provincial." John Cowper Powys, bidding farewell to America recently in one of our great magazines, after a long sojourn in this country, said of the Middle West:

> This is the real America; this is—let us hope!—the America of the future; this is the region of what may, after all, prove to be, in Spenglerian phrase, the cradle of the next great human "culture."

When Christopher Morley was out in Iowa last Fall, he remarked on its freedom, permitting expansion "with space and relaxing conditions for work." Future artists, he wisely observed, "are more likely to come from the remoter areas, farther from the claims and distractions of an accelerating civilization."

So many of the leaders in the arts were born in small towns and on farms that in the comments and conversation of many who have "gone East" there is today a noticeable homesickness for the scenes of their childhood. On a recent visit to New York, after seven continuous years in the Middle West, I found this attitude very striking. Seven years ago my friends had sincerely pitied me for what they called my "exile" in Iowa. They then had a vision of my going back to an uninteresting region where I could have no contact with culture and no association with kindred spirits. But now, upon my return to the East, I found these same friends eager for news and information about the rich funds of creative material which this region holds.

I found, moreover, a determination on the part of some of the Eastern artists to visit the Middle West for the purpose of obtaining such material. I feel that, in general, such a procedure would be as false as the old one of going to Europe for subject matter, or the later fashion of going to New England fishing villages or to Mexican cities or to the mountains of our Southwest for materials. I feel that whatever virtue this new movement has lies in the necessity the painter (and the writer, too) is under, to use material which is really a part of himself. However, many New York artists and writers are more familiar, through strong childhood impressions, with village and country life than with their adopted urban environment; and for them a back-to-the-village movement is entirely feasible and defensible. But a cult or a fad for Midwestern materials is just what must be avoided. Regionalism has already suffered from a kind of cultism which is essentially false.

I think the alarming nature of the depression and the general economic unrest have had much to do in producing this wistful nostalgia for the Midwest to which I have referred. This region has always stood as the great conservative section of the country. Now, during boom times conservatism is a thing to be ridiculed, but under unsettled conditions it becomes a virtue. To the East, which is not in a position to produce its own food, the Middle West today looks a haven of security. This is, of course, the basis for the various projects for the return of urban populations to the land; but it is an economic condition not without implications for art. The talented youths who, in the expensive era of unlimited prosperity, were carried away on waves of enthusiasm for projects of various sorts, wanting nothing so much as to get away from the old things of home, now, when it all collapses, come back solidly to the good earth.

But those of us who have never deserted our own regions for long find them not so much havens of refuge, as continuing friendly, homely environments.

As for my own regon—the great farming section of the Middle West—I find it, quite contrary to the prevailing Eastern impression, not a drab country inhabited by peasants, but a various, rich land abounding in painting material. It does not, however, furnish scenes of the picture-postcard type that one too often finds in New Mexico or further West, and sometimes in New England. Its material seems to me to be more sincere and honest, and to gain in depth by having to be hunted for. It is the result of analysis, and therefore is less obscured by "picturesque" surface quality. I find myself becoming rather bored by quaintness. I lose patience with the thinness of things viewed from outside, or from a height. Of course, my feeling for the genuineness of this Iowa scene is doubtless rooted in the fact that I was born here and have lived here most of my life. I shall not quarrel with the painter from New Mexico, from further West, or from quaint New England, if he differs with me; for if he does so honestly, he doubtless has the same basic feeling for his material that I have for mine—he believes in its genuineness. After all, all I contend for is the sincere use of native material by the artist who has command of it.

Central and dominant in our Midwestern scene is the farmer. The depression, with its farm strikes and the heroic attempts of Government to find solutions for agrarian difficulties, has emphasized for us all the fact that the farmer is basic in the economics of the country—and, further, that he is a human being. The farm

strikes, strangely enough, caused little disturbance to the people of the Middle West who were not directly concerned in them; but they did cause both surprise and consternation in the East, far away as it is from the source of supplies. Indeed, the farm strikes did much to establish the Midwestern farmer in the Eastern estimation as a man, functioning as an individual capable of thinking and feeling, and not an oaf.

Midwestern farmers are not of peasant stock. There is much variety in their ancestry, of course; but the Iowa farmer as I know him is fully as American as Boston, and has the great advantage of being farther away from European influence. He knows little of life in crowded cities, and would find such intimacies uncomfortable; it is with difficulty that he reconciles himself even to village life. He is on a little unit of his own, where he develops an extraordinary independence. The economics, geography, and psychology of his situation have always accented his comparative isolation. The farmer's reactions must be toward weather, tools, beasts, and plants to a far greater extent than those of city dwellers, and toward other human beings far less: this makes him not an egoist by any means, but (something quite different) a less socialized being than the average American. The term "rugged individualism" has been seized upon as a political catchword, but it suits the farmer's character very well.

Of course, the automobile and the radio have worked some change in the situation; but they have not altered the farmer's essential character in this generation, whatever they may do in the next. More important so far as change is concerned have been recent economic conditions, including the foreclosing of mortgages; and these factors, threatening the farmer's traditional position as a self-supporting individual, threatening even a reduction to a kind of American peasantry, brought on the violent uprisings of the farm strikes and other protests.

The farmer is not articulate. Self-expression through literature and art belong not to the set of relationships with which he is familiar (those with weather, tools, and growing things), but to more socialized systems. He is almost wholly preoccupied with his struggle against the elements, with the fundamental things of life, so that he has no time for Wertherism or for the subtleties of interpretation. Moreover, the farmers that I know (chiefly of New England stock) seems to me to have something of that old Anglo-Saxon reserve which made our ancient forebears to look upon much talk about oneself as a childish weakness. Finally, ridicule by city folks

with European ideas of the farmer as a peasant, or, as our American slang has it, a "hick," has caused a further withdrawal—a proud and disdainful answer to misunderstanding criticism.

But the very fact that the farmer is not himself vocal makes him the richest kind of material for the writer and the artist. He needs interpretation. Serious, sympathetic handling of farmer-material offers a great field for the careful worker. The life of the farmer, engaged in a constant conflict with natural forces, is essentially dramatic. The drouth of last Summer provided innumerable episodes of the most gripping human interest. The nomadic movements of cattlemen in Wisconsin, in South Dakota, and in other states, the great dust storms, the floods following drouth, the milk strikes, the violent protests against foreclosures, the struggles against dry-year pests, the sacrifices forced upon once prosperous families—all these elements and many more are colorful, significant, and intensely dramatic.

It is a conflict quite as exciting as that of the fisherman with the sea. I have been interested to find in the little town of Waubeek, near my home, farmer-descendants of the folk of New England fishing villages. Waubeek has not changed or grown much since it was originally settled, because it was missed by the railroads and by the paved highways. The people of this community have kept as family heirlooms some of the old whaling harpoons, anchors, and so on which connect them with the struggle which their ancestors waged with the sea. But their own energies are transferred to another contest, and their crops come not out of the water but out of the land. I feel that the drama and color of the old fishing villages have become hackneyed and relatively unprofitable, while little has been done, in painting at least, with the fine materials that are inherent in farming in the great region of the Mid-American States.

My friend and fellow-townsman Jay Sigmund devotes his leisure hours to the writing of verse celebrating the kind of human beings I have been discussing. He is as much at home in Waubeek— perhaps more so—as in the office of his insurance company. I wish to quote a poem of his in this place.

#### VISITOR

I knew he held the tang of stack and mow—
  One sensed that he was brother to the soil;
  His palms were stained with signs of stable toil
And calloused by the handles of the plow.

Yet I felt bound to him by many ties:
  I knew the countryside where he was born;
  I'd seen its hillsides green with rows of corn,
And now I saw its meadows in his eyes.

For he had kept deep-rooted in the clay,
  While I had chosen market-place and street;
  I knew the city's bricks would bruise his feet
And send him soon to go his plodding way.

But he had sought me out to grip my hand
  And sit for one short hour by my chair.
  Our talk was of the things that happen where
The souls of men have kinship with the land.

I asked him of the orchard and the grove,
  About the bayou with its reedy shore,
  About the grey one in the village store
Who used to doze beside a ruddy stove.

He told me how the creek had changed its bed,
  And how his acres spread across the hill;
  The hour wore on and he was talking still,
And I was hungry for the things he said.

Then I who long had pitied peasant folk
  And broken faith with field and pasture ground
  Felt dull and leaden-footed in my round,
And strangely like a cart-beast with a yoke!

There is, of course, no ownership in artistic subject matter except that which is validated by the artist's own complete apprehension and understanding of the materials. By virtue of such validation, however, the farm and village matter of a given region would seem peculiarly to belong to its own regional painters. This brings up the whole of the ancient moot question of regionalism in literature and in art.

Occasionally I have been accused of being a flag-waver for my own part of the country. I do believe in the Middle West—in its people and in its art, and in the future of both—and this with no derogation to other sections. I believe in the Middle West in spite of

abundant knowledge of its faults. Your true regionalist is not a mere eulogist; he may even be a severe critic. I believe in the regional movement in art and letters (comparatively new in the former though old enough in the latter); but I wish to place no narrow interpretation on such regionalism. There is, or at least there need be, no geography of the art mind or of artistic talent or appreciation. But painting and sculpture do not raise up a public as easily as literature, and not until the break-up caused by the Great Depression has there really been an opportunity to demonstrate the artistic potentialities of what some of our Eastern city friends call "the provinces."

Let me try to state the basic idea of the regional movement. Each section has a personality of its own, in physiography, industry, psychology. Thinking painters and writers who have passed their formative years in these regions, will, by care-taking analysis, work out and interpret in their productions these varying personalities. When the different regions develop characteristics of their own, they will come into competition with each other; and out of this competition a rich American culture will grow. It was in some such manner that Gothic architecture grew out of competition between different French towns as to which could build the largest and finest cathedrals. And indeed the French Government has sponsored a somewhat similar kind of competition ever since Napoleon's time.

The germ of such a system for the United States is to be found in the art work recently conducted under the PWA. This was set up by geographical divisions, and it produced remarkable results in the brief space of time in which it was in operation. I should like to see such encouragement to art work continued and expanded. The Federal Government should establish regional schools for art instruction to specially gifted students in connection with universities or other centers of culture in various sections.

In suggesting that these schools should be allied with the universities, I do not mean to commit them to pedantic or even strictly academic requirements. But I do believe that the general liberal arts culture is highly desirable in a painter's training. The artist must know more today than he had to know in former years. My own art students, for example, get a general course in natural science—not with any idea of their specializing in biology or physics, but because they need to know what is going on in the modern world. The main thing is to teach students to think, and if they can to feel. Technical expression, though important, is secondary; it will follow in due

time, according to the needs of each student. Because of this necessity of training in the liberal arts, the Government art schools should be placed at educational centers.

The annual exhibits of the work of schools of this character would arouse general interest and greatly enlarge our American art public. A local pride would be excited that might rival that which even hard-headed business men feel for home football teams and such enterprises. There is nothing ridiculous about such support; it would be only a by-product of a form of public art education which, when extended over a long period of time would make us a great art-loving nation.

Mural painting is obviously well adapted to Government projects, and it is also highly suitable for regional expression. It enables students to work in groups, to develop original ideas under proper guidance, and to work with a very definite purpose. I am far from commending all the painting that has gone onto walls in the past year or two, for I realize there has not been much success in finding a style well suited to the steel-construction building; but these things will come, and there is sure to be a wonderful development in mural painting within the next few years. In it I hope that art students working with Government aid may play a large part. My students at the State University of Iowa hope to decorate the entire University Theatre, when the building is finished, in true fresco; and there is to be regional competition for the murals and sculpture in three new Iowa postoffices—at Dubuque, Ames, and Independence.

I am willing to go so far as to say that I believe the hope of a native American art lies in the development of regional art centers and the competition between them. It seems the one way to the building up of an honestly art-conscious America.

It should not be forgotten that regional literature also might well be encouraged by Government aid. Such "little" magazines as Iowa's "Midland" (now unfortunately suspended), Nebraska's "Prairie Schooner," Oklahoma's "Space," Montana's "Frontier" might well be subsidized so that they could pay their contributors. A board could be set up which could erect standards and allocate subsidies which would go far toward counteracting the highly commercialized tendencies of the great eastern magazines.

But whatever may be the future course of regional competitions, the fact of the revolt against the city is undeniable. Perhaps but few would concur with Thomas Jefferson's characterization of cities as "ulcers on the body politic"; but, for the moment at least, much of their lure is gone. Is this only a passing phase of abnormal times? Having at heart a deep desire for a widely diffused love for art among our whole people, I can only hope that the next few years may see a growth of non-urban and regional activity in the arts and letters.

# Notes

## Chapter 1.  The Early Landscapes

1. Examples of Grant Wood's school drawings are in the John B. Turner Collection of early Grant Wood works, Cedar Rapids Art Center, Cedar Rapids, Iowa.

2. The fifteen-year-old Grant Wood derived the composition of *Currants*, down to its boxed initials, from the vertical sketches of delicate stems, leaves, blossoms, and seeds illustrating a chapter entitled "Decorative Arrangement" in the book *The Principles of Design* published by Ernest A. Batchelder in 1904 (Chicago). Batchelder based his compositions on Japanese models.

3. The biographical material in Part I originates from personal interviews with Grant Wood's friends and associates, from a week's visit with his sister Mrs. Nan Wood Graham of Riverside, California, and from a conversation with his brother, Frank Wood, of San Diego.

4. In his often inaccurately anecdotal, undocumented, and unauthorized biography *Artist in Iowa; A Life of Grant Wood* (New York, 1944) Darrell Garwood inferred that Hanson and Wood published an article entitled "Peer Gynt's Cabin and Other Log Houses Associated with the History and Romance of Norway." This article, however, as it appears in *The Craftsman* (22 [September 1912] pp. 582–596) bears the name of Catherine D. Groth as its author.

5. The mortgage was foreclosed on his mother's house, which had been rented to undependable tenants while she and her daughter Nan lived with Mrs. Wood's sister, also a widow. When warm weather returned, Wood purchased with a one-dollar deposit a wooded lot high on a bluff overlooking Indian Creek in Kenwood Heights. There, drawing on memories of his farmer father who had died in 1901, he spent the summer erecting a small cabin and growing a vegetable garden, painting whenever he could. By late fall he had started to build two small hipped-roof houses in the village of Kenwood Park on adjoining lots purchased by Paul Hanson, who agreed to give Wood the lot at 3118 Grove Court, S.E., in return for his labor. Since the summer cabin was not heated, the Woods moved into a makeshift but stove-equipped shack, also owned by Hanson, until early in 1917 when one of the houses was finished enough to shelter them from the wind and snow. While the Wood women and the Hansons lived in the completed house, Grant Wood and Leonidas Dennis, who was helping him with the carpentry, slept in the unfinished, unheated house. Meals consisted of canned beans. Mrs. Nan Wood Graham provided this information in an undated letter from early 1973.

6. The dating of works from the end of World War I to Wood's first trip to Paris in 1920 is aided by a small single-fold catalogue printed for the exhibition of his paintings and of works by his friend Marvin Cone. The exhibition was held in the Picture Galleries of Killian's Department Store, Cedar Rapids, October 9–22, 1919. Of the twenty-three paintings listed for Wood, I have to date located eleven.

7. In 1927 Wood painted harvest scenes on canvas covering all four walls of the dining room, "The Corn Room," in the Hotel Chieftain, Council Bluffs, Iowa. These scenes included a farmhouse, barns, silo, and windmill, in addition to the fields of shocked corn. A real wood-rail fence attached to the wall protected the murals.

In 1970 only fragments of these murals survived the destruction of the dining room when the hotel was remodeled into a home for the aged. A set of three oil-on-canvas murals also painted by Wood in 1927, with overall dimensions of 6′ × 24′, was completely salvaged from the walls of a conference room in the hotel by Dr. Milton Heifetz, a Los Angeles neurosurgeon. Depicting the Mormon settlement of Kanesville, which later became Council Bluffs, the scenes of these murals were based on an anonymous view of the original village painted in 1849. See Donald D. Jones, "The Grant Wood Murals—It's Farewell to Iowa," *Kansas City Star*, August 9, 1970, Section D, p. 1.

## Chapter 2.  Backyard View of Europe

1. The small tract of land extending over a wooded hill is discussed by Wood in an article in *The New Country Life*, April 1917, entitled "No Trespassing" (p. 118). In it Wood recounts the abuse that he, his family, and his small preserve of nature suffered from thoughtless picnickers who left their litter and took the flowers, berries, and nuts. Wood's own knowledge and appreciation of nature is expressed throughout the article, and the following passage presages the composition and spirit of his mature landscapes:

> The view from the hilltop was vast and splendid, and even on hottest days the high land was swept with cooling breezes. The piece was well dotted with oak, elm, and nut trees, and alluring paths ran to the bluff's edge, while the slope in spring was a carpet of flowers. We were delighted with our find, and in the first flush of possession wanted to share it with the whole world.

2. George Moore, *Modern Painting* (London, 1898), p. 248.

3. Quoted in Gustave Geffroy, *Claude Monet, sa vie, son temps, son oeuvre* (Paris, 1922), p. 189.

4. Marvin Cone discussed his friend Grant Wood and their experiences in Paris on a radio interview broadcast from WMT, Cedar Rapids, Iowa, April 17, 1942. Unpublished transcript in the possession of Mrs. Nan Wood Graham, Riverside, California.

5. Postcards from Wood to his mother postmarked Paris, July 6, 10, 13, and 16, 1920. Postcards sent home from Paris during this trip are in the possession of Mrs. Nan Wood Graham, Riverside, California.

6. Postcards from Wood to his mother, sent from Paris in an envelope in August 1920. In the possession of Mrs. Nan Wood Graham, Riverside, California.

7. Postcard from Wood to his mother, postmarked Paris, August 11, 1920. In the possession of Mrs. Nan Wood Graham, Riverside, California.

8. The academic nude male figure was painted with a neo-Impressionist technique, its division of colors corresponding to evenly distributed brushstrokes. Wood nicknamed it "Spotted Man," but in 1934 he reworked and refined the surface to a finer texture so that the figure lost most of its spots. Wood shipped the painting to his New York dealer Maynard Walker as an entry in a National Academy exhibition. Letter from Grant Wood to Maynard Walker, December 22, 1934, Archives of American Art, National Collection of Fine Arts Library, Smithsonian Institution, Washington, D.C. Of his paintings *The Spotted Man* and *Portrait of Nan* were the only ones in his possession at the time of his death.

9. In 1940 this painting was transferred to the Grand Lodge of Masons in Cedar Rapids, Iowa.

10. The frame of *The Adoration of the Home* bears the inscription "This Mural Celebrating Cedar Rapids As a City of Homes Was Painted by Grant Wood for Henry S. Ely and Company, Realtors." As an "outdoor mural" the picture stood under a canopy next to the Ely office at an intersection in the middle of town.

The academic style of its composition and naturalistic figures doubtlessly found inspiration in the murals painted by Allen E. Philbrick in 1911 for the interior of Louis Sullivan's Peoples Savings Bank in Cedar Rapids. Flanked by two bucolic farm scenes, its central panel allegorizes Industry, Banking, and Commerce. Banking sits enthroned on an exedra accompanied by female allegories, industrial workers, and a railroad man. Silhouetted against a gold-leaf sky, the town of factories and houses fills the background.

11. Ernest A. Batchelder, "How Medieval Craftsmen Created Beauty by Meeting the Constructive Problems of Gothic Architecture," *The Craftsman*, 16 (April-September 1909), pp. 44–49.

12. Ernest A. Batchelder, "Carving as an Expression of Individuality: Its Purpose in Architecture," *The Craftsman*, 16 (April-September 1909), pp. 60–69.

13. Edward Hopper, "John Sloan and the Philadelphians," *The Arts*, 11 (April 1927), pp. 169–179.

14. *Ibid.*, p. 173.

### Chapter 3. *American Gothic* and Late Gothic

1. The contract was for $10,000. Naomi Doebel, "Memorial Window for Island Building Will Be Symbol of Peace and Tribute to Heroic Dead," *Cedar Rapids Gazette*, January 13, 1929.

2. The large academic, allegorical female figure also appeared hovering over a chest in an emblem that Wood designed for the Cedar Rapids Community Chest in 1927. Holding a plaque above her head, she looks directly out at the public. On either side sculptural, relieflike figures represent youth, old age, poverty, the disabled, and education. Five years later these figures formed the background of a photographic rendering in pencil portraying John Northcott, who died while directing the Community Chest drive in 1933. Wood's drawing formed a full-page ad in the *Cedar Rapids Gazette*, December 3, 1933.

That an academic female allegory was far from novel to Wood is recalled by a mural that he produced for Harrison High School. The mural depicted "Democracy Leading the World on to Victory" along fifty feet of a corridor in a new annex. Democracy hovered above the heads of figures representing the Army, Navy, Science, and Labor, who gazed at a copy of President Wilson's declaration of war. The school building was destroyed by fire in 1929.

Mythological female figures accompany male counterparts on a set of doors that Wood designed and painted in classical form for the study of Mr. Van Vechten Shaffer late in the 1920s.

3. Doebel, "Memorial Window for Island Building," *Cedar Rapids Gazette*, January 13, 1929.

4. *Ibid.*

5. Wood designed and executed rooms for the Turner Mortuary and for several private residences including the homes of Van Vechten Shaffer, Herbert Stamats, and G. Stewart Holmes.

6. That Grant Wood suddenly discovered Late Gothic painting when in Munich and simply chose between it and contemporary German painting, which was labeled *Neue Sachlichkeit*, as the major influence on his new style has been too often maintained without proper comparison of his post-Munich paintings with specific works from either source. For example, Oskar Hagen stressed the former as the cause of Wood's change, while H. W. Janson insisted that it had to be the latter. For quoted statement by Hagen see Margaret Thoma, "The Art of Grant Wood," *Demcourier*, 12 (May 1942), p. 8. For Janson's surprisingly untested contention see H. W. Janson, "The International Aspects of Regionalism," *College Art Journal*, 2 (May 1943), pp. 110–115. Or see H. W. Janson, "Benton and Wood, Champions of Regionalism," *Magazine of Art*, 39 (May 1946), p. 199.

7. A visit to Nuremberg is indicated by an unfinished oil sketch of its famous Schöner Brunnen painted in the city's central marketplace. This sketch appears on the back of the painting *Indian Creek*, 1929, an oil on canvas, in the possession of the Chamber of Commerce, Cedar Rapids,

Iowa (Plate 8). Another painting, entitled *Market Day, Nuremberg,* was exhibited in the Little Gallery, Cedar Rapids, in early 1929.

8. Irma R. Koen, "The Art of Grant Wood," *Christian Science Monitor,* March 26, 1932.

9. Quoted in Koen, *ibid.*

10. The line marking a railroad behind his head serves as a reminder to his descendants that John B. Turner, after arriving in Cedar Rapids in 1872, worked in the railroad mail service for twelve years.

11. Wood signed and dated the painting twice, first on the lower left, "GRANT WOOD 1928," and then in the lower right, "GRANT WOOD 1930," when he added the oval frame.

12. Oskar Hagen, *The Birth of the American Tradition in Art* (New York, 1940), p. 26.

13. After *John B. Turner, Pioneer* and *Portrait of Gordon Fennell, Jr.,* Wood painted portraits on panels, using in 1929 a thick composition called Upsom Board, which he replaced with the newly manufactured masonite by 1932. To size the somewhat loose, fibrous surface of the former, he applied several coats of Moore's White Undercoat, an oil-base paint, instead of a gesso ground. Thus, contrary to a general assumption that Wood thoroughly adopted the techniques and materials of the old Northern European masters, he never used egg tempera as underpainting. His "glaze technique" consisted of "wash glazes" with a single tint of color applied as a unifying tone over large areas of finished painting or over the entire work. This was lightly brushed onto the surface and then blotted with a rag before being sprayed with retouch varnish as a dryer in preparation for the next coat of glaze.

14. Quoted in Irma R. Koen, "The Art of Grant Wood," *Christian Science Monitor,* March 26, 1932.

15. Mary Lackersteen, an active member of the Cedar Rapids Community Theater, played the role of the affluent city woman. To add to the reality of the setting, the painting originally included a chicken-wire fence more than a fourth of the way up from the bottom. Through it could be seen the feet of the chicken, the gloved hands of the city woman, and the bottom edge of the farm woman's Loden cloth jacket. Wood finally eliminated the chicken-wire area in order to emphasize the country-versus-city theme.

16. Quoted in Irma R. Koen, "The Art of Grant Wood," *Christian Science Monitor,* March 26, 1932.

17. Wood discovered the house in Eldon while visiting a friend, John Sharp, who photographed it for him. Personal interview with Mrs. Nan Wood Graham, September 1971, Riverside, California.

18. "Open Forum," *Des Moines Sunday Register,* December 21, 1930.

19. See, for example, the opening paragraphs of Edgar Allan Poe's *The Fall of the House of Usher,* where the narrator approaches and enters the Usher mansion.

### Chapter 4. *Stone City* and the Fantasy Farmscape

1. Two of several Colorado views painted during a summer visit to Estes Park with David Turner in 1927.

2. Ben Shahn, *The Shape of Content* (Cambridge, Massachusetts, 1957), p. 44.

3. *Ibid.*

4. Dorothy C. Miller and Alfred H. Barr, Jr., ed., *American Realists and Magic Realists* (New York, 1943), pp. 5–6.

5. "Grant Wood Explains Why He Prefers to Remain in Middle West in Talk at Kansas City," *Cedar Rapids Sunday Gazette and Republican,* March 22, 1931.

6. An unpublished two-page typescript inscribed and dated "Grant Wood 1921" in the possession of Mrs. Nan Wood Graham, Riverside, California.

7. *Ibid.*

8. *Ibid.*

9. Thomas Craven, "Grant Wood," *Scribner's,* 101 (June 1937), pp. 21–22.

10. Grant Wood, *Revolt Against the City* (Iowa City, Iowa, 1935), pp. 15, 22, 26. (See Appendix.)

11. *Ibid.,* pp. 21–22.

### Chaper 5. A Comic-Sense View of American Fables (and Foibles)

1. According to Arnold Pyle, his assistant, Grant Wood borrowed a rocking horse to serve as a model for the Paul Revere mount which appears in the painting. Personal interview, February 1971, Cedar Rapids, Iowa.

2. Whether knowingly or not, Grant Wood did add a touch of retaliatory irony in choosing Leutze's *Crossing the Delaware* for the background of his *Daughters of Revolution.* Leutze, a German-American, painted the huge canvas in Düsseldorf, where he had actively participated in the Revolution of 1848. The painting was intended to inspire continued struggle for a democratic German republic. See Barbara Groseclose, "Emmanuel Leutze, 1816–1868: A German-American History Painter," dissertation, University of Wisconsin—Madison, 1973.

3. "A Patriot First to Edward Rowan," Letters to the Editor, *Cedar Rapids Gazette and Republican,* May 14, 1933. The Little Gallery under the direction of Edward Rowan was an experiment in community art patronage sponsored by the American Federation of Arts and financed by the Carnegie Foundation.

4. "News from the States," *Saturday Review of Literature,* 10 (August 12, 1933), p. 47.

5. "Art in the 1934 Fair," *Chicago Daily News,* June 18, 1934.

6. Rousseau Voorhies, a representative of Macmillan Publishing Company, reported meeting Gertrude Stein through Bernard Fay. Fay had edited her *The Making of Americans* and attended her salons in Paris in 1933. He told Voorhies that she often praised Grant Wood and quoted her as exclaiming, "We should fear Grant Wood. Every artist and every school of artists should be afraid of him for his devastating satire." "Gertrude Stein Praises Grant Wood," *Montrose* (Iowa) *Mirror,* July 17, 1934.

7. Quoted by Park Rinard in a catalogue for a Grant Wood exhibition at Lakeside Press Galleries, Chicago, 1935, and in his catalogue essay for the Fifty-Third Annual Exhibition of American Paintings and Sculpture of the Art Institute of Chicago in 1942.

8. Grant Wood made this statement in 1940 to a meeting of the Milwaukee College Club composed primarily of women. See "This War to Give America Art Leadership, Wood Says," *Milwaukee News Sentinel*, January 7, 1940.

9. As quoted in Bob Sherwood, "Grant Wood Disdains Desire to Belittle Washington," *Cedar Rapids Gazette*, February 26, 1939.

10. Macon L. Weems, *The Life of George Washington* (Cambridge, Massachusetts, 1962), p. 12.

11. Wood suggested Peale's painting as a source of inspiration when he stated:

> It didn't seem right to separate Parson Weems from the story he invented. So I decided to include him in the picture. One of the things about the old colonial portraits that has always amused me is the device of having a person in the foreground holding back a curtain from or pointing at a scene within the scene. This, it seemed to me, was a very appropriate way to get Parson Weems into this particular picture.

"Grant Wood Tells the Story of Latest Work," *Iowa City Press-Citizen*, January 6, 1940.

As with most of Wood's major figures, the face of Parson Weems was based on that of an actual person. Professor John E. Briggs, University of Iowa, served as his model.

12. *Ibid.* Wood also spoke of plans to paint a parody of the Pocahontas-Captain John Smith fable. For some unexplained reason, the captain was to be seen rescuing the Indian maid. The idea, however, never reached even a sketch stage.

13. According to his sister, Mrs. Nan Wood Graham, Grant Wood was a political independent who had become a Democrat by the time of his death. Personal interview, Riverside, California, September 1971. *The Birthplace of Herbert Hoover* should not necessarily be interpreted as a personal tribute to the ill-fated Republican President during the difficult months of his term. In a letter dated February 7, 1975, Mrs. Graham informs me that the painting had been "requested" by a group of Iowa businessmen who intended to present it to Herbert Hoover. The President, however, did not approve of the painting because it obscured the cabin in which he had been born by including the later large house. Consequently, the businessmen did not buy the work. After 1932 Wood did not care to exhibit the painting and was relieved when it was sold to Gardner Cowles of *Look* magazine through Ferargil Galleries in 1934. Letter from Grant Wood to Maynard Walker, May 15, 1934, Collection of Archives of American Art, National Collection of Fine Arts Library, Smithsonian Institution, Washington, D.C.

14. Cf. portraits of Mr. and Mrs. William Brown by John Smibert, c. 1740, Johns Hopkins University Collection, Baltimore; of Jeremiah Lee by John Singleton Copley, 1769, Wadsworth Atheneum, Hartford, Connecticut; and of Chief Justice and Mrs. Oliver Ellsworth by Ralph Earl, 1792, Wadsworth Atheneum.

15. The initial objections to the picture, publicly recorded in letters to the editor, concentrated on the head of the woman, which to many Iowa observers seemed forbidding. The man impressed those who wrote in as potentially kind or at least trustworthy ("Open Forum," *Des Moines Sunday Register*, December 21, 1930). By World War II the official corporate interpretation viewed the pair as expressive of positive, self-contained independence in place of self-righteous complacency. An article entitled "A Portfolio of Posters" in *Fortune* magazine of August 1941 suggested that the painting be used on a poster as "a symbol of the independent don't-tread-on-me character that Americans recognized as peculiarly American." (*Fortune*, 24, p. 79.)

16. Quoted by Park Rinard, Wood's appointed biographer, in the memorial Grant Wood Foreword to the catalogue of the Fifty-Third Annual Exhibition of American Paintings and Sculpture, The Art Institute of Chicago, 1942. Wood's statement regarding *American Gothic* is also quoted in a *Cedar Rapids Gazette* article by Dorothy Dougherty, "The Right and Wrong of America," September 6, 1942.

17. This growing consensus might be measured in the annual adaptations of *American Gothic* in political cartoons and various social satires.

18. The theme of female dominance in the endless "battle for the breeches" recurs in numerous prints beginning in the fifteenth century. The plucked rooster gained infamy in two of Goya's *Los Caprichos*, Nos. 19 and 20.

H. W. Janson insisted that the central figure of Wood's *Adolescence*, in order to be art-historically legitimate, had to be based on the plucked chicken representing the "Platonic biped" in the chiaroscuro woodcut *Diogenes* after Parmigianino by Ugo da Carpi (c. 1450–1525). See "The Case of the Naked Chicken," *College Art Journal*, 15 (Winter 1955–1956), pp. 124–127.

19. At least two earlier farmer figures standing with a horse or horses were produced by Wood: the farmer with a horse and calf on the left side of his "outdoor-mural" painting *Adoration of the Home*, 1922 (Figure 61), and a farmer between two horses in a small opaque watercolor sketch of 1923 now in The John Nelson Bergstrom Art Center and Museum, Neenah, Wisconsin.

20. The professors portrayed in *Honorary Degree* were two administrators at the University of Iowa, Dean Carl E. Seashore and Professor Norman Foerster.

21. 1936 and 1937 were years of graphic-art production for Grant Wood. During the spring of 1936 he completed twenty drawings in crayon and gouache for illustrations in a children's book by Madeline Darrough Horn entitled *Farm on the Hill* (Figures 136–140, 186, 187, 188). Later in the year he designed a book jacket for *Plowing on Sunday* by Sterling North (Figure 127) and one for *O Chautauqua* by Thomas Duncan (Figure 128). Also, the first sketches for *Main Street* reached New York in January 1936, and by December William Kittredge of Lakeside Press, Chicago, the printer, received the finished drawings (Figures 114, 116–122). The ninth drawing, *Village Slums* (Figure 115), arrived later, in March 1937. (Correspondence between George Macy and Grant Wood, George Macy Companies, Inc., New York City.) In 1937 Wood began a series of nineteen lithographs for distribution by the Associated American Artists, New York City. By the end of that year he had completed five.

22. That *Main Street* in particular stemmed from Lewis' experiences while growing up in Sauk Center, Minnesota, is detailed by Mark Schorer, *Sinclair Lewis, An American Life* (New York, 1961), p. 273. Lewis confessed his love for the leading characters in *Main Street* and for several of the supporting people, despite their lack of conscious intelligence. As quoted in Schorer, *Lewis*, p. 301. To Mencken, Lewis wrote that Babbitt was not all boob, that in fact he tried to keep his "Solid Citizen" from being merely burlesque and indeed found him lovable. As quoted in Schorer, *Lewis*, pp. 291, 302. Contrary to Mencken, the Nietzschean elitist, Lewis kept his democratic faith. While neither he nor Grant Wood had clear-cut partisan convictions in politics, they both remained essentially liberals despite the antiprogressivist mood in the 1920s.

23. Sinclair Lewis, *Main Street, the Story of Carol Kennicott* (New York, 1922), Chapter 20, Part II, p. 242.

24. For example, journalism professor Frank Luther Mott of the University of Iowa posed for *The Booster*; Dr. Sherman Maxon, the son of the artist's wife Sara, masqueraded as *The Radical*; and the model for *The Good Influence* was Mrs. Mollie Green, hostess at an Iowa City hotel restaurant. Personal interview with George D. Stoddard, former dean at the University of Iowa, Spring 1973.

25. Lewis, *Main Street*, Chapter 15, Part VII, p. 185.

26. *Ibid.*, Chapter 35, Part III, p. 413.

27. *Ibid.*, Chapter 16, Part V, pp. 201–202.

28. *Ibid.*, Chapter 31, Part III, p. 374.

29. *Ibid.*, Chapter 16, Part VI, p. 204.

30. *Ibid.*, Chapter 12, Part I, p. 146.

31. *Ibid.*, Chapter 39, Part II, p. 445.

32. *Ibid.*, Chapter 21, Part I, p. 250.

33. A lithograph, *Family Doctor*, 1941, commissioned by Abbott Laboratories, Chicago, focuses on the same slender hands holding a stethoscope and thermometer over a pocket watch. The hands belonged to Wood's physician, Dr. A. W. Bennett of Iowa City.

Mark Schorer submitted that Carol and Will Kennicott represent the two halves of Lewis' nature: the one discontented and intolerant of her surroundings and the other complacent. A Lewis quotation admits to the former. See Schorer, *Sinclair Lewis*, p. 286.

34. Sinclair Lewis apparently accepted Wood's interpretations, for he wished to buy at least two of the original drawings. His desire was relayed to Wood in letters from George Macy in 1936. Correspondence file of George Macy Companies, Inc., New York City.

35. Alfred Kazin, *On Native Grounds* (New York, 1956), pp. 174–180.

36. Charles Manson, the secretary, was embarrassed by this exposure when it suddenly appeared at a dinner commemorating his devoted service. Conversation with Gordon Fennell, Cedar Rapids, Iowa, Summer 1973.

37. "A Portfolio of Posters," *Fortune* magazine, 24 (August 1941), p. 79.

38. Correspondence between George Macy and Grant Wood from December 1937 to January 1941. Correspondence files of George Macy Companies, Inc., New York City.

## Chapter 6. Success Turned Cosmopolitan

1. The first talk Wood gave after *American Gothic* was to the fourth annual regional conference of the American Federation of Arts in Kansas City, Missouri.

2. As late in his career as February 1940 Grant Wood lectured on regional art at U.C.L.A. and at the University of California, Berkeley.

3. "The Long Voyage Home as Seen and Painted by Nine American Artists," *American Artist*, 4 (September 1940), pp. 4–14. The other painters were Thomas Hart Benton, Ernest Fiene, Robert Philipp, James Chapin, Raphael Soyer, George Biddle, George Schreiber, and Luis Quintanilla. The paintings of the movie traveled as an Associated American Artists exhibition throughout the country.

Grant Wood's painting *Sentimental Ballad* was purchased by Walter Wanger. It depicts a group of seamen, including a Norwegian, a Swede, and a Cockney, on shore leave in a Limehouse pub after a long voyage through a war zone. Grant Wood rearranged the actual scene to accent Barry Fitzgerald, whom he seated alone at a table. From an extremely low eye level, the observer assumes a seat in the movie audience and looks up at the revelers. From left to right, photographic action-portraits picture the actors John Qualen, John Wayne, Thomas Mitchell, Joseph Sawyer, David Hughes, and Jack Pennick. The dizzying angles they assume comply with Wood's method of composing a painting by "thirds" along each edge. The bright, ruddy faces, Wayne's pink tie, the patterned jacket, scarf, cap, and trousers emerge as spotlighted from a murky background of stippled browns and dark gray.

4. The foremost of the American quasi-Surrealists, Peter Blume, gained fame during the winter and spring of 1930–1931 with his paintings *Parade* and *South of Scranton* (Figure 98). In 1934 he won first prize at the Carnegie International, where Grant Wood's *Dinner for Threshers*, while not awarded, was voted most popular by the visiting public.

Although undoubtedly coincidental, an even closer resemblance may be seen between the composition of Wood's first book cover and the Museum of Modern Art's example of Edward Hicks' various versions of *Peaceable Kingdom*. The Quaker Hicks (1780–1849) was a true folk-art primitive and as a religious man considered painting "the inseparable companion of voluptuousness and pride . . . enrolled among the premonitory symptoms of the rapid decline of the American Republic." See Edward Hicks, *Memoirs of the Life and Religious Labors of Edward Hicks* (Philadelphia, 1851), p. 71.

5. Grant Wood based his drawing for the cover on a sculpture prepared for him by Florence Sprague, then head of the Plastic Arts Department at Drake University. She worked from a live model selected by Arnold Pyle from Stone City Art Colony students in the summer of 1933 ("Artist, Sculptor Use Their Imaginations for Design," *Des Moines Register*, January 28, 1934.)

6. A group of unresolved pencil sketches assailing the disastrous 1938 Munich conference caricature Hitler as a snarling wolf and the deceived Chamberlain as a weak-kneed lamb. Left in a drawing pad at Wood's death, the sketches progress from rough to finished as if intended for one of his more unorthodox paintings or, more traditionally in keeping

with such a subject, an edition of lithographs.

7. Book review section, *Boston Evening Transcript*, July 22, 1939.

8. See John Drury, *Historic Midwest Houses* (Minneapolis, 1947), "American Gothic, Grant Wood House. Iowa City. Built 1858," pp. 129–131. See also Park Rinard, "Grant Wood Restores an Heritage of Charm," *Our Home*, No. 2, 1939, pp. 16–17.

9. They were married March 2, 1935, separated in September 1938, and divorced in 1939.

10. Clubs and societies had formed a significant diversion first in Cedar Rapids and later in Iowa City. In the twenties Wood and a group of friends founded a lunch society called the Garlic Club, the name derived from a habit he had acquired in Paris of rubbing garlic in a bowl before tossing salad.

After going to Iowa City to teach at the university, Wood lunched regularly with journalism professor Frank Luther Mott at Smith's Cafe near the campus and through him joined another society. In the late twenties Mott too had formed a lunch club with the aid of John Townes Frederick, editor of *The Midland*, a literary magazine intended to encourage literature in the Middle West. Called the Saturday Luncheon Club, its purpose was to invite leading American writers to informal meals where they might talk casually at the table, departing from the usual practice of a formal speech or lecture. Sherwood Anderson, Joseph Wood Krutch, e. e. cummings, Robert Frost, Carl Sandburg, and Henry A. Wallace were some of their guests.

In 1934 the Saturday Luncheon Club reorganized itself into The Times Club with a membership limited to three hundred. To enhance an atmosphere of informality, Mott and Wood in addition originated the Society for the Prevention of Cruelty to Speakers. A two-room "clubhouse" above Smith's, consisting of dining and sitting rooms, was obtained rent-free from the owner for the Society and decorated in what Grant Wood described as "the worst style of the late Victorian period." Following their talks, refreshments and improvised entertainment in the clubhouse were to amuse and relax such "interesting people" as Stephen Vincent Benét, John Erskine, MacKinlay Kantor, Gilbert Seldes, and Nicholas Roosevelt, who also agreed to pose in old-fashioned costumes for "stunt" photographs.

The black musicians Rosamund Johnson and W. C. Handy and black poets James Weldon Johnson, Countee Cullen, and Langston Hughes numbered among the guest speakers. Gertrude Stein had also accepted an invitation but because her plane was grounded failed to appear. See Frank Luther Mott, *Time Enough, Essays in Autobiography* (Chapel Hill, North Carolina, 1962), pp. 134–143.

11. Edward Alden Jewell, "Visions That Stir the Mural Pulse," *New York Times*, May 27, 1934.

12. Adeline Taylor, "Easterners Look Wistfully at Midwest as Nation's Art Crown Brought to It; Grant Wood Lionized on New York Visit," *Cedar Rapids Gazette*, October 21, 1934.

13. In Cedar Rapids Wood had given paintings to his friends and neighbors or sold them at token prices. In late 1930 he was pleased to receive a three-hundred-dollar purchase award for *American Gothic* from the Chicago Art Institute. For *Victorian Survival, Portrait of Nan, Fall Plowing,* and *Arbor Day* he raised his price to five hundred dollars.

*Birthplace of Herbert Hoover* was priced at six hundred and *Daughters of Revolution* seven hundred. *Midnight Ride of Paul Revere* sold for four hundred dollars. A personal price list is in the possession of the artist's sister, Mrs. Nan Wood Graham, Riverside, California.

14. Mrs. Marquand purchased *Spring Turning* in 1945 when it was resold by Maynard Walker.

15. Edward G. Robinson sold *Daughters of Revolution* for $67,000 in 1958 to the Greek shipping magnate Stavros Niarchos, who in turn sold it to the Cincinnati Museum. Maynard Walker sold *Dinner for Threshers* three times: first to Stephen Clark, then to Edwin Hewitt, and finally to George M. Moffett. A few years ago Wildenstein & Co. sold the painting once more to a private collector in New York.

16. Adeline Taylor, "Easterners Look Wistfully at Midwest," *Cedar Rapids Gazette*, October 21, 1934.

17. Jewell, "Visions That Stir the Mural Pulse," *New York Times*, May 27, 1934.

18. Taylor, "Easterners Look Wistfully at Midwest," *Cedar Rapids Gazette*, October 21, 1934.

19. *Ibid.*

20. Wood, *Revolt Against the City*, p. 27.

21. Edna Barrett Jackson, "Cedar Rapids' Art Colony, Seed Sown in Turner Alley," *Cedar Rapids Republican*, September 12, 1926. Other members of the Fine Arts Studio ready to participate in the colony were Ernest A. Leo, a music teacher; Bernice Ladd, an acting instructor working in Chicago; Bonnie Fisher, a dancer; and Flora Hromatko-Taylor, a violinist. Several business friends of Grant Wood, including Dave Turner, Henry Ely, and John Reid, were looked to for help in raising financial support.

22. Hazel Brown, *Grant Wood and Marvin Cone, Artists of an Era* (Ames, Iowa, 1972), pp. 42–43.

23. In 1929 Wood hung an exhibition of his work in the Little Gallery which included three recent portraits and flower studies but featured a large number of small oils done during his trip to Germany.

24. Report of the Little Gallery to the Fifth Annual Regional Conference of the American Federation of Arts, March 31, 1932; "Experiment in Cedar Rapids," Edward Rowan Papers, Archives of American Art, National Collection of Fine Arts Library, Smithsonian Institution, Washington, D.C.

25. The faculty consisted of Marvin Cone, figure drawing; David McCosh, composition; Arnold Pyle, framing and painting; Adrian Dornbush, painting; Grant Wood, advanced painting; and Edward Rowan, art appreciation and theory. Grace Boston of Cedar Rapids functioned as business manager. For the second summer Francis Chapin, lithography, and Florence Sprague, sculpture, joined the faculty.

26. Robert Cron, "Iowa Artists Club Forms Art Colony in Deserted Stone City Mansion," *Des Moines Sunday Register*, May 8, 1932. See also Grace Boston, "Stone City Is Ideal for Colony and Art School Planned by Cedar Rapids Artists," *Cedar Rapids Sunday Gazette and Republican*, May 15, 1932.

27. Faculty members slept in a row of fourteen horse-drawn ice wagons contributed to the colony by Joseph T. Chadima, owner of the Hubbard Ice Company (Ralph Clements, *Tales of the Town, Little-known Anec-*

*dotes of Life in Cedar Rapids* [Cedar Rapids, Iowa, 1967], p. 96). The painters decorated the sides of their wagons, Grant Wood indulging his fantasy with a mountain scene (Figure 133).

28. The average number of visitors for each of the first five Sundays was a thousand people and twice that for the last day of the session. Most came from nearby farms and small towns, but some came from around the state and from across the Mississippi. A ten-cent admission helped cover expenses. The band from the Men's Reformatory in Anamosa furnished entertainment along with local poets, singers, and folk musicians. Fifteen dollars, the standard asking price for a painting, usually declined to whatever offer was made, and toward evening remnants were auctioned off. Frederick A. Whiting, "Stone, Steel and Fire," *American Magazine of Art*, 25 (December 1932), pp. 339–340.

29. Its treasurer, John Reid, President of National Oats Company, and Grant Wood planned to issue stock and buy the ten acres of land and buildings rented at Stone City. Furthermore, the Carnegie Corporation contributed a thousand dollars to extend the project. This sum was finally used for paying off debts. Edward Rowan, "Notes on Stone City," Stone City Scrapbook, Edward Rowan Papers, Archives of American Art, National Collection of Fine Arts Library, Smithsonian Institution, Washington, D.C.

30. Edward Rowan, appointed Assistant Technical Director of the PWAP, moved to Washington, D.C. He subsequently assisted Edward Bruce in the Section of Fine Arts of the Department of the Treasury.

31. University President Walter Jessup and Professor Rufus H. Fitzgerald, Director of the School of Fine Arts, persuaded the conservative acting head of the Department of Graphic and Plastic Arts, Professor Catherine Macartney, to recommend Grant Wood for a position as lecturer for the period January 1 to June 1, 1934. Jessup had in the preceding year procured $200,000 for a new art building, mainly from the Carnegie Foundation and the federal government, and was anxious to bring an internationally known artist and his student assistants onto the campus.

The School of Fine Arts dated back to 1909 when Charles A. Cumming, a beaux-arts academician, institutionalized his dominance over art training in Iowa. The art faculty consisted of his former students, all of whom were members of the Iowa Art Guild founded by him as a means of protecting academic classicism from realism, Impressionism, or any radical post-Impressionist developments. Upon his retirement in 1927 his disciples, including Miss Macartney, stood intact ready to continue the grand tradition.

In opposition to the conservatives, realists with tendencies toward moderately modern styles of expression organized the Iowa Artists Club in the late twenties and enjoyed the encouragement of Edward Rowan 'and the Little Gallery. A motivating factor behind the Stone City Colony was to provide a liberal training unavailable at the university.

The arrival of Wood and his PWAP group at the university in 1934 represented a major coup for the liberal faction. Despite a clash between the Macartney group and the Wood group during the spring student exhibition, Wood rose to an associate professorship in the fall with plans and funds to carry out the murals at Iowa State University in Ames plus murals for the State Historical Library at Des Moines.

From letters and memos written by R. H. Fitzgerald, Director of the School of Fine Arts, University of Iowa, from March 1934 into the fall. Manuscript Collection, Special Collections, University of Iowa Library, Iowa City, Iowa.

32. The oil-on-canvas murals for the Iowa State University Library staircase, begun in the spring of 1934, reached their walls in three stages. The first three panels represent *Veterinary Medicine, Farm Crops,* and *Animal Husbandry* as an integrated barnyard triptych (Figure 190). The second group, equally appropriate for a college of agriculture and mechanical arts, illustrate *Ceramics and Chemistry, Mechanical Engineering,* and *Aeronautics and Civil Engineering.* A narrow pair of window-flanking panels, above the landing, depict *Childcare* and *Home Economics.*

Dedicated to technological advance, the subjects were arranged in a strict symmetrical order of equipment, machinery, and men as a composition of parallel diagonals, overlaying a "grid" of horizontals and verticals. Intricately detailed settings, clothing, and machines intensify through their multiplication an expressionless automation among the figures. The color scheme consists of low-keyed tones of yellow ochre, red, black, white, and denim-blue. A predominance of yellow ochre relates to the yellowish Minnesota travertine of the architecture.

On June 16, 1937, an additional three-panel oil-on-canvas mural depicting pioneer farmers clearing the land and plowing (Figure 189) was installed in a twenty-three-foot alcove in the lower lobby of the Iowa State University library. Again sketched, drawn, and designed by Wood, the actual painting progressed in the hands of eight student assistants, supervised in this case by Francis McCray, an instructor of figure drawing at the University of Iowa. The central panel is eleven feet high; the end panels are both eleven by nine feet. ("Iowa State University Library Murals," *Messenger-Chronicle*, Fort Dodge, Iowa, June 17, 1937).

A quotation from Daniel Webster, "When tillage begins, other arts follow. The farmers therefore are the founders of human civilization," supplied the theme of the alcove panels as a prelude to the murals of the staircase. Six more panels were to represent the fine arts in the reading room of the library but they never reached even a sketch state.

33. Grant Wood to Edward Alden Jewell, quoted in "Visions That Stir the Mural Pulse," *New York Times*, May 27, 1934. The federal government actually continued to fund the murals, and with the aid of another Carnegie grant Wood planned to carry forward other projects, including murals for the State Historical Library in Des Moines. Typescripts of letters written by R. H. Fitzgerald, Director of Fine Arts, University of Iowa. Manuscript Collection, Special Collections, University of Iowa Library, Iowa City, Iowa.

34. Grant Wood repeated this same argument throughout 1934 and 1935. It appears in several interviews and newspaper articles as well as in his essay *Revolt Against the City*. See "Holds Art of the Future Must 'Mean Something'—Reach the People. Urges Federal Backing," *New York Sun*, October 10, 1934; Adeline Taylor, "Cedar Rapids Artist Sponsors Movement for Native Art by Regional Development with Federal Backing," *Cedar Rapids Gazette*, October 21, 1934; Wood, *Revolt Against the City*, pp. 39–43.

35. "Holds Art of the Future Must 'Mean Something,'" *New York Sun*, October 10, 1934.
36. Wood, *Revolt Against the City*, pp. 41–42.
37. As quoted by Gordon Hendricks, *The Life and Work of Thomas Eakins* (New York, 1974), pp. 270–271.

### Chapter 7. Regionalism Precipitated

1. *Time*, (December 24, 1934), pp. 24–27.
2. "Aim of the Colony," Stone City Colony and Art School Brochure, Stone City, Iowa, Summer 1933.
3. Letters to John Steuart Curry, Westport, Connecticut, from Grant Wood, Iowa City, John Steuart Curry Papers, Archives of American Art, National Collection of Fine Arts Library, Smithsonian Institution, Washington, D.C. The letter of April 16, 1936, encourages Curry to return to Kansas with the possibility of teaching at Stephens College. William Allen White in Emporia, Kansas, had also suggested Kansas Agricultural College. A letter dated April 23, 1936, mentions a teaching position at the University of Illinois.
4. Thomas Hart Benton, *An Artist in America* (New York, 1937), pp. 258–259. Benton attended a dinner given for Grant Wood by Ann Hardin, sister of Ring Lardner, in New York City in October 1934. Wood introduced Benton's lecture in Des Moines, Iowa, January 20, 1935, and entertained him in Iowa City three days later. In a letter to Maynard Walker, his New York dealer, December 22, 1934, Wood judged Benton's lecture trip to the Midwest "a very wise move" since "the middle western field is going to open up one of these days in a big way for Benton, Curry and myself." Regarding a convergence or alliance of Wood, Benton, and Curry, Wood wrote, "I'm serious when I say that Curry and Benton should be coming into the territory soon. Sara [Wood's wife] is working on it, is up in Minneapolis now, and the *Time* article should help a lot." (Archives of American Art, National Collection of Fine Arts Library, Smithsonian Institution, Washington, D.C.)
5. John Steuart Curry, address to students at the University of Wisconsin, Madison, as quoted by Laurence E. Schmeckebier, *John Steuart Curry's Pageant of America* (New York, 1943) pp. 123–124.
6. Grant Wood, "John Steuart Curry and the Midwest," *Demcourier*, 11 (April 1941), pp. 2–5.
7. Thomas Hart Benton, "American Regionalism, a Personal History of the Movement," *The University of Kansas City Review*, 18 (Autumn 1951), p. 42.
8. *Ibid.*, pp. 43–44. See also Thomas Hart Benton, "What's Holding Back American Art?," *Saturday Review of Literature*, 34 (December 15, 1951), pp. 9–11, p. 38. Benton ended this article by conveying his attempts to console Wood and Curry during their last days against oversensitivity to harsh criticism and the decline in public taste for their pictures.
9. See Bret Waller, "Curry and the Critics," *Kansas Quarterly* special issue on John Steuart Curry, 2 (Fall 1970), pp. 42–55.
10. Milton Brown, "From Salon to Saloon," *Parnassus*, 13 (May 1941), p. 194.
11. See H. W. Janson, "The International Aspects of Regionalism," *College Art Journal*, 2 (May 1943), pp. 110–115. Three years later Janson wrote a lengthy, inaccurately researched article unconditionally condemning Benton and Wood as enemies of modern art comparable to the *Reichskulturkammer* of Nazi Germany. See "Benton and Wood, Champions of Regionalism," *Magazine of Art*, 39 (May 1946), pp. 184–186, pp. 198–200.
12. Samuel Kootz, *New Frontiers in American Painting* (New York, 1943), pp. 10–14.
13. Peyton Boswell, "New Year's," *Art Digest*, 1 (January 1, 1927), p. 8.
14. Lewis Mumford, "American Taste," *Art Digest*, 2 (October 1, 1927), p. 11.
15. "Even a Colonial Kitchen Was Beautiful," *Art Digest*, 2 (February 1, 1928), p. 12.
16. *Art Digest*, 5 (September 1, 1931), p. 5.
17. *Art Digest*, 1 (December 1, 1926), p. 7.
18. Benton, "American Regionalism," p. 41.
19. "New York Season," *Art Digest*, 5 (Mid-October 1930), p. 16.
20. "Sculptor Wins First Prize at Chicago's Annual Exhibition," *Art Digest*, 5 (November 1, 1930), p. 6.
21. "Water Color Annual," *Art Digest*, 5 (November 15, 1930), p. 8.
22. "Dr. Mather's View," *Art Digest*, 5 (December 1, 1930), p. 19.
23. "The South's Challenge," *Art Digest*, 2 (October 15, 1927), p. 1.
24. Dorothy Grafly of the *Philadelphia Public Ledger* quoted in "Wants Protection," *Art Digest*, 2 (Mid-April 1928), p. 3.
25. Albert Sterner, "Assails French Art," *Art Digest*, 5 (November 15, 1930), p. 19.
26. "Roughnecks," *Art Digest*, 5 (March 1, 1931), p. 23.

### Chapter 8. Regionalism *vs.* the Industrial City

1. John Crowe Ransom et al., *I'll Take My Stand* (New York, 1930).
2. Benton, "American Regionalism," p. 41.
3. Wood, *Revolt Against the City*, p. 9.
4. Josiah Royce, *Race Questions, Provincialism, and Other American Problems* (New York, 1908), p. 61.
In 1902 Royce delivered a Phi Beta Kappa address at Iowa State University in which he stressed his theory of "Higher Provincialism." A "genuine provincial spirit" protective of regional uniqueness must be preserved, Royce told his Midwestern audience, as a means of combating "national industrialism" and "mass culture." According to Frank Luther Mott, this warning from Royce greatly impressed Clarke F. Ansley, head of the English Department at the university, who became a faithful exponent of "the new regionalism in American literature." "Ansley's young men" under the direction of John Townes Frederick founded *The Midland* in 1915 as a nonprofit literary magazine meant to compete against "the domination of commercial expediency in the literary world" centered in New York. From the beginning, however, the material printed in *The Midland* came from all parts of the country, and in 1930 Frederick changed its subtitle to "A National Literary Magazine." He moved its office to Chicago, where it expired in 1933, a victim of the Depression.
See Frank Luther Mott, *Time Enough, Essays in Autobiography* (Chapel Hill, North Carolina, 1962), pp. 124–130.

5. See R. H. Wilenski, *John Ruskin* (New York, 1967), pp. 192–243.
6. In 1933 T. S. Eliot delivered a series of lectures at the University of Virginia in which he explained his theory of homogeneous community. Discussed by Alexander Karanikas, *Tillers of a Myth, Southern Agrarians as Social and Literary Critics* (Madison, Wisconsin, 1969), p. 93.
7. Donald Davidson, "The Trend of Literature," *Culture in the South*, ed. W. T. Couch (Chapel Hill, North Carolina, 1935), pp. 198–199.
8. Wood, *Revolt Against the City*, p. 21.
9. *Ibid.*, p. 23.
10. *Ibid.*, p. 24.
11. *Ibid.*, pp. 22–23.
12. "Grant Wood Explains Why He Prefers to Remain in Middle West in Talk at Kansas City," *Cedar Rapids Sunday Gazette and Republican*, March 22, 1931.
13. Wood, *Revolt Against the City*, p. 19.
14. *Ibid.*
15. "Iowa Cows Give Grant Wood His Best Thoughts," *New York Herald Tribune*, January 23, 1936.
16. Benton, *An Artist in America*, pp. 261–269.
17. *Ibid.*, p. 262.
18. Thomas Hart Benton, *An American in Art* (Lawrence, Kansas, 1969), pp. 265–266.
19. Benton, *An Artist in America*, p. 41.
20. *Ibid.*, p. 63.
21. John Crowe Ransom, "Reconstructed But Unregenerate," in *I'll Take My Stand*, Ransom et al., pp. 19–20.
22. Benton, "American Regionalism," p. 43.
23. Benton, *Artist in America*, p. 29.
24. *Ibid.*
25. Unpublished manuscript in the possession of Mrs. Nan Wood Graham, Riverside, California. Inquiry is dated October 1937. Grant Wood's reply is dated November 16, 1937.
26. *Ibid.*
27. *Ibid.*
28. Ernest A. Batchelder, *Design in Theory and Practice* (New York, 1910), p. 261.
29. Grant Wood specialized in resurfacing walls with a textured plaster stained to achieve an aged stucco appearance which he complemented with built-in cabinets, shelves and niches (Figure 15). For accessories to this setting he designed foliated, latticework candle holders (Figure 147) duplicated in wrought iron by his cousin George Keeler, a metalworker, and fashioned his own copper pots. For the waiting room of Frances Prescott's office at McKinley High School he created an oak "mourner's bench" to be used by students sent to the principal for discipline. He carved its Gothic back rest with three grotesque heads and a punning, tongue-in-cheek inscription (Figure 146).
30. Letter from O. K. Burrows, Personnel Administration, Cherry-Burrell Corporation, to E. M. Giles, General Office, dated March 24, 1958. For each of the portraits, which were painted from photographs he himself took, Grant Wood received twenty-five to thirty-five dollars, depending on the size of the frames, which he also made. Another painting in this same commission viewed the J. G. Cherry factory building (Figure 162).

*Ten Tons of Accuracy* is not in its original condition. Sometime in the 1940s it was reproduced as an illustration for a piece of direct mail regarding the manufacturing of ice cream freezers and was "sharpened" for the purpose. (Personal interview with O. K. Burrows, November 1974. Burrows was assistant advertising manager of the Cherry Company in 1925 and was in charge of the commission for the paintings and their display in Indianapolis.)
31. Wood, *Revolt Against the City*, p. 32.
32. Wood, "John Steuart Curry and the Midwest," p. 3.
33. Thomas Hart Benton, "Form and the Subject," *Arts*, 5 (June 1924), p. 306.
34. Benton, *An American in Art*, p. 48.
35. Benton, "Form and the Subject," p. 306.

## Chapter 9. Art Theory for Rural Regionalism

1. Davidson, "The Trend of Literature," pp. 198–199.
2. Allen Tate, "Regionalism and Sectionalism," *New Republic*, 69 (December 21, 1931), pp. 158–160.
3. Robert Penn Warren, "Some Don'ts for Literary Regionalists," *American Review*, 8 (December 1936), pp. 146–150.
4. This trio of grotesque figures also exposes Benton's anti-Semitic, anti-intellectual, and antihomosexual prejudices.
5. See Matthew Baigell, ed., *A Thomas Hart Benton Miscellany* (Lawrence, Kansas, 1971), pp. 39–65, 111–156.
6. John Steuart Curry, "What Should the American Paint," *Art Digest*, 9 (September 1935), p. 29. Curry singled out a painting by Jacob Burck of a striker being attacked by mine guards as one of the few propaganda pictures that has "enough reality to be remembered."
7. Thomas Hart Benton, *Arts of Life in America* (New York, 1932), p. 13.
8. Helen Lieban, "Thomas Benton—American Mural Painter," *Design*, 36 (December 1934), p. 26.
9. Ruth Pickering, "Thomas Hart Benton on His Way Back to Missouri," *Arts and Decoration*, 42 (February 1935), p. 20.
10. Donald Davidson, *The Attack on Leviathan* (Chapel Hill, North Carolina, 1938), pp. 82–83.
11. Thomas Hart Benton, "Art and Nationalism," *The Modern Monthly*, 8 (May 1934), pp. 232–236. Originally this article was presented as a lecture to the New York section of the John Reed Club.
12. Letter from Grant Wood to Howard Johnson, undated, on Stone City Colony and Art School stationery, in possession of Howard Pyle, Cedar Rapids, Iowa.

Edward Bruce, chief organizer of the short-termed PWAP and later Director of the Treasury Department Section of Fine Arts, which he hoped would become permanent, declared his preference for paintings that made him "feel comfortable about America." Speech delivered to Roosevelt cabinet meeting, 1937. Quoted by Richard McKinzie, *The New Deal for Artists* (Princeton, New Jersey, 1973), p. 57.
13. Grant Wood was selected by an advisory committee appointed by the Section to paint a mural for an entranceway in the new post office building in Washington, D.C. See *Cedar Rapids Gazette*, April 21, 1935. He was one of eleven painters chosen, along with Thomas Hart Benton,

George Biddle, John Steuart Curry, Rockwell Kent, Eugene Savage, Leon Kroll, Reginald Marsh, Henry Varnum Poor, Boardman Robinson, and Maurice Sterne. Wood resigned from the group "on account of previous commitments," including the Iowa State University Library murals begun under the auspices of the PWAP. See McKinzie, *The New Deal for Artists*, p. 58. See also Olin Dow, "The New Deal's Treasury Art Program: A Memoir," *Arts and Society*, 4 (1963–1964), p. 59. As an assistant to the director, Edward Bruce, Dow was in charge of Section projects east of the Mississippi River.

14. Stone City Colony and Art School Brochure, Stone City, Iowa, Summer 1933.

15. Thus in spite of the brochure's final paragraph inviting any painter with a "definite message" to use any means of expressing it, conservative, eclectic, or radical, Wood and Dornbush both apparently discouraged whatever they considered extremes of nature-distorting abstraction at the risk of producing an ingrown standardization of subject matter or stylistic conformity. As Dornbush simplistically summed up the situation: "There was complete freedom of subject matter as long as it was understandable." See Edward Rowan, "Notes on Stone City," Stone City Scrapbook, Edward Rowan Papers, Archives of American Art, National Collection of Fine Arts Library, Smithsonian Institution, Washington, D.C.

16. Wood's concern about the loss of content to technique was not limited to traditional landscapes. Regarding his painting *Stone City* he stated: "Too damn many pretty curves, too many personal mannerisms caused by fear that because of a close style of painting I might be accused of being photographic. I am having a hell of a time getting rid of such mannerisms." As quoted by Forbes Watson, "The Phenomenal Professor Wood," *American Magazine of Art*, 28 (May 1933), p. 285.

17. See Howard W. Odum and Harry E. Moore, *American Regionalism* (New York, 1938), pp. 3–51, 168–187. For a critical discussion of Odum's regionalism as attacked from a Southern Agrarian point of view, see Donald Davidson, Chapter XIV, "Howard Odum and the Sociological Proteus," *The Attack on Leviathan*, pp. 285–311.

18. Wood, *Revolt Against the City*, p. 39.

19. *Ibid.*, p. 29.

20. *Ibid.*, p. 37.

21. *Ibid.*, p. 25.

22. *Ibid.*, p. 26.

23. Quoted by Peyton Boswell in "Wood, Hard Bitten," *Art Digest*, 10 (February 1, 1936), p. 18.

24. Wood, *Revolt Against the City*, p. 38.

25. "Indiana Artists Termed 'Local Color Painters' by Grant Wood; Sees Work as 'Not Good Material,'" *Indianapolis Times*, February 26, 1935.

26. Wood's letter is quoted in full in a Letter to the Editor from Cyril Clemens, *Saturday Review of Literature*, 25 (February 28, 1942), p. 11.

27. Witness the lasting popularity of Norman Rockwell, who forthrightly insists that he is simply an illustrator.

28. "Grant Wood Explains Why He Prefers to Remain in Middle West," *Cedar Rapids Sunday Gazette and Republican*, March 22, 1931.

29. Tate, "Regionalism and Sectionalism," pp. 58–60.

## Chapter 10. Social Background: the Noble Yeoman

1. Grant Wood's difficulties in the department of art derived primarily from a conflict between studio work and academic studies. As he explained in a letter to the Director of the School of Fine Arts, January 26, 1940, he conceived of the art curriculum at the university as a program of "creative work" in which the art student could develop without "being overwhelmed" by academic, "fact memorizing" requirements, in particular by courses in art history. Wood was of the opinion that Lester B. Longman, an art historian and chairman of the department since 1936, overemphasized the historical approach. This, he believed, diverted students of painting from deliberate methods of figure study, composition design, color, and value.

At the end of 1940 the painter-illustrator Fletcher Martin, a visiting instructor in the department, accused Wood of tracing photographs for portrait heads as well as training his students to paint exactly as he did in order to utilize their work as major parts of his paintings. While Longman discounted the second charge, he too disparaged Wood's ability to draw and criticized his portrait figures for their dependence on photographs. He also accused Wood of overpublicizing himself. Such personal attacks led to a complete impasse between the two, which ironically forced them into a compromise solution.

Upon his return from a leave of absence during the year 1940–1941, Wood was to have his own separately budgeted studio where he would teach a course in advanced oil painting to graduate students and advanced undergraduates. A separate enrollment for unclassified students wishing to work only with Grant Wood would be administered through the office of the School of Fine Arts Director. However, any degree candidate taking Wood's course was to meet all academic as well as studio requirements and prepare a thesis within the art department. No students were to work on commissioned paintings, for example murals, during class hours for academic credit. Wood agreed to this arrangement but became fatally ill before the beginning of the new academic year.

From letters, memoranda, reports, and typescripts of interviews dating from January 26, 1940 to June 28, 1941. Manuscript Collection, Special Collections, University of Iowa Library, Iowa City, Iowa.

2. Letter from Grant Wood to King Vidor, April 26, 1941, in possession of King Vidor, Beverly Hills, California.

3. From one billion dollars in 1919, Iowa's farm income dropped to three hundred and thirty-six million dollars in 1921 and fluctuated between four hundred and six hundred million dollars for the remainder of the decade. The average gross income on Iowa farms of two thousand dollars in 1919 sank to fifteen hundred in 1921. After a brief rise in 1924, the average remained below two thousand until 1930, when it slid even lower. Howard Bowen, *Iowa Income: 1909–1934* (Iowa City, Iowa, 1935), pp. 10–25.

4. Theodore Saluotos and John D. Hicks, *Agricultural Discontent in the Middle West: 1900–1939* (Madison, Wisconsin, 1951), pp. 435–448.

5. David A. Shannon, *Twentieth Century America* (Chicago, 1963), pp. 334–335.

6. Rural population of Iowa declined by approximately 170,000 inhabitants from the beginning of the century to 1930. In the 1920s alone its

urban population increased by ten per cent. During the same decade the population of cities over 25,000 rose by one-third. U.S. Bureau of Census, Fifteenth Census of the United States, 1930.

7. Wood, *Revolt Against the City*, p. 33.
8. An inscription on the frame that Wood made for *Young Corn* reads "To the memory of Miss Linnie Schloeman whose interest in young and growing things made her a beloved teacher in Woodrow Wilson School."
9. In the only completed chapter of his autobiography begun in 1935 Wood wrote of the joys of his boyhood on the farm. "Return from Bohemia," 128-page typescript, Archives of American Art, National Collection of Fine Arts Library, Smithsonian Institution, Washington, D.C.
10. Wood, *Revolt Against the City*, p. 31.
11. Richard Hofstadter, *The Age of Reform* (New York, 1955), pp. 62–77.
12. *Ibid.*, pp. 125–128.
13. *Ibid.*, pp. 82, 121–124.
14. *Elkader Register*, March 31, 1921, as cited in Don S. Kirschner, *City and Country: Rural Responses to Urbanization in the Twenties* (Westport, Connecticut, 1970), p. 27.
15. *Wallace's Farmer*, June 8, 1923, as cited in Kirschner, *City and Country*, p. 49.
16. Wood, *Revolt Against the City*, p. 7.
17. *Ibid.*, p. 13.

### Chapter 11. Cultural Tradition: the Machine and the Garden

1. Henry Nash Smith, *Virgin Land: The American West as Symbol and Myth* (Cambridge, Massachusetts, 1950).
2. The first three chapters of Hofstadter's classic study of the Progressive Era, before and after, stand as the clearest and most attractively written essay demonstrating the use of the agrarian myth and its "soft" image of the yeoman as a shield against the "hard" commercial realities that American farmers as small businessmen had to accept, Populist rhetoric notwithstanding.
3. Leo Marx, *The Machine in the Garden; Technology and the Pastoral Ideal in America* (Oxford, England, 1964).
4. Three other recent books, though not centrally concerned with the agrarian myth or the garden ideal of pastoralism, evaluate social and cultural developments in the United States in terms of paradisiac myths of nature and relate to Wood's idealized pictures of nature as a decorative farmscape. *The American Adam* (Chicago, 1955) by R. W. B. Lewis examines the dialogue between two parties of American writers during the second quarter of the nineteenth century. There were those writers who looked to the future with great hope for an America thoroughly separated from Europe and the past, and those who looked nostalgically at the past, burdened by the doctrine of inherited sin and the conviction that the present and the future were incurably corrupt. *The Quest for Paradise* (Urbana, Illinois, 1961) by Charles L. Sanford interprets American culture as a manifestation of a myth of Eden which underlies such national preoccupations as moral regeneration, progress, and material success. In progressing westward from Europe in pursuit of paradise, Americans, he maintained, sought a standard for building a civilization

through inherited conventions of nature. Predictably they located the Garden of Eden at some midpoint between savagery and civilization in a rural landscape. In his book *Wilderness and the American Mind* (New Haven, Connecticut, 1967) Roderick Nash pointed out preferences for pastoral landscape from classical antiquity to the pioneer phase of American settlement and suggested that an instinctive attraction to open land and a natural abhorrence of the forest wilderness expressed itself in the release that settlers experienced in reaching the Western plains. The plains were seldom referred to as wilderness.

5. Douglas C. Stenerson, "Emerson and the Agrarian Traditon," *Journal of the History of Ideas*, 14 (January 1953), pp. 95–114.
6. Frank Lloyd Wright, *An Autobiography* (New York, 1943), p. 89.
7. *Ibid.*, p. 169.
8. *Ibid.*, p. 171.
9. *Ibid.*, p. 326.
10. As quoted by James Thomas Flexner, *That Wilder Image, The Painting of America's Native School From Thomas Cole to Winslow Homer* (New York, 1962), p. 34.
11. *The Country Gentleman*, 1 (January 13, 1853), p. 217.
12. *The Country Gentleman*, 1 (June 2, 1853), p. 346.

A half century later, when the rural population was decreasing rapidly, the new magazine *Country Life in America* appealed mainly to the wealthy to leave the congested cities and join the farmers as neighbors. Concurrently, the natives on the land were to stay put in harmony with their environment, a harmony which the magazine would inspire through picture articles regarding the "artistic in rural life" (*Country Life in America*, 1 [November 1901], pp. 24–25).

### Chapter 12. Pastoral Farmscapes for a Technological Society

1. Marx, *Machine in the Garden*, p. 25.
2. *Ibid.*
3. *Ibid.*, p. 26.
4. *Ibid.*, p. 141.
5. Generations of enlightened conservation could possibly approach the pastorial ideal of a continental garden if machinery were used only in organic relation to the topography and ecology of the land.
6. Marx failed to draw a distinction between the pastoral ideal of a garden and the agrarian myth which calls for the yeoman and subsistence farming. In fact, he equated the "true agrarians" with large-scale agriculture, while Jefferson and the Southern Agrarians considered agrarianism to be anti-industrial, anticommercial subsistence farming. *Machine in the Garden*, p. 126.
7. Wood compared the location of this painting with the Czechoslovakian neighborhoods in Cedar Rapids. He also considered both spring paintings of 1941 as patriotic statements in face of the encroaching war, representing the good life at stake, "inspired by a new appreciation of an America tranquil in a warring world, of democracy free and hopeful, of a country worth preserving." Interview with Grant Wood, *Cedar Rapids Gazette*, June 29, 1941.
8. The middle distant figure of *Approaching Storm* was incorporated as a symbolic accessory to Wood's *Portrait of Henry Wallace* for a *Time* magazine cover, September 23, 1940 (Figure 170). As a sequel to

*Approaching Storm*, the thunderhead was broken up into an angular pattern of white clouds allowing the sun to shine down on both the farmer and the Secretary of Agriculture.

9. A more domestic image of female predominance takes form in the illustrations Wood drew in 1936 for *Farm on the Hill,* the children's book by Madeline Darrough Horn dedicated to the preservation of the small family farm. In a matriarchal household Grandma rules, and she, along with Cora, the hired girl, acquires a monumentality in Wood's interpretation (Figure 186). Grandpa and Hank the hired man stop work to eat popcorn and a sandwich respectively, assuming poses and expressions which in addition to their stereotyped clothes mark them as innocent rustics (Figure 187).

10. Edwin Markham, *The Man With the Hoe and Other Poems* (New York, 1899), p. 17. Unlike *The Man With the Hoe,* another Millet figure, *The Sower,* became a popular image in the United States. For example, a version in sculpture by Lee Lawrie strides atop Nebraska's skyscraper capitol building in Lincoln.

11. This problem resulted in the most vulnerable and criticized aspect of Wood's teaching. Students, as is their wont, tended to copy his methods, circumventing directives of personal experience and maturation, thus becoming "little Grant Woods."

12. This formula was publicized by a reporter who witnessed a Wood critique in his art clinic at the University of Iowa in 1935. See *The Daily Iowan,* November 3, 1935.

13. Marx, *Machine in the Garden,* pp. 24–33.

14. As quoted by Marx, *Machine in the Garden,* p. 174, from a Thomas Carlyle essay of 1829, "Signs of the Times," which appeared in the *Edinburgh Review.*

15. Thomas Carlyle's skepticism toward the machine as the controlling symbol of a new age is concisely discussed in Marx, *Machine in the Garden,* pp. 170–180.

16. Jacques Ellul, *The Technological Society* (New York, 1964), pp. 390–410.

17. *Ibid.,* pp. 339–340.

18. Marx, *Machine in the Garden,* pp. 209–214.

# Index

*Page numbers in italics indicate illustrations*

# Photo Credits